Careers in Art

An Illustrated Guide

Second edition

WITHDRAW

Careers in Art
An Illustrated Guide

Second edition

Gerald F. Brommer

Joseph A. Gatto

DAVIS PUBLICATIONS, INC.
WORCESTER, MASSACHUSETTS

Careers in Art

Copyright © 1999
Davis Publications, Inc.
Worcester, Massachusetts U.S.A.

Publisher: Wyatt Wade
Editorial Director: Helen Ronan
Production Editor: Nancy Wood Bedau
Manufacturing Coordinator: Steven Vogelsang
Assistant Production Editor: Carol Harley
Editorial Assistance: Robin Banas
Copyeditor: Lynn Simon
Design: Jeannet Leendertse

Library of Congress Catalog Card Number:
98–071023
ISBN: 87192-377-7
10 9 8 7 6 5 4 3
Printed in the United States of America

Preface

Much of our environment has been designed by artists. Everything around us that is not part of the natural world is the product of artists' ideas and designs. Art is drawing, painting, sculpture, ceramics, and glass blowing, of course; but it is also hubcaps, shoes, chairs, buildings, and computers. Artists and designers are responsible for the appearance of our homes, schools, and workspaces; for the things we wear and play with; for our transportation and communication; for our magazines, sports, and entertainment. We literally live in a designers' world.

Your Interests

Perhaps you enjoy drawing and painting and making three-dimensional objects, and you feel you might commit yourself to a career in art or design. That is a major step, and the purpose of this book is to show you some of the options available when choosing among art careers.

How do you know that an art career is for you? If you are interested in all aspects of art; if you like to work with color, line, texture, form, and shape; if you like to invent combinations of visual elements and solve design problems; and if you always enjoy these activities, then a career in art is a logical choice. The chances of success are good, and the opportunities are extensive and rewarding.

A Variety of Art Careers

The visual arts have a vital role to play in tomorrow's world. A major part of our economy relies on products, and the products of industry are designed by creative people. The more the designers' work relates to the pressing needs of our business and industrial economy, the greater their financial reward.

This is an age of communication, filled with images in publications, cyberspace, TV, and film—images created by artists. In order to thrive, business, industry, government, and education must find immediate ways to reach the minds, influence the attitudes, and arouse the emotions of great numbers of people. Creative visual communicators who fill this need are well rewarded.

Fine artists—painters, sculptors, printmakers, and craftspeople—must sell their work to earn a living; sales of fine art tend to increase and decrease with the trends in the national economy. Establishing a fine-arts reputation takes time; in the meantime, many artists combine their creative activities with other kinds of income-producing work, often in art-related areas.

A Look at the Future

At a time when job security is diminishing and people make several career changes in their working life, careers in art and design are likely as stable as any others, and are often more personally rewarding.

Many aspects of contemporary life require creative people: architecture; product, industrial, and publication design; film; theme parks; TV and special effects; illustration; teaching; art history; conservation; and galleries and museums. These areas grow with the national economy, and many designers, by their creative efforts, will aid that growth.

How to Prepare

Right now, take as many art courses as you can. Look at and study the work of top designers, especially in professional magazines. Think about which college or art school will benefit you the most in establishing your career goals. This book will help you choose a school. Listings of schools, programs, professional organizations, books, Web sites, and magazines are also included. Such information can be used to guide your career decisions.

Do You Fit into This Picture?

Here is a checklist of what is essential to successful careers in art and design. These qualities will be reiterated throughout the book.

✓ **Adaptability.** In a world that is constantly growing, designers must be flexible in their approaches and techniques, responding to the changing needs of their clients.

✓ **Diversity.** Designers need an array of skills, art techniques, writing and speaking abilities, and creative approaches to a variety of design problems.

✓ **Solid design background.** No matter what the career area, basic drawing and design skills are vital.

✓ **Computer literacy.** All aspects of design make extensive use of computer technology. Knowledge of today's computer programs is important, as are continued familiarity with and mastery of upgrades and new software.

How to Use the Book

This book provides important information for anyone interested in an art career. The Table of Contents lists the careers that are treated in detail; more are summarized at the end of each section.

Careers in Art is written for the following audiences:

■ **Students** will find information on how to prepare themselves for college and careers, and will be exposed to a multitude of career choices. They will find names and addresses of colleges, and places to write for more detailed information.

■ **Teachers** will find sources of career information. Career descriptions will help them advise their students and will provide some insights into possible course additions that would prepare students for college and careers.

■ **Curriculum specialists** will review the requirements that students need to fulfill for college and careers. This information helps specialists set curriculum goals and choose possible course additions.

■ **Guidance counselors** will find an assortment of art careers and a list of schools from which to obtain catalogs and course information. The personal qualities necessary for success in certain career areas are also included.

■ **Parents** will find hundreds of careers that will help them enable their children to make informed career decisions. Parents can learn about various kinds of art careers, see artists in action, and note what types of environments their children might encounter as artists.

Each section includes information on the career area, the typical jobs, the personal qualities necessary for success in the career, alternate careers, the steps that can be taken now, and which colleges offer necessary programs. Armed with such information, students should find it easier to decide upon suitable career areas.

Profiles are interspersed throughout the book. These describe the activities of artists and examine projects and cooperative programs in various career areas. They describe selected careers in personal, specific terms.

Professional Insight sections, statements by respected designers and artists, introduce each career area. These professionals express their enthusiasm and offer encouragement to young artists.

The last section of the book, *Resources*, provides essential information. It lists current books and video tapes that provide details about specific careers, and magazines of interest to artists and craftspeople. Web sites with career information can be found here, as well as the names and addresses of professional organizations. Also included is a chart that profiles many American and Canadian college art programs.

Contents

Introduction

introduction

Preparing for a Career in Art and Design

This is an exciting time to pursue a career in the visual arts. The opportunities available are diverse, and artists now receive more recognition than ever before. Shopping centers, buses, theaters, airports, and highways need designers. Advertising, packaging, publications, and industrial-design career opportunities are growing. Schools at all levels need art teachers to motivate the next generation of artists. Practically every business, industry, and school in the nation requires the skill and imagination of an artist, and artists can justly consider themselves part of a profession that has served humankind for its entire existence.

The history of the visual arts is the history of creative men and women whose careers were spent creating visual images and designing objects to enrich people's lives. Such noble goals are idealistic and theoretical. Practical application of such idealism will be found in the hundreds of art-related careers described on the following pages.

The twenty-first century holds extraordinary opportunity...

David R. Brown, president, Art Center College of Design. Photo: © 1991 Steven A. Heller, Art Center College of Design, Pasadena, California.

David R. Brown

The twenty-first century holds extraordinary opportunity for designers, artists, filmmakers, photographers, and those who create with the new tools and media offered by the computer. A prestigious research firm recently proposed a new model for world economic and social activity in the twenty-first century. Visually, it is a pyramid that suggests both the hierarchy and the pace of evolution of human enterprise and social organization. At the base of the pyramid is agriculture. Above it, infrastructure; then manufacturing, services, and finally information —the age we seem to be in right now. At the top, representing the next era, is "design and experience."

The implication is that quality of design and quality of experience will become the overarching and inclusive social values of the new future. Some perceive that this future has already arrived. Designers and visual arts professionals have had a tremendous impact on the world we live in, the things we live with, and what we value. They will no doubt continue to do so. Many of us believe, however, that design in the future will be more about making sense than about making things; more about making meaning out of life and work than about making more money simply for the sake of making more money. Value overrides quantity.

We seem caught in a period dense with transitions and contradictions. Before, change was new; today, change is the norm. Before, people had few choices; now, people have too many. Before, we had a few staple sources of information; today, there are many and they're merging rapidly in what has been termed "the digital blizzard." Before, we relied on tradition to guide us; today, we're in a mode of continuous retrofit. Before, we lived and worked in an information environment dominated by words and numbers; today, that environment is predominantly visual and visceral. Evolving computer-based technologies and the new digital media are the driving forces behind a hybridization of careers, freeing photographers, fine artists, illustrators, and graphic designers to initiate and collaborate on projects beyond the traditional boundaries of their disciplines.

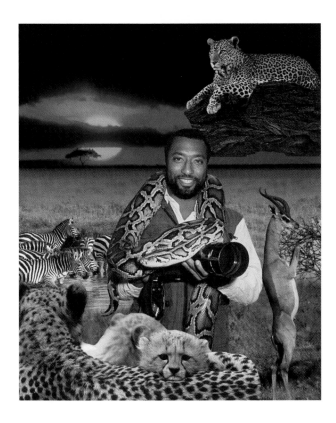

Photographer Clayton Fogle with a few of his subjects. A Professional Insight by Fogle appears on page 90. Digital montage courtesy the artist.

What about an Art Career?

As you read through this book, your concept of the term "art career" will probably change drastically. When most Americans think of an artist, they imagine a person working in a cluttered and well-lit studio, absorbed in finishing a wonderful painting, surrounded by stacks of unfinished or unsold works. While this scenario may be true at times, for every such isolated image, there are many hundreds of other art people who are drawing, painting, sketching, designing on a computer, building models, meeting with clients, consulting with producers and directors, teaching, adjusting cameras, or otherwise using the skills of their varied art backgrounds in careers that affect nearly the entire world's population.

Just about everything around us that is not natural has been designed by a career artist of some kind. Books, automobiles, buildings, boxes, clothes, jets, movies, computer programs, tools, toys, roads, signs, and shoes are all conceived, designed, and realized by artists. What kinds of people are they?

Artists are creative problem solvers. Their skill at finding solutions to visual design problems carry over into graphic design, architecture, digital design, animation, video-game design, sculpture, interior design, or mall signage.

Artists are design-conscious. Because their training and education have included an emphasis on design and composition, they can adapt those skills to a visual project or design problem.

Artists tend to enjoy experimentation. They explore media, and work with various subjects, in different ways, to communicate ideas. They enjoy the process of trial and error in order to achieve a new solution to a problem. Creativity and experimentation complement each other.

Artists are self-disciplined: they need to be able to motivate themselves to produce! When working for others, they must meet deadlines, perhaps work for long periods on a single project, and make efficient use of time.

Artists are visually aware. They are aware of light and dark; texture and line; good design and poor; and the relationships of shape, color, size, and form. With care, they note things in their environment and can adapt their findings to solve design problems.

Artists listen to criticism. They listen first and then decide on a course of action. They accept praise and criticism equally, knowing that both make a better artist or designer.

Artists enjoy talking about art. They like to talk to other artists, friends, business associates, clients, or anyone else about their own ideas of art and design, and specifically about projects on which they are working. Verbal communication is critical in the world of design.

If most of these descriptions fit you, and you like to work with a variety of art projects, then look at this book carefully. A career in art or design may be for you.

Ceramist Ed Forde creates unique forms in clay. A Professional Insight by Forde appears on page 166. Photo courtesy the artist.

Their art is a visual expression of their personal feelings about subjects or ideas of intense interest to them. They work for and to please themselves, even though they intend to share their work with the world through gallery or exhibition sales. Even though the term "artist" suggests painters, drawers, printmakers, sculptors, and many craftspeople, such artists are by far a minority among career artists. The fine arts as a career opportunity are explored starting on page 155.

Art produced by artists other than fine artists was formerly called commercial art, but today is simply termed *design*. Designers work for magazines, book companies, TV stations, or clothesmakers; for advertising studios, film companies, or toolmakers; for local or worldwide clients; in one- or two-person studios or in huge design firms; as free-lance designers or corporate employees. Major fields of design include the following:

- *Environmental design.* Architecture, landscape architecture, interior and display design.
- *Graphic design.* Package, publication, and type design; digital design; signage; illustration; technical and medical illustration; and photography.
- *Product and industrial design.* Toy and tool design; ergonomics; computer-assisted design.
- *Fashion design.* Clothes, accessories, and costume design; illustration; and photography.
- *Entertainment design.* Film, TV, multimedia, animation, digital design, virtual reality, theme parks, theater and stage design.

The basic training for careers in either fine art or one of the design fields is the same. Skill in drawing, painting, visual design, sculpture, and art history are the fundamentals. Experience with crafts such as ceramics, textiles, and jewelry help broaden the background for any career in art or design. Through coursework comes the development of the ability to solve design problems with creative solutions.

Fine-Art or Design Careers

Fifty years ago, artists were often imagined to be poverty-stricken, radical thinkers who lived in bohemian disarray. Parents were extremely reluctant to allow their sons or daughters to take up artistic careers. Art as a hobby was acceptable, but as a career? Never!

Today, creative visual artists are respected professionals. Career artists help shape the look and design of the world, provide entertainment, and enrich our lives while making a comfortable, exciting living.

Fine art includes painting, sculpture, printmaking, and some of the more sophisticated crafts. Most fine artists create for aesthetic reasons, for social comment, for decoration, and/or to enhance the life and environment of clients, art buyers, or corporations.

What about Computers?

In the twenty-first century, information processing will continue to be a major industry, with computers naturally a major force. Most design businesses today—graphic, product, digital, industrial, or fashion—are technology-driven. The pace and possibilities offered by computer technology have caused major changes and new directions in design.

Computers are now indispensable tools for design, and computer experience is essential for a design career. Not only computer literacy but also specific software experience is often a prerequisite for a job. There are many facets to the world of computers and design. These include audio, video, animation, three-dimensional rendering, and complex interactivity. Marketable skills are obtainable in art schools, technology centers, and colleges that specialize in providing these basics for the changing needs of the design industry.

With the rapid changes inherent in computer technology, artists and designers must remain flexible, keep their creativity at the fore, and not be seduced by the relatively quick gratification offered by computers. A designer should be computer-proficient but not computer-dependent. Fundamental skill in drawing and an understanding of visual design are essential and should not be lost or subordinated to technology.

Drawing is still the base of all visual communication, since it is the point of initial inspiration (idea sketches), the method of presenting concepts (visualizations), and the means of visually describing changes, differences, and possible alterations in concepts and conclusions.

Designers use a variety of software programs to satisfy specific needs, and can produce results rapidly, increasing output and profitability. Creative designers, however, must be careful to sustain depth and content in their work and not sacrifice quality to speed and the "latest tricks" available to computer users.

Some design firms are decentralizing so that their employees may work at home and modem their work to the office. Electronic linkage allows firms to communicate with their clients, employees, and pro-

duction-output facilities. See page 116 for an example of how such teamwork is carried out on a global basis.

Computers not only create changes and challenges, but they also create vast opportunities for designers who are open to such change. It is clear that the creativity of the designer will remain dominant over the tools and processes of the computers. A fundamental working knowledge of design and drawing are necessary for all basic design processes, whether or not they involve computers.

Computers will not replace graphic designers, but they will continue to be an indispensable tool to expand production, increase profits, and enlarge the possibilities for creative visual solutions. See page 56 for more thoughts on computer technology.

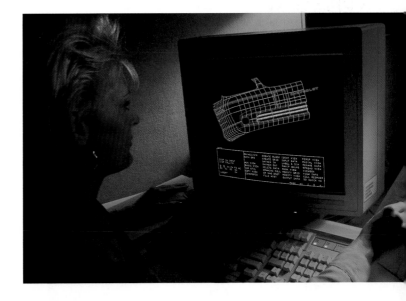

A designer works on her computer to modify the three-dimensional design for a quarter panel surface. Computers with specialized programs are used by most designers, who can change ideas and surfaces quickly and with ease. Photo courtesy General Motors Corporation.

Art, Design, and the American Economy

When we consider that the vast majority of objects created and used today have been designed by artists, and when we consider that our gross national product is based in part on the sales of these objects, it is not difficult to recognize the impact that designers have on our lives and our national economy. Without career artists, we would have no magazines and few books, no useful tools, no stylish clothes, no efficient offices in which to work, no ergonomic equipment, and no comfortable furniture for our homes (and no homes to hold the furniture). We rely heavily on artists to design things for us, but we sometimes take them for granted, not appreciating them, their work, or their impact on our lives.

A look through this book provides a glimpse into the world and work of artists who affect us almost every minute. The economic impact alone of removing their work from the world would be devastating. For instance, in Los Angeles, the manufacture of toys in 500 companies provides 6,000 jobs and $4.3 billion in annual worldwide sales. The apparel industry in this one city creates $15 billion in annual sales, followed closely by New York, with only slightly less. Consider the work of artists and designers in the film industry, which announces weekly the dollar figure paid by moviegoers in the tens of millions of dollars. There are 13,000 different magazines published every month in our country alone. They would not exist without art directors and graphic designers, and their billions of dollars in sales and advertising would be lost to our economy. The design and manufacture of automobiles, supersonic aircraft, photographic equipment, sports gear, and communication and medical equipment begins in the mind and on the drawing board of creative artists.

Consider the thousands of museums and galleries that exhibit and sell the work of creative artists. Go into a bookstore and imagine how those thousands of books would look without pictures, cover illustrations, or graphic design. Or enter a theme park and try to find an object not planned by a designer.

The careers presented in this book account for the design of products, the building of structures, the entertainment of everyone, the cultural edification of millions, the reading enjoyment of us all, the beautification of our indoor and outdoor environments, the clothing of a nation, and the enhancement of our life. Imagine life without them!

Career artists not only design products but also generate services that account for significant additional business. Consider the art educators and museum personnel, interior designers and landscape architects, framers and art directors, photographers, graphic designers and fashion illustrators, multimedia artists and animators, art writers, historians and critics, art therapists, police artists, and art consultants. These career artists—perhaps you among them—will continue to energize the global economy well into the twenty-first century.

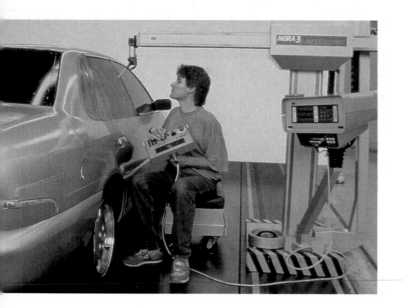

After a concept car has been imagined, designed, and tested on computers, the information is sent to a production studio where this automatic milling machine scribes the three-dimensional model. Without an extensive system of designers, the car would never exist. Photo courtesy of Ford Motor Company.

Portfolios and Résumés

When you start looking for a career position, your success will not be determined only by your school, degree, or job experience, but also by your portfolio, résumé, and interview.

PORTFOLIO. A portfolio reveals your artistic abilities. You will use your first portfolio, filled with examples of your best work, when you apply to art school. You will need another when you look for your first art-related job. Later on, you will likely update your portfolio in order to make occasional career moves. In preparing your portfolio, consider the following:

- Include classwork and independent work.
- Include a variety of media.
- Artwork should be neat and clearly labeled.
- Present your work simply, without fancy matting or decoration.
- Include ten to twenty pieces of your best work.
- Use a substantial folder or portfolio to hold the work securely.
- Mount small work on boards of the same size.
- If you include simple written statements about your pieces, check spelling and punctuation.

When preparing a portfolio to present to an art school, contact the school for specific requirements. Follow directions. Many schools have "portfolio days," when prospective students can consult with admissions counselors.

Your portfolio will be the single most important indication of your artistic abilities—for your entire career. Present yourself and your work in the best possible light. Be enthusiastic. So important are portfolios to career artists and designers that art schools and colleges offer courses in the development and presentation of them.

RÉSUMÉ. A résumé is a written record of your personal information, educational background, and work experience. Although you might write one to accompany your portfolio, it likely will be the first contact you have with a future employer. Students entering art school may not need a résumé, but they will certainly need one when they begin to search for a job.

There are many ways to write a résumé. Choose information that presents you positively. What you say, how you say it, and how you design the presentation of the information will determine, to a great extent, whether you get an interview—or a job.

The layout of your résumé should be simple and easy to follow, and should include the following:

Personal information. Name, address, phone, and so on. Optional information may include your date of birth, marital status, and state of health.

Educational information. All school background, with dates. Include honors, special skills, foreign languages, computer experience, and so on.

Work experience. Show all your work experiences, with dates, starting with the latest employment.

Professional associations. If you are a member of any organizations at the student or professional level, list them.

You may want to list career goals and any shows or exhibitions of which you have been a part. Be brief: ideally keep your résumé to a single, well-organized page.

Select fine white paper, and use an output device that provides sharp, clear lettering. Books, computer programs, and services can help you in résumé preparation.

———————

Lynne Berman reviews slides of artwork in Tomashi Jackson's (grade 12) portfolio during Portfolio Day at the Los Angeles County High School for the Arts. Photo by Joseph Gatto.

———————

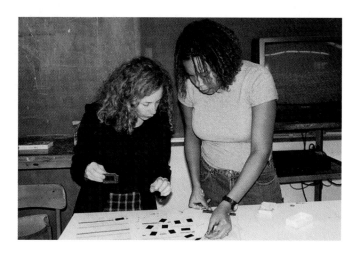

Choosing a College or Art School

Art schools provide the maximum amount of art instruction per semester because the student concentrates primarily on art and design classes. College and university art departments offer four-year programs with a fine-arts major resulting in a baccalaureate degree (B.F.A.). A four-year student taking a variety of subjects will receive fewer hours of art instruction than an art-school student.

Art schools and college art departments often become known for areas in which they excel. Generally, if you are interested in a design career, you should attend an art school; but if architecture or a fine art career is your goal, you may want to attend a college or university. Checking the school's course list will give you an idea of its strengths and weaknesses.

What should you look for in an art school or college? Keep the following in mind:

CURRICULUM. Examine the course offerings. Are there sufficient courses in your major area of interest, and enough supplemental courses to provide a broad base in other areas? Is there a strong fundamental program? Are business courses available? Is a degree offered? Are there student branches of professional organizations in your field of interest? Is a post-graduate program available?

LOCATION. Most artists and art activities in the design fields are found in large urban complexes because that is where many art jobs are located. Field trips and work-study programs may also be available. Some smaller community schools also have outstanding programs and teachers.

SIZE. Schools that offer a wide range of art experiences and have faculties large enough to provide multiple insights are generally considered to be the best schools. Usually, the larger the school, the greater the variety of professional teaching. However, larger schools can be intimidating to a first-year student. Also, these schools may have inflexible curricula and requirements. Consider your personality and specific needs when you weigh alternatives.

FACULTY AND ALUMNI. Does the faculty contain well-known artists? Are respected designers among the school's graduates? Art schools often hire successful designers to teach part-time, bringing their practical expertise into the classroom. Work-study programs can result from such contacts.

CAMPUS. If a campus social life appeals to you, you may want to attend a college or university. Art schools are often located in a downtown area without a campus, and without many campus activities.

ACCREDITATION/REPUTATION. Colleges need accreditation to be recognized by the academic world. Reputable art schools belong to several professional accreditation systems. The reputation of the school you choose can have a powerful impact at the beginning of your professional career.

CATALOGS/WEB SITES. School catalogs and Web sites contain information you'll need to make your selection. They generally include:

- accreditation information
- school's history, facilities, environment
- campus size, student life
- alumni associations, library information
- admission policies, tuition data, living expenses
- grants, scholarships, student-loan information
- courses offered, major fields
- degree programs offered
- professional associations
- work-study programs, internships
- job-placement information
- graduate programs offered
- faculty information
- required entrance exams
- portfolio requirements

Select a School Carefully

One of the first questions asked of a young designer looking for a job is "What school did you attend?" The quality of your education is important, because each institution has distinctive qualities. Ask practicing professionals or an art teacher for suggestions for the best schools. A visit to one or more art schools or

universities (especially during year-end exhibitions) will give you a chance for personal reactions to the academic environment and the quality of student work. Inform the school of your plans to visit: they are as interested in you as you are in them.

Entering the Job Market

At the moment, searching for a job might seem a long way off. Just remember that competition for good design-career positions is fierce. It is never too early to learn how to introduce yourself to the art world.

If you intend to make a living producing fine art, you will need to contact galleries, agents, corporate art advisors, Web sites, or other sources for your work. Establishing your name, building a following of interested buyers, and making gallery contacts takes time.

To begin a career in design, you will need to show your portfolio and résumé to prospective employers. Perhaps your college or art school will have a placement service that can make initial contacts for you. Friends in the arts may help make your job-seeking easier. All artists must make contact with studios, schools, galleries, TV studios, offices, or personnel managers. Think about the following when you do so:

INITIAL CONTACT. Phone or write ahead of time to arrange a date and time for a meeting.

RÉSUMÉ AND PORTFOLIO. They are essential. See page 17.

CONTACT LIST. Make a long list of potential employers. Obtain names from the yellow pages or from career-counseling advisors at school. Check classified ads under headings for advertising, art, graphic designer, and graphic artist. Inquire at employment agencies. Network at art directors' clubs, advertising, or illustrators' clubs. Visit Web sites related to design. Ask faculty members. Look through trade publications. Ask your friends. Let as many people as possible know you are looking for work. Even the most unlikely acquaintances may know of a useful contact.

INTERVIEW. Arrange interviews by telephoning and setting up a meeting, or by writing or faxing to a contact person (include your résumé and a request to meet the person). Once made, confirm the arrangements in writing. Be businesslike. Be on time. Dress appropriately. Speak clearly. Explain your portfolio and résumé concisely. Allow the interviewer to ask questions about you and your work.

Be prepared to answer questions about your grades, extracurricular interests, jobs, the type of work you are looking for, computer programs you use, the entry-level salary you are expecting, and references. Much of this information should already be in your résumé, but interviewers often want to hear you speak them.

Interviews usually do not end with job offers. Write to all who interviewed you, thanking them for their time and interest in you and for any advice they may have offered.

When job offers arrive, weigh them carefully. How do they fit your immediate and long-range plans? Your first job will be like an apprenticeship—you will begin to learn the business and establish a foundation for your art career.

Art schools prepare students for entry into the job market. This student at the Fashion Institute of Design and Merchandising (FIDM) works in the interior design workroom. Courtesy FIDM. Photo by Beth Herzhaft.

Environmental Design

part one

Environmental Design

When people take time to look around them, the extraordinary contributions of environmental designers become apparent. All types of buildings are planned, designed, and built under the direction of architects; and the spaces in and around them are designed, decorated, furnished, planted, and paved according to the designs of other artists.

Urban structures begin with the concepts and sketches of architects and the renderings of architectural delineators. These preliminaries are followed by the work of building contractors, engineers, interior designers, space planners, furniture designers, architectural graphics specialists, and color consultants.

Large buildings and exotic designs are impressive because of their size and visual impact, but just as important are the fine details of color, texture, materials, and lighting that make up the immediate environment of our houses. The careers explored in the following pages pertain to these environments.

Explore options,
enjoy the process,
and be flexible.

Michelle R. Rickman, designer, Davida Rochlin Architecture; instructor, Los Angeles County High School for the Arts; admissions counselor, UCLA Departments of Art and Design.

Professional Insight

Michelle Rickman

My career path, like most of my life, has been a winding road. As a child, I decided that I wanted to be an architect, but a dull high-school drafting class convinced me to try other things. I became a humanities major in college and was able to combine architectural history, philosophy, and anything else that caught my attention. However, my passion for architecture continued to be the strongest pull on my life, so I stayed in school and pursued a masters degree in architecture at UCLA.

After graduation, I fell into three jobs almost simultaneously. I began work at a small architecture firm, started teaching at a magnet high school for the arts, and became the admissions counselor for the Departments of Art and Design at UCLA. Although incredibly busy, I have discovered that between the three jobs all of my expectations are being met. *Practicing traditional architecture* allows me to continue my architectural training and to experience what real-world architecture is about. *Teaching* gives me the opportunity to stay in school and design in a safe space—plus I get to teach the class that I wished for when I was in high school myself. And *counseling* provides me with security, autonomy, and a sense of satisfaction in being able to help students of all ages with their educations and careers.

Perhaps someday the three jobs will coalesce into one career that will satisfy all of my needs. Until then, I will continue to juggle all of them and enjoy their differences as well as their similarities. In my role as admissions counselor, I often encourage students to explore their options, to enjoy the process, and to be flexible about the end result. After all, you never know where even the straightest path can lead you.

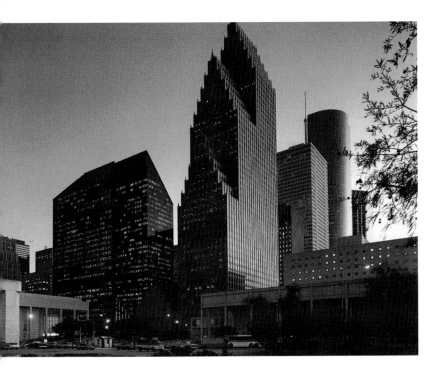

Architecture is the physical culmination of ideas, dreams, plans, and sketches. Often, hundreds of people are involved, and all must have the same goal: to create a beautiful and functional structure. The completed work of architects is documented by architectural photographers who find the best possible angles and viewpoints to showcase the structures. Here, Richard Payne uses soft evening light to create a dramatic mood for a city skyline. Courtesy Richard Payne.

Architecture

The definition of architecture has not changed much since Roman times, when it was described as "convenience, strength, and beauty." In his book *Form and Structure of Twentieth-Century Architecture*, Talbot Faulkner Hamlin describes the elements of architecture as "use, construction, and aesthetic effect." The words are different, but the definitions are synonymous.

Use means the function of the structure. Architects must insure that the building will do what it was designed and built to do. Houses should shelter families. Office buildings must be comfortable, well-organized places to work. Entertainment centers must handle large numbers of people attending presentations of various types. The design of a manufacturing plant differs from the design of schools or libraries. Successful architecture provides the best possible use of space for those who will use that space.

Construction means the assembly of the physical parts of the building—windows, walls, foundation, ventilation—that are made of concrete, steel, aluminum, and glass. The stability and enduring quality of the structure is paramount. "Use" indicates how people occupy a space; "construction" refers to the structure itself, not human occupation of it. These two elements are always planned in harmony, and both are essential to successful architecture.

Aesthetic effect means the ultimate appearance of the building. Will it be pleasing to look at? Will it fit into its surroundings? Will it be desirable in the community? Will it reflect contemporary tastes? Aesthetic concerns should be inseparably tied to use and construction. Ugly buildings may be functional and well built, but they blight the environment they occupy.

The characteristics of architectural design place a building in a certain time. The mammoth concrete and brick structures of Rome; the cathedrals of thirteenth-century Europe; the graceful temples of China and Japan; American Art Nouveau buildings from the 1900s; and the airline terminals, high-rise structures, and sports stadiums of today all reflect certain needs. Contemporary architecture satisfies demands for fuel efficiency while catering to the use of new building materials and techniques. Some dramatic designs reflect a company's desire to establish a specific corporate identity. Other designs are intended to blend gracefully into their surroundings.

Architect

The role of architect has changed considerably in the past several decades. The position used to consist of designing buildings and supervising their construction, but due to today's complex technologies and concern with total environment and legal restrictions, architects must be master coordinators as well. Architectural specialization is now the norm: the building of huge structures requires a team of architects, engineers, contractors, and manufacturers' representatives. The chief architect must coordinate the contributions of specialists to produce a structure that is no longer the work of a single person.

Some architects coordinate mammoth projects; some design single-family homes, condominiums, schools, and churches; others specialize in remodeling existing structures. An architect must be a creative artist, a practical scientist, and an astute businessperson all at the same time.

Architect Arata Isozaki designed the Museum of Contemporary Art in downtown Los Angeles. His use of color and a feeling of intimacy exemplify many contemporary medium-sized buildings. Photo by Gerald Brommer.

What does an architect do?

The basic job of an architect is to design buildings, but the full task is far more complicated than that. Before making the first sketch, the architect must interview the client to find out what uses are to be made of the space. The architect estimates costs, establishes budgets, and studies local zoning and building codes. Initial ideas can then be put on paper. For large projects, an architectural delineator visualizes the concepts of client and architect.

The exterior appearance of the structure—an office building, for example—should reflect the client's ideas and the corporate image, as well as conform to community plans. However, the use of interior space is the heart of an architect's plan. For large buildings, the architect plans workspaces, traffic flow, stairways, and storage, and contracts engineers to help design the structural elements, heating and air conditioning, plumbing, lighting, and ventilation. For a house, the architect considers similar functions, but on a more limited scale, and sees that space is used efficiently.

The architect then chooses the materials to be used, from the concrete foundation to the brass doorknobs. The job requires on-site experience, an updated knowledge of products and materials, and an insight into what clients expect. The architect's drawings show how the building will be put together. Every square foot of the building is drawn and identified by its dimensions and the materials to be used.

Large architectural firms often undertake the design and construction of entire areas that may consist of several buildings and the surrounding parking facilities, roads, and landscaping. Such a total urban environmental package is called a *system*, and its design also involves planning air quality, public transportation, tunnels, and accompanying signage. Many career artists are involved in such environmental design teams.

For every large architectural firm specializing in environmental design, there are hundreds of smaller offices that deal with houses, stores, churches, apartments, small office buildings, theaters, and markets. The types of careers available in such smaller offices are similar to those in large firms, but the size of projects and total budget differ.

What qualities are helpful to an architect?

The ability to draw is essential and an interest in mechanical drawing is a must, but architects must also be able to coordinate a team of other specialists. Architects have to be able to envision future buildings and like working with many kinds of materials. An enjoyment and understanding of mathematics and three-dimensional form is necessary for a career oriented to dimensions, proportions, and figures. An analytical mind and the ability to remember details are assets. Architects must work well under pressure on complex projects and enjoy research and the study of architectural and art history.

What other careers require similar qualities?

Many of the environmental-planning careers discussed on the next few pages require the ability to draw, plan, visualize, and coordinate the efforts of others. A city planner, landscape architect, space designer, facility planner, architecture teacher, and commercial interior designer have such abilities in common. Careers that involve drafting ability (industrial designer, drafter, model builder, environmental planner) and several areas of industrial design also require similar qualities.

What can you do now?

Because architects must be able to draw and work with mathematics, drawing classes and mechanical drawing (drafting) classes are essential. Take as many art classes as your schedule will permit, and be sure to include an art-history class. Geometry, trigonometry, and solid geometry are the most pertinent mathematics courses. English, physics, and chemistry courses will also help you. Take all the history and humanities classes you can.

Part-time work—in a drafting office or with any industrial, manufacturing, or construction firm—will help prepare you for a future in architecture. Any job related to architecture—plumbing, electrical installation, building materials, real-estate or construction work—is a good source of experience.

Check *Resources*, page 221, for the names of helpful magazines and architectural organizations.

Donald L. Stull, FAIA is the president and owner of Stull and Lee, Inc., Architects and Planners. Photo by Joanne Ciccarello ©1992.

What schools offer necessary programs?

All states require architects to be licensed. A license can be obtained when an architect has earned an architectural degree and has had three years of on-job experience in an intern development program. Most college architecture students enroll in a five-year program of study at a private or state university with a school of architecture. Because such a school is often fully enrolled, apply to several schools. Courses at the college level begin with freehand drawing, architectural design, drafting, mathematics, and general studies. Later courses include principles of design and construction, design projects, construction documents, lettering, study of materials, mechanics, construction costs, writing specifications, and urban planning.

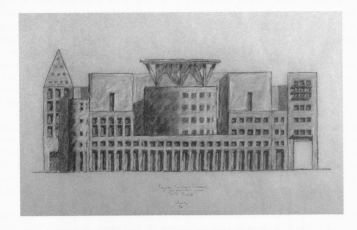

The idea sketch, which is not accurate, does not contain any details or notes on materials or colors. It is the seed from which the structure eventually grew. South façade. Photo by Marek Bulaj.

Profile

An Architectural Project

The people of Denver, Colorado needed to update and expand their downtown library, and they desired something special. The project involved renovating the historic Denver Central Library (150,000 square feet) and creating an adjoining land-mark building (390,000 square feet).

After a four month design competition among leading archi-tects, Michael Graves was chosen. His design features a seven-story limestone exterior, with copper roofing and sid-ing. The interior is comfortable, warm, and welcoming. It includes natural-finished, solid maple accents such as pil-lars, windowsills, and table lamps. To accommodate bur-geoning technological needs, more than fifty miles of

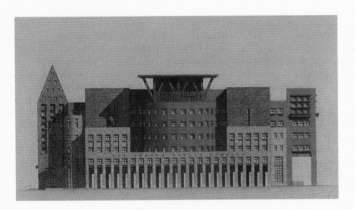

The architectural rendering or delineation that shows exterior colors, materials and details. South elevation. Photo by Marek Bulaj.

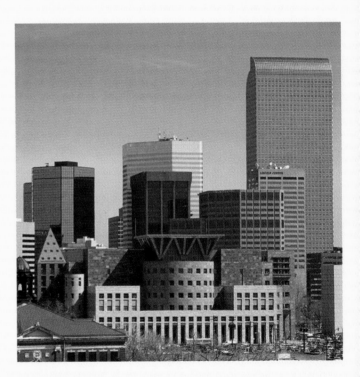

The finished library as viewed from the south, seen in relation to Denver's down-town skyline and the old library at lower left. Photo by Tim Hursley.

fiber-optic cable and copper wire are concealed within ceilings, walls, and floors. The award-winning design took one year to complete, and was accomplished in association with the architectural firm of Klipp, Colussy, Jenks, Dubois of Denver, Colorado. Construction required three years, and was finished within the projected budget. Graves describes the library:

The project involves complete renovation and significant expansion of the original library building designed by Burnham Hoyt in 1956. This building is part of the Civic Center Historic District, and is listed on the National Register of Historic places.

The design envisioned the expanded Denver Central Library as an important civic structure reflecting the activities and architecture of its community. The original building maintains the institution's presence on Civic Center Park. The 390,000-square-foot addition stands to the south, forming a backdrop for Hoyt's composition. A strong new public image is established along Thirteenth Avenue, facing future development and parking to the south.

The scale and coloration of the addition allows the original library building to maintain its own identity as one element of a larger composition. Two major public entrances establish an east-west axis through the expanded building, developed as a Great Hall. This three-story vaulted space is the central public room of the building, allowing visitors to become oriented to the facilities provided on all levels. Special rooms at the edge of the building offer visitors views of the city and mountains beyond.

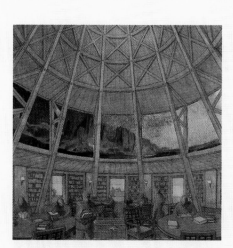

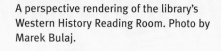

A perspective rendering of the library's Western History Reading Room. Photo by Marek Bulaj.

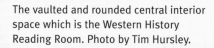

The vaulted and rounded central interior space which is the Western History Reading Room. Photo by Tim Hursley.

Architect Frank Gehry's ideas often begin with a freely constructed model, which he changes as the concept for the site evolves. This model is the basis for the Guggenheim Museum Bilbao in Spain (1997). Gehry's design is influenced by the scale and texture of the city of Bilbao. Courtesy Frank O. Gehry.

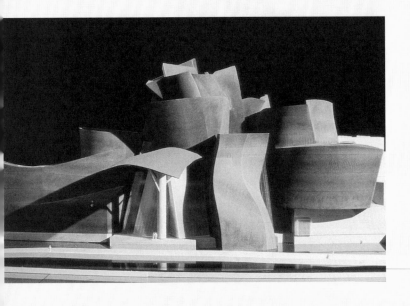

Architect: Frank O. Gehry

Raised in Toronto, Canada, Frank Gehry moved to Los Angeles in 1947. He received his architecture degree from the University of Southern California (1954) and studied city planning at the Harvard University Graduate School of Design. Since then, he has built an architectural career that has spanned four decades and produced public and private buildings in America, Asia, and Europe. Hallmarks of Gehry's work include a particular concern that people exist comfortably within the spaces that he creates, and an insistence that each building address the context and culture of its site.

His work has earned him several of the most significant awards in the architectural field, including, in 1989, the Pritzker Architecture Prize, perhaps the premiere accolade of the field, honoring "significant contributions to humanity and the built environment through the art of architecture."

Gehry's work has been featured in major professional publications, national and international trade journals, and many other major magazines. His drawings and models, as well as his designs for cardboard furniture and his interpretations (in various forms and materials) of fish, have been exhibited in museums around the world.

He describes his design process:

There is a reality of process when you make a building. You have a client, a context, a budget, a given history, and the process requires some understanding of all of these forces. There is intellectual involvement with the client also. I do that with models and sketches, working back and forth. I use two or three different model scales at the same time so that the finished building is the issue, rather than the model. What I am most interested in is the finished building.

I have a different sense of working than others. If I sit down with too much premeditation, it's not successful. I have to work very intuitively so I inform myself a lot about the project and the people. I work in the models—trying things, trying forms, looking. I try something and I take it off, then I try it again, and the work slowly evolves, a piece at a time. If I too

consciously premeditate, I don't enjoy it, I don't find it as exciting, and the end result isn't as good. Clients often ask me to describe where I'm going, but I can't do that. I can explain the process up to a certain point and the choices made, and I can give them an idea of the trajectory.

In the end, I want each building to be one idea, inside and outside, one aesthetic. In the end, my buildings are completely a response to the client: their site, their requirements, their program, their budget, and of course, their schedule.

Located in Santa Monica, California, Gehry's studio has a staff of over sixty people, and includes extensive model-making facilities and a model-building staff capable of executing everything from scale architectural models to full-size mock-ups. The firm uses a network of sophisticated computer-aided design workstations in the development of projects and in the translation of designs into the technical documents required for construction. They use CATIA, a three-dimensional computer modeling program originally designed for the aerospace industry. This program is supplemented by more traditional two-dimensional CAD programs.

The unique combination of model building and mock-up capabilities, materials research, and the application of advanced computer systems and construction techniques permits Frank O. Gehry & Associates to develop designs in a rational process, beyond the traditional limits of architecture.

The design of the Guggenheim Museum Bilbao recalls the historic building materials of the riverfront. The building, shown in progress, demonstrates a thoughtful response to the historic, economic, and cultural traditions of the area. Courtesy Frank O. Gehry.

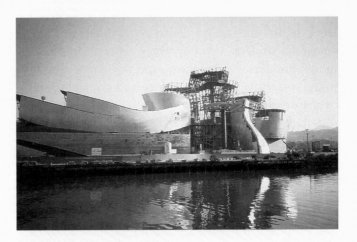

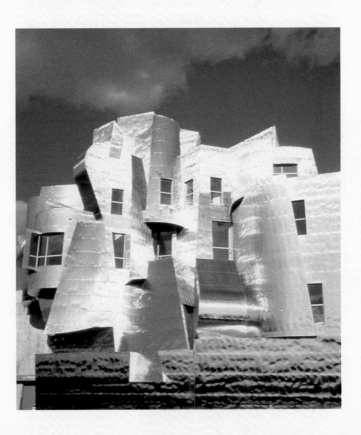

The Frederick R. Weisman Art and Teaching Museum (1993) is located on the campus of the University of Minnesota in Minneapolis. It is designed to house several collections, traveling exhibits, an auditorium, galleries, offices, a theater, a sales shop, and storage areas situated in a four-level structure. It has won several major architectural awards. Courtesy Frank O. Gehry.

Urban Designer

While architects are involved with the design and construction of houses, megastructures, and industrial and commercial complexes or systems, there are architecturally trained people who work on an even larger scale. Nearly every American city has an urban designer, who is usually an architect, because the job involves buildings and the urban environment. But an urban design office employs experts from many other fields: urban geographers, urban environmentalists, demographics experts, drafters, model builders, hydrologists, and engineers. Their joint concern is the maintenance and improvement of the urban environment.

Many communities, after years of discussion and compromise, have developed master plans to control and direct their growth and development. An urban designer is usually in charge of such plans and is responsible for implementing them. Urban designers' offices are crowded with plans of completed projects and proposals for revisions and additions. Decisions on new streets, street closures and variances, parks, bike paths, new tracts, marinas, and harbors are made by these designers. The look and feel of the community is in their hands.

What does an urban designer do?

Because urban designers work for city governments, they are directly involved with other government agencies and must consult and advise other city officials. They work with their own staff to monitor the visual appearance of the city and insure the balanced development of commercial, residential, industrial, and recreational elements. Although architects and corporations propose the construction of a high-rise structure, the urban designer decides whether it will enhance the community or be detrimental to it.

Are pocket parks needed? Is vertical space too congested for another high rise? Is traffic flow being considered when new structures are proposed? Are industrial areas encroaching on established residential neighborhoods? Should a stream be developed as a visual attraction or contained in a culvert? Such questions—those that the urban designer must answer—address the beauty, function, and ultimate welfare of the community.

Typical projects for urban designers include harbor redevelopment, planning for a municipal sports complex, revitalization of the urban core area, development of shopping malls, and planning for industrial parks.

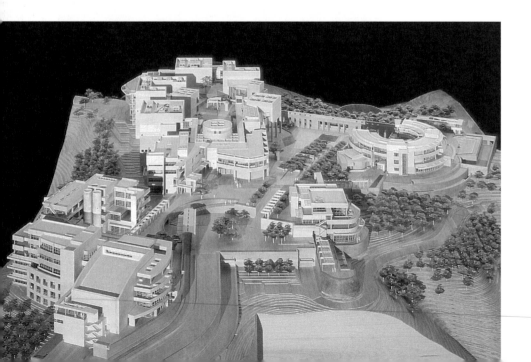

Richard Meier headed the architectural team that developed the 110-acre Getty Center site in the Santa Monica Mountains. Urban planners use models or detailed two-dimensional presentations to illustrate their plans. Included in this model are a parking structure and shuttle station (bottom); an elevated shuttle route that parallels the main access road; the sited building complex with pedestrian and vehicle circulation, landscaping, drainage systems, modifications in the hillsides, and freeway access, in relationship to the surrounding environment. Courtesy J. Paul Getty Trust, Los Angeles. Photo by Tom Bonner.

What qualities are helpful to an urban designer?

Urban designers must be able to work with others on a team. Not only are verbal communication skills important, but so too is interest in community affairs, drawing and sketching, mathematics, and architecture. Urban designers work behind the scenes and often must let others take credit. While coordinating the efforts of many specialists, they must have knowledge of demographics, urban geography and geology, and the workings of city government. A background in the history of architecture and cities is also helpful.

What other careers require similar qualities?

Architectural background, the ability to work with a variety of people, and the skill to handle and supervise large projects indicate that the successful urban designer could also be a successful architect. Because of the vast background needed for the job, urban designers often become consultants to large corporations in areas such as real-estate development, environmental planning, corporate expansion and planning, airline-terminal development and operations, harbor and marina development and supervision, and the establishment of military installations, industrial complexes, and parks.

What can you do now?

If your early career goal is to be an urban designer, begin to broaden your interests as well as to focus on architectural preparation. Take drawing and mechanical drawing courses as well as other art and art history classes. Sociology, geography, and history are important, as are English classes that stress communication.

Photography, with an emphasis on the city as subject, is an excellent hobby that will help you understand urban development. Public speaking and debate groups will help you develop the ability to express yourself clearly and think on your feet. Part-time and summer work on social programs, in the park department, or in any area of architecture will help you prepare for your career. Working with landscape contractors or gardeners would also be useful.

Make an appointment to talk with an urban designer. Ask him or her how you can best prepare for your career. Perhaps you can get a part-time job in an urban designer's office—even if it is only sweeping floors, dusting the drafting tables, or running errands.

Look through magazines in the library. There are journals especially for urban designers, and all architectural magazines will help you understand the demands and rewards of such a career.

What schools offer necessary programs?

A strong architectural background is essential to an urban designer. Colleges and universities with outstanding architecture departments will best prepare someone interested in this field. Check the charts at the back of the book. Schools in larger urban areas will probably offer direct contact with urban problems and solutions.

Many architects and designers must work together to plan complex urban development. This view of Baltimore's Inner Harbor shows construction planned and carried out between 1958 and 1982.

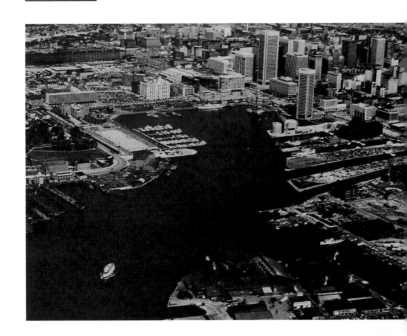

Landscape Architect

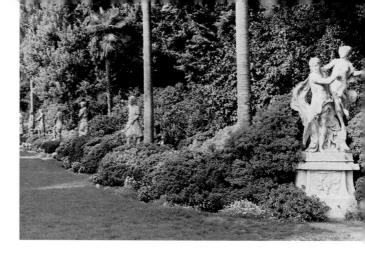

Planned gardens such as these at the Huntington Museum in Pasadena provide unique settings for museum buildings. Photo by Helen Ronan.

We often do not consciously see the work of landscape architects. Do you, as you walk through a bustling urban plaza, notice what a landscape architect has done? When you are driving along an urban freeway or are fascinated with the gorillas in an exciting zoo habitat, do you realize that *these* are examples of landscape architecture? Although the rocks, trees, and other plants are visible, the design often is not.

For over one hundred years, American landscape architects have been shaping our environment by preserving, planning, designing, and managing the land to blend the qualities of nature successfully with the needs of people. Landscape architecture is one of the most encompassing design fields, combining art, science, engineering, architecture, and technology. The profession creates new cities, preserves wildlife habitats, designs recreational spaces, and makes our urban environments attractive. Landscape architects shape the outdoor spaces where we live, work, worship, relax, and renew ourselves.

What does a landscape architect do?

Simply, landscape architects design landscapes. But because many building projects are so large, and have such extensive landscaping requirements, entire teams of experts are necessary. The landscape architect must coordinate the efforts of many people before beautiful, natural-looking surroundings can be produced.

Landscape architects meet with clients, architects, or builders early in a project's planning stages to discuss drainage, land contours, and the use of existing trees and natural landforms. They prepare site plans and construct models to illustrate potential land use, drainage, and elevations. With architects, they establish a plan for location of buildings, traffic flow, and plantings. This plan takes into consideration such factors as view, wind direction for cooling and ventilation, and sun for natural light and solar power.

With help from staff, landscape architects select plants for every part of their design. Ideas are shown to clients in elevation drawings, schematic renderings, and technical drawings (see Landscape Drafter, page 35).

The implementation of the overall design is then carried out under the direction of the landscape architect. Grading, soil preparation, drainage, irrigation or watering systems, and lawn seeding are his or her responsibilities.

Most landscape architects run their own offices, serving clients such as building contractors, architectural firms, government agencies, developers, or homeowners. Others work in large architectural firms, often in a specialized area of landscape design and construction. About thirty percent of all landscape architects work for governmental agencies responsible for city planning; highway beautification; recreational areas; golf courses; and national, state, and regional parks. Most of the work is in urban areas.

What qualities are helpful to a landscape architect?

Just as the field of landscape architecture is varied, so too are the skills and qualities necessary. Landscape architects must be sensitive to landscape quality, and also be able to communicate accurately and work with team members. The ability to visualize landscapes— even before the first shovelful of dirt is turned—is valuable. So is knowledge of construction documents, building codes and specifications, weather patterns, and ecology. Essential are a background in architectural and art history, and an ability to analyze problems and seek creative solutions.

What other careers require similar qualities?

The career of any member of the landscape architectural team would be suited to a person interested in landscape architecture. Landscape drafter, grading supervisor, land-contour designer, and landscape installer are all related; and all work toward a similar goal—providing a natural environment for buildings and roadways. Golf-course designers, city planners, and urban environmentalists must have similar qualifications.

Small landscaping contractors require similar expertise but usually confine themselves to working on individual houses, apartments, or small projects. They are responsible for every phase of the planning and implementation of ideas, and are involved in planting and maintenance.

What can be done now?

All the suggestions given for architecture can be repeated here. Art classes and mechanical-drawing classes are essential. Ecology, botany, and geography courses are all recommended. Strengthen your ability to sketch and plan by working often in a sketchbook.

Photography, with emphasis on structures, sites, landscapes, and plant life is a useful hobby. Part-time work in any architecture-related job is ideal, as is work with a landscape contractor or gardener. Employment in a tree or plant nursery or a park is helpful. Even projects in your own yard can give you excellent experience in planning, designing, and arranging natural elements.

Magazines that will provide ideas in this area include all architectural magazines and also *Better Homes and Gardens, House and Garden*, and *Sunset*. Write to the American Association of Landscape Architects for other career information (see page 226).

What schools offer necessary programs?

Colleges with strong architectural schools will offer some emphasis in landscape architecture. The American Society of Landscape Architects (ASLA) has accredited the programs of about fifty schools. The skills required for drafting, model building, cost estimating, traffic flow, environmental planning, construction document preparation and reading, and the like are available at those schools. Check ASLA schools in the charts at the back of the book. Some agricultural schools have landscaping programs, and their catalogs detail the courses and training available.

Along with a general background in architecture, courses in surveying, landscape construction, plant materials and design, and the study of weather patterns are necessary for the landscape architect. Landscape contractors may work without formal architectural training, but the expertise needed for larger landscaping projects requires college study, years of experience, and a state-approved license.

Landscape architects plan the trees, flowers, walkways, ponds, watering, and lighting of open areas that usually surround buildings. Photo courtesy TRW.

Every TRW employee has either a view of changing seasons, or the atrium's year-round greenery. Photo courtesy TRW.

Shaping the Corporate Landscape: TRW World Headquarters

When TRW chose an historic, heavily wooded, environmentally sensitive area for its 500,000-square foot corporate headquarters, the design team proposed allowing the stunning landscape to define its image. The team's first priority was to save the "culture" of the site, which meant not only preserving trees, but also maintaining the character of the 120-acre former estate in Lyndhurst, Ohio.

Landscape architects advised on the design of built features such as "invisible" underground parking and a center atrium that allows every employee a view of the outdoors. In addition, they coordinated all aspects of the site development project, including protecting and relocating hundreds of trees and plants; educating construction teams and monitoring the site to guard against accidental damage; restoring historic gardens and placing large-scale outdoor sculptures.

In the process of integrating an international headquarters and an historic estate, landscape architects subtly shaped a corporate setting that reflected TRW's commitment to the environment and to the community.

—American Society of Landscape Architects

Other Careers in Architecture

Only about ten percent of people trained in architecture become full-time licensed architects. The training of the others is not wasted, however, because most of the graduates work at closely related careers. Many architects find that they enjoy drafting, teaching, or model building. Some launch full careers as consultants, planners, advisors, and teachers.

Architectural Critic/Writer

(See Art and Architecture Critics, page 206.)

Architectural Drafter

Architectural drafters prepare finished, accurate working plans and detailed drawings of architectural and structural features. From rough sketches, they make the detailed drawings, later used in the preparation of construction documents, that builders and

engineers use in constructing buildings. Much of this drafting is completed using computer aided design and drafting programs (CADD). Drafters must be able to read plans and specifications, work with dimensions and proportions, and have a knowledge of construction techniques and terms.

Architectural Delineator or Renderer

After listening to the ideas of the client and the architect, and collecting information from other members of the architectural team, the delineator will first make some quick sketches. The delineator then makes a large illustration of the proposed structure, usually computer-generated or done in ink or colored pencil. Some delineators are employed by architectural firms, but others work on a free-lance basis, providing illustrations of the finished project before the plans are even drawn.

City Planner

(See Urban Designer, page 30.)

Landscape Drafter

Landscape drafting is similar to architectural drafting, except that it requires work with natural landscape features, trees, and plants. Landscape drafters prepare scale drawings and tracings from rough sketches or from figures and data provided by the landscape architect. They prepare site plans, drainage and grade plans, lighting and paving plans, and traffic-flow patterns. They also complete plans and drawings for irrigation and watering systems, plantings, and details of garden structures and elevations.

A knowledge of plants and landforms is necessary, but most important is the ability to draw, measure, and finalize the sketches and concepts of landscape architects and environmental planners.

Model Builder

(See also Other Careers in Film, TV, and Multimedia, page 140.)
Model builders work in industrial-design offices as well as in architectural firms. They build three-dimensional models of completed buildings, complexes, or portions of cities. When huge redevelopment projects are considered, model builders construct miniatures of the project so that lay people, engineers, city planners, environmental designers, and government officials can visualize and better understand the project.

Model builders use wood, aluminum, plastics, and plaster to indicate how a structure will be related to its environment. As with architectural delineation, models often sell construction projects to a community or to prospective financial backers.

Mural Artist

Mural artists are usually free-lance fine artists or graphic designers who have a special flair for designing large wall spaces. Such decoration is usually symbolic of the corporation or corporations that occupy the building. Many state and local governments set aside a small percentage of the total new construction budget to provide art for public places.

Mural designers and artists often have a background in interior design, graphic arts, or painting. A sound knowledge of color coordination, graphic symbolism, and architectural graphics is also helpful.

Playground Designer

Playground designers work with landscape architects and recreation and park departments to design and supervise the construction of playgrounds. They provide children with places to climb, slide, crawl, jump, and run. Playground designers are concerned first with safety, and then with the use, feel, and look of the forms they use. Appearance and appeal of the forms are important, but so too is consideration of the playground's visual impact on the surrounding community. Playground designers are usually trained in industrial design and have a special interest in children's activities and working on human-scale projects.

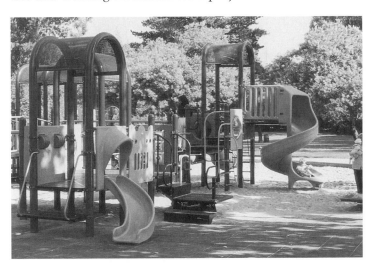

Teachers of Architecture

(See Art Education, page 177.)

Theme-Park Designer

Theme parks are popular family entertainment attractions. Theme-park design teams begin with soil studies and environmental-impact reports. The teams then hold meetings to plan areas for size, function, and traffic flow. Architectural plans are created and drawn; and individual rides, games, displays, shops, arcades, and other entertainment features are designed and built. A large number of artists from various career areas are involved in these processes, but the coordination of the whole project is the responsibility of the architect in charge—the theme-park designer.

Remain flexible and follow your dream.

Linda Umgelter-Shull, certified
interior designer

Linda Umgelter-Shull

"I have been an interior designer for more than 26 years. A lot of change has occurred during that time, both in my profession and in the people that are in it.

I was fortunate to have been given the opportunity to work for several leading interior-design companies, starting for a company that specialized in retail projects (offices, banks, department stores, hospitals, etc.), and moving from assistant to head of the department. My position eventually offered me the chance to travel all over the world (Singapore, the United Kingdom, Hong Kong, Canada, and Australia), implementing the best the United States had to offer in design to these fascinating projects.

After all this excitement in my life, I made the decision to leave my staff position and embark on marketing my talents on a free-lance basis. This was at a time when not many designers worked at home, and I was told it would not work. It did, however; in fact, it worked very well. I enjoyed years of fruitful, exciting, and abundant work that continued until 1990. Since that time, I still have my free-lance work; however, I have been forced to rethink not only the kind of design I do, but my market as well. The kind and amount of work available to me also changed, and, like many others, I was forced to become flexible. Flexibility is a key word in today's interior-design market.

If you are embarking on a career in interior design, I would recommend you seek a well-rounded education in all disciplines. In today's world, you must be able to not only execute the design, but be conversant in all the mechanics involved. You need to be capable in all phases of sketching, rendering, material selection, job-site coordination, making working drawings, and staying within a prescribed budget.

No matter how much the world and the design market have changed, I would not alter any of my decisions to be a designer. My advice to anyone thinking about pursuing a career in interior design is to do so. My choice was specializing in retail projects, but the economy has changed that. My love of the profession and what I can do have not changed. Remain flexible and follow your dream."

Interior and Display Design

As far back as cultural history goes, people have tried to make their interior environment comfortable and beautiful by such decorating as hanging blankets or scratching or painting designs on walls. As homes became more permanent, these decorations became more sophisticated. Trade with other areas of the world brought exchanges of decorative elements. When times or people were prosperous, decorations were lavish; simpler living conditions dictated a dependence on solid, utilitarian items.

Interiors reflect the lives and interests of their occupants, and the converse is also true: people are influenced by their surroundings. Interior designers understand this and work closely with clients to create functional, beautiful environments. Even before an architect has finished supervising the construction of a building, new tenants contact interior designers and facility planners to begin the process of designing its interior. Owners of new homes, condominiums, and offices often seek professional help in space design and the selection and arrangement of furniture and accessories. Owners of department stores, shopping malls, specialty stores, and other shops require professional advice on formats, traffic-flow patterns, colors, lighting, textures, displays, fixtures, and accessories that will draw customers and make shopping an enjoyable experience.

The interior-design field includes careers directly involved with interior planning and design, as well as related areas such as the design and manufacture of wallpaper and custom wall coverings, fabrics, furniture, floor coverings, lighting fixtures, and other items and materials. Most of the people employed in these industries have training and background in interior design. There are specialists in limited categories such as interior rendering, dining-table arrangement, antiques, kitchens, color consulting, commercial offices, and decorative hardware; there are also designers who work with individual clients, advising and assisting them with every phase of their project.

Display design reaches in three major directions: merchandise display in stores and malls, museum and gallery displays, and exhibit displays for conventions and temporary exhibitions. When you visit museums and when you attend conventions or shop in department stores, you walk into the work of display designers. After studying the objects on view, take time to look at how they are displayed: the lighting, display stands and cases, arrangements of the elements, traffic flow, ease of viewing, and so on; and you will become aware of what display designers do.

Every aspect of a store interior is planned, color-coordinated, and built according to the concepts of an interior designer. The interior of Goudchaux's Maison Blanche in Lakeforest, Louisiana, was designed by Linda Umgelter-Shull. Courtesy Chaix and Johnson, Architects.

Interior Designer

A building, whether residential or commercial, may have outstanding architectural merit and structural integrity, but most people live and work inside, not outside. This is the realm of interior designers, who coordinate the efforts of manufacturers, consultants, dealers, and clients. Residential designers work with individual clients to create interiors for single rooms or entire homes, apartments, or condominiums. Commercial or contract designers work on larger projects with individual clients, corporation boards, or hotel or department-store management teams.

Professional interior designers are qualified by education and experience to solve problems related to the function and quality of an interior environment. They are competent in areas of fundamental design, space planning, color coordination, and selection of visual art. They learn to understand the needs of clients through discussion and analysis, and are able to design efficient, pleasant interiors.

Working arrangements for interior designers vary. Some have their own studio and free-lance for a variety of clients. Some join design firms as an assistant or associate designer; others are employed by retail or office-furniture outlets to advise their clients. Architectural firms employ interior designers to work on their design teams; and hotel and department-store chains, restaurants, and large corporations may employ them to work on new or remodeled buildings.

What does an interior designer do?

Designing interiors is more complicated than re-arranging furniture or painting the walls a new color. Although some jobs involve simply selecting some new furniture and redecorating a few walls in a single room, others involve planning and coordinating all the interior arrangements of a gigantic building complex or department store.

Interior designers evaluate projects; plan space; and consider layout, work flow, and comprehensive design. They select furniture, fabrics, wall and floor coverings, accessories, and art elements. They may specialize in residential or commercial accounts. Some work only with new structures, but others redesign existing spaces. However, all interior designers must first consider the individual characteristics of clients and then design suitable interiors.

Interior designers often use architects' plans and work in several computer programs to develop three-dimensional visualizations and floor plans. They present their concepts to clients by using scaled floor plans, color and material charts, material samples, photographs or drawings of furnishings, and color renderings or sketches. After discussion and modification, the designer gives the final presentation, which includes cost estimates for all items in the project, as well as estimates for labor, materials, custom work, and consultations.

Colors, textures, traffic flow, accessories, floor coverings, two- and three-dimensional art, plants, and the feelings and desires of the client must be coordinated by the interior designer. Courtesy Steve Chase and Associates, Palm Springs.

When the presentation designs and specifications are accepted by the client, the designer purchases the furnishings or has them custom-made, and supervises their installation. The designer hires and coordinates the work of all the craftspeople and consultants—until the last hinge and light switch are in place.

Every design firm, large or small, must deal with mounds of paperwork: specifications, orders, estimates, costs, catalogs, and administrative details. The working hours of an interior designer are often irregular and are spent drawing plans, making models, shopping, and meeting with clients, subcontractors, or craftspeople. Comparable amounts of time are often spent inside and outside the studio.

What qualities are helpful to an interior designer?

Interior designers must be able to see the design possibilities in an empty room. They must also have a strong sense of design, be able to draw and sketch well, and enjoy working with many different materials. They must have a strong sense of color, form, and scale, and possess patience and an imaginative, creative approach to problem solving. Interior designers should enjoy working with and for people, have strong communication skills, and be well organized and businesslike if they are to handle the detailed nature of their work.

What other careers require similar qualities?

People with interior-design backgrounds work in many career areas that serve the entire industry. Such related careers include lighting specialist; wallpaper and wall-covering designer; fabric designer; floor-covering specialist; and designer of accessories, decorative hardware, kitchen and bathroom fixtures, and the like. Related jobs include interior renderer, drafting detailer, color stylist, interior architectural delineator, interior decorator, furniture- and interior-sketch artists, and interior illustrators.

Manufacturers of boats, automobiles, buses, trains, and airplanes often employ interior designers to design and supervise the manufacture of furniture, interior features, food-service systems, and accessories. Industrial designers and interior designers work closely together in these areas. Writers for design trade magazines and popular home magazines also come from the ranks of interior designers.

What can you do now?

If you are interested in interior design, take art classes of all types. Drawing, painting, art history, and design classes are extremely valuable. Word processing and business courses are excellent electives; and English, history, public-speaking, and psychology courses are also useful.

Part-time work in an interior-design studio or designer's shop is ideal. You can gain valuable experience by working in almost any department store's home-furnishing section. Your practical skills and knowledge can be strengthened by working for a carpenter, cabinetmaker, lampmaker, upholsterer, ceramist, or furnituremaker.

Titles of magazines that can provide you with good interior-design direction are on page 224.

What schools offer necessary programs?

Beginning a successful career in interior design without a formal education from an accredited school is almost impossible. Associate membership in the American Society of Interior Designers (ASID) calls for a minimum of graduation from an accredited school with a degree or major in interior design, or graduation and diploma from a three-year professional school. After a two-year apprenticeship under a professional designer, a designer may apply for membership in ASID. Schools that have student chapters of ASID are desirable, and those that are accredited with FIDER (Foundation for Interior Design Education Research) are recommended. See the charts at the back of the book.

Facility Planner

Facility planning has gained importance as building costs have increased and space has become more valuable. In simplest terms, facility planners determine how to use a client's space to obtain the greatest benefit at the least cost. They work with architects in the early planning stages, developing design programs that specify the kind and amount of space required. Architects base their arrangements of interior spaces upon these design specifications.

Facility planners may work for architectural firms, large interior-design offices, or consulting firms that have clients in both the architectural and interior-design fields. Governmental agencies, hospitals, prisons, schools, shopping malls, utilities, and various businesses call on facility planners for advice and recommendations. Some large firms may have facility planners on organizational teams within the corporate structure.

Facility planners come from interior-design or architectural programs or from the fields of business, economics, public administration, or urban planning. Many planners who work in both areas of planning and analysis have an undergraduate degree in one field and a graduate degree in the other.

What does a facility planner do?

Facility planners analyze and recommend. They develop long-range plans for space utilization for large corporations or government agencies. Such plans project the number of employees needed for fifteen- or twenty-year periods, and planners calculate the space necessary to maintain efficiency and comfort over that time. They work with a variety of computer programs to aid them in developing the best use of space.

Facility planners also lay out space within offices. They make up space standards for certain jobs so that all employees with similar jobs have similar amounts of space. They analyze their client's needs and plan how walls and furniture should be placed to maximize available space.

There are two areas of facility planning that are sometimes combined in one job, and sometimes separated into two. These are *facility analysis* and *space planning*. Facility analysts gather and analyze data. They may develop questionnaires or conduct interviews to find out which departments in a company are growing, what special equipment is needed, and what special spaces (libraries, conference rooms, vaults) are required.

Space planners work with floor plans as well as with actual spaces. They plot current locations of walls, furniture, computers, and light sources, and examine traffic use by measuring square footage and determining which tasks are done where. They may recommend more efficient furniture or the removal of walls. They draft, make models, draw sketches, and prepare graphics for their reports and presentations.

What qualities are helpful for a facility planner?

Facility planners must be able to analyze situations and make decisions and recommendations. Well-developed mathematical skills, drafting and sketching skills, and the ability to read design plans are all needed, along with a graphic-design background. Because they are constantly in contact with people in all phases of work, facility planners must be able to speak easily about their projects. Strong computer and research skills along with the ability to make decisions and solve problems are necessary for a career in facility planning.

What other career areas require similar qualities?

Because facility planning touches on both architecture and interior design, these fields might be of interest. For someone interested in space planning, optional careers include space consultant, city planner, urban designer, office-furniture and systems designer, or any other career that deals primarily with making workspace more efficient. Space efficiency is an important consideration in the design of mobile homes, ships, recreational vehicles, airplanes, and stage sets.

A person more interested in facility analysis might also find these positions interesting: analyst on an architectural team; consultant to corporations and government agencies; graphic artist who specializes in

reports, charts, data, and visual presentations; graphic artist who designs company reports, summaries, and yearly reports to stockholders.

What can you do now?

Take all the art classes you can, and place an emphasis on drawing and drafting. Also take mathematics courses to strengthen your ability to work with figures, solve problems, and make analytical judgments. Public-speaking classes, debate teams, and English classes will help develop communication skills. Work hard to develop computer skills, especially with database programs. Try to obtain part-time work in any drafting capacity. Any jobs listed in the sections on architect (see pages 25, 31, and 33) or interior designer (see page 39) would provide valuable experience.

Architectural, interior-design and industrial-design magazines would be of interest (see page 224).

What schools offer necessary programs?

Facility planners come from both architectural and interior-design backgrounds, so study or a degree in either discipline is excellent. Schools with large departments in either area will offer the courses needed to pursue the career of facility planner. Space planners need to concentrate on design theory, drafting, and graphics; and facility analysts need courses in research design, statistics, economics, and writing. For the most complete training, take as many courses as possible in both areas.

Give special consideration to schools accredited by FIDER (Foundation for Interior Design Education Research). Refer to the charts beginning on page 229.

A large, complex structure poses a variety of space utilization problems. Facility planners must consider such problems before presenting their recommendations to architectural teams. Photo courtesy Omni International, Atlanta.

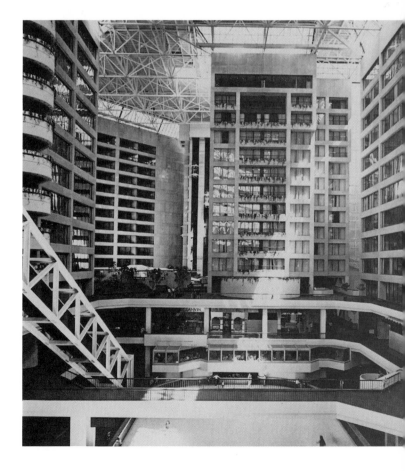

Profile

An Interior Design Firm

Zoltan Kovacs was born and educated in Budapest, Hungary, where he received a degree in architecture. After the defeat of the popular uprising in Hungary in 1956, he emigrated to the United States, where he studied architecture at Ohio State University.

Kovacs moved to Los Angeles in 1959, where for fifteen years he worked for the architectural firm of Weldon Beckett and for Integrated Design Associates. In 1974, he founded the firm of Kovacs and Associates, intending to specialize in a full range of design services for the hospitality industry—hotels, inns, resorts, and casinos. These services include master planning, interior design, and decoration and structural alterations, as well as complete architectural concept and design projects. Additional design services include coordination of graphics, signage, and art consulting. By handling all aspects of a property's design—from interiors to printed materials, signage, and artwork—the firm can produce a cohesive and integrated look.

With a permanent staff of ten designers (it swells to more than twice that number during major projects), Kovacs and Associates has established a reputation for taking a client's concept and interpreting it to create a customized environment, providing exacting documentation and specifications to include in their architectural and engineering documents, or to incorporate into their competitive building or direct-purchasing packages.

Heather Kovacs, senior designer with Kovacs and Associates, studies furniture requirements and specifications prior to submitting ideas to a client. Custom-designed furniture and fabrics are characteristic of the firm's commitment to create integrated, customized environments. Courtesy Kovacs and Associates.

Included in their design packages are custom-designed furniture, fabrics, wall and floor coverings, artwork, lighting, and environmental layouts. The designers have provided services to over 200 hotel projects because of their reputation for taking a client's concept and creatively interpreting it to design a customized environment that will inspire, entertain, and satisfy.

Since 1984, Kovacs and Associates has been involved in casino-hotel design, and is now considered one of the top casino and resort-design firms in the world. Major projects include The Trump's Castle Hotel and Casino in Atlantic City, the Las Vegas Hilton Hotel and Casino and The Flamingo Hilton in Las Vegas, and the concept and design for a Hilton Hotel that will recreate parts of Paris. Other hotels, resorts, and casinos are located in Reno, San Francisco, Anaheim, Sun Valley, Hawaii, Florida, Arizona, and Texas. All of this creative nationwide interior and architectural design is produced in a rather small design studio in the Los Angeles suburb of Toluca Lake.

Ida Dunofsky, senior designer, meets with furniture company representatives Bob Gross and Mitch Zerg. To insure client satisfaction, designers must be aware of the options currently available. Courtesy Kovacs and Associates.

Zoltan Kovacs at work on the exterior-design concept for a large hotel and casino complex to be built in Las Vegas. The theme for the 3,000-room hotel, casino, restaurant, shops, streets, and walkways complex is the city of Paris, complete with a half-scale replica of the Eiffel Tower. Courtesy Kovacs and Associates.

Exhibit and Display Designers

Exhibit and display designs are a form of visual merchandising. The services of exhibit designers are sought by museums, galleries, showrooms, trade shows, manufacturers' representatives, and department stores. Some of these specialists may be employed on the permanent staff of large museums or companies; others may free-lance or work for consulting or architectural firms.

The skills offered by exhibit and display designers are in increasing demand. Displays are used to attract customers for possible sales, and the designer is an integral part of the merchandising team, as important as the graphic artist who prepares advertisements. The importance of these designers to the economic welfare of their clients is huge and immediate.

What do exhibit and display designers do?

Designers who plan and construct exhibits and displays work with a variety of products and materials. They develop visual presentations to be used in permanent collections, temporary exhibits, and traveling exhibitions for all types of museums and galleries. Exhibit designers decide which paintings hang together, how they are hung, and which ones receive prime positions. They are also responsible for designing and constructing display stands and cases, platforms, lighted boxes, and security systems for the effective exhibition of three-dimensional objects.

Exhibit designers in merchandise marts must use display techniques, props, color, lighting, fabrics, and mannequins to attract and hold the attention of buyers. Displays in department stores and specialty shops rely on immediate visual impact; it is vital to their survival in the marketplace. Display designers work closely with fashion consultants, owners, and managers to select and display clothing. Exhibitors at trade shows and state, county, and world's fairs are in constant need of designers who can show manufactured goods, agricultural products, wares, and crafts to the best possible advantage.

Design directors in large department stores have mechanical-drafting ability, carpentry skills, good color sense, and some knowledge of the history of art, furnishings, and decoration. They keep abreast of trends in textiles, furnishings, and fine arts. Window-display designers work directly under them.

Exhibit and display designers make sketches and scale models to present to their clients. They are experts at using lights for dramatic effect, building three-dimensional display units, employing type and graphic symbols, and using space effectively to unify an exhibit.

What qualities are helpful to an exhibit and display designer?

Exhibit and display designers must have a wide range of interests, because they need to draw on many resources in their work. They should be familiar with fashion design and photography and have a background in graphic design. An understanding of space planning, interior design, and merchandising techniques is helpful. Not only do the designers have to be adept at drawing plans and objects and building models, but they should also possess good verbal communication skills, be able to work with others, and be able to meet deadlines.

What other career areas require similar qualities?

College graduates with knowledge of exhibit and display design are also equipped for careers with display teams in galleries, theme parks and convention centers, and for consulting to companies that require visual merchandising. Other related areas of interest include model building, commercial and industrial graphics, display lighting, theatrical lighting, gallery management, and advertising design.

What can you do now?

Art classes in drawing, painting, three-dimensional design, and crafts are useful for careers in exhibit and display design. Designing and constructing stage sets provides experience with lights and building from models. Working as an artist on a yearbook staff provides useful background in graphics and layout, and in meeting deadlines and working closely with others.

Go to museums to study display techniques; look carefully at displays in department stores, shops and shopping malls. Study them at close range to see how they are designed and constructed, how the products are displayed, and how lighting is used.

Part-time work in a store's display department is an ideal introduction to this career area. Express interest in designing window displays for small shops, businesses, and your local library.

What schools offer necessary programs?

Art schools with strong interior-design departments are recommended (see the charts at the back of the book). They provide special emphasis in design areas fundamental to a career in exhibit and display design. Some schools offer majors in exhibition design or sales display (check catalogs or the Internet for this information).

Art schools that stress industrial design often offer classes in display and exhibition techniques, which are used in industry, trade fairs, and merchandise marts. Fashion-oriented schools provide classes and experience in displays that feature clothing, models, mannequins, and accessories. Museum schools provide direction in arranging displays of paintings, sculpture, crafts, and multimedia.

Display techniques include the design, construction, and arrangement of stands, stages, panels, cases, and effective lighting. The exhibit designer, Neil Forsyth, constructed this preliminary model of wood and plastic. The actual booth was built based upon this model. Courtesy Neil Forsyth.

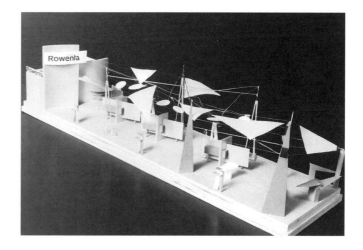

Note the importance of color, shape, and spatial relations in this trade show display of appliances for Rowenta at the International Housewares Exhibition. Photo: ©Oscar and Associates, Chicago.

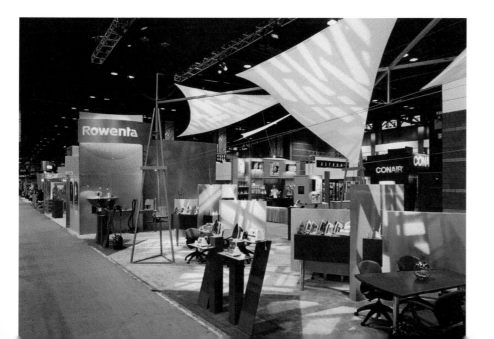

Other Careers in Interior and Display Design

Antiques Specialist

Antiques specialists deal in the single area of interior design that has to do with furnishings and accessories of previous eras. They purchase, restore, refinish, and sell items to the public or to interior designers. They may also act as consultants or appraisers.

Contractor's Assistant (Contract Designer)

A contractor's assistant works on the planning team for builders and contractors who plan and decorate model homes, apartment complexes, office suites, condominiums, or custom-built houses. The assistant coordinates the work of many suppliers to design and furnish rooms.

Design Assistant

Design assistants help designers in the entire operation of their programs. They oversee workshops and stockrooms and supervise business operations. They must have interior-design and computer skills, a knowledge of construction, and the ability to manage an office.

Design Consultant

Design consultants are specialists in one or more areas of interior design, such as lighting, color, draperies, window treatments, kitchens, or baths. They free-lance from their own office, or are employed by furniture or department stores, manufacturing firms, architects, design studios, or supply houses.

Detailer

Detailers make finished drawings from the rough sketches of designers. Their drawings and computer printouts must include notes on dimensions, materials to be used, finishes desired, and any other information that makes the drawings clear and complete.

Facility Analyst

(See Facility Planner, page 40.)

Floor-Covering Designer

Rugs, carpets, runners, and mats of all kinds are designed by floor-covering designers, who often work for the manufacturers of the products. They have a knowledge of the use and application of various materials, as well as the production processes, so they can design items and supervise production.

Floral Designer

Floral designers use wire, pins, tapes, foam, and a variety of tools to design living, dried, or artificial displays of flowers. They trim and arrange materials in bouquets, wreaths, sprays, and terrariums. Floral designers must have a knowledge of color, flowers, and design. They often work with interior designers to create custom displays for residential or commercial spaces.

Interior Decorator

Interior decorators are often free-lancers who decorate existing rooms and spaces, usually in homes or offices, with objects and materials that can be purchased in stores. They show their clients color combinations, fabric and paint swatches, wall coverings, carpet samples, furniture catalogs, and accessories. They suggest decorations and arrangements. Decorators usually work for a fee and a commission on sales and contracted work. They study art appreciation, art and furniture history, and color theory and design.

Interior Renderer

(See also Architectural Delineator, page 34.)
Interior renderers prepare perspective drawings and water-media paintings that illustrate how a proposed and furnished interior will look. They use building plans as the basis of their work. They are usually free-lance artists who do their work for architects, interior designers, or clients who wish to show plans to a building contractor. Large architectural and interior-design firms often have several interior renderers on their staffs.

Manufacturer's Representative/ Showroom Manager

Manufacturer's representatives work for large companies that specialize in the production of home furnishings and decorator materials. They sell their products to buyers from stores, designers and their clients, architects, builders, and contractors. This is done at the factory or at central merchandise marts, where the representatives coordinate displays, recommendations, and sales activities.

Parade-Float Designer

Parade floats are large, mobile display units designed to communicate an instant visual message. Float designers work for their clients within certain space, cost, and material limitations, and make color renderings of the anticipated floats. They employ a variety of materials in the floats: flowers, cloth, plastic, paper, wood, and metal. Such work is seasonal, unless the designer has contracts from float clients around the country.

Photo Stylist

(See also Other Careers in Photography, page 100.) Photo stylists arrange products and accessories to be photographed for national advertisements and publicity or promotional literature. They may plan entire room settings or simple product vignettes for manufacturers and advertising or public-relations agencies.

Set Designer

(See Scenic Designer, page 144.)

Space Planner

(See Facility Planner, page 40.)

Staff Designer

Staff designers are employed by large companies, hotel chains, and franchise operations to plan and coordinate the interiors, furniture, and accessories in their buildings. This type of work is often handled by consulting firms, but if the company is large enough and the demand is constant, a staff designer will be included in the design team.

Teacher

(See also Art Education, page 177.) Art schools, fashion institutes, colleges, and universities offer courses in interior and display design. They hire teachers with design experience. Reputable programs are endorsed and accredited by national design associations with rigid requirements, such as the Foundation for Interior Design Education Research (FIDER) and the American Society of Interior Designers (ASID).

Wall-Covering Designer

Wall coverings include wallpaper, grass cloth, photo murals, laminates, printed patterns, and custom applications such as murals, fabrics, printed papers, tapestries, weavings, and wood. Some wall-covering designers work with interior designers, planners, and clients to custom-design and produce the coverings for interior spaces. Others design for companies that manufacture wall-covering products for the interior-design industry or retail sale.

Window-Display Designer

Window-display designers work on the staff of large department stores or other large retail outlets. Often, they are free-lance artists who contract to do a series of windows in different stores or the shops in a large shopping mall.

Writer for Home Furnishings Publications

(See also Publications Design and Illustration, page 73.) Some people combine a background in interior design with writing abilities and become home-furnishing writers or editors. They may work for trade or consumer magazines, or for newspapers. Also, designers may write advertising copy for their clients.

Publications require feature columnists, reporters, illustrators, department editors, and editors-in-chief. Writers report on current styles and trends; new products and materials; and outstanding interior-design projects, renovations, or adaptations. They may attempt to predict future trends. See page 224 for names of trade and consumer publications dealing with interior design.

Designing for Communication

deli

part two

Designing for Communication

When you choose a career in design that communicates, you become part of an industry that has had a major influence on world economies for centuries. Cave painters, scribes, artisans, type designers, and printers practiced the art of design; and more recently, Web-page designers and videographers have done so. As old and important as the profession is, today it is often not fully understood. Just what does a graphic designer do?

The term "graphic design" originally referred to images and symbols that were written, printed, or engraved, and therefore were part of the graphic arts. As technologies were developed, the world of the graphic designer expanded to include images that were not only printed, but also projected by film, recorded on video tape, and generated by electronic scanning. Graphic design has taken on a newer, more comprehensive meaning. Design areas overlap extensively when graphic designers work with advertising, environmental, industrial, interior, film and TV, and publication designers. (See Part 4, Entertainment Design, for information regarding related careers.)

The computer has revitalized the role of the artist and designer . . .

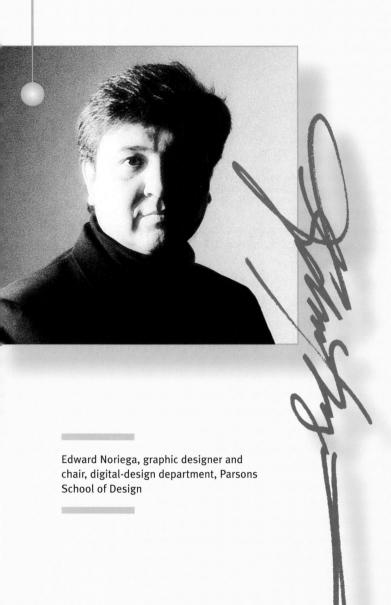

Edward Noriega, graphic designer and chair, digital-design department, Parsons School of Design

Edward Noriega

It is an understatement to say that technology has changed the way we live. The computer has revitalized the role of artist and designer in our society. No longer is the image of a "starving artist" valid. It is an opportune time to become an artist, designer, or art educator. Technology provides the artist and designer with solid employment skills and global exposure.

To say that the computer is "just a tool" (like a hammer or pencil) undermines its use and potential. The function of the computer is much broader. It provides the artist/designer with a plethora of tools yielding immediate results. With the use of a computer, an artist/designer can conceptualize, develop, and publish a product within minutes. Time and economics have been a major reason why industry is driven to use this very functional medium.

The biggest concern in art schools is the issue of tactility vs. expediency. Should a student be encouraged to drop all "traditional" courses (drawing, painting, constructing, drafting, cutting, and pasting) in place of technology? Are these courses even relevant? Especially since industry is now demanding such a high level of computer literacy and skill.

This is clearly a transitional period in art education. Many educators like myself are striving to answer that question and learn the new and changing technologies. It is inappropriate to say, "the computer can do it all." *An artist will always rely on his or her convictions, craft, concepts, and skill to produce art.*

It is the responsibility of the educator to teach students how to use the computer as one of many tools for producing art. Working with the computer invariably changes the way the creator thinks and produces work. The evaluation and merit of all computer generated work must be recognized by its visual dialogue, technical sophistication, and personal contribution.

marzipan

Publication design is a major component of the graphic-design field. This clean magazine layout was given a silver award by the Society of Publication Designers. Created for *Martha Stewart Living*, the design team included creative director Gael Towey, art director Eric Pike, designer Claudia Bruno, photo editor Heide Posner, and photographer Carlton Davis. Courtesy Society of Publication Designers.

Graphic Design

The graphic designer holds a unique place in the competitive world of communications. While we may speak of the importance of design, the public is not generally aware of its impact. Everything we wear, read, ride in, and live in has been created by an industrial or graphic designer. Our newspapers, books, and magazines are the products of graphic designers; so are logos, signs in stores and restaurants, cartoons, annual reports, brochures, gift wrapping, greeting cards, packages of all kinds, all the advertising in print and on TV, and all the images on Web sites and the Internet.

Graphic design is a business. Design awards recognize the ability to create something that is beautiful and functional; some graphic designs are now part of museum collections. But design must also reflect a responsiveness to market factors, and designers must know about sociological and economic trends. We are well aware of being part of a global economic community. The design community is an integral member of that community. Many firms that employ designers have foreign branches or offices. People entering the graphic-design field should recognize that they are functioning at the center of the business world.

The ultimate importance of graphic design as a profession is its impact on business. Graphic design incorporates an aesthetic experience and a creative endeavor, yet its alliance to business and its ability to serve clients' needs define its place and status in our economy. The overriding common denominator of successful people in graphic design is their ability to maintain the highest creative standards without losing sight of their role as director of a business and their importance to the business of the world.

Graphic Designer

In today's complex business environment, there are many aspects to the field of graphic design. Graphic designers were once known as "commercial artists"; they designed book and magazine pages, worked in advertising agencies, and created logos. The field has gone far beyond that concept. This section details a few of the aspects of graphic design, and more are discussed on pages 56 and 68.

When you open this book and note the arrangement of type and visual images, or when you look at a magazine, watch a TV commercial, enter a theme park, "surf" the Internet, and read signs, you are affected by the work of graphic designers. Our commercial world is shaped, decorated, and punctuated by their work.

Graphic designers are the architects of the printed word—both in print media and in the moving multimedia images on TV. They combine the resources of illustrators, typographers, photographers, copywriters, and computer specialists to create visual presentations intended to attract attention and sell products or ideas. In a sense, they are artists who have design skills and understand the psychology of marketing. They work with architects, computer programmers, environmental and digital designers, copywriters, exhibit designers, catalog companies, corporate executives, newspaper staff, and package and product designers. Although graphic designers rely on their creative and artistic skills, it is their alliance to business—their ability to serve their clients' needs and to promote products and concepts—that makes them vital elements in today's economy.

What does a graphic designer do?

The essence of graphic design is visual communication. Graphic designers are visual problem solvers who take the ideas of businesspeople and translate them into something that the public can grasp. Their designs—whether for packages, advertising, or TV—must not only be exciting, imaginative, and compelling, but must also impact the intended market.

Many variations on the graphic-design process are possible. In a typical scenario for printed material, an art director explains the client's needs to the graphic designer. After research and analysis, the designer works on initial ideas called roughs, which give clients and art directors several possible solutions. Simultaneously, copy writers and/or editors work on the content of the piece. When the visual roughs are modified and the most effective one is approved, the designer completes detailed layouts using the newly written or updated text. Graphic designers work with their resources (typographers, desktop publishing specialists, illustrators, photographers) to finish all the elements of the program on time. Printed proofs show how the material will look. Success or failure of the graphic production is determined by public reaction.

Graduates with a graphic-design major begin their career by working in studios under the direction of more experienced designers. Some graphic designers become specialists in certain products (trademarks, books, magazines, TV graphics, packaging), and others enjoy the challenges of working for many different clients. They can work in design studios, for corporations, or as free-lance designers.

Gary Ashcavai, a graphic designer working for Sun Microsystems, uses several computers and programs to fill the corporate-design needs of the company. Photo by Pat Kraemer, Courtesy the designer.

Some logos, such as the NBC peacock, are recognized by almost every American. This graphic-design element identifies the entrance to the TV facility in Burbank. Photo by Gerald Brommer.

What qualities are helpful to a graphic designer?

Graphic designers should have artistic talent, good design sense, imagination, and style. An enjoyment of research and the assembly of projects is also an asset. In addition to being able to sketch and draw well, they must be adept at lettering, understand typefaces, and have a command of a variety of computer programs. They must possess a keen awareness of shape, color, form, and contrast, and be able to visualize ideas and concepts. Being able to work well with others, respond favorably to criticism and correction, and meet deadlines are critical to the graphic designer's success.

What other careers require similar qualities?

Careers across the board in the graphic- and industrial-design fields require similar qualities. The ability to organize people's efforts to solve a problem is needed in urban planning, architecture, environmental design, and the film and TV industries. Museums, department stores, publications, public-relations firms, and corporations need the services of artists with graphic design backgrounds.

What can you do now?

Take drawing, basic design, drafting, painting, photography, crafts, printmaking, graphic design, and computer courses. Put your best work into your portfolio. Part-time work for a design firm or free-lance designer provides excellent experience in the field. Look at other, related graphic-design careers for work that would be helpful, and also check magazines that feature graphic design (see page 224).

What schools offer necessary programs?

Art and design courses at community colleges will sharpen the skills needed for further education. Trade schools may help your development in the production aspects of graphic design: photography, design, and computer skills. Four-year art colleges and art and design schools that offer accredited degrees in graphic design are listed in the charts beginning on page 229. Some of these schools offer a fine-arts approach; others stress the advertising aspect of graphic design. Refer to catalogs or the Internet for clarification of each school's approach. A visit to the schools and a look at student production will help you determine if their direction coincides with your own feelings about art and graphic design.

Historical Perspective

Everywhere you look, you see new ways to do things, new methods of solving problems—computer graphics, digitized typography, color scanners, and so forth. All of these technical developments make possible finer-quality results, with less labor and expense than ever before. This is indeed a time for learning...

It has been said that by the year 2000, the largest industry in the United States will be the communications industry. And that is the industry that we as graphic designers will be part of. It is now being created by scientists and engineers. It will remain to be shaped by artists and graphic designers. Technology cries out for art!

—Aaron Burns, a founder of the International Typeface Corporation (ITC), in 1983

Mike Salisbury relaxing in his studio.

Logo for the film Jurassic Park. Courtesy Mike Salisbury.

Graphic Designer: Mike Salisbury

Mike Salisbury started in the art business when he was fifteen years old, making friends and some money painting cars with images of flames and bloody eyeballs. He attended the University of Southern California, then became a graphic designer. Because of a wide range of personal interests, over the years he has also been a magazine art director, advertising-agency creative director, illustrator, photographer, film director, writer, and teacher at schools like UCLA and Art Center College of Design. He believes that diversity of interests and skills is not only important; it is essential.

Salisbury has been a part of the creation of some All-American icons like the Levi's 501 brand, Michael Jackson, and the Jurassic Park logo. He has worked with more than a hundred clients with recognizable names like Warner Bros. Pictures, and his work is part of the collections of the Museum of Modern Art, the Smithsonian Institution, and the Library of Congress.

The following are Mike Salisbury's secrets of success:

1. *Visualize. This saves a lot of paper, pencils, and computer time and gives you something to do in the car or while waiting in line at the movies. It makes you think. Alone. And thinking is where the big ideas come from.*

2. *Presentation. "If it don't look good, it ain't gonna sell!" That's the business you are in—making things look good. Do it for yourself, even if it costs you. Most people you present your work to will not know what you do or how you do it, but they will know if it doesn't look good!*

3. *Sincerity. When selling your work, be enthusiastic and honest, and simply explain what you did and why. That's all!*

4. *Study. Many advancements have been made in the arts—use them! Use the tools, symbols, and language of visual, written, and oral communication by learning them. Have fun learning. The more you learn, the more you earn.*

5. *Ask. If you don't understand the information the first time (all the necessities you need to help you do your job, like deadlines, budgets, specs, etc.), call back and ask. Why look stupid later when the work you did is all wrong?*

6. *Take notes. The human memory doesn't work all that well as a recording instrument. Notes make the information register in the brain. Documentation is also a great way to settle any argument later.*

7. *Talk. Discuss. Test your ideas on others. Get their input. This helps you build confidence.*

8. *Be on time. Period! In everything, from attending meetings and conferences and getting work in under deadlines. No excuse is a new excuse.*

9. *Say please.*

10. *Say thank you!*

Advertising design and illustration for Levi's 501 Jeans. Courtesy Mike Salisbury.

Some Thoughts about Graphic Design and the Computer

...if you are not an artist, the computer will not turn you into one.

Many areas of design are heavily dependent upon computers. How do artists and designers feel about computers? Are they a blessing or a curse?

Jeffrey Lerer, artist and instructor of advanced computer animation at Pratt Institute in Manhattan said in the 1996 *Communication Arts Advertising Annual,* "[L]et me demystify the computer: The computer is simply an array of tools. ...if you are not an artist, the computer will not turn you into one. The computer will never eliminate the artist unless you want to eliminate quality."

Lerer sees the future as a place with much demand for the work of artists, most of whom will use the computer in some way. He states: "There is going to be more and more room for the independent artist/photographer...to satisfy all those demands for graphics on the Internet, digital television, endless channels and more magazines than the planet should have."

There will continue to be a place for handmade or analog art, but mostly for customers and clients who can pay for the time involved with it. The subtle quality of a drippy color mix and the organic hand-drawn line cannot exactly be duplicated by the computer, but at a time when speed and low cost are essential to survival, the computer satisfies urgent needs. How can an artist who takes seven hours to do something by hand compete economically with a computer artist that can do it in a half-hour?

Rita Armstrong is head of the computer graphic-design placement department of Roz Goldfarb Associates, a recruitment consulting firm. She suggests that keeping as up-to-date as possible with technology is wise. Armstrong comments on the software and hardware skills needed to enter the design field in Goldfarb's *Careers by Design* (see page 222). Indicating that Macintosh is the dominant system for graphic designers, she says that the best software to learn "is in constant flux. ...An example is the manner in which Quark has supplanted Pagemaker.

Digital-designer Ron Kriss created this design as an advertisement for the 1996 Atlanta Olympic Games, using Quantel Video Paintbox software. Courtesy Ron Kriss.

Currently my clients want to hire Quark experts who have a strong knowledge of at least one other program. In most cases they are using Adobe Illustrator and/or Freehand. Some familiarity of Photoshop and scanning techniques is always a plus."

But this need will likely change. Creative director Tom Weisz points out, "Today's graphic designer or communication professional has the opportunity of a lifetime if they recognize their process is likely to change and they are adaptable to that change. We are at the door to a whole new world of communication." *(Careers by Design)*

Roz Goldfarb comments on the relationship of artists and computers: "While the future may be foggy, certain truths are evident. The technology is being harnessed and the designer has to assess his or her role as the arbiter of design and taste." *(Careers by Design)*

Experts in the graphic-design field are virtually unanimous in thinking that computer literacy and familiarity with various software programs is essential to working as a designer. Yet, in the process of preparing for such careers, there is a need to strengthen the fundamental skills of drawing and painting, and to develop a basic understanding of visual design. As Jeffrey Lerer states, "These are tough things to bring together," but careers in any design field rely on a balance of these elements. Be prepared!

With the proliferation of Internet resources, graphic artists with both visual design skills and computer expertise are always in demand.

From Art Director to Web-Site Design Director: Norbert Florendo

Norbert Florendo's career path is one of many whose direction has been significantly affected by computer technologies. Destined to be a professional artist, Florendo's interest in art started very early in life. He took every opportunity he could to create artwork, look at an art book or go to a museum.

He took his commitment to art through college. Studying first as a painter, he then turned his attention to graphic design at The Cooper Union, in his home town of New York City. He remembers, "during college, I would pick up free-lance art jobs, learning new techniques from professionals. With both school and free-lance work, I was well prepared for a full time art career."

Beginning as an art director for a small fashion magazine, Florendo continued working for advertising agencies, newspapers and commercial printers. On many projects he would team up with other creative people, like illustrators, photographers, and designers. "Each one of us had a part to play in completing a project," he emphasizes.

An advertising, design and typographic creative director for 28 years, Florendo became creative director for Agfa Compugraphic's Type Division. At Agfa Compugraphic, he had world-wide responsibility for selecting and developing type designs for the high-end typographic market.

Florendo maintains an interest in type design. He worked in partnership with Ed Benguiat (see page 58) as typographic consultants to the design committee of the 1992 Summer Olympic Games. Always open to learning, he says "I soon became interested in how computers could be used to create art and designs."

His involvement with computer-generated graphics, animation and interactive presentations began in 1986. Florendo's interactive interface designs and intuitive navigational tools have received written plaudits from *MacUser*, *Home-Office Computing*, *Publish*, and *MacWorld* magazines. He has also written many articles on typography and electronic publishing.

Now the director of Acme Digital Lab in Wilmington, Massachusetts, Florendo oversees the creation of Internet Web sites and CD-ROMs. Yet, his interest in art comes full circle. "When I have a chance, I still love looking at art books and museums, even on the Internet."

Type Designer

Almost every piece of graphic design makes use of words; in fact, some advertisements and design programs use only words. Successful graphic designers must have complete knowledge of lettering and letterforms, along with typography.

Early type designs were based on handwriting, and type styles evolved for centuries to suit the growing needs of the printing industry. Thanks to computer programs, type fonts and styles today are in the thousands, with new designs being created almost daily. Ironically, in our digital age there has been a resurgence of interest in hand lettering and calligraphy.

What does a type designer do?

All the type you have seen in print was designed by type designers. For hundreds of years, there were only a limited number of type styles, because type was cast in metal and the use of many styles would have been extremely cumbersome and costly. Today, typefaces are designed to be reproduced by digital processes. Artists must design the typefaces; computer software can only modify existing fonts.

Type designers may work for a digital type foundry such as Adobe, Font Bureau, or ITC; for a design firm as graphic artists who also design type; or they may be self-employed. They work with the traditional elements of letters, but make innovations and distinctive departures and additions. These differences are subtle, but to graphic designers who must choose letters that complement an ad format or illustration theme, such unique characteristics are essential. A company may have type designed and patented to be used exclusively by its marketing department.

Type designers must carry out their concept in all letters of the alphabet, both upper- and lowercase. All the elements of the typeface must work well together. Designers may sketch ideas and draw letterforms by hand, scan the shapes into the computer and continue to refine them; or they may begin on the computer with a drawing program. Special software is available to help in the design and creation of type fonts.

What qualities are helpful to a type designer?

Neatness and a sense of proportion are essential to all artists working with lettering. They must work in great detail and in small formats. The artists must be exact in their work and have the patience necessary for analyzing and fine-tuning it, especially when working on long-range projects. Familiarity with software fonts and current graphic design trends are also hallmarks of a successful type designer.

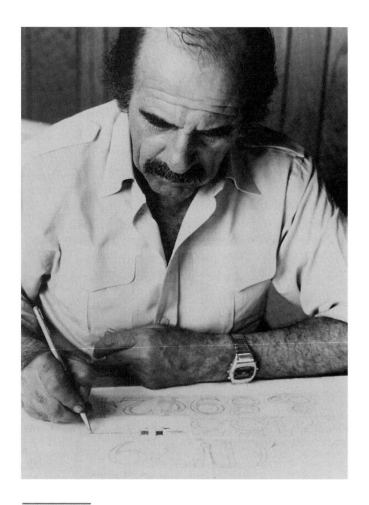

Type designer Ed Benguiat works on the pencil outlines of a typeface that emphasizes subtle curves and a variety of visual weights. Photo courtesy Type Face Corporation.

Dolores Crunchy

Type Designer: Tobias Frere-Jones

Because of his background in graphic design, Tobias Frere-Jones was familiar with press proofs and type-specimen books. He says, "I knew at some level that somebody, somewhere, has the job of drawing the letters. But it was only when I began to get some training as a writer that it made sense to bother with the shape of the actual letters. I was shown the sorts of things you could do with language, the power that it can have. Then it suddenly felt really important to go draw the letters themselves."

Frere-Jones was studying type design and spent three months designing a "very conservative, straightlaced sort of text face." He also spent about three days designing a playful typeface which began with "goofing off" on the back of a napkin.

"... I took a short trip to Berlin to a type vendor, and I showed him the very conservative text face; he wasn't really that interested in it. Very reluctantly, I showed him this other thing [Dolores] that was just so stupid and dumb that surely he would think I was joking. But he thought it was absolutely fabulous and dragged me off into the other room and showed me contracts and packaging and so on. I walked out of there with a contract."

How does Frere-Jones feel about being a published type designer? "I went to the supermarket about a week ago. I was walking past the aisles of peanut butter, jelly, and jam, and so on, and there's this brand of peanut butter that says in big letters across the front, 'Crunchy'—as opposed to 'Creamy'— and it says it in Dolores. I have this jar of peanut butter in my office here. I've made the big time: I'm now on a jar of peanut butter."

Frere-Jones has the following advice for aspiring type designers: "Go to a local printer or service bureau and get a specimen book. Spend a lot of time drawing, looking, and thinking. I think one of the important things is the ability to think abstractly. If you feel at home with more abstract concepts, this is definitely your line of work."

What other careers require similar qualities?

People who like to work with type will feel at home in areas related to the printing trade: desktop publishing, prepress, and design. Careers in various publishing industries require expertise in working with type, reproduction, and printing. The qualities of patience, care, neatness, and exactness are required in graphic design, industrial design, drafting, technical illustration, sign painting, and architectural graphics.

What can you do now?

Include drafting, drawing, design, art history, and printmaking among your art classes. Sign up for print shop if it is available. Lettering or calligraphy classes may be available from the extension divisions of colleges. Check with your local art schools.

Work on publications is a natural outlet for an interest in type. Part-time jobs in printing shops provide practical work with type, desktop publishing, and the actual printing process.

Magazines and other periodicals that can offer career suggestions and ideas include *Print, CA (Communication Arts), Eye,* and *U & lc* (Upper and lower case). You can get an idea of type styles by studying the fonts available for computers. Your library probably has books on lettering.

What schools offer necessary programs?

All colleges and art schools with good graphic design departments have courses in type design. (Check the charts beginning on page 229). School catalogs or Web sites will indicate if such courses are available.

Logo Design and Corporate Identity

The respectability of graphic design as a profession is indebted to the emphasis on corporate identity beginning in the 1950s. Designers like Paul Rand, Lester Beall, and Raymond Loewy lifted graphic design to a respected position with their exciting corporate-identity programs and logo designs. As a result, bold, direct symbols and logos readily identify major corporations such as Mobil, Saturn, Shell, Honda, IBM, Volkswagen, Hilton, NBC, United Parcel Service, and hundreds of others, and are essential design elements in the corporate structure of America.

A brand name or corporate logo is often a company's most valuable asset, serving to distinguish its products from those of its competition with the identifying image of a recognizable trademark. The omnipresence of such corporate identities has generated a heightened literacy of the eye. Ellen Lupton, writing in the 1996 *Communication Arts Advertising Annual*, states: "To be literate in contemporary culture means not only to know the letters of the alphabet, but to recognize a vast range of logos, brand names and product images."

Lettering and company names are often welded together so that the typeface of a corporate name becomes a distinguishing element in corporate identification. Company names such as Ford and Campbell's are identified as much by the unique look of their name in type as by the name itself.

Even though they usually have graphic-design departments, large corporations—when they decide to revise and update their image—often call upon graphic-design consultants who specialize in corporate design. Working on corporate-identity programs can be demanding, expensive, and time consuming, often taking over a year to complete. The type of graphic designer suited to this field is a person with a strong interest in pure graphics and one who loves design theory, problem solving, working with symbols, and developing logos. Because corporate design involves working with management and executives, the designer must be able to communicate effectively.

A single example demonstrates the process and research involved in corporate logo design. In 1994, Landor Associates was asked to redesign the Federal Express corporate image. Because of the global expansion of Federal Express, executives wanted to develop a global corporate symbol recognizable all over the world—on packages, planes, and trucks. The registered service mark "FedEx" was refreshed with the company's original colors of purple and orange, only slightly changed to be more readable and more easily reproduced. The name "Federal Express" was included in the new design. The new FedEx/Federal Express logo is instantly recognized around the world, but it took a full year of research, interviews, discussions, and 400 preliminary sketches before five possible concepts were chosen. The final selection was made by a team of corporate executives. The new image evolved from the close collaboration between client and designer and resulted in a dynamic logo and identity program.

FedEx service marks used by permission

Corporate ID: Can You Name the Company?

Shape can make a product or service stand out from the competition on package labels, on signage, or on TV. Distinguishing shapes and forms communicate across cultures in any language. A recognizable shape provides visual identity even in places where the brand name may be difficult to pronounce. On this page are shapes that have become synonymous with their companies or products. See how many you can name. If you can name them all, their designers have succeeded in producing effective designs.

The following explain the reasons behind each element in the FedEx/Federal Express design:

A friendly typeface is a hand-drawn combination of several existing typefaces. Upper- and lowercase letters project a friendly and approachable feeling. Running letters together and joining the *d* and *E* suggest speed and connectedness.

A secret arrow was created by customizing the letterform size and shape of the *E* and *x*. The resulting arrow suggests speed and directness. Can you see the hidden arrow?

The service mark Federal Express was also included due to its fame and recognition around the world which served to associate FedEx with Federal Express as a powerful brand.

The color carries over from the old logo design and helps retain the continuity and integrity of the corporation.

Advertising Agency

The purpose of advertising—a visual and written solution to a marketing strategy—is to sell a product or service. Whether the ad is on TV, in newspapers or magazines, or in a direct mailing, it is designed to send the message "buy me!"

Advertising-agency workers use all media (print, video, audio, film, digital, multimedia, and broadcast) to plan, create, produce, and place advertising for their clients. Our entire economy relies on advertising to tell the public what is for sale and why they should buy it. Advertising agencies handle the newspaper and magazine ads, radio and TV commercials, billboards, direct-mail pieces, catalogs, exhibits, and other promotions for large corporations, whose advertising budgets run into many millions of dollars per year.

There is much more to advertising, however, than the visual presentation by graphic designers, and most agencies are made up of teams with four major responsibilities: 1) account management, 2) media, 3) creative design, and 4) production. In small agencies, people may work on several teams.

Members of the creative team working with marketing account executives form the key players in most agencies. The team is a combination of art directors and copywriters who work closely together. This creative and marketing talent devises the advertising strategy with and for the client. The media department makes the decisions for placement of the advertising in print and broadcast, because they buy the space and time.

The difference between a design firm and an advertising agency is that the agency *places media*, which means that they buy space in print media or time in broadcast media for their clients. Design firms often do art and design work for ad agencies, but they don't sell the advertising material to the media.

About 167,000 workers are employed by American advertising agencies, with many of them working on Madison Avenue, in New York. Other major concentrations are in Los Angeles, Chicago, Houston, Atlanta, San Francisco, Dallas, Detroit,

Minneapolis, and Miami. Small agencies are found throughout the United States.

TV, cable, radio, newspapers, and magazines offer excellent career opportunities in advertising. Interactive media is making huge strides; and direct-mail, catalogs, event marketing, and national newspapers round out the potential career areas in advertising design. Artists and designers are best suited to the creative and production segments of advertising agencies.

What do graphic designers do in advertising agencies?

Graphic designers work with the creative team and plan and produce the needed graphics and visual images required for the advertisement. They use computers to design page layouts including type and visual images. They may also draw some layouts. Designers work to present the best possible arrangement of visual elements.

Graphic designers in advertising work as team members. Other team members at an advertising agency often include the following:

Creative directors and art directors are responsible for every phase of developing an advertisement, from initial storyboards to final production. They work with other team members to create and produce the visual materials. They work with clients to develop advertising approaches and with other teams to devise a budget and schedule.

Copywriters furnish the words for print advertisements and broadcast commercials. They confer with clients and creative directors to understand the products and learn the aim of the client. The copy may be headlines, jingles, slogans, descriptions, conversations, or other attention-grabbing ideas. Copywriters check all facts, spelling, and grammar.

Type directors research and try different type faces, often designing those needed for special circumstances. The type style must coordinate with the product, the layout, and the image and goal of the client.

Prepress specialists finalize all aspects of the digital files before sending them to the printer.

The copywriter, art director, and **account executive** (sales representative) present design choices for

the client's consideration. The client can see how the ad will look in a magazine or newspaper, on a billboard, or on TV. After final approval from the client and the legal department, the project goes to the production department.

In TV and radio **production departments**, broadcast coordinators work with scriptwriters, art directors, digital designers, and others to prepare the commercial. Casting, music, sound, lighting, studio space, film, tape, and special effects are some of the elements that must be coordinated to produce an effective, successful advertisement.

What qualities are helpful to a designer in an advertising agency?

Designers need to be able to work with others in team situations for a common goal—to please their client. Besides having imagination and style, they must have perseverance and be able to meet deadlines. Designers must be adept at drawing and sketching, understand lettering and type design, and be able to transform ideas into visual concepts. Precision and attention to detail, along with an excellent sense of color, are helpful to the designer, who must also understand current design trends.

What can you do now?

Employers prefer graduates with degrees in graphic design, visual communication, or related fields. Computer literacy and mastery is essential. Study perspective, color harmony, and composition; learn to work in all media. Lettering, illustration, and type-design courses will be useful, as will command of a foreign language.

Develop a portfolio of your best work, including examples from the areas mentioned above. Join a professional society, such as the American Institute of Graphic Arts or the American Advertising Federation (see listing on page 226). Study advertising and graphic-design magazines (see listing on page 224).

What schools offer necessary programs?

Graphic design is a combination of art, advertising, graphic arts (printing and typography), and photography. Prepare yourself as much as possible in all these areas if you plan a career in advertising. Close proximity to a major city will enable you to visit large, established studios and agencies. Some faculties include successful art directors and ad-agency executives. Check the charts beginning on page 229 for schools offering graphic-design courses and programs.

Typical Advertising Agency Structure

Package Designer

Package designing combines the three-dimensional skills of an industrial designer with the two-dimensional expertise and design sense of a graphic designer. Bottles, tubes, boxes, and protective overwraps are the creations of package designers. These designers are also responsible for the graphic symbols, words, color, and design of labels.

Some packaging is simply utilitarian, providing safe storage and shipping, and easy handling. Other packaging is designed to attract the attention of consumers. Package design can also help project a specific corporate image.

There are primary and secondary packages. Primary packages—such as soft-drink cans, ketchup bottles, or toothpaste tubes—remain with the product throughout its use. A secondary package holds the primary package. Secondary packages include boxes, cartons, tubes, wrappings, bags, or the complex packages that hold electronic or other instruments to protect them from damage. Package designers design not only the containers, but also the graphics, illustrations, small print, logos, and any other graphic elements. Package designers are often free-lance artists, but many are employed by corporations or large graphic-design firms.

Change is the mark of the packaging industry. About eighty percent of the business today consists of products that did not exist ten years ago. Manufacturers are constantly looking for faster, newer, safer ways of packaging, with emphasis on recyclable materials, since packaging accounts for about one third of America's solid waste. Designers are also concerned with issues such as safety, tamper-resistant packaging, closure, reuse, and child-proof containers. Package designers stay up-to-date and share their concerns and ideas by joining organizations such as the Package Designers Council (see page 226).

What does a package designer do?

The final results of package design give little indication of the planning, effort, and creative expression that

Type, photography, and logo and graphic designers were needed to complete the visual presentation of these products. Courtesy Fiskars.

went into them. Package designers begin their problem-solving processes after meeting with clients and art directors, then by designing many possible solutions. These ideas are evaluated and modified, and the three or four best ones are formally presented. Samples can be quickly generated for final approval. Often, the client selects several possible solutions, basing the final decision on constructed models that can be manipulated, held, opened, and closed.

Package designers may develop presentations to demonstrate the effectiveness of their ideas. Color renderings of the packages illustrate their potential appearance in advertising media. Photographs of the models indicate the package's visual impact. These ideas are either approved by the clients, art directors, or corporate boards, or are sent back for further modification. When the package designs are approved, they are sent to manufacturers to be produced.

What qualities are helpful to a package designer?

Package designers are proficient at three-dimensional design, model building, and graphic design. They must also be adept at sketching and visualization of ideas, have excellent computer skills, and understand the products with which they work. An analytical mind coupled with the ability to problem solve visually will complement the designer who can work well with clients and art directors to meet deadlines. Speaking and writing abilities, along with resourcefulness and a willingness to experiment, are generally hallmarks of a successful package designer.

What other careers require similar qualities?

Package designers would likely be comfortable working in graphic-design studios or advertising agencies. The ability to work as part of a design team is critical to any graphic- or industrial-design situation.

Skill with three-dimensional materials and computer technologies is necessary for careers in stage design, architectural graphics, TV set design, display design, and model building.

What can you do now?

Take art classes in drawing, painting, three-dimensional design, sculpture, drafting, and graphic design. Business, psychology, mathematics, English, creative writing, and consumer science classes are also useful. Model building is an excellent hobby directly associated with package design.

Because computer skills are essential to package designers, try to develop and expand those skills by working with a variety of software programs. Software undergoes constant change, so check trade magazines (see below and on page 224) for programs in current use. Refer often to these publications.

Collect examples of creative packaging. Study examples of packaging in department stores, and observe its use on TV and in magazine advertisements. Some science and industry museums and trade fairs contain fine examples of package design.

Part-time work in any graphic-design situation (sign painting, department-store display, label design and production, graphic design) or in a grocery store, where containers are handled and sold, would be helpful.

Magazines that provide insights into good packaging include *ID (Industrial Design Magazine)*, *Packaging Digest*, *Package Engineering*, *Packaging*, *Packaging Technology and Engineering*, *Packaging Week*, *Design News*, *Design Quarterly*, *Print*, and *CA (Communication Arts)*.

What schools offer necessary programs?

Art schools and colleges with good industrial-design programs offer excellent courses in package design. Many graphic-design curriculums also include such courses. A strong background in three-dimensional design, graphic design, and product design and development are necessary to begin a career in package design. Check the charts at the back of the book.

Degrees in industrial design are not essential, but will broaden your opportunities in package design. Some trade schools provide practical courses in model building, product photography, and graphic design, which might be the basis for further study or the start of a career.

Wayne Hunt of Hunt Design Associates.

Environmental Graphic Design: Hunt Design Associates

Environmental graphic design (EGD) emerged in the 1970s as a way of *making space* (and movement through space) *understandable*. Signs and symbols were designed and built to direct people through malls, buildings, transportation terminals, campuses, and other public spaces. Ten years later, designers were trying to *make space meaningful*; to incorporate motifs and elements into their signage and programs that helped people relate emotionally to their environment. For instance, malls were designed with a theme that reflected their region or were based on a local industry or attraction.

Currently, the field of environmental graphics relates to the built environment as a nexus of information. As such, it is in direct opposition to the pull of cyberspace, which tends to lure people into small rooms equipped with incredible technologies. EGD artists try to lure people into public spaces where commerce, entertainment, education, and culture is encountered. Artists are involved with both sides of this war for the human spirit.

HUNT
DESIGN
ASSOCIATES

Exhibit featuring the Bill of Rights designed for Unocal. Photo by Bob Wortham.

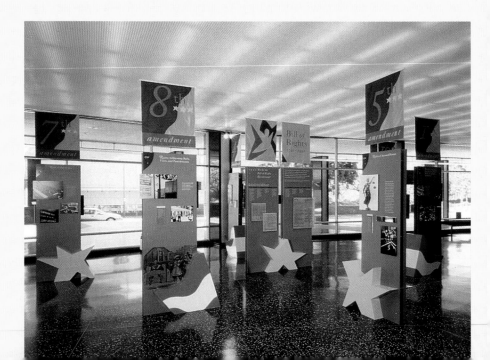

Environmental graphic design is a growth industry: membership in the Society for Environmental Graphic Design (SEGD) increased from fifty in 1977 to more than 1,100 today. Environmental graphics is probably the least understood area of graphic design, simply because it is so all-encompassing. Its purview extends from signage and way-finding systems to architecture, urban planning, landscape design, public art, and many other design areas.

Spaces have lifespans and must constantly be renovated and made visually exciting. EGD therefore is part of the renovation of museums, shopping malls, educational environments, concert spaces, theme parks, and other public spaces.

One of the leading environmental graphic designers is Wayne Hunt, who, with a staff of nine extremely creative designers, is involved in projects worldwide. Hunt Design Associates, founded in 1977, is a graphic-design consulting firm specializing in identity, signage and environmental graphics, programs for public spaces, gathering places, retail projects, entertainment centers, and hospitality and multiuse developments. Their services include graphic identity (logos), master planning, concept consultation, programming, schematic design, design development, and documentation and implementation supervision.

Wayne Hunt and his firm have received numerous awards from the SEGD. Hunt has received other honors and awards and has coauthored the book *Designing and Planning Environmental Graphics*. His work has appeared in all the major industrial- and graphic-design magazines in the United States, Germany, and Japan. In addition, Hunt is on the faculty of Art Center College of Design, where he teaches a course in environmental graphics and systems.

Information graphic design for the children's exhibit at the Los Angeles Zoo. Photo by Jim Simmons and Annette Del Zoppo.

Entrance design for Universal Studios Hollywood. Photo by Chet Froehlich.

Graphic Design: Corporate or Free-lance?

The Case for Corporate Designing

Even though most people do not think of corporations as having their own design departments, many major corporations have one. Some corporations have "in-house" departments staffed with exceptional designers who can satisfy all the design needs of the company, from corporate-identity programs to annual reports to stationery.

Designers often work for companies and advertising agencies that specialize in producing graphically designed products: magazines, books, greeting cards, corporate reports, and advertising programs of all types. Others work in-house for department stores, malls, motion-picture and TV studios, and government agencies. Still others work for publicity firms, mail-order houses, or commercial printing companies. Designers working on salary can take advantage of the benefits available to all other workers in the company.

Among these advantages are the sharing of company benefits: paid vacations, medical-insurance plans, sick or maternity leave, profit-sharing plans, savings and pension plans, and so on. Salaries of in-house designers are competitive with those of designers in design firms—probably higher than in publishing firms and lower than in advertising agencies.

For those who want to work in suburban areas, a corporate job might be ideal, since many industries have left city environments. Some corporations allow their designers to work at home or in home studios; the designers communicate regularly with their corporate office via fax and modem. This resembles a free-lance situation, but the designer works steadily for a single corporation.

Mitchel Ahern, shown here "in motion" producing an interactive CD-ROM, is employed by Eastern Acoustic Works. He is a member of a small corporate design team who acts as Webmaster and Interactive Media Developer. Ahern uses several workstations and servers to accomplish his electronic design tasks. Photo ©1997 by Michael Carroll.

The Case for Free-lancing

Rather than working for an employer, a free-lance designer works independently, obtaining work from different sources. Free-lancing can be an excellent way of sampling a variety of working environments.

Many people like to free-lance not only for the diversity of experience, but also for the flexible hours and the tax benefits they receive. When you free-lance, you are self-employed and can usually deduct such items as business expenses, supplies, and office space. These deductions, however, are offset by the federal self-employment tax. On a temporary basis, free-lancing is a good way of waiting for the perfect job to come along. It also allows art buyers in corporations to become familiar with you—your work, your style, and your capabilities.

Working free-lance is quite common in the graphic-design field, where over one-third of all designers are free-lance. One reason for this is that many companies do not require the full-time services of a graphic designer and find it more economical to hire designers on a part-time or contract basis when they are needed. Some companies simply like the diversity of working with a variety of designers.

There are advantages to being a free-lance designer, other than possible tax savings and schedule flexibility: you are your own boss; you select your own clients; you bill each client separately; and you can work from your own home or studio. However, there are also disadvantages: no art director helps make decisions or takes responsibility; you must work directly with the client; you have no company benefits. If you are sick, there is no one to fill in for you. You are also responsible for all your own operating and studio costs, such as rent, utilities, computers, supplies, phones, and messenger services. Also, if clients fail to pay their bills you will either have to accept a loss, or take legal action to collect money for the work you have completed.

Some free-lance designers prefer to work through an agent or representative rather than spend valuable time finding and meeting with clients, picking up and delivering jobs, and so on. Names of agents can be found in the yellow pages or *The Creative Black Book* (see page 222). The agent handles everything, including negotiations, meetings, and billing. At times, an agent can get an artist a better-paying job than the artist might find independently. Agents usually charge twenty-five percent of gross billings: all work must be billed through the agent, including work you find for yourself. If you work with an agent, you will have a legally binding contract with him or her: if you break it, you will still have to pay a commission for some time afterwards. Working with agents is more common among illustrators and photographers than graphic designers.

How to Decide?

The decision of whether to work for an employer or to free-lance really depends upon the temperament of the individual artist. Some people enjoy the freedom associated with free-lance work, but others become anxious not knowing where the next job or paycheck is coming from. One may like the structure, organization, and security of a corporate position. Another may relish making all his or her own choices. One may like to work with other designers, but another may like to work independently. Weigh the pros and cons on each side; perhaps you will try both ways of working in your career. Some designers who have worked for corporations then set up their own studio. Others move into a corporate structure after having worked free-lance.

Talk to free-lance designers and those who work for corporations or businesses. Discuss the options with graphic-design instructors who may know your temperament and work habits. Then make up your own mind.

The home studio of free-lance book designer Janis Owens. Photo by Janis Owens.

Other Careers in Graphic Design

Advertising-Agency Fashion Art Director

(See Other Careers in the Fashion Industry, page 126.)

Advertising-Agency TV Art Director

(See Other Careers in Film, TV, and Multimedia, page 140.)

Airbrush Artist

Expert at painting with airbrushes (small art tools that spray fine mists of color), airbrush artists are often illustrators. They are either free-lance or studio artists and are often fine artists who are hired because of their special skills or style of working. Some airbrush artists specialize in photo retouching (see also Other Careers in Photography, page 100) although most retouching is done by computer.

Architectural Graphic Artist

(See Other Careers in Architecture, page 34.)

Art Director

After meeting with creative directors, clients, and group supervisors, art directors take on the responsibility for entire design projects. They work with the design staff to select color, type, and images. They may call on free-lance artists to supply necessary elements of the program, but they are accountable for all aspects of the project. Art directors are graphic designers who work their way up the corporate structure.

Art-School Design Teacher

(See Art Education, page 177.)

Book-Jacket Designer

(See Other Careers in Publication Design and Illustration, page 88.)

Calligrapher

(See also Letterer, below.)
Calligraphers need not work from prescribed styles. Their job is to embellish and decorate, not simply to letter. They use a variety of special pens, and must constantly practice to keep their work fluid and under control. Advertising agencies, special-events promoters, and civic and cultural agencies may request their services.

Cartographer

A cartographer makes maps, a career that combines a knowledge of geography with an interest in lettering and art. Maps such as topographic sheets or air-pilot charts require technical accuracy; vacation-area maps or illustrated diagrammatic presentations have less stringent requirements.

CD-Jacket Designers

Most covers for CDs, CD-ROM packages, and videos are designed on computers by free-lance designers. Sometimes, both musicians and art directors have strong input in design decisions. The designer often supplies four or five possible designs before final decisions are made.

Creative Director

Creative directors occupy the top design positions in advertising agencies and design studios. They work directly with clients and art directors. See the chart on page 63.

Greeting-Card Designer

(See Other Careers in Publication Design and Illustration, page 88.)

Illustrator

(See Editorial Illustrator, page 78.)

Letterer

(See also Calligrapher, above.)
Letterers are skilled in hand lettering with pens, brushes, ink, and paint. In spite of the thousands of typefaces available electronically, designers often require a unique style of lettering, and therefore the expertise of letterers.

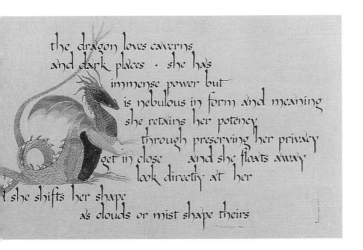

Marilyn Pinaud. *Shedragon*, 1984.
Watercolor, gold leaf, Chinese stick ink on
Roma paper, 26" x 18 1/2" (66 x 47 cm).
©Marilyn Pinaud 1984. Photo by Tom Fiorelli.

Letters are made up of definite, separate parts: vertical, horizontal, round, half-round, and slanted strokes. Lettering by hand requires great skill and hours of practice.

Multimedia Graphic Artist

(See page 138.)

Outdoor-Advertising Designer

Outdoor-advertising designers work for billboard companies and postermakers and must be well-qualified graphic designers. Their work is usually seen on huge displays or "boards" that are used primarily for advertising products, services, or events. Some boards are painted, but others are printed and then applied to the display panels.

Photographer

(See Photography, page 91.)

Poster Artist

(See Sign Painter, below.)

Retail-Store Art Director

Retail-store art directors, who work for a large department or chain store, plan the ads that a store places in various publications. They design the store's posters, counter signs, and point-of-purchase displays, and coordinate the elements of graphic design, type, color illustration, and photography to present a unified store image.

Senior Art Director

(See Advertising Agency, page 62.)

Sign Painter

Sign painters design, draw, lay out, and paint letters and designs on a variety of surfaces. They use drawing and measuring tools to insure accuracy. The medium they use depends on the location of the finished work and the quality of the surface. Sign painters must have knowledge of letter styles, type, color, and design. They often custom-design lettering styles. Most sign painters also work with vinyl letters produced using special equipment.

Silkscreen Artist

Numerous jobs are connected with commercial silkscreening. Silkscreen companies supply production services for many types of clients, and some manufacturers have their own silkscreen departments. The commercial silkscreen process is used for posters, and clothing, and to decorate a variety of materials. Nearly all the work is accomplished with the use of computers. Silkscreen artists design layouts, prepare silkscreen frames, and finally print the work by hand or by machine. A typical job would progress from an original electronic design on disk, through a color separation process and generation of film, then to transfer of the design onto the actual silkscreen for printing.

Title Designer

(See Other Careers in Film, TV, and Multimedia, page 140.)

Web-Site Designer

The increased use of interactive Web sites, home pages, and on-line services requires designers to make useful, attractive, and colorful pages. Museums, galleries, corporations, and large ad agencies have such designers on staff, but many free-lance designers prepare the thousands of well-designed Web pages seen on the Internet every day.

The publication designer
is a visual journalist.

Bride M. Whelan, executive director of the
Society of Publication Designers

Bride M. Whelan

Developing a singular identity for a publication is vital for its
credibility and its level of relevance in today's economic mar-
ketplace. A consumer magazine on the newsstand, an annual
report, a catalog or a trade or professional journal, must pro-
vide a visual identity in a creative, coherent and accessible
manner. This enormous visual responsibility is the province of
the publication designer.

In the publishing industry, publication designers (art direc-
tors, creative directors, and design directors), are graphic
designers trained to visually position the elements of photog-
raphy, illustration and type, to more accurately convey the
printed word. The creative collaboration between the editorial
and the visual is not secondary, but of equal value in the look
and message of a publication.

The advent of the computer changed forever the way publica-
tions are produced. And software revolutionized the speed by
which a publication is developed, as well as the printing
itself. This extraordinary innovation challenged the entire
industry, and it is just the beginning. Working with the print-
ed page and utilizing interchangeable technological tools
within a variety of applications, publication designers rein-
forced their value to editorial teams.

In America, the publishing industry is the largest employer
after the United States government and the auto industry.
The development of technology, and the pace of information,
confirms the need for well-designed and understandable
printed material.

The historic reawakening and the development of emerging
countries and governments of Eastern Europe, Asia and
Africa, will allow more free and full participation in obtaining
information through print and imagery. This transformation
has opened vast markets of readers, buyers and participants
for *visually developed information*.

Communication skills, defined by precise and understandable
images, offers trained graphic designers a multitude of
employment and creative options for the twenty-first century.

This two-page spread from *Saveur* invites the reader into the world of fine cuisine. The visual impact of magazines must compel a reader to purchase and remain a devotee. Courtesy Society of Publication Designers.

Publication Design and Illustration

In spite of dire predictions in the 1960s that TV would soon replace newspapers and magazines, the print media continue to be dynamic means of moving information and ideas. They have met the challenge of TV and have succeeded mainly by becoming more specialized. Many magazines are not even sold to the public in stores; they can be obtained only by subscription or by joining certain organizations. Art magazines are one category that has proliferated in the past thirty years: there are specialized publications for graphic and industrial designers, fine artists, and art historians.

In the United States today, there are over 1,800 daily newspapers, 13,000 magazines, and 1,600 TV stations. Several hundred book publishers release over 45,000 new titles each year. Editors employ words, images, color, and layouts to make the transmission of information as interesting and attractive as possible. All of these editorial functions require artists, art directors, illustrators, desktop designers, graphic designers, photographers, and printers.

What would the thousands of newspapers and magazines be without the graphic designers who are responsible for the look and feel of their contents? The style, individuality, and personality of the publications are all provided by the designers. Illustrators and photographers supply the visual images that make publications sparkle and inform, thereby enhancing the communicative abilities of the publication staff. Book publishers maintain art staffs or work with consultants, agents, or free-lance designers, illustrators, and photographers who design the book pages and provide images. Software designers develop programs that help all of these artists and designers produce their work quickly and efficiently.

The arrangement of all the parts of books, magazines, brochures, and newspapers is the responsibility of art directors and graphic designers. The illustration of such publications is the work of illustrators and photographers. The actual preparation and printing are technical and production processes of the graphic-arts industry; the financing and distribution of the printed products are the responsibility of the publisher. In such cooperative ventures, no one could function fully or successfully without the skills and abilities of the others.

Magazine Design

Magazine Publishing

Magazines can be classified into many specialized categories. Consumer magazines are the best known because many homes subscribe to some of them, and they are highly visible at newsstands. However, business publications that supply information to industries, various professions, and trade and financial groups are a much larger category.

For an idea of the kind of special-interest magazines produced in our country alone, look at page 224 to see the large number of art and design magazines published regularly. There are actually far more than those listed, but the degree of specialization available is evident from the various titles.

The visuals and text of a magazine must be designed so that all issues have a continuity of style and format, which produce a characteristic look. Each feature article is usually treated independently, because the design, type, headings, and illustrations must reflect the nature of the article and its content. The art director and editor work together to establish the look and feel of each page, and graphic designers and the production staff work out the details. The in-house editor and art director usually design the covers. Ready-to-print advertisements, sent by advertising agencies and clients, are arranged on the pages by the design staff.

Organization

Magazines differ in their publication times: weekly, biweekly, monthly, quarterly, semiannually or annually. A weekly publication naturally requires the largest design staff, but no two magazine staffs are organized in exactly the same way. However, a typical set-up can be described. If you check the masthead of various magazines, you will see similar structural outlines.

At most magazines, the **publisher** is in charge and is responsible for coordinating all activities, including editorial, sales, circulation, production, and finance. The **editor** (also called the editor-in-chief or the executive editor) heads up the editorial department, and several people report to him or her: the

A painting by Chris Polentz illustrates our culture's fascination with magazine publication. Courtesy the artist.

managing editor makes sure everything is completed on schedule and within the budget; **associate editors, assistant editors,** and **editorial assistants**—who often write and edit some of the copy themselves—put the magazine together by working with writers, illustrators, designers, and photographers.

Creative directors or **art directors** are in charge of design, layout, concept, and appearance of the publication. They direct illustrators and designers in their specific activities, and also direct photo shoots. They generally are experienced graphic designers who have worked their way up the corporate structure.

Depending upon the size of the publication and the staff, **associate** and **assistant art directors, graphic designers,** and **production artists** round out the editorial-design staff. **Photo stylists** and **photo editors** might also be included in the design department. The **designers** (see page 52), who generally use software

programs to furnish finished designs, are primarily involved with hands-on implementation of design decisions. Along with the usual design and computer skills, they must have an understanding of the magazine's subject matter and be able to visualize the editor's focus and intent. Even when moving from one magazine to another, designers usually work within a subject matter that they understand well, such as travel, sports, art, or lifestyle. In smaller publications, staff responsibilities usually overlap; a single person will be required to handle several different aspects of publication.

The design and content of these magazine covers, along with the interior design, are the responsibility of art director Charles Pates. Photos courtesy Charles Pates.

Creative Director: Charles W. Pates

Charles W. Pates is creative director, the top design job, of award-winning magazines. He worked his way to this career position by following the usual steps of designer, art director, senior art director, and creative designer of several magazines. Born and educated in England, he began his design career with the initial issues of *Geo*, and he has won several design awards.

He moved to the *New York Times* as art director and then to *Life* magazine as senior art director. There he produced regular issues plus the special fiftieth-anniversary issue (for which he won design awards), the Olympics issue, and five weekly Gulf War issues.

Pates is now creative director for the monthly and quarterly health and lifestyle magazines *Men's Fitness* and *Prime Health and Fitness*. He is responsible for the creative and editorial direction of both magazines and has been involved in setting up two of the publications' Web sites. Under his design leadership, *Men's Fitness* has become one of the top five men's magazines in the country.

In addition to his magazine work, Pates has taught at various universities and is a member of the faculty of the Columbia University School of Journalism.

Book Designer

Since approximately 45,000 books are published in the United States each year, book publishing represents one of the largest employers of graphic designers. Many book designers work for publishing houses, where they are responsible for the appearance and readability of each book. They may design the book's covers, but that is often done by an art director and illustrated by a free-lance artist. Some book designers prefer to free-lance so that they can work for several publishers from their home studio. (See page 68.)

Book designers work with drawing and page-layout software to arrange visual images, text, and diagrams in the most attractive formats possible. Specialized book-design software can be custom-designed for specific publishers or particular books.

Joy Aquilino is a book editor for Watson-Guptill Publications in New York, where she works with graphic designers to produce art books. During the design process, she is in constant contact with authors, designers, and her publisher, until each book is finished and in print. Photo by Liz Harvey.

What does a book designer do?

A designer is given a manuscript (hard copy and electronic files) by the editor or art director, along with size and shape specifications, number of pages, and the budget. Images are supplied by the author or an art editor who is assigned to secure them.

The designer first reads through the manuscript and discusses it with the editor, and thumbnail sketches are made to show the organization of chapters. From approved ideas, sample pages are designed, showing all the elements—type margins, image placement, titles, captions, and headings. The designer selects type style and size. The sample pages are checked and refined.

The designer then works with a master page containing standard elements for the book such as trim size, margins, and placement of text boxes. The entire book is composed using the master pages. The author and editor check the book. Any necessary changes are made, usually by the designer.

What qualities are helpful to a book designer?

Book designers must be adaptable to new techniques and styles and open to the suggestions of editors, art directors, and authors; yet they must also be able to inject their own personality and concepts into the process. This requires sensitivity to other people and to the content of the text. The designers should like to work with words and type, have a good sense of design, and understand the entire printing process. Successful book designers, most of whom are experienced graphic designers, are able to stay focused while working alone under strict deadlines on long-range projects.

What other careers require similar qualities?

Careers in all areas of publishing would be of interest to book designers. Art editors, design directors, graphic designers, design consultants, cover artists, and instructors in book design have common goals and qualifications. Magazine production and free-lance cover design, Web-page design, or CD-ROM design may appeal to book designers. Corporate

Book Designer: Janis Owens

Janis Owens seems to have fallen into book design. Her interest in art began in high school; however, she "just couldn't take it seriously. I didn't think people could live at their hobby." She majored in art history at Rollins College, and left after two years because she had taken nearly every art course the college offered. She considered enrolling in an art school, but decided to "work for a few years and see if anything else came up."

There was then no such thing as a graphic design major in college; that sort of training was obtained on the job. Working as a secretary at Little, Brown and Company gave Owens an opportunity to learn about the book publishing business. She eventually moved up in the production department to the position of designer.

Owens spent more than ten years at Little, Brown and designed books for eight of those years. She began free-lancing while still at Little, Brown and found she liked it. After a couple of years, she had five outside jobs going at once. She decided to strike out on her own, realizing that "my job was getting in the way of my free-lancing!"

In spite of increasing specialization in colleges and art schools, Owens feels that hands-on experience is still the best way to become a designer. "One of my favorite expressions is 'get a job!' You must start working at book design, take it off the theory shelf and put it into practice. Be patient. Don't expect to do it in a year. Be willing to do a lot of routine work along the way. It's better to work with a good designer than to sit at home waiting to be offered a top-level job."

designers and art directors are involved in projects similar to book design, particularly those artists involved in creating brochures, pamphlets, and annual reports.

What can you do now?

Sign up for art classes in drawing, painting, print-making, design, art history, and graphic design. You would benefit greatly from a broad background in a variety of subjects, because book designers work on all types of books. Become acquainted with book-binding and paper manufacturing.

Part time work in a printing shop or service bureau will provide practical working knowledge of printing processes. Any graphic-design work is beneficial. A job in a bookstore will familiarize you with contemporary book design and allow you to see how customers react to different books and designs.

Titles of magazines that provide insights into this career area are listed on page 224.

What schools offer necessary programs?

Schools with strong graphic-design departments will provide an excellent background for book design. Schools in areas where many publishing houses are located (Boston, New York, Philadelphia) might have added available resources in the form of field trips, seminars, visiting instructors, special courses in book design and typography, internships, and part-time job opportunities. Check the list at the back of this book, as well as Web sites or catalogs from various schools.

Courses in desktop publishing and graphics will help you stay abreast of developments in software technology. Trade schools may provide excellent training in areas such as computer skills, and printing.

Editorial Illustrator

Illustration closely resembles fine-art painting in many ways, but its purpose is less aesthetic and more practical. Editorial illustrators are artists who illustrate books, magazines, newspaper articles, storyboards, posters, and an occasional advertisement. Some editorial illustrators work on the staff of large magazines, newspapers, or publishing houses, but most are free-lance artists.

The individual styles of various artists are extremely important in the field of editorial illustration. One artist's style is appropriate for children's books, and another's may be suitable for romantic stories. Some illustrators specialize in certain media. Pen and ink, watercolor, acrylic, black-and-white, collage, and line drawing are examples of such specialties. Other illustrators specialize in certain subjects, such as automobiles, people, animals, landscapes, or sports activities.

What does an editorial illustrator do?

An illustration job begins at the art director's desk (see page 70), where the most important concepts of a book or article are noted. The art director then calls in an illustrator to discuss the various possibilities. The artist is generally chosen by the art director for his or her characteristic style and technique. After some sketch ideas are approved, the illustrator begins work on the assignment.

Editorial illustrators create the artwork, matching the proportions of the space called for in the art director's layout. They may work at any size: the image will be photographically or digitally reduced to fit the page. When illustrators have finished their work, the art director approves the work or requests changes. The final work is photographed or directly scanned. An electronic version of the image is placed into the document file for eventual printing in the publication. In book, magazine, and newspaper work, there are production deadlines to meet, and artists must work within these time restrictions. Magazines and newspapers will not wait!

Illustrators do their work not only in painting and drawing media, but also electronically. When free-lance illustrators are not working on an assignment, they usually are at work improving their skills and their portfolio. They send résumés and reproductions of their work to as many art directors as possible, since self-promotion is necessary until their reputation is established.

What qualities are helpful to an illustrator?

Above all else, editorial illustrators must be able to draw and paint. They must be able to work rapidly and efficiently with clients and art directors, and be comfortable working under deadlines. They must excel at creating illustrations that parallel the written word. Good design sense and an understanding of typography and current illustration style are characteristics of competent editorial illustrators. They must also be flexible and aware of competition, and be able to change their approach when tastes change.

Don Maitz used a mixed media technique to create this science fiction illustration for *Aliens*. Photo courtesy *Today's Art*.

What other careers require similar qualities?

The ability to draw and paint, so essential to editorial illustrators, is also necessary in all other types of illustration: fashion, advertising, product, storyboard, and architectural rendering. Successful careers in illustration may lead to positions such as art director, art supervisor, or other executive or administrative positions. Many illustrators, however, prefer to remain at their drawing board, producing quality illustrations.

Free-lance illustrators require self-discipline to meet deadline schedules and to set their own working timetables. These qualities are also essential in fine-art artists and craftspeople, who must maintain definite schedules to be able to produce work for galleries.

Many illustrators exhibit their drawings, prints, and paintings in galleries, both physically and in the virtual world of the Internet. Galleries can provide outlets for artwork, and additional sources of income.

What can you do now?

Enroll in all the drawing, painting, and two-dimensional design classes available to you. Any and all art classes will provide good working experience with a variety of media, but painting and drawing remain most important for illustrators.

Collect examples of excellent illustrations from magazines, and file them by subject matter, style, or artist. Learn to recognize top illustrators by their styles and work, and notice the subtle changes in their work from year to year. Study illustrations in children's books, and take note of illustrations in other books, periodicals, brochures, and posters. Check the *Art Directors' Annual* for the work of top illustrators each year. Check with a local art directors' club for information about their meetings and exhibitions. Ask to be added to their mailing list.

Titles of magazines that will help you understand illustration career opportunities are on page 224.

Fine Art or Commercial Art?

It is my opinion that art can be divided into two categories: fine art and commercial art. My work fits the commercial art category because each painting is created to fulfill a specific need. Clients hire me to paint solutions to meet their requirements. Clear communication is a necessity. I sell artwork. I sell a product, and therefore the customer is always right. I approach the subject and my work from a business perspective.

—**Chris Polentz, free-lance designer, illustrator, and teacher**

Chris Polentz created this image for Reebok. Photo courtesy the artist.

What schools offer necessary programs?

Some schools offer a major in illustration and can prepare students for any type of illustration work. Other schools offer majors in specialized illustration fields, such as editorial or fashion illustration. Almost every art school and most colleges and universities with extensive art departments can prepare people for careers in editorial illustration. Such a course of study consists largely of drawing and painting classes. Figure drawing, rapid sketching, painting in all media, and printmaking provide the wide range of experience necessary for the illustrator. Check the charts beginning on page 229.

Illustrator George Molina Sy at work in his home studio.

Profile

Illustrator: George Molina Sy

George Molina Sy can clearly remember his first childhood attempts at drawing and copying the Sesame Street characters. His focus has changed often since then, and now encompasses projects from rainforest concerns to the deterioration of the earth's ozone layer.

Encouraged by his family, Sy continued his education with an art focus, graduating from Cal State University Los Angeles with a major in art and a concentration in illustration. He took the attitude that projects done in college were executed as though working for a client (the instructor). He gives credit for this work discipline to his instructor, mentor and friend, Ron Kriss, saying, "the first day I attended one of his art classes was the day I subscribed to this work ethic."

The Saint is an airbrush illustration done for a TV-series advertisement. Photo courtesy the artist.

Level Rising is an acrylic illustration dealing with concerns about global warming. Photo courtesy the artist.

After much prodding from concerned individuals, he found new creativity within himself and from other artists past and present. This led to experimentation with new color palettes and to exploring glazing techniques.

When he set out to introduce himself to art and design firms, Sy first distributed information—a resume and colored samples of his artwork. This brought work from *Media and Values*, a Los Angeles-based magazine that is concerned with the effects of mass communication on people. He executed spot and full page illustrations in black and white initially. He met with art directors and writers and discussed the articles. Sy remembers, "it was a great feeling to be a part of this creative team, not to mention the chance of getting published." He went on to do work for Pacific Asia Museum, designing their brochures, annual reports, invitations, and other printed materials.

Sy states, "every illustration is a constant challenge and learning experience. I recently got a chance to try the field of children's book illustration. This was new for me because instead of one or two pieces, many illustrations were used to tell the story. The author said that one thing aside from my portfolio that made her decide to pick me to do her illustrations was my willingness to listen to her ideas. Three months later, with twenty-eight airbrushed illustrations and her story, we completed the book.

"You really have to like what you do," Sy explain. "There will be times when ideas just are not there; at the same time when creative ideas flow easily there is no stopping you. You must learn to level these highs and lows with a love for the work, an intense desire to succeed, and a strong work ethic."

Sy pursued a masters degree in illustration, deciding to further his education "because I wanted to do a body of work that represented me and my illustration ideas." His thesis was a series of illustrative concerns about the state of our environment, completed through researching books, newspapers, and magazines.

Conceptual illustration is an essential part of Sy's work. He says, "it need not always be narrative, but I try to hold the viewer's attention by illustrating singular ideas rather than the whole story. By combining thought-provoking images, each composition illustrates a certain statement that urges the viewer to sort things out."

Sy considers his first efforts typical of many beginning illustrators. In the early stages of creating, his enthusiasm ran high. Ideas and images flowed easily and he used radiant color schemes. Then he often experienced a creative block.

Cartoonist/Comic-Strip Artist

Cartoonists use exaggeration and a finely honed drawing technique to make their point quickly and clearly. A good cartoonist develops insight into political situations, finds the humor in problems and their possible solutions, delineates the character of people, and articulates ideas and goals in an attractive or incisive way. Cartooning includes gag cartoons, comic strips, cartoon panels, political satire, editorial cartoons, advertising and illustration cartoons, and animation. Gag and comic-strip artists want to entertain; editorial and political cartoonists want to influence public opinion. Some cartoonists work for small papers or magazines; some for large newspaper chains. The work of some cartoonists is syndicated. Cartoonists use all media but rely mostly on brush, pen and ink, wash, and crayon.

The cartooning field is very competitive. Individual cartoons can be sold to newspapers or magazines, but comic-strip artists must have a fresh idea or style to get a syndicated strip. There is a broad market, however, for advertising cartooning, commonly used in newspapers and magazines and on TV to sell products and ideas.

What does a cartoonist do?

Ideas are the lifeblood of every cartoon. Local happenings, political trends and events, worldwide situations, sports, or other subjects can trigger an idea for a cartoon. Gag cartoonists who cannot always generate ideas will rely on gag writers, to whom they pay a percentage of their income from each published cartoon.

All cartoonists—whether they work on speculation, belong to a newspaper staff, or are syndicated—must draw continually. Established artists refine their ideas before sending them to publishers. Cartoonists seeking initial contacts prepare dozens of panels or strips to deliver to potential publishers, hoping for acceptance.

Every Wednesday, cartoonists in New York deliver their work to magazine offices or independent newspapers, hoping for a sale. These weekly rounds are a ritual that has been in effect in New York for many years. Many cartoonists from across the country send batches of twenty or more "roughs," or sketches, to editors. Some editors accept or reject the cartoons immediately; others keep them longer before deciding.

What does a comic-strip artist do?

Comic-strip artists work on their own, at their own pace. Once they have established a story line (this is often done by the artist, but may be done with a collaborator) and have drawn the principal characters, production begins. The artist prepares the script and animates its dialogue in much the same way he or she would create a storyboard. The artist breaks down the sequence into strips of several panels each, and makes linear roughs in pencil. When satisfied with these, he or she inks them with pen or brush. If values are part of the technique, the artist adds them with gray ink washes or with patterns. He or she gives each strip a publication date, and ten or twenty are sent together to the newspaper's comic-page editor. If the strip is syndicated, the originating newspaper office sends the copyrighted artwork to every paper that buys the material.

Cartoonists breaking into the comic-strip field need a great story idea, an engaging main character, and a distinctive style. They must prepare at least a two-week sequence, two to three times larger than the printed product, for consideration.

What qualities are helpful to a cartoonist?

Cartoonists must naturally be able to draw well and use line expressively. They must also be able to letter well in a style compatible with their art. Good work habits are critical; these include working constantly and consistently, meeting production deadlines, and being self-disciplined and self-motivated. Editorial cartoonists must have a strong interest in political affairs and be able to present complicated issues in simple graphic terms. All cartoonists must work quickly, have a fertile imagination, be able to generate ideas daily, and have an awareness of what other cartoonists are doing.

What other careers require similar qualities?

All fields of cartooning require the ability to draw well. Because some forms of cartooning resemble illustration in technique, style, and purpose, linear illustration is a possible alternative career area. Children's book illustration, technical drawing, medical illustration and fashion illustration require techniques similar to those used in cartooning.

Some cartoonists are fine-art painters and divide their production time between the two areas. Others enjoy teaching cartooning or other art courses.

Designing humorous greeting cards (see Other Careers in Publication Design and Illustration, page 88) can be an excellent alternative career for talented cartoonists. Animation work (see Film Animation Artist, page 133) in film and TV requires skills and abilities similar to those required for cartooning, although the ideas and concepts are supplied by others.

What can you do now?

Take art classes in drawing, design, painting, and printmaking. Get involved with making posters, lettering, and working on a school newspaper, as a cartoonist if possible.

Study the styles of many cartoonists. Collect examples (newspapers, magazines, and greeting cards are good sources), and keep a file of them. Draw constantly, and work to develop a cartoon style of your own.

Many magazines contain cartoons that can help you understand style and exaggeration. Look through *The New Yorker*, for example, and check the editorial pages of your newspaper. Check *The Writer's Digest* for cartooning tips.

What schools offer necessary programs?

Many art schools and colleges offer courses in the concepts and techniques of cartooning. All types of drawing courses are essential, and computer classes are recommended. Graphic-design classes and lettering are also important.

Check the Web sites or catalogs of various schools to see if they offer courses in cartooning or animation. Schools with well-known cartoonists on their faculty are highly recommended.

No degree or specific background is required for selling cartoons or comic strips to publishers, but good art experience in school will help prepare you for alternate career opportunities as well as provide competition and personal contacts.

"MY DOG ATE THE DISK MY HOMEWORK WAS ON."

Cartoonists must come up with many new ideas for their work, but they must also be able to find ways to use old ideas with a new twist. Cartoon by Jim Borgman, courtesy *Cincinnati Enquirer.*

Jim Borgman, as seen by a camera. Courtesy the artist. Photo by Robert Flischel.

Editorial Cartoonist: Jim Borgman

The cartoon as a form of art was first published in newspapers in the late nineteenth century to show the satire and humor of topics and people in the news, and to make political comments. Cartoons are usually single panels or sequences of panels that relate a story.

Since his very first drawing for the *Cincinnati Enquirer* in June, 1976, Jim Borgman's editorial cartoons have delighted readers all across America. He is considered to be in the small handful of artists at the top of his profession. He has won every major award in his field, including the prestigious Pulitzer Prize in 1991.

Borgman was born in Cincinnati and graduated *summa cum laude* from Ohio's Kenyon College. He was hired by the *Cincinnati Enquirer* one week after graduation, based on his weekly cartoons in the *Kenyon Collegian*.

Jim Borgman, as seen in his own distinctive style of caricature. Courtesy the artist.

Great Moments in Civil Rights:
THREE ANGRY WHITE GUYS OCCUPY STOOLS AT A NORTH CAROLINA LUNCH COUNTER TO PROTEST AFFIRMATIVE ACTION. NOBODY NOTICES AND THE POINT IS PRETTY MUCH LOST.

His work is notable for its warmth, compassion, and paradoxically, for its biting edge. His political insight and social perspective have earned him a reputation as a provocative and surprising commentator. He claims to have a contrary nature, and says, "If the crowd starts leaning one way, I instinctively lean the other way. My cartoons are works in progress, done in the spirit of firing up the American debate."

King Features Syndicate distributes Borgman's cartoons to about 200 newspapers daily, and his work frequently appears in the *New York Times* "Week in Review," *Time, Newsweek,* and *U.S. News and World Report.*

About his own system of constructing editorial cartoons from idea to finished drawing, Borgman says the following:

"Any given cartoon probably began as a note scratched on a Post-It pad and stuck to my dashboard while driving to or from work. That process is fed by listening to NPR, talk radio, free-associating topics in my head and generally daydreaming. By the time I gather these notes together and bring them into my studio, several of the idea seeds are usually sprouting. From them I draw pencil roughs, just so the ideas won't get away, and also to get some idea of what the image will look like before I start inking it.

By early afternoon I feel the need to start the final drawing. If I've got lots of ideas lying around I may draw several, which gives me the breathing room to occasionally have a day when I just read and write ideas. I used to start from the ground up each day, but I now find my week more fluid, with some days devoted more to writing, some to drawing, some to the piles of paper that collect around me.

I find the drawing time to be the most enjoyable. I used to be painfully self-conscious about style and influences, but some years ago I went cold turkey and stopped looking at everybody else's work, in an effort to hear my own drummer more clearly. When you come out the back of that wringer you can begin to enjoy the simple act of drawing, loving the way the ink goes down on the paper, the feel of the brush in your hand, getting behind the lines you're drawing.

I draw with a fine red sable brush and some fine-tipped permanent markers. Most of the originals look like battlefields, documenting all the skirmishes and ambushes that took place along the way. That's the joy of looking at originals, seeing the glob of white-out with a simple line drawn across it and wondering, 'What in the world happened here?' I find it exhilarating.

Most weeks I draw six editorial cartoons plus Wonk City, my once-a-week political comic strip. When asked what advice I have for aspiring cartoonists, I always say, 'Work from within yourself. Pay attention to your own rhythms rather than what you think editorial cartoons are supposed to look like. Feel an opinion rise up within you and then find a way, no matter how unorthodox, to say that opinion exactly as you experience it.'"

Borgman illustrates the need to be aware of important and often controversial issues, and the ability to illustrate and express his opinion of them to his viewers. Courtesy the artist.

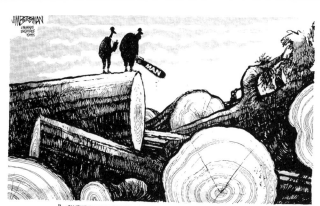

"...ON THE BRIGHT SIDE, THE ENDANGERED SPECIES LIST IS DOWN TO ONE."

Technical Illustrator

An increase in the demand for technical illustrators naturally accompanies the growth of technologies. These artists are employed in many areas of industry, and each area requires artists with special capabilities. The interior of an automobile engine or a complex electronic component may be illustrated in detail so that mechanics and technicians can understand the function and placement of parts. Some artists draw exploded views of units for catalogs or assembly procedures. Various operation manuals are filled with the work of technical illustrators, presented simply and completely.

Complex machines, now commonplace, could not be built or understood without the drawings of technical illustrators. Electronics plants, airplane and automobile plants, missile factories, and government agencies make use of such skilled artists. All types of

Technical illustrations are not always limited to use in publications. Lucy Synk, an illustrator who specializes in natural history and environmental science, works on preliminary sketches for a mural. Photo courtesy Chase Studio, Inc.

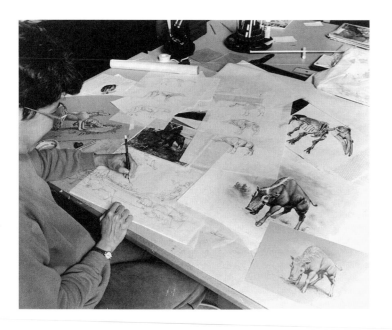

museums, mapping establishments, and technical-book companies rely on technical illustrators to visualize their concepts and products.

Technical illustrators are employed by companies involved in space exploration, meteorology, geography, earth sciences, scientific research, medicine, environmental protection, and nuclear energy. They are specialists who work in their field of expertise and interest, and they may be called on to illustrate anything from a nuclear reactor to the eyeball of a rainbow trout.

What does a technical illustrator do?

Technical illustrators either work in the art department of large corporations or agencies, or are freelance artists whose area of expertise is well known to industrial firms and corporations that require technical illustrations. Some technical illustrators work in art studios that have a reputation for fine work in technical fields.

The illustrators discuss the requirements for each assignment with scientists, authors, engineers, or art directors. They must research, study, photograph, sketch, and make detailed notes about the objects they will illustrate. After rough sketches are approved for concept, content, and comprehensiveness, technical illustrators complete the final illustration, usually intended for reproduction in manuals, textbooks, or assembly or service instructions.

Technical illustrators work in a variety of software programs and media, depending on the desired appearance of the published work. Some use pen, brush, ink, or washes for black-and-white reproduction. Some use an airbrush to reproduce the texture of finished products; others use watercolor or acrylic paints. Whatever media is used, extreme attention to detail is absolutely essential.

Technical illustrators use several types of projections and perspectives to produce the clearest possible images. The success of the illustration is not in how many people think it is beautiful, but in how useful and explicit it is. For this reason, the illustrator's job is not finished until the reproduction process is completed and the printed illustrations are tested in the shops, or appear in manuals, catalogs, books, or brochures.

What qualities are helpful to a technical illustrator?

Regardless of the field covered, careful attention to detail is essential. Technical illustrators must be able to meet deadlines and use their chosen media to portray their subjects simply and clearly. They must have an analytical mind and enjoy devising ways to explain processes with pictures. They must often think like engineers or scientists. In fact, combining their art with another area of interest—such as biology, engineering, or botany—is critical. Computer expertise is often necessary, along with being adaptable to new techniques and products. A strong capability in drawing and sketching is essential, as is the ability to visualize finished products from spoken concepts.

What other careers require similar qualities?

All fields of technical illustration call for artists with similar qualities. Medical illustrators, cartographers, schematic diagrammers, and engineers of certain types must have similar abilities and interests.

Industrial designers often work with concepts and sketches to make the finished drawings from which production models are built (see Other Careers in Industrial Design, page 118). In fact, industrial design and technical illustration are closely related in their emphasis on detail and need for clarity, simplicity, and completeness.

Drafters in architecture, construction, product design, and package design require qualities, interests, and abilities similar to those called for in successful technical illustrators.

What can you do now?

Take drawing, painting, graphic-design, and drafting classes. Pursue studies in areas of special interest, such as biology, physics, botany, or mathematics.

Study technical illustration in books, manuals, and assembly instructions to learn techniques and to classify methods of illustration. Keep files of good examples, and make note of areas that are of particular interest to you. Work in your sketchbook to develop style, technique, concepts, and methods of showing perspective. Study industrial-design magazines, and

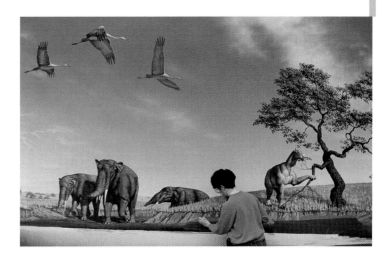

Lucy Synk painting the final mural at the new geology hall, Burpee Museum of Natural History, Rockford, Illinois. Photo courtesy Chase Studio, Inc.

send away for brochures and pamphlets that contain fine technical illustration.

Part-time work in graphic-design studios will provide background in processes and techniques. Work in printing establishments or service bureaus is also useful production experience. Jobs in areas of special interest to you can give you valuable background experience.

What schools offer necessary programs?

Schools that offer sound programs in general illustration usually have several courses geared toward technical illustration. Such courses usually concentrate on techniques (airbrush, rendering, perspective) rather than specialized areas of interest (medicine, aircraft, geography). Once you start a career in a specific industry, you will receive on-the-job training in the technology you are illustrating.

Schools near major centers for certain technologies (for example, automobiles in Michigan, solar power in Arizona, or oil-drilling equipment in Oklahoma) often provide special courses to help supply those industries with competent illustrators. Check college catalogs or the Internet for such details.

Other Careers in Publication Design and Illustration

Airbrush Artist

(See Other Careers in Graphic Design, page 70.)

Architectural Delineator

(See Other Careers in Architecture, page 34.)

Bookbinder (Bookmaker)

Some bookbinders custom-bind individual hardbound volumes for collectors, but most operate machinery and cut, sew, and glue the various parts of books in production situations. They use sewing machines, hand presses, and cutters for their work in large publishing or printing firms. Some bookbinders also do custom repair work for libraries and schools.

Book-Jacket Designer

Book-jacket designers are employed by studios specializing in book-jacket design, or may be free-lance illustrators who work for various publishing firms. They combine type and illustration or photography to create a book jacket that arouses public interest. They may also hire illustrators and photographers to provide artwork.

Botanical Illustrator

This specialist's area requires illustration techniques along with a strong interest in plants of all types. The work of botanical illustrators appears on pages of pamphlets, books, and magazines, usually in the form of detailed pencil drawings, pen-and-ink illustrations, colored-pencil work, or watercolors.

Caricaturist

Caricaturists are primarily free-lance artists who work for newspapers and magazines, but who may also be involved in advertising, illustration, and greeting-card design. The necessary skills are similar to those of cartoonists, but caricaturists exaggerate facial or body features to create a sometimes comic but completely recognizable drawing of a particular person.

Cartographer

(See Other Careers in Graphic Design, page 70.)

Chart Artist

Chart artists are graphic designers who specialize in making charts and diagrams that summarize data and present visual statistics. They may work in art agencies or for publishers of books, textbooks, and magazines that use such material. They are often cartographers who are especially interested in and expert at chartmaking.

Children's-Book Illustrator

The styles and techniques that children's book illustrators use are especially attractive and eye-catching. The work of these artists appears in picture books, religious literature, juvenile nonfiction and novels, and school textbooks and workbooks. The illustrators are usually free-lance artists whose portfolios are well known to publishers of children's books. In the United States, several awards are given each year to illustrators and designers of children's books.

Fantasy Illustrator

(See also Science-Fiction Illustrator, below.) Some illustrators work with images that have never been seen by people. They deal with subjects that are prehistoric, futuristic, or alien to our culture. They illustrate books and magazines and may be called upon to prepare storyboards for film sequences.

Greeting-Card Designer

Greeting cards are a billion-dollar-a-year industry. Photographers, designers, illustrators, and cartoonists are finding more work every year in greeting-card design. Some artists work for large companies such as Hallmark; others are free-lance artists who sell their ideas and art to several companies. Most card designers were illustration majors in art school; some are graphic designers. Often, illustrators and designers hold one job and free-lance their card ideas and art as a second source of income.

Industrial Illustrator

Artists who are excellent renderers and who can work from blueprints and plans can be successful industrial illustrators. They use all necessary media to

render finished products for reproduction. They work from plans, not actual products, and so differ from technical and other illustrators.

Medical Illustrator

Medical illustrators create graphics of all types to educate the general public, to instruct doctors, and to demonstrate a variety of biological problems and anatomical situations. They design for publications, film, TV, and exhibits, using both two- and three-dimensional techniques. They must be accomplished in many techniques and feel at ease in graphic design, illustration, and basic technical illustration. Strong foundations of medical knowledge insure the authenticity and clarity of their visual interpretations.

Mural Artist

(See Other Careers in Architecture, page 34.)

Photo Researcher

Photo researchers work with art directors, book designers, and authors to obtain photographs and art for reproduction in various publications. They conduct their research on the Internet, in public and private libraries, museums, and private collections, and through public-relations sources and photo and art archives in this country and abroad. Usually on the art staff of book and periodical publishers, they work with free-lance photographers and photo agencies.

Product Illustrator

Product illustrators are generally free-lance artists who work with advertising agencies, mail-order catalog publishers, or industrial clients. They use any required medium to make realistic presentations of manufactured items. Such items might include furniture, automobiles, tools, toys, packaged items, or garden equipment.

Science-Fiction Illustrator

(See also Fantasy Illustrator, above.)
Science-fiction artists combine basic illustrating skills with the resources of their imagination. They often use mixed-media techniques to achieve surrealistic effects. They illustrate the pages of books and magazines; design posters, toys, and games; and work in film, video, and TV.

Technical drawing of a GM engine. Digital image courtesy General Motors.

Science Illustrator

Illustrators with special interest in one or more areas of science—such as geography, biology, anthropology, zoology, or oceanography—use their combination of interests and skills to illustrate concepts, ideas, and objects for such publications as books, pamphlets, textbooks, and instruction manuals. They work in several media and must be adept at seeing detail and drawing accurately what they observe.

Storyboard Illustrator

(See Other Careers in Film, TV, and Multimedia, page 140.)

Teacher

Students who are interested in learning about publication design and illustration need teachers to show them appropriate styles and techniques. Art schools and colleges usually hire teachers with practical experience in these areas.

I heaved a sigh of relief and looked to see if any other bears were coming.

Clayton A. Fogle, wildlife photographer

Clayton A. Fogle

Imagine being sandwiched between two 500-pound grizzly bears and savoring the experience! As a wildlife photographer, my work has placed me in countless dramatic situations. My memorable grizzly encounter took place in Alaska's McNeil River Sanctuary, on one of my many photographic expeditions to the 49th state. I was—and still am—overwhelmed by the beauty and danger of Alaska, and I believe my photographs poignantly tell the story of America's last wilderness.

The huge grizzlies were so close, they would've filled the frame with a 24 mm lens. Nonchalantly the bears almost brushed my trembling figure as they ambled down to the McNeil River. I heaved a sigh of relief and looked to see if any other bears were coming, and then continued to photograph the incredible sight of a large concentration of grizzly bears. As the ranger warned, "The bears have the right of way." I have no problem remembering that rule.

Not all my photographic expeditions are as exciting as those to visit Alaska's bears, because hummingbirds and deer, salmon and butterflies, eagles and other animals appeal to me and my cameras. The January gathering of 3000 bald eagles along the Chilkat River near Haines, Alaska, is a powerful remembrance and a birdwatchers' and photographers' heaven.

Photographing wildlife is an exciting career if you are deeply interested in both photography and animals. You need to fully understand your cameras, photographic techniques and light . . . and love heading into wilderness areas.

After getting a degree from Brooks Institute with a film major, my past photographic experiences include scientific and industrial movies and videotapes, and my still photographs have been printed in many magazines. But my real passion is wildlife photography which challenges both the photographer and the lover of the incredible wilderness.

Fashion photography students work to pre-
pare a fashion layout for an assignment at
the School of Visual Arts, New York. Photo by
D. Modricker.

Photography

Photography is an important part of almost every art career listed and discussed in this book. Photographers are involved in fine-arts and commercial applications. They take pictures not only for weddings, sports, and news events, but also for scientific and medical research, industry, advertising, and graphic design. Photography's importance in graphic design is the reason it is discussed in this section of the book.

A picture can often send a message much faster than the spoken or written word, and photography is a major means of communication. TV, newspapers, magazines, books, and the Internet all use photography to tell stories and sell products.

Photographers use a variety of cameras, film, and accessories to do their specialized work. They use colored filters, floodlights, reflectors, electronic flashes, and sophisticated darkroom equipment. However, their most important tool is their knowledge of design, proportion, and composition, and their understanding of optics and light.

Although the names of fine-art photographers like Ansel Adams and Wynn Bullock are well known, there are thousands of photographers working in commercial fields whose names are never recognized.

They work in areas of portrait, architectural, museum, and aerial photography; they shoot products, food, machinery, sporting events, and myriad other subjects.

Some photographic experts prefer to work in darkrooms and may manage labs that develop and print the work of others. The experts in these custom labs handle developing, enlarging, copying, and printing; and they prepare prints for publication and other forms of reproduction. They work for advertising agencies, publishers, free-lance photographers, and fine-art and commercial photographers; and they are essential to many areas of advertising art and graphic design. As digital photography gains precedence in many areas of the vast photographic field, more and more specialists are needed with a background in technical processes such as how light and color affect image quality, and how to successfully adjust images digitally.

Photographers of distinction usually have become expert in other areas as well. Combinations such as photography and sports journalism, meteorology, or architecture can increase the demand for the photographer's work. This book uses photography to show you hundreds of examples of artists and their work. Without these images, the book would be words alone. With them, the world and work of career artists and designers comes to life.

Photojournalist

The popular image of a photojournalist is that of a debonair photographer, draped with several expensive cameras, covering exciting events in exotic parts of the world. The majority of photojournalists, however, work for newspapers, TV stations, and magazines, covering routine events at home.

Most photojournalists begin their career by working for newspapers or TV stations. Several skills are involved: handling spot news, such as fires and accidents, sports, business, local events, and enterprise (feature shots); illustrating feature articles; and recording social gatherings. The challenge to photographers is to extract interesting images from routine assignments. Photographers with added ability in art and design have an edge in composing meaningful pictures.

To break into the photojournalism field, consider your options. One way is by showing your portfolio to editors and being hired for a position. This is commonly the case for small or weekly newspapers. Another way is to free-lance until a publication hires you. Some photographers prefer to free-lance throughout their career, selling individual images or photo essays to various publishers. You may consider an internship as well—either paid or on a volunteer basis. The field is a fairly competitive one for larger newspapers due to the limited number of positions available.

A photojournalist's complete portfolio should include excellent examples of photographic work including spot news, sports, features, illustrations, etc. and proof (contact) sheets. Editors look for images with storytelling impact; by looking at proof sheets that show all the images taken in sequence, editors can easily see how sensitive the photographer is to subject, story, people, and context.

What does a photojournalist do?

Photojournalists are required to take pictures, develop film, and make prints or scan images. They must be familiar with all types of equipment and must handle many types of cameras, including digital cameras. Some small newspapers may require photojournalists to own their own cameras, but most newspapers and magazines supply the required cameras, lenses, and film, and also provide darkrooms in which to finish the work.

Newspaper photographers are assigned to cover events on their own, or to accompany reporters and take pictures to illustrate specific articles. Magazine photographers have longer-range projects that may involve travel and more personal approaches. Magazines such as *People, Life, Sports Illustrated, Time, Newsweek,* and many movie magazines are built around the work of photojournalists.

What qualities are helpful to a photojournalist?

It is essential that photojournalists know how to use all types of cameras and equipment. They must be adept at darkroom procedures, familiar with scanners and computers, be able to work under pressure, and meet deadlines as required. Photojournalists must be sensitive to the personal situation of their subject, work well with other people, and be tactful and patient. Quick reaction to changing situations combined with artistic talent, a strong sense of visual design, imagination, and creativity are qualities critical to the successful photojournalist. For the free-lance photojournalist, business-management skills are helpful.

What other careers require similar qualities?

Any photographic career calls for similar abilities and qualities. Some graphic designers have a strong interest in photography and can use their skills when working in design agencies. Free-lance photographers and graphic designers must be knowledgeable in similar areas of visual design and photographic techniques.

Some printing and publishing careers call for photographic abilities and expertise. Photographers can combine their skills with other interests (architecture, science, travel, animals, sailing) to create a satisfying career.

What can you do now?

Take courses in drawing, design, art history, photography, and computers. Become familiar with digital photographic technology as well as traditional photo-

graphic techniques and equipment. Study images of all kinds, especially in your area of interest. Practice taking photos with an emphasis on improvement. Active membership in a photography club is also a good idea.

Part-time work in camera shops or photographic labs and jobs at printing or publishing companies can be very valuable. Work as a photographer on student publications will teach you the basics of photojournalism. Titles of related magazines are on page 224.

What schools offer necessary programs?

All schools with photography departments offer courses that teach the skills necessary for photographic careers. Check the charts at the back of the book. Because photojournalists should have broad experience, they should take other art and design classes, as well as courses in history, art history, English, and creative writing. A portfolio-preparation class is a must!

You need not have a degree to land a job; editors generally hire according to your portfolio, not your schooling. Completion of a degree, however, assures editors that an applicant has passed required courses and is able to handle necessary procedures.

Facts on Photographers

In 1990 about 120,000 photographers and camera operators worked in the United States. Nearly half of all photographers are self-employed, many working in portrait or commercial studios. The next largest group works as photojournalists.

The number of photographers and camera operators is expected to increase to about 138,000 by the year 2005. The use of visual images in communications, education, entertainment, marketing, and research will create a demand for photographs, videocassettes, training films, and other visual aids. Industrial photography will employ photographers to make videotapes and motion pictures for use in meetings, sales campaigns, and public relations work. Photographers with technical and scientific know-how should have little trouble finding work. Opportunities will be excellent in fields such as medicine, health care and environmental protection, biology and other scientific and medical fields.

—**Chronicle Guidance Publications,** *Brief 12, Photographers*

Photojournalists must be aware of unplanned pictures, which might be more interesting and have more appeal than the assigned photographs. Courtesy *The Los Angeles Times.* Photo by Randy McBride.

Fashion Photographer

Fashion photography covers a range of photographic activities and purposes. In large cities, photographers may take pictures for department-store catalogs, or work for garment manufacturers; in a small town, they may take photos for newspaper ads for local specialty shops. There is a need for some sort of fashion photography in almost every city.

Although they specialize in fashion work, fashion photographers must have a complete training in all aspects of photography. They often study fashion history and observe at a modeling school to learn how models move. The photographer can then communicate more easily with models and other people in the fashion world.

A look through magazines and newspapers in your home or school library will reveal the fashion photographs of dozens of photographers. Photo by Gerald Brommer.

Free-lance photographers keep a portfolio of their fashion work to show to prospective clients or new accounts. They may also have a portfolio for any other specialty, such as food, room interiors, or sports.

What does a fashion photographer do?

Fashion photographers may shoot a special photo session for a client, on location or in a studio. In the session, the client—the manufacturer, a store, or the designer—supplies the apparel; the photographer or designer hires the models. Studio sessions are set against a seamless paper backdrop or with appropriate props, where lighting conditions can be controlled. The photographs from these sessions are used for magazine advertisements, catalog illustrations, or feature articles in fashion magazines.

Fashion photographers may also photograph models in action at fashion shows or special live presentations. In such cases, they set their lights and arrange their equipment before the show begins, and shoot rapidly when the action starts. The client uses the pictures in newspaper and magazine news stories, in trade publications, or for publicity purposes. These photographers may also be asked to photograph models and clothing at a shopping mall, on a yacht, or in a foreign country. On such assignments, a project art director may supervise shooting sequences and site selection.

For magazine advertisement layouts, the photographer is usually given suggestions. The art director provides rough sketches that indicate to the photographer whether to have the model standing, sitting, moving, and so on.

What qualities are helpful to a fashion photographer?

Fashion photographers are adept at all types of photography and are capable of using all of their equipment to create the proper mood and result for clients. They must work under tight deadlines, follow directions exactly, understand the requirements of each job, and be able to communicate with the models. They work with both color and black-and-white photography and should have excellent darkroom skills. If they are using digital cameras, they must also have computer skills. In addition to having a sound under-

standing of design and composition, a fashion photographer needs to be strongly self-disciplined, motivated, and able to work long hours and be available at inconvenient times.

What can you do now?

Get involved in many art classes (drawing, painting, and design) and photography classes. Become familiar with software for digital photo enhancement and retouching. Part-time work in a camera shop and involvement with a photo club will give you some practical experience. Completing photo assignments for a yearbook or newspaper will accustom you to working with people and furthering your own picture-taking and darkroom techniques. Any magazines that specialize in photography will acquaint you with equipment, cameras, and techniques. See page 224 for related periodicals.

What schools offer necessary programs?

Most art schools and universities offer some form of photography major (check the charts at the back of the book). Write for catalogs or check the school's Web site to see how your anticipated area of interest is treated. Look at the school's facilities: equipment, studio space, and materials. Find out what you can about the photography faculty and their area of expertise. Fashion photography should be taught by someone with experience in the field.

Fashion design and photography are brought together by students at the Fashion Institute of Design and Merchandising (FIDM). Above, the work of student designer Erika Mari Quayle is photographed on the runway of the annual student showing by Beth Herzhatt. Below, Brad Lansil photographed a pair of models wearing clothes from Macy's. Students learn to pose models, design lighting, search for exciting angles, shoot action photos, and develop a personal style. Photos courtesy FIDM.

Product and Food Photographers

Photographers work in a service business. Talent and awareness are essential; good equipment is necessary; and attention to detail and reliable techniques are required. The most important task of any photographer, however, is to satisfy the needs of the client. Product and food photographers are specialists with similar functions.

What does a product photographer do?

Product photographers take pictures of products in ways that make them dramatically appealing. They work with agency art directors, clients, or corporate art directors to make the photographs clearly understandable to their audiences. The photographers may be free lance, or employed by magazines or agencies. They often work on location at factories or showrooms, but they also bring products to their studio, where they can more carefully control the environment.

Product photographers learn to use backgrounds, light, and shadow to present their subjects to best advantage. Photo by Georgia Schwender.

Product photographers may photograph models, full-sized mock-ups, or actual products (see Industrial Design). They work in both color and black and white. They control lighting, background, scale, value, and mood to suit the product and the needs of the client. Their work may be used to advertise products or to sell new ideas to potential manufacturers.

Some of the photographs in the industrial-design section of this book are examples of the work of product photographers. These photographers not only take the pictures and prepare them for use in a variety of ways, but also invoice customers, determine costs, and set up production schedules.

What does a food photographer do?

The proliferation of specialty food magazines, advertising, and newspaper food sections has increased the need for food photographers. Their functions and techniques are similar to those of product photographers, but the subject matter is far different. The studios of food photographers generally have a functioning kitchen with a sink, stove, tables, counters, and windows. These photographers work with food editors, cooks, and food stylists who direct the arrangement, cooking, and preparation of all food, utensils, tables, and accessories. Although food photographers may do these tasks on their own, magazines often require that specialists oversee the projects.

What qualities are helpful to product and food photographers?

Both product and food photographers must know how to handle a variety of cameras, lights, reflectors, and related equipment. They must also invest in such equipment and in studio space. Both types of photographers must be extremely aware of and understand mood, detail, light, color, and contrast; their techniques must satisfy the specific need of the client. The photographers must be service-oriented, work easily with clients and with assistants, have patience, be able to meet deadlines, and be comfortable working at the direction of others. Skill in business practices rounds out these qualities.

What other careers require similar qualities?

Almost every other type of photography career calls for similar qualities. The photographer must be aware of the need to satisfy the clients. Competition is keen; if the work is not of the necessary quality, there are many other photographers waiting to take over the account. Many product photographers would be comfortable in corporate photography situations, where numerous photo applications are required.

What can you do now?

Superior photography, like excellent painting, is based on a knowledge of design. Take not only photography classes, but also drawing, painting, design, and art history. Chemistry and physics will help you understand developing processes and the science of lenses, filters, light, and electronics. Computer classes are essential to an understanding of digital photography.

Work on student publications, and join a camera club. Active participation in school events, and practical photographic experience, will give you confidence. Part-time work in a photography lab, in a camera store, with a local publication, or in a design studio provides excellent experience and practical training.

Titles of some magazines that will prove helpful are on page 224. Superb examples of product photography are in *Designer's Choice, Industrial Design*, and the advertisements of *Architectural Digest*. Excellent food photography can be found in *Gourmet, Bon Appétit*, and *Good Housekeeping*.

What schools offer necessary programs?

College, universities, and art schools offer courses of study in photography. Some photography schools (such as Brooks Institute in Santa Barbara, California, and Hallmark Institute of Photography in Turners Falls, Massachusetts) offer excellent background in several special areas.

For photography, portfolios and production are far more important than a degree, but employers and clients can be assured of your excellent training and business practices if you are a college graduate. Check the charts beginning on page 229 for schools with photography departments, and use the Internet for research, if possible.

Toronto food photographer Douglas Bradshaw works with food stylist Shirley Seto in setting up a shot of a hamburger for an ad campaign. Photographers and stylists must work well together to please clients and produce images that are appealing to the public. Courtesy Douglas Bradshaw.

Photographer Fred Watkins relaxes at home. Photo by Lou Cordero.

Watkins covers White House happenings for *Ebony* on a regular basis and has built a rapport with staff members there including honor guard R. J. Ross. Photo by Lou Cordero.

Profile

Photographer: Frederick L. Watkins, Jr.

In the highly competitive field of journalistic photography, the personal qualities of persistence and perseverance can be rewarded with steady and intriguing work. Look at the career of Fred Watkins, for example. Watkins is a staff photographer at Johnson Publishing Company, the firm that publishes *Ebony, Jet,* and *Ebony Man.*

Because his father was both a pastor and a portrait photographer, Watkins grew up around cameras. He chose to study social work and photography, taking photos for his school yearbook on his way to earning a B.A. degree in 1978. After graduating, he worked with youth offenders until a tragic event caused him to rethink his career plans. Watkins turned his attention to photography and applied for a position in New York with Time, Inc. He reapplied several times before he was hired as a photo lab technician.

His duties included washing and drying negatives for the staff photographers of Time-Life, but he always had a goal. At night, he shot pictures of celebrities around town. For two years, editors rejected his work because his photos were too similar to those of other photographers. Watkins nearly gave up. "I felt like throwing in the towel several times," he said.

Then he got his break. Watkins photographed tennis star John McEnroe kissing Tatum O'Neal, and *People* magazine published the photo. The photo credit led to coverage of events featuring Andy Warhol and Michael Jackson.

Time, Inc. began to assign Watkins to cover events for *Time, Life,* and *People* magazines. Watkins also found freelance clients and rounded out his portfolio with public relations and promotional images, and formal and informal portraits. He went on to work for ABC taking promotional photos for *Good Morning America.* He submitted photos to wire services for national distribution while he continued taking still photos of ABC movies. He continued free-lancing, often setting up shoots for the advertising campaigns of Fortune 500 companies.

In 1988, Watkins was offered a job at Johnson Publishing Company in New York City. He worked there for six years and was promoted in 1994 to the Washington office. He had always said, "I didn't want to be considered a black photographer; I wanted to be considered a good photographer." The offer to work for *Ebony*, however, came at the right time. Watkins was ready to settle down in northern Virginia and travel fewer miles for his assignments.

Watkins covers Washington events for *Ebony,* and also is called upon to direct photographers from the magazine's other bureaus when they come to town for major events. Although he is still needed occasionally in New York or another city, he is not living out of a suitcase as he once did. Sometimes he takes his family on assignment so they can have the opportunity to travel. Watkins has covered stories in South America and has traveled to seven African countries with President Clinton. He enjoys his work and the variety of personalities he comes in contact with, from celebrities to ordinary people.

Karen Williams, a Washington lawyer, poses for Watkins as he shoots an *Ebony* feature on African-Americans who serve on corporate boards. Photo by Lou Cordero.

Watkins packs a variety of cameras, lenses, filters, lights, and other equipment for easy transport to any location. Photo by Lou Cordero.

Other Careers in Photography

Aerial Photographer (Space Photographer)

From aircraft, aerial photographers take pictures of segments of the earth. Their photographs are used for such varied purposes as the study of natural land-forms, city-development plans, mapping, and survey-ing. Photographers working with satellite cameras show weather conditions, land-use patterns, military operations, and ecological phenomena.

Biological Photographer

Usually employed by hospitals or medical laboratories, biological photographers take pictures to illustrate scientific publications or research. They use still, video, and TV cameras to record anatomical structures, microscopic specimens, plant and animal tissues, and physiological and pathological processes. Such work requires a combination of intense interest in science or medicine as well as strong abilities in photography (see also Medical Photographer, below).

Mark Berndt filming a package of television commercials for Folgers Coffee in Venice, California. Courtesy Mark Berndt.

Commercial-Studio Photographer

Commercial studios are generally large operations, employing specialist photographers and technicians. Such studios are able to take on assignments in architecture, interior design, product development, catalog photography, illustration, and advertising. The work is often done for advertising-agency art directors or their clients.

Corporate Photographer (In-Plant Photographer)

Many companies employ photographers as part of their corporate technical staff. A large company may hire from one to ten or twenty photographers. (General Motors' photographic department has about fifteen employees.) Manufacturing concerns are typical environments for such in-plant photographers, but so are department stores, large banks, insurance companies, mail-order catalog houses, libraries, museums, government agencies, and police departments.

Fine-Art Photographer

(See Other Careers in Fine Art, page 164.)

Industrial Photographer

(See Product and Food Photographers, page 96.)

Law-Enforcement Photographer (Police Photographer)

Photographers who work in or for police departments must have a combination of interest in both law enforcement and photography. Some are free-lance photographers; others are police officers who specialize in photography. Large crime labs employ several full-time photographers who take pictures and operate specialized darkrooms and equipment. Areas of specialization include evidence gathering, forensics, color techniques, processing and printing, motion-picture work, photomicroscopy, and radiography.

Legal Photographer

Legal photographers work for lawyers. They take pictures of accidents, crime scenes. and any other objects and events of which lawyers, prosecutors, and detectives need a visual record. They are paid for their photographs and any time they must spend in court, and are required to have a knowledge of legal procedures.

Medical Photographer

Every large hospital has on staff at least one medical photographer, who uses still, motion-picture, and video cameras to record surgical procedures and any special or public-relations events for hospital records and for publicity. Surgeons, pathologists, the laboratory staff, and public-relations officers make use of medical photographers, who have a knowledge and understanding of medical procedures as well as skill in photography.

Microfilm Supervisor

Microfilm supervisors coordinate the efforts and activities of people engaged in microfilm reproduction, laboratory processing, computer-output microfilming, and optical-character recognition. They are expert in using and repairing all microfilm equipment.

Museum Photographer

(See Other Careers in Art Museums, page 192.)

Photographer of Fine Art

Some photographers specialize in taking color or black-and-white pictures or color slides of artwork for artists. The results are used for posters, publicity releases, magazines, books, or an artist's personal records. The photographer must be knowledgeable about art, color, and various art techniques in order to emphasize what the artist wishes to express in his or her artwork.

Photographic Colorist (Tinter)

Usually working in portrait studios, colorists apply oil colors or other tinting media to photographs to produce lifelike tones.

Photographic Engineer

No guided missile or satellite goes into space without a detailed photographic record of its development and function. The use of photography to solve engineering and scientific problems employs many photographic specialists. Such specialists must have an engineering background to accompany their expertise in photographic sciences. Most photographic engineering work is done for engineering firms (such as Rockwell International Corp. or TRW), for governmental agencies (such as NASA), or for production corporations (such as Lockheed Martin Corp., Ford Motor Co., or RCA).

Photographic Salesperson

An interest in all phases of photography combined with a desire to work with people and an ability in sales are the qualities of a photographic salesperson at retail or wholesale levels. Such a person might operate a neighborhood retail camera shop or sell photographic-studio services to clients in commercial or industrial fields.

Photography/Fine-Art Gallery Owner

(See Gallery Owner/Director, page 196)
Photography that is considered fine art is displayed and sold in galleries that specialize in such photographs. The gallery owners have a thorough knowledge of photographic history, techniques, and applications. They understand the market for such products and can articulate their opinions on style, techniques, subject matter, and quality.

Portrait Photographer

Portrait photographers outnumber all other kinds of photographic specialists. They record family groups, graduations, weddings, birthdays, and other special events. The photographers use of a variety of cameras, film, and processes to create portraits that range from black-and-white pictures to dye-transfer work that rivals good portrait painting.

Retoucher

Photographic retouchers are called upon to enhance photographs to the specifications of customers or photographers. The majority of photographic enhancement is accomplished with the use of computers, but traditional retouchers use pencils, watercolors, brushes, cotton swabs, and airbrushes in their work.

Teacher of Photography

(See Art Education, page 177.)

Product and Fashion Design

part three

Product and Fashion Design

The products we use and the clothes we wear make up the biggest slices of the American economic pie. The designers of these products are therefore responsible to a large degree for the economic well-being of our country and much of the rest of the world. Products and fashions designed here are manufactured and sold worldwide.

Industrial designers shape products. From concept to manufacture, they are responsible for the quality, aesthetic appeal, and function of items that consumers purchase and use. Their skill and expertise have positive effects on our lifestyle and physical environment.

Fashion designers head up an industry that is annually responsible for over 100 billion dollars in sales of clothing, accessories, and jewelry. The apparel/textile/fiber complex is the nation's leading single employer. The fashion industry requires steady concept and style changes from imaginative designers, many of whom are young artists new to the field. Design modifications are often based on ethnic dress, trends in art, sporting events, or international influences.

I personally gain a deep satisfaction seeing the objects that I've created, used by people . . .

Sam Lucente, director of user experience, Netscape Communications Corporation

Sam Lucente

As a child I had dreams of being an artist. Creating drawings, paintings, sculpture, and pottery became a passion. In school, with the encouragement of my parents, I studied fine arts and art history, and also found myself fascinated with woodworking and mechanical devices. While taking apart appliances in my father's workshop, it never crossed my mind that someone had actually worked to make the objects usable and beautiful. Later I studied at one of the leading design schools that offered a degree in industrial design—a profession involving a delicate balance of art and engineering.

Industrial design is the practice of analyzing, creating, and developing concepts and specifications of products and systems for the mutual benefit of the user and the manufacturer. Through formal education and work experience, the designer gains a specialized understanding of the visual, tactile, safety, and convenience criteria of products.

First the problem must be understood, such as how to design a better joystick control for video games. Then data must be gathered about the people who will use the product or system. Initial sketches are made by hand, followed by detailed models created with computer-aided design software. The ability to think, sketch, and build three-dimensional objects sets the industrial designer apart from other designers. These concepts are communicated via drawings, models, reports, and verbal presentations. Today, products and systems can be very complex, so designers often work with other business and development experts on small teams. Your ability to work within groups is crucial to your success.

The industrial designer plays a major role in creating the objects (artifacts) that define our culture. As long as humans have been on earth, they have created utensils for living. Almost everything human-made that you see is designed. Some of these things add to the visual clutter in our environment and some bring a sense of pleasure. As an industrial designer, I personally gain a deep satisfaction seeing the objects that I've created, used by people around the world as part of their everyday lives.

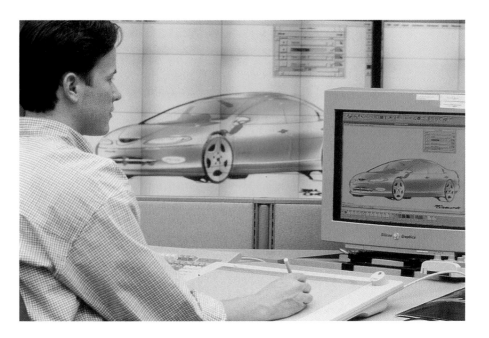

Chrysler Corporation designer Bill Chergosky works on options for the Intrepid.
Photo courtesy Chrysler Corporation Product Development.

Industrial Design

Industrial design is the designing of products to be manufactured by industrial processes. This field includes everything from space stations to knives and forks, from bicycles and toys to computers and pencils.

Even though not named as such, industrial design had been a vital part of the human experience for thousands of years. Consider that arrowheads, planting sticks, levers, ladders, and wheels all were made to improve people's lives and working conditions. Look around you today. Almost everything you see has been designed. If it is manufactured by people and for people, it is a product of industrial design.

Industrial designers are the Renaissance men and women of today—working with their heads and their hands. Their work starts when a need arises, and they design a product to satisfy that need. They compile research, sketch ideas, explore with computers, build models, develop prototypes, test, refine, and redesign—all with people and proposed uses in mind.

Industrial designers are skilled in working with three-dimensional forms. Along with an awareness of aesthetics, they have a knowledge of synthetic and natural materials, technology, manufacturing processes, and ergonomics. They design products, packages for those products, and the tools to make them. They design for the general consumer and for business, industry, and transportation.

Louis Sullivan, an American architect, coined the phrase in the 1890s that was to become the credo for industrial designers: "form follows function." This means that the form of an object is determined by how it will be used. A chair is something on which we sit (that is its function), but it is also something that we must look at (that is its form). First, it must be useful and comfortable; second, it must have a fine appearance, enhanced by the designer's choice of texture, color, style, and decoration. Industrial designers are experts on the way people and products work together.

Industrial designers may work free-lance, or for design consulting firms, or on the design staff of a manufacturing company, or in educational institutions, government agencies, or research firms. In each of these situations, they must understand the basics of engineering and speak the language of engineers. If a product has mechanical parts, engineers will create them but industrial designers determine how they will look and how easily, comfortably, and safely they will handle. An industrial designer is an artist, engineer, philosopher, environmentalist, and business executive —and he or she gives form to our future.

Product Designer

Industrial, or product, designers work in every manufacturing industry. They are hired to create products by combining their artistic talent, design sense, understanding of consumer needs, ergonomics, and knowledge of various materials and manufacturing processes. They must know what competing manufacturers are producing and be aware of style trends. They research product performance, work with samplemakers to develop prototypes, and estimate sales impact on the potential consumer market.

A proposed design may be for a new product, or it may be an improvement to an old product. A successful product must be made of materials that will last for the life of the product and that are suitable for its intended use. The product must be profitable, satisfy consumer need, and be affordable to the buyer. Product designers therefore have an enormous impact on the nation's economy.

What does a product designer do?

Successful product designs are the result of months of creative thinking and sketching, research and analysis, and samplemaking and testing. Product designs are usually the cooperative, creative efforts of a design staff.

When a product is first proposed, a research specialist studies the design problem and compiles information. Product designers use that information to make sketches and computer images of their own and competitors' products. The new design must look better, work better, and, if possible, cost less than the competition's. A selection of rough drawings or printouts that present several solutions will be narrowed to two or three possibilities. These are converted into clay or foam models to assess the three-dimensional effect of the forms. Adjustments and revisions are based on the wishes of designer and client.

Computer-aided industrial design (CAID) systems help the designer make working drawings and explore forms. In automated production, designs are transferred directly through computer links to production machinery.

Using detailed rendering and input from engineers, the product designer helps a samplemaker develop a presentation model. This full-scale model is constructed of the proposed materials and is an actual working product, a one-of-a-kind sample. When the working model is approved, drafters develop working drawings for the factory tooling and production. Product designers supervise all phases of product development, insuring that the finished products reflect their ideas and meet their standards for quality, function, and appearance.

This digital voice recorder was designed in response to the need for a small, hand-held recorder that uses digital-voice storage rather than conventional tape. Design by Human Factors Industrial Design, Inc. Photo by A. Layman.

What qualities are helpful to a product designer?

Product designers enjoy doing research, experimenting on the computer, and spending long periods of time on single projects. They are aware of trends in styles and technology, adaptable to new concepts, and willing to try new approaches to problems. They have excellent drawing skills along with an inquiring mind. Product designers must have confidence in their ability, and be able to work with others on a team. They must communicate effectively, both verbally and in writing.

What other careers require similar qualities?

Industrial designers have a wide range of skills. Many careers parallel theirs. Package designers, graphic designers, interior designers, and environmental planners need similar qualifications. The work of photographers, model builders, samplemakers, and sales representatives is closely related to product development. A product designer might also enjoy a supervisory position in manufacturing, or in wholesale or contract showrooms. He or she might also free-lance in any number of design-related positions, and could function as a corporate art director.

What can you do now?

Take drawing, painting, and art-history classes, along with drafting and three-dimensional design or sculpture. Product photography and model building are excellent and productive hobbies. To become aware of current product design, spend some time in a variety of retail stores.

Part-time work in a drafting office is valuable. Jobs in a manufacturing company, carpenter shop, or design studio will give you useful background. A position as store clerk allows you to handle products and become familiar with designs, public reaction to products, and consumer psychology.

The names of magazines that may provide some career guidance to future product designers are on page 224.

Form Follows Function

When it comes to flexibility, nothing beats Black & Decker's wildly successful SnakeLight. In a market where the average price is just $6, consumers are paying $30 for a product that lets them work "hands free" under car hoods, under sinks, or in a closet.

The key to the SnakeLight is its bendable, tubular body, which can be coiled cobralike on the ground, wrapped around a pole, hung over a sink, or even draped around your neck while you work. It comes in three forms: a white-colored body for home, a black shop model with a mounting bracket, and a red model for cars, which runs off a cigarette lighter. Form couldn't follow function any better.

—Business Week, June 5, 1995

What schools offer necessary programs?

Schools with industrial-design programs feature courses in general product design. Check the charts at the back of the book. Some schools emphasize certain types of products in their course offerings (furniture, automotive, or ceramic design, for example). Check catalogs or Web sites for specialties that interest you.

Though not required in the design department of many manufacturing plants, a degree assures the employer that you have solid design training and background. Your portfolio, however, remains the prime selling point when you are looking for a job.

Furniture designer Charles Gibilterra in his design studio, displays the bentwood formations that will be the basis for his next major chair design.

This chair bears the designer's name and is called the Gibilterra Chair, designed for Vecta. Photo by Andy Post.

Profile

Furniture Designer: Charles Gibilterra

Charles Gibilterra's life is design. From his glass-box floating studio to his garden to his home to his work, design is always evident. Throughout his career, he has remained flexible by working in several media, in several design areas, and with several kinds of products. His development as one of America's premier furniture designers illustrates the necessity for being versatile and continually interested in new directions and influences.

Gibilterra grew up in Los Angeles and studied architecture and industrial design at USC, on a General Motors scholarship awarded to him for automobile design. His first career direction was as an exhibit designer, after which he moved into interior design. With his industrial-design background, he soon found himself designing custom home and office furnishings for his clients, simply because what he and they wanted was not available in the market.

Designing such custom pieces led him to open his own design firm in 1974, and his first group of chairs and tables designed for Brown-Saltman changed the fashion of residential furniture. Using beetle-eaten and mineral-stained pine and natural finishes, he created an informal "California" style, based on natural forms and materials.

Since his early design successes, Gibilterra has had many award-winning residential and commercial product lines, all documented in exhibits, books, and design publications.

Gibilterra's designs feature the use of bentwood, stainless steel, teak, glass, leather, and fabrics. He often bases his creative bentwood and stainless-steel forms on natural forms that he finds in driftwood, seashells, and the living forms of nature. His fabric designs are based on swirling water, sand formations, low-tide riverbeds, and other water forms. The walls of his studio are not lined with photos of his own work, but with driftwood, dried seaweed, twigs, branches, and natural rock formations. From these, Gibilterra derives the energy and inspiration for his designs.

Gibilterra has taught courses in interior and furniture design at California State University, Northridge. His personal artistic explorations have included ceramics, bonsai, sculpture, and painting; and he is an enthusiastic landscape photographer. He is a free-lance designer who responds to nature and to beautiful forms. Color, texture, pattern, form, and shading beckon his attention, arouse appreciation, and evoke his joy. His product designs reflect all of this.

Several designs using stainless steel and leather are featured in lines presented by Brueton. Courtesy the designer.

Gibilterra designs public seating in a variety of interchangeable combinations. This bentwood grouping is in the line of the American Seating Company. Photo by Charles Gibilterra.

Toy Designer

A career in toy design might sound like fun, but it is a major and serious business, with over ten billion dollars in sales per year. Toy designers and manufacturers must consider safety standards, child psychology, production, packaging, and promotion. Of course, there is also a playful part of the business—the research and designing of new toys. Toys must be safe, cost-effective—and fun.

Innovative toys begin with sketches and drawings based on research and fashion information, and then designers and model builders take over. Designers must know about product design, graphics, textiles, computers, sound technology, and robotics—and what today's kids like! Toys are as varied as the children who play with them, and fall into three major categories: hard toys, soft toys, and games.

What does a toy designer do?

Most designers specialize in one market area: girls' or boys' toys, preschool or toddler toys, or school-age toys. The entire design process is similar to that of other industrial-design projects: concept, sketch, design, model building, and final production.

What qualities are helpful to a toy designer?

Toy designers perform all the functions of other industrial designers, but they work on a smaller scale. They must like to work in miniature, therefore, and must be aware of changes in children's interests and in industry trends. A toy designer is innately curious, has a rich imagination, and enjoys research and working on long-range projects. He or she can think three-dimensionally, with an emphasis on form, and also is able to work well with other people.

What other careers require similar qualities?

All industrial-design careers require similar qualities. The specific interests and goals may vary, but the processes (research, sketching, designing, model building, and production) are similar. Many toy designers begin their career in industrial design.

What can you do now?

Take drawing, painting, sculpture, ceramics, design, and drafting classes; supplement them with special-interest areas such as auto shop, wood shop, or family and consumer science. Model building and photography are useful hobbies. A job in a toy store will give you practical experience. Study the toys that seem most popular, and keep notes on them and their design ideas. Collect fine toys, toy catalogs, and advertisements from children's magazines. Keep an organized file of designs and trends.

What schools offer necessary programs?

Schools with good industrial-design programs are best. Check the charts at the back of the book for schools that offer industrial design. One school that offers toy-design courses is the Fashion Institute of Technology, in New York City, which works closely with the Toy Manufacturers of America.

Being a toy designer means creating toys that maximize the positive impact they can have on children, and therefore on society. Jeremy Madel sketches in the toy design studio, Otis College of Art and Design. Photo by Ave Pildas.

Toy design studio, Otis College of Art and Design. Photo by Ave Pildas.

Sean Lee and his favorite toy development, Gak. While toys appeal to a child's desire for fun, they serve a deeper purpose by helping to advance a child's cognitive, emotional, psychological, and social development.

Funny Business

In Sean Lee's business, you won't be told to quit fooling around. In fact, being too serious could get you in trouble if you're a toy designer.

The '93 graduate of California State U., Long Beach, fell into the toy industry when he landed a sweet internship at Mattel, Inc. the summer before his senior year. He was studying industrial design, which covers everything from VCRs to toothbrushes. After graduation, Mattel rehired him to work with the activity toys design group.

"I don't think I could do anything else," Lee says. "There is constant communication and playing around. It's a very fun group atmosphere at Mattel."

There's no such thing as a typical work day for Lee, who is involved in everything from brainstorming toy ideas to meeting with engineers to decide how a toy will actually operate.

"Some days, our group will get together and go to Venice Beach and spend the whole day there coming up with new ideas for toys," Lee says.

So what will the toy maker think of next: He won't say —of course. But his favorite project so far is some gooey goop called Gak.

In case you haven't seen—or touched—Gak, here's Lee's description: "It's really colorful, very slimy, oozy stuff that's cold and clammy when you touch it."

—*U*, **The National College Magazine, May, 1996**

Ergonomist and Human-Factors Designer

Work in the field of ergonomics or human factors (human engineering) deals with the problems people encounter in the use of tools, furniture, equipment, and systems of various kinds. Ergonomists design to reduce human errors and frustrations, and to add to productivity and satisfaction. They gather and analyze data and observe how people move and use the products; then they improve product design. The products and systems they design must not only meet the needs of the user, but they must also be safe, comfortable, and easy to use. Properly designed products hold up well under use and fit in well with other equipment.

What does an ergonomist do?

Ergonomists apply their skills to a broad range of jobs, systems, and products, such as computer hardware and software, aerospace systems, communications, transportation, tools, medical devices, and consumer products. They conduct field and laboratory research. They work in teams that usually include industrial designers, design engineers, job analysts, product engineers, systems analysts, safety experts, marketing professionals, physicians, and production workers.

Ergonomists take part in the design of products but also work with moving people, communicating information, and redesigning systems. The design aspect of human factors is centered on such products as bathtubs, seat belts, farm tractors, wheelchairs, computer hardware, airplane cockpits, kitchen utensils and appliances, and thousands of other products.

In product design, for example, ergonomists help designers and engineers produce an automobile that has enough space for a tall driver and at the same time allows a short driver to reach all the controls. They design dashboard displays and controls to maximize operator performance and comfort.

With whatever product or project they become involved, their goal is efficiency, safety, and comfort for the user or the group of users. In so doing, they greatly influence the design of products and merchandise, and have a direct impact on the economic well-being of the companies for which they work.

What qualities are helpful to an ergonomist?

Ergonomists should have leadership skills and the ability to motivate others, but they also need to be able to work well with people in team situations. They need to possess good communications skills and confidence in their work, and have the decisiveness and organizational ability to be able to work under pressure and deadlines. In addition to drawing and sketching ability, ergonomists generally have a broad variety of interests and enjoy research and analysis.

Body Planning

The Animal is a revolutionary wet suit, created by a design team at Vent Design Associates to resolve the problems inherent in most surfing outfits. To give the swimmer freedom of movement, the fabric must be thin and supple, yet it has to be as thick as possible to retain body heat.

The designers' solution was a thick neoprene material with built-in striations for elasticity. Anatomically oriented grooves have been molded into the neoprene. The result is striking, with configurations that suggest the markings and ferocity of an exotic beast.

Courtesy Vent Design Associates.

What other careers require similar qualities?

Because human factors deal with the dynamics of people and their use of products or systems, ergonomists might be product designers, interior designers, facility planners, industrial designers, industrial psychologists, social psychologists, and job analysts. The ability to work on teams is helpful in all kinds of design firms and in many consulting organizations.

What can you do now?

Most ergonomists have a master of science degree, and the background necessary for this includes not only research and design skills, but also a focus on anthropometrics, biomechanics, psychology, history, mathematics, writing, and the environment.

On your own, study the products that you use—determine why you like them or why they feel good in your hands. Learn to analyze systems and why they work or don't work well. Look at and read industrial- and graphic-design magazines (see page 224) to see how products, systems, and graphics are used, written about, and advertised. Become aware of your environment, and analyze its strengths and shortcomings. Consider joining the Human Factors and Ergonomics Society (see page 226).

What schools offer necessary programs?

Some art schools and universities with a strong industrial-design department offer basic courses in ergonomics. Most industrial- and product-design sequences include studies in ergonomics and human factors. Check on the breadth of industrial-design programs in schools that interest you by studying catalogs or Web sites; generally, the stronger the program, the better your foundation in human factors will be.

The Colgate *Total* toothbrush is a redesigned product: it has a unique bristle configuration for improved cleaning and a handle that fits well in a human hand. Design by Human Factors Industrial Design, Inc. Photo by A. Layman.

To Err is Human

Human engineering (ergonomics) got its big push during World War II, when it was found that many of the new and complicated weapons were useless because they exceeded the capacities of their human operators. This same kind of mismatching of people and machines is common today in modern industry, in the skies above us, and on our highways. It is this fact, together with the technological demands of space research and defense needs, that is the challenge for human factors engineers. Their job is to redesign present equipment and devise new equipment so that human errors, accidents, and frustrations can be reduced and efficiency increased.

—Alphonse Chapanis, pioneer in the field of ergonomics, quoted in *Career Opportunities in Human Factors*, *Reprint 517*, November, 1993

Automotive Design Team

Automobiles are not the product of a single designer, but of the cooperative efforts of dozens of people working on design teams that include engineers, stylists, and production people. New designs are the result of years of research, computer analysis, planning, and development.

Marketing researchers gather information from consumers, salespeople, mechanics, production workers, and designers. This information is passed on to product-planning specialists, who propose changes based on these findings and their own ideas. This "paper program" is evaluated on the basis of projected engine requirements, safety standards, and costs. Stylists, whose primary concern is design and appearance, make preliminary sketches of interior and exterior ideas. After management approves the overall plan, the stylists complete the details of the design.

Idea drawings such as this are often the starting point for future designs. Aspects of such sketches may appear in production models several years down the line. Courtesy General Motors Corporation.

What do automobile stylists do?

Stylists prepare hundreds of sketches and computer printouts of ideas for an automobile and its parts. Each idea complements the others; the design must be unified and coordinated. Design ideas are gradually developed from these sketches into an acceptable styling theme. The most promising of these designs are built into full-size clay models over a wooden framework: three-dimensional representations of the stylists' drawings. A plaster mold is made, from which Fiberglas™ models are produced. These models, fitted with glass and wheels, and perfectly painted and trimmed, look exactly like production models. The most promising model is selected by company executives and design specialists, and development continues.

Designers who specialize in textiles, colors, fashions, and plastics build the interior parts. They make full-scale renderings from which full-size models (called *trim bucks*) are made in wood. Actual fabrics and paints are used on the bucks to show their final appearance. The design of the automobile is now set, although production is many months away.

What do design engineers do?

While stylists work on the appearance of the car, design engineers plan the nearly 13,000 parts that go into it. These parts require hundreds of sketches, computer printouts, final renderings, and detailed drawings by drafters and computer specialists so that tools can be made to produce the parts. Industrial-design engineers must design every bolt, belt, housing, and clamp to make all the parts fit and work together. Many designs are not entirely new, but are modifications of existing parts. Computers are used in much of this design work.

After all elements are checked by computer for stress, durability, and function, experimental parts are handmade in the company shop. These are also tested, and prototypes are constructed and tested before final production plans are put into operation.

What qualities are helpful to an automotive designer?

Automotive stylists and design engineers must be able to work as part of an extensive team. They must be imaginative and flexible enough to work around such

restrictions as space, cost, and projected use. They must be able to turn data into visible ideas, and must be able to communicate those ideas. Familiarity with the uses and characteristics of materials, a good foundation in color and design, and the ability to work easily with computers are essential. Although the designers sketch and render in two dimensions, they must be able to think and work in three dimensions. An understanding of budgets is also important.

What other careers require similar qualities?

Industrial-design work in any large manufacturing plant is similar to the work of automotive designers. All such situations require teamwork, good verbal communication, and familiarity with a variety of materials and processes. Drawing and rendering ability is common to all industrial-design careers.

Experienced automobile designers make excellent industrial-design consultants because of the range of materials and products with which they have worked. Design of carpets, fabrics, seating, and control panels are related careers in other industries.

What can you do now?

Take drawing, painting, design, drafting, and art-history classes. Automotive shop classes will give you a chance to work on body design and styling. Physics and computer classes will familiarize you with the mechanical aspects of automobile construction. Model building is an excellent hobby.

Part-time work in any graphic- or industrial-design studio is ideal, and work in a garage or an automobile parts and accessories shop will give you practical experience.

Collect brochures from auto dealers and pictures from magazine ads that show superior styling and design features. Draw and photograph cars as an excellent way to learn about their forms and functions. Restyle and redesign parts of your own car.

Magazines that may help you determine your career direction in automobile design include *Road and Track, Motor Trend, Product Design and Development*, and *Modo* (Italy).

An industrial designer working on drawings for a radio module to fit into a Cadillac dashboard. Several designs will be considered before the final selection is made. Courtesy General Motors Corporation.

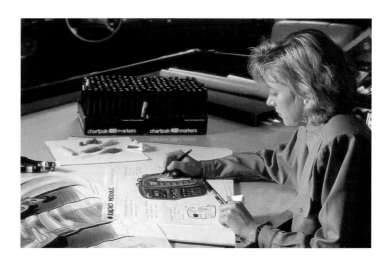

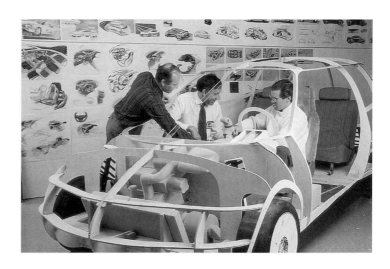

Full-scale buck trims, made of wood in GM's shops, allow full testing for size, comfort, utility, design, and appearance. Courtesy General Motors Corporation.

What schools offer necessary programs?

Some art schools place special emphasis on automotive design. Automobile companies generally select their designers and stylists from such schools. Acquire a good industrial-design background. Check each school catalog or Web site to see if your needs will be met. Investigate schools in the Detroit, Chicago, and Fort Wayne areas, and Art Center College of Design, in Pasadena. See the charts at the back of the book for industrial-design programs.

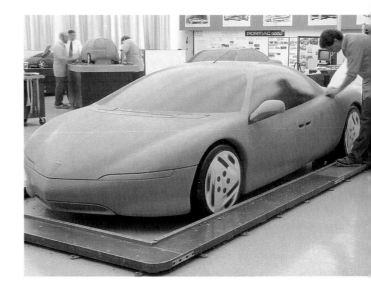

Clay models of cars are fashioned, finished, and painted to allow stylists to check and modify exterior design and appearance. Some automobile companies are replacing this step of the design process with different technologies. Courtesy General Motors Corporation.

Global Design, Teamwork, and CAID

Industrial designers have come a long way from the days when they worked over a slanted table, using a slide rule, straight edge, French curves, and pencils to design products. Imagine! Industrial designers in several parts of the world, linked together by high-speed computer networks, can now design a product that will be assembled simultaneously on several continents. Examples from the automotive world illustrate the flexibility and cooperative qualities necessary for success in the changing realm of industrial design.

Global team design: a new trend

There are strong concentrations and communities of industrial designers in various parts of Europe, North America, and Asia that can be linked in global, cross-functional networks. Ford Motor Company, for example, has linked product-development teams in different parts of the world. These teams cooperatively design cars that can be manufactured and sold in almost identical form in different countries. The Ford Contour and Mercury Mystique in North America (the Mondeo in other parts of the world) is the first automotive product of this global design strategy.

European-based teams designed, developed, and made Mondeo's four-cylinder engine and manual transmission while Americans designed, developed, and built its V-6 engine, automatic transmission, and air conditioner. The teams worked together via global hookup to develop the structural forms and aesthetics. Designers at Ford workstations in seven design centers (in the United States, Germany, Great Britain, Japan, Italy, and Australia) cooperated on concept development in the same "virtual" studio. This global design-team process can reduce the time it takes to develop a car from five years to three years—increasing efficiency and profitability.

Computers increase efficiency

Time can also be saved by computer testing rather than building full-size prototype models to be aerodynamically tested and run through actual crash tests. "Computer models running in virtual wind tunnels and against digital crash barriers can quickly achieve more reliable testing results," according to Del Coates, CAID editor of *Innovation*, the quarterly journal of the Industrial Design Society of America.

Chrysler's California design studio develops concept sketches electronically, and modelers use full-size plots of these drawings to build full-size clay or foam models. Whereas design teams used to make three or four of these full-size models before choosing which direction a new car design should take, designers now "build" them in the computer and project them full-size. Savings are tremendous.

Ford plans to replace clay models with computer-generated holographic technology that it is developing in cooperation with several companies, universities, and government agencies. Such cooperative efforts require not only technical, design, and manufacturing expertise, but also communication skills, both written and oral, of the highest order. General Motors continues to develop its own CAD software cooperatively with several firms, but generally seems committed to using clay models to work out design kinks.

One European manufacturer has eliminated clay models altogether in a full commitment to computer-aided industrial design (CAID) and has reportedly done away with traditional sketching. The designers build small foam models of their ideas almost immediately. This basic three-dimensional form is scanned and converted into 3-D computer data that the designer fleshes out with CDRS software. The finished design is sent electronically to a shop that can mill a full-size foam model overnight, ready to be painted. Any necessary alterations and adjustments can be made quickly on the computer model and processed immediately.

A Japanese firm reportedly developed a new car in two years, using already-produced components, with the concept automobile developed on computers.

They used stored CAD files of previously designed parts that can be recalled and adapted at will. They expect in this way to achieve production of a newly designed car with such components in a time frame of six months, from concept to finished product.

Cooperation and communication lead to success

While the aesthetic aspect of design can often be a problem, and the shaping of a complete automobile is still a difficult and complex project, the means of solving these problems with technology is coming closer to realization. The industrial design of other products, from kitchen gadgets to furniture, continually undergoes similar adaptation and adjustment to technology and human usage (see Ergonomist and Human-Factors Designer, page 112). This is a major reason why industrial design is such an exciting and dynamic career field. Traditional design concepts, creativity, aesthetics, and computer technology are wedded into a highly efficient and productive team effort, whether it is carried out in a local studio or globally by huge corporations.

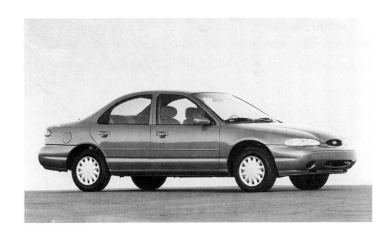

The 1997 Ford Contour was the first automobile designed by a computer-networked team from several continents. Courtesy Ford Motor Company.

Other Careers in Industrial Design

Airline Interior Designer (Stylist)

The interior of a plane is custom-designed to project an airline's corporate image. Seating, overhead storage, food-service systems, colors, interior walls, windows, and carpets, are unique to each airline. They are designed by artists and industrial designers working for the airline or for the design firms that the airline consults. Designers must consider such factors as efficiency, appearance, and comfort.

Automobile-Design Detailer

Detailers work with drafters and designers to produce drawings of automobile bodies or chassis parts. Detailers include specifications and designers' notes so that complete mock-ups can be made in the planning stages of development, or so that machinery can be built to make parts for production models.

Automobile Interior Designer

Automobile interior designers use metal, plastics, and fabrics to create the components of automobile interiors. They are aided by project supervisors as they design and coordinate headliners, seats, dashboards, steering wheels, door panels, sun visors, and the like.

Detailer

Detailers make complete drawings or design layouts of individual parts for engineers and architects. They provide dimensions, material specifications, and other information needed for each part.

Drafter

Drafters prepare accurate working drawings from rough sketches, specifications, and the calculations of designers, engineers, and architects. Their drawings or computer printouts provide necessary information for the manufacturing process. There are over 350,000 drafters employed in the United States; most of them work in industrial areas.

Every manufacturing industry employs drafters, most of whom use computer-aided design (CAD).

They enter information into their computer and then refine the image, which can be rotated or viewed in three dimensions from any angle.

Furniture Reproducer

Furniture reproducers generally work in large manufacturing companies, preparing working drawings and templates of antique or custom furniture from which to make authentic reproductions.

Glassblower (Glass Technologist)

Glassblowers develop specifications, make sketches, and blow and shape glass for test tubes, retorts, and flasks. They also design and blow components for condensers, vacuum pumps, barometers, and thermometers.

Heavy-Equipment Designer

The massive equipment used to move earth, drill wells, and create energy from wind and water are all conceived, drawn, and presented by equipment designers. This specialized area of industrial design involves technology as much as design, and is more concerned with production capability than with aesthetic appearance.

Industrial Illustrator

(See Technical Illustrator, page 86.)

Lighting Designer

Lighting design is an offshoot of interior design, but the design and production of lighting systems and fixtures is the realm of industrial-design specialists. Lamp shops are filled with the work of the designers who work for large manufacturers of mass-produced products. Custom design and installations are often required for offices, libraries, galleries, museums, theaters, arenas, and some condominiums and homes.

Model Builder

Model builders work for manufacturers or design firms, or are free-lancers. Their work is based on the instructions of designers and stylists. They use materials such as wood, metal, plastic, paper, and glass. The models may be full-sized or miniature versions of proposed products, and are used to build prototypes, tools, and production models. Model builders usually

have a background in sculpture, jewelrymaking, machine shop, photography, or design.

Ornamental-Metalwork Designer

Using various joining techniques, ornamental-metalwork designers plan and create grills, latticework, statuary, railings, lighting fixtures, and the like. They often design tools and templates for shaping and finishing such products. They must be familiar with mechanical, welding, and brazing techniques, and must have some background in drawing and design.

Product Photographer

(See Product and Food Photographers, page 96.)

Safety Clothing and Equipment Designer

Safety designers combine elements of both fashion and industrial design in their career. They develop practical clothing and equipment to protect workers from a variety of industrial hazards. They draft plans for the equipment and make patterns for the clothing.

Senior Designer (Design Director)

(See Other Careers in Graphic Design, Art Director, page 70.)

Sports-Equipment Designer

A surge in recreational and sporting equipment usage has accompanied the fitness trend. Designers of the equipment are familiar with its use. Most work for large manufacturing companies that make ski equipment, tennis racquets, bicycles, windsurfing equipment, in-line skates, golf clubs, and other types of equipment for professional and amateur athletes. These designers often modify and adapt previous ideas, but are also involved in designing new equipment.

Stencilmaker

Stencilmakers work for carpet manufacturers, laying out and cutting patterns and stencils used in printing multicolored designs on rugs. They use opaque projectors, stencil knives, pencils, brushes, ink, and paint in their work. They make pencil copies of symmetrical designs on tracing paper and indicate sizes and color specifications. They prepare proof copies for design directors and inspect the production pieces for accuracy.

Tool Designer (Tool- and Equipment-Design Specialist)

Tool designers design a variety of cutting and drilling tools and related dies, jigs, templates, and fixtures, either for production work or for experimental use in all types of metalwork. They use geometric and algebraic formulas and standard engineering-tool data to design tools and machines. These industrial specialists must have a background in mechanical drawing and engineering, and in working with metals. They draw preliminary sketches and concepts, work on computers, and make detailed drawings for submission to machine builders and diemakers.

Transportation Designer

The design process for other forms of transportation is similar to that for automobiles, and includes the designing of railroad rolling stock, buses, trucks, airplanes (personal and commercial), recreational vehicles, motorcycles, and the like. Certain technologies are standard for each kind of production, and the respective designers must know the use and function of equipment. Designers work with engineers, model builders, and drafters in preparing sketches, renderings, models, mock-ups, and presentation models for their company. They are expert at research, idea testing, and data compilation, as well as drawing and developing concepts.

. . . fashion is about a designer expressing himself or herself . . .

Jane Wu, designer and instructor

Jane Wu

Fashion design is not only about picking out the right colors or following the latest trends. It is about the beauty of line; the harmony of textures and colors; and the balance of the finished composition.

I was introduced to this philosophy through my fine arts training while attending Los Angeles County High School for the Arts (LACHSA), where I learned about the Gestalt theory. When a piece of art is finished, you should not be able to add or take any line, value or shape from the piece. It is complete. This theory did not digest well when I first heard it, and it was not until I started teaching at Otis Art Institute that I realized the importance of that lesson.

Basically, the theory translates to the thought process of an artist or designer who is a problem solver, using line, shape, texture, color, value, form, space and proportion to develop compositions. All these elements make up the art work whether it is a painting, garment or sculpture. I look at fashion designing in a unique way because of this philosophy. I feel fashion is about a designer expressing himself or herself through design and the fashion medium. Because I now understand that being an artist is about being a problem solver, I feel I could move into any design field and apply the same theory to help me succeed.

My career is still unfolding for me. I still have a long way to go and much to learn. I have been blessed with wonderful teachers at LACHSA and Otis and I have had the honor of teaching at both of these schools. I've enjoyed the pleasure of handing down valuable information to the next generation of designers. It makes me proud to think that my students will be able to join the work force and become effective designers. They not only create but innovate.

The fashion industry will always be an industry. It will always be about money, catching the next trend and staying on top. However, if a designer maintains his or her spirit of innovation and artistic excellence, there will always be the possibility of becoming another legend.

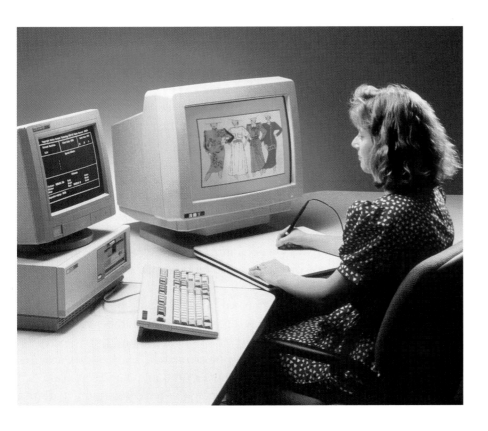

A fashion-design major is working with a Gerber Creative Designer Computer System at FIDM. Personal sensitivity and creativity are still essential to successful designing, even when using computer-aided design for fashion. Courtesy Fashion Institute of Design and Merchandising.

Fashion Design

Every year, Americans spend over 100 billion dollars on clothing, accessories, and jewelry, helping to make the apparel/textile/fiber industry the nation's largest single employer. Because people have always been interested in clothing, fashion designers hold a unique place in society. In choosing and wearing their clothing, people show the creativity, imagination, and ingenuity of these artists. The American fashion industry's primary centers are New York City, Los Angeles, and Dallas, but the existence of the fashion world is felt in every urban center, in the form of advertising agencies, merchandising outlets, and custom designers.

Mass production of clothing begins when a high-fashion designer shows his or her collection to buyers, private customers, merchandising staffs, and fashion editors. They decide what the trends for the season will be; when copies, "knockoffs," "copy-downs," and adaptations can appear; and which designs will serve as a starting point for their lines. Advertising campaigns in magazines and trade papers precede actual production and test the mass market. When the time is right and the orders are coming in, production begins. Design and production are followed by sales. Fashion merchandising is the critical link in the system. If the clothing is advertised and sells very well, the whole process is considered successful.

The world of fashion includes a broad spectrum of designers, products, and services. Although we are most conscious of the designers themselves, they are supported by fashion illustrators, photographers, and models; textile, jewelry, and accessory designers; textile and patternmaking technologists; advertising, display, and exhibit designers; apparel production managers, fashion buyers, and merchandisers; showroom managers, advertising and communications specialists, fashion editors, and writers. Fashion design is a true team effort.

Fashion Designer

Fashion is a reflection of its time. Contemporary consumers come from a wide range of backgrounds and lifestyles, and fashion designers must consider this diversity when they create their designs. Apparel designers constantly ask such questions as: Who is my customer? How does he or she want to look? What materials and costs must be considered?

Some fashion designers have their own studio and staff; some are free-lance designers, selling their ideas and sketches; some work with limited lines of apparel, and others work for manufacturers who produce apparel for the mass market. Regardless of the type of clothing being designed, the process is quite similar. The inspiration behind the designs is what differs.

What does a fashion designer do?

All fashions begin as sketches. These may be original drawings done by a famous dressmaker, the ideas of an aspiring designer, or copy sketches that will be knockoffs of more expensive designs. Designers keep

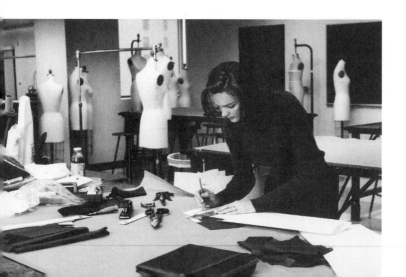

A fashion-design student spends many hours working in spaces such as this to design and construct fashion items that are personal statements and yet are viable in the marketplace. Courtesy Fashion Institute of Design and Merchandising. Photo by Brad Lansil.

extensive research files of photographs, magazine pages, tear sheets, and drawings of apparel designs. They study *Women's Wear Daily*, the trade paper that reports on current trends. They consult buyers and merchandising experts on developing trends, and combine this research with their own ideas in an attempt to come up with something new and different that will sell.

The fashion designer works out his or her ideas—for single pieces, matching items, ensembles, and the like—in detail on paper or computer. When the sketches or printouts are approved by clients or company owners, muslin samples are made on dress forms by craftspeople who work directly from the drawings.

When finished fabric samples are available, a price—based on the approximate number to be manufactured, the materials to be used, and the expected time involved—can be estimated. The samples are previewed by selected buyers and merchandisers from large store systems, or by the buyers who make up the company's or studio's clientele.

Prospective buyers suggest changes in the samples according to their knowledge of their own buying public. Any necessary changes are made, tentative delivery dates are scheduled, and tentative orders are taken. The apparel line is thus pared down to its best-selling items, and they are put into planning. Production starts when confirmed orders are in hand.

Production patternmakers measure each part of the sample and develop a pattern for the item in one basic size: 34 for women and 36 for men. From this basic piece, all the other sizes are measured and adapted. The finished patterns go from cutters, who may cut up to 300 pieces of cloth at a time, to sewers, who finish the work. Finished pieces are distributed to the stores that placed orders. Merchandisers and retailers take over the consumer research, completing the fashion cycle by advertising and selling the goods.

Free-lance designers and designers who operate their own fashion studio or boutique follow similar procedures, but work with a limited staff on a smaller scale. Their creations are often original in concept and design, and might only be produced singly or in very limited quantity. Such individually designed pieces are generally very expensive.

What qualities are helpful to a fashion designer?

Fashion designers must have a creative imagination and be ready to adapt to new ideas and styles. They enjoy clothing research and are avid observers of contemporary trends, fads, and ethnic influences. They are adept at drawing and sketching, and interested in color, textures, and surfaces. Fashion designers must work well with other people, meet deadlines, and accept and apply helpful criticism. Good communication skills, both visual and verbal, along with business skills are also marks of a successful designer.

What other careers require similar qualities?

All elements of the fashion cycle require people with similar personal qualities: intense interest in fabrics, colors, and textures, and in creating clothing that satisfies current tastes. Designers of sports specialty clothing and equipment work under similar competitive conditions (see Other Careers in the Fashion Industry, page 126). Interior designers have a similar interest in colors, textures, and materials (see Interior Designer, page 38). Teachers of family and consumer science must have a related background, training, and interest. Costume designers in theater, film, and TV require the same training, but generally have a stronger interest in period fashions.

What can you do now?

Take all the art courses you can: drawing, painting, sculpture, design, printmaking, and art history. Family and consumer science, English, and world and American history all have direct bearing on fashion design. Involvement with a school or community theater group may give you a chance to design costumes and period clothing, and to work with fabrics and colors. Part-time work in department stores or specialty shops can provide valuable insight and allow you to work with clothing, customers, merchandising managers, and display designers.

Magazines and trade papers will keep you up-to-date on fashion ideas and products. Look into publications such as those listed on page 224.

What schools offer necessary programs?

Most schools with a well-rounded art program offer courses in fashion design, and some have a strong emphasis in the field. Check the charts beginning on page 229. Schools near apparel-production centers often host visiting experts, arrange tours of plants, and offer part-time work programs as part of their curriculum. Although a college degree is not essential to becoming an excellent fashion designer, it assures employers of your substantial background and training, and will ready you for the competitive design regimen that faces every newcomer to the field.

Some of the fashions of the world's top designers are kept in museum collections. This ensemble by Rudi Gernreich is in the costume collection of the Fashion Institute of Design and Merchandising (FIDM). Courtesy Fashion Institute of Design and Merchandising.

Fashion Illustrator

Drawing the latest styles and fashion trends is one of the most popular and practical careers open to the artist specializing in illustration or fashion design. A quick look through any major newspaper will show that fashion illustrators are employed on the advertising staff of department and chain stores. Others work for textile companies, pattern houses, garment manufacturers, and design houses such as Donna Karan or Chanel. Some work for publications or for advertising agencies that handle fashion accounts. Still others are free-lance illustrators, called upon for seasonal work or special promotional programs.

The heart of fashion illustration is drawing the human figure. Illustrators must be able to show how fabrics fall on the body, whether they cling or stand

Fashion illustration in gouache by designer/illustrator Jane Wu. Courtesy the artist.

free, and whether they move with or against the body. The ability to draw figures in motion is essential. Some artists specialize in children's, women's, or men's apparel.

Fashion illustrators reproduce textures and patterns—the roughness of tweed, the translucency of chiffon—so that they are recognizable when printed in newspapers. They are familiar with current hairstyles, cosmetics, shoes, and jewelry, as well as seasonal sports, school activities, and ethnic influences.

What does a fashion illustrator do?

Typical fashion-illustration assignments follow a similar pattern, regardless of the agency or working situation of the artist. The advertising art director supplies a rough sketch layout of the proposed ad so that the illustrator will know how the page will look and where each illustration will go. The garment to be illustrated is modeled; the illustrator has the model move and stand in various poses. When the pose is decided upon, the illustrator sketches line and value to suggest the feeling of the clothes and the details. He or she then makes finished drawings for reproduction.

Illustrators use their design background to make final decisions about the arrangement of elements on the page. They get the maximum benefit from the space available. Most stores require a certain "look," or atmosphere, in all their illustrations; when this atmosphere is changed by store management, illustrators must be able to change their techniques and media accordingly. The finished drawings must meet newspaper and advertising deadlines and must attract the attention of potential customers. Illustrators do not design clothes; they present finished products to the public in an attractive way.

What qualities are helpful to a fashion illustrator?

In addition to a talent for drawing and painting, illustrators must possess taste, flair, and an understanding of current fashion trends. They must be able to meet deadlines, work well with other designers, art directors, clients, and advertisers, and be receptive to the ideas of others and adaptable to new concepts and techniques. A background in fashion, fashion history,

This illustration is an example of artwork produced for commercial sewing patterns. Pastel, charcoal, and colored pencil, 10 x 16" (25 x 40.6 cm). ©Kathleen K. McCarney 1998.

design, and composition, along with an understanding of the philosophy of advertising, foster the development of an illustrator's unique style.

What other careers require similar qualities?

Fashion illustrators might be interested in magazine and book illustration, fine-art painting, fashion design, merchandising, and teaching figure drawing or fashion illustration. Because product illustration requires the ability to draw well and quickly, that career might also be considered. Some phases of graphic design (such as quick sketching or concept illustration) and interior design (such as drawing and rendering) require qualities similar to those of an illustrator.

What can you do now?

Take drawing, painting, and sculpture classes. Use your sketchbook often: a consuming interest in drawing is the mark of a potential illustrator. Look closely at the techniques and styles used in fashion advertising in newspapers and magazines, especially *Vogue, Harper's Bazaar, Glamour, Mademoiselle, Town and Country* and *WWD*. Sketch such designs, and work with a variety of materials and techniques.

Part-time work in specialty or department stores will help you understand buyers' interests and fashion merchandising. Visit art schools and watch fashion-illustration classes in action. College courses that prepare you for a career in illustration are drawing, life drawing, fashion drawing, painting, photography, anatomy, fashion advertising, illustration, graphic design, color, and art history.

What schools offer necessary programs?

Schools that have a fashion-design department (check the charts beginning on page 229) offer a major in fashion illustration. The basic courses are similar to those in fashion design, but the emphasis is on drawing and illustration techniques and skills. Some trade schools offer courses in basic fashion illustration. A degree in fashion illustration will show prospective employers that you have substantial training and experience in both fashion design and illustration, and are competent at drawing, design, and the mechanical skills necessary for quality illustration.

Other Careers in the Fashion Industry

Accessory Designer

Accessory designers work with many materials to provide accent for fashions. They generally work for the companies that manufacture the products, but many are free-lance designers. They sketch, design, and supervise the basic models for accessories such as purses, neck ties, belts, shoes, pins, necklaces, scarves, and stockings. They usually have a strong background in fashion design.

Active-Sportswear Designer

The vast field of sports clothing is a special-interest area for designers. Clothing for skiing, cycling, hiking, in-line skating, and numerous other games and activities must be designed to meet specific requirements and provide any necessary protection.

Organized sports such as hockey and gymnastics also require specially designed equipment and clothing. Designing for these special areas requires a thorough knowledge of the sports and a background in materials, fashion design, and sports safety.

Fashion Art Director

The fashion art director is a staff member of an advertising agency, department store, or magazine, and is responsible for the production of ads for stores, malls, or manufacturers who produce fashion items. He or she must work with photographers, models, and illustrators, and must have a solid background in graphic and fashion design.

Fashion Consultant

Fashion consultants are employed by department stores and specialty shops to offer advice to individual clients and store personnel. They are trained in fashion design, coordination, and merchandising. Some consultants are free-lance specialists who work for several stores or individual clients who rely on their expertise and fashion knowledge.

Fashion Copywriter

Fashion copywriters write ad copy that appears in magazines and newspapers and on TV. They work for advertising agencies, department stores, or specialty shops and malls, and can write effective copy for the promotion of men's, women's, and children's clothing, as well as for accessories and related fashion products.

Fashion Curator

Fashion curators are specialists who work for museums, foundations, or historical societies, and are expert at restoration, preservation, and identification of styles and fabrics. They might also be in charge of historical costume displays at the institution that employs them.

Fashion Director

Fashion directors, or fashion coordinators, are employed by stores and work with apparel buyers to give a unified look and tone to the store's lines. They promote the image of the store by producing fashion shows and arranging for special promotions. They are aided by publicity directors who have a strong fashion background. Some fashion directors are responsible for photographic coverage in newspapers and magazines.

Fashion Editor/Writer

The fashion industry and the buying public are kept up-to-date on what is happening in the fashion world by editors and writers who work for fashion magazines or write fashion material for other magazines or newspapers. They travel to show openings, review current trends and styles, work with photographers to develop feature articles, and inform their readers of fashion developments and industry events. They have a strong background in fashion design and merchandising and are articulate about clothing, accessories, and design.

Fashion Merchandiser

Although fashion merchandising has little to do with design and art, it is an important link in the fashion cycle. If goods are not sold, the system breaks down. Fashion merchandisers are buyers, fashion promoters, directors, department managers and salespeople, merchandise managers, personal shoppers, inventory-

Students learning about fashion photography on location in Santa Barbara. Photo by Paul Meyer.

control workers, copywriters, display designers, and consumer-relations officers. Many of these careers are best served by a fashion-design background, but others require a fashion merchandising emphasis in college.

Fashion Photographer

(See page 94.)

Fashion Specialist

In addition to display directors and fashion coordinators, there are several other specialized fashion careers. Bridal consultants plan and coordinate wedding clothing and accessories. Fashion stylists prepare models for fashion shows and photographic shoots; they work with art directors in planning wardrobes, accessories, and makeup.

Patternmaker

Patternmaking technology requires knowledge of the principles on which commercial garment sizing is based. With the use of an industrial software program, original design ideas are transformed into muslin and paper patterns in a basic size from which a sample garment is made. These samples are reviewed and refitted, and adjustments are made. The resulting pattern serves as a manufacturing standard. Related careers include pattern drafter, pattern grader, supervisor, production executive, and production manager.

Textile Designer

Textile designers can be classified into three groups: weavers, surface designers, and related designers and artists. Most work for manufacturers, designing and supervising the production of finished materials. Some are free-lance artists who design and produce fabrics for sale to manufacturers.

Weavers construct cloth on looms, and often work from their own original patterns. They may work on hand looms, but more often they design patterns to be woven on commercial looms. Their fabrics are woven quickly and in large volume.

Surface designers create patterns that are printed on existing fabrics. The printing may be silkscreened or block printed by hand or by machine, depending on the quality and quantity desired by the manufacturer.

Some textile designers also create wallpaper, linoleum, and floor-tile patterns. These artists also design rugs, decorative upholstery fabrics, writing paper, towels, linens, and other patterned surfaces.

Theater/Costume Designer

(See page 148.)

Visual-Merchandising Designer

These specialists design window and store displays that draw attention to fashion ideas and featured styles. They work with promotion experts, merchandisers, and department managers in selecting apparel and accessories for displays. They are expert at display techniques, lighting, use of mannequins, the draping of materials, and three-dimensional and graphic design. Their displays set a tone in the stores and are often coordinated throughout a store system. They work with other store-display artists to coordinate seasonal and topical promotional programs.

Entertainment Design

part four

Entertainment Design

We love to be entertained, and artists working in various areas of entertainment design shape the visual imagery of our cultural environment. Their importance is so great that Oscars, Emmys, and other awards are given to designers who make outstanding contributions to our world of entertainment. The economic impact of the film industry alone is staggering, and in a great part is due to the visual effects generated by creative designers.

When you are fascinated by the special effects in a film, intrigued by the graphic effects in a TV commercial, or awed by the stage set, lighting effects, and costumes of a Broadway play or other stage production, you are sensing the impact of these product designers. Through their efforts and expertise, our lives are richer and our entertainment is visually more stimulating.

Our entertainment experience has been broadened by the design and construction of theme parks with incredible rides that often include stunning special effects. The imagineers and designers who conceive and bring these to reality are part of the entertainment-design field.

My love affair with

animation has not ceased . . .

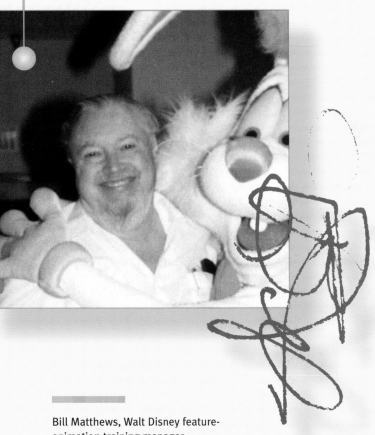

Bill Matthews, Walt Disney feature-
animation training manager

Professional Insight

Bill Matthews

I've loved animated films all my life, and like most of us grew up on cartoons. When I first saw Walt Disney's *Fantasia*, I knew that I wanted to spend my life working on such wonderful creations. For forty years I have been involved in working with the Disney animation studios, developing animated sequences for NASA, building a professional-level animation program in Toronto, Canada, and setting up a talent scout program for new artists interested in animation.

Interest in animated films has spawned many competitors and has raised the caliber of talent required to enter this demanding but rewarding industry. There are also opportunities in television (commercial advertising, music video programming, television specials, and children's programming) and related fields (interactive video, computer games and CD-ROMs, travel films, industrial, educational, religious, and medical films). Opportunities abound in these as well as other areas of the entertainment industry.

Careers in animation must necessarily emphasize strong drawing skills. Master the ability to draw the human form from live models, as it will help you draw and paint better, design and sculpt better. Because animation is a *moving art form* involving multiple images that recreate real life movement, you should be sketching loosely and quickly, animals and human beings in the act of movement. Figure drawing and rapid sketches are the two types of drawings that animation studios and producers will study before hiring you. Your portfolio should also contain samples of your painting and design skills, anything that shows your imagination. Good art schools which emphasize the importance of drawing, and which employ leading professional artists on their faculties, will give the necessary direction, inspiration, and one-on-one guidance that every future animator really needs.

My love affair with animation has not ceased and the more I see each year of the new artists, the new expressions they're creating, and the growing demand for more good artists, I know we will enter the new millennium with great anticipation of what's next for the development of animation."

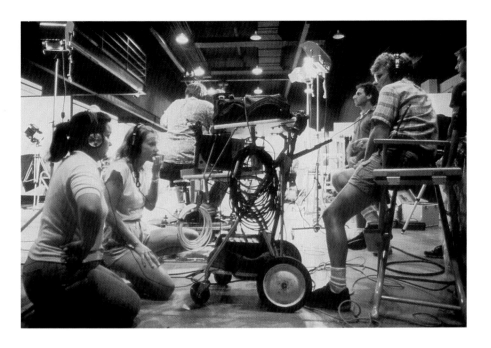

Film careers begin in art schools or universities, where classes prepare students to understand the problems of the work environment. Film students at Art Center College of Design learn to direct, edit, light, write, and produce films. Photo ©Steven A. Heller, Art Center College of Design.

Film, TV, and Multimedia

The entertainment industry is one of the fastest growing segments of our national economy as we move into the twenty-first century. Career artists, photographers, directors, and designers of various kinds are playing major roles in this development, often working together with directors and producers in unprecedented cooperation.

While Los Angeles and New York continue to lead the world in film-career opportunities, many other states have provided locations for soundstages and production facilities that employ thousands of artists of all types. Work on film is exploding because of the global demands for Hollywood's products. Construction of fourteen sound stages in Manhattan Beach, California, provides work for 1,800 film-production people, even as Virginia, Arizona, North Carolina, and Ontario, Canada, are building similar projects to lure film companies to their state or province.

The TV industry does not necessarily require huge soundstages, natural sunlight, or the accompanying satellite industries that film usually demands, and TV-career opportunities are available in most major cities around the country. With the fantastic growth of the cable industry, interactive TV, and other TV-related industries, there is great need for graphic designers, photographers, computer-assisted-design specialists, and digital designers.

More and more artists are becoming involved with setting the tone and developing the designs that tie productions together. Film artists and technicians are now judged by their abilities in areas such as motion graphics, graphic design through time, computer-oriented art and graphics, and work in expandable fields of art such as special effects, visionary magic, and animation.

College curricula for career preparation in film, TV, and multimedia include such courses as set design, quick sketching, color rendering, animation techniques, production techniques, digital design, sound recording, film writing and photographic communication, painted film, virtual space exploration, invisible effects, and illusions of reality. Careers in film, TV, and multimedia require a specialized art background.

Film Artists

Even though Oscars are awarded to honor top figures in every aspect of filmmaking, it is through incredible cooperation and coordination of many gifted people that effective films are created and produced. Fine film is an art form, and many film careers are based on art and design backgrounds, as a look at some of them will verify.

What do film artists do?

Producers coordinate the work of all the people working on the film. They are responsible for the budget and schedule. They read scripts, set the tone for the production, and are responsible for the successful daily operation of the cast and crew.

Directors head the production team and shape the film by translating the script from pages of type to moving images. They rehearse the cast and guide the actors in their portrayal of the film's characters. They are responsible for scenery, lights, props, and equipment. They call in special-effects people when needed.

Cinematographers work closely with the director on the interpretation of each scene. They find sets, scenes, locations, and moods that will underscore the purpose of the film. They direct the *photographers*, working with framing, lighting, composition, and exposure to achieve the desired effects.

Art directors are responsible for the overall look and design of the film. They work with the producer, director, cinematographer, and costume designer to create the right historical and architectural style for sets, costumes, and scenic backgrounds. They look for appropriate locations and supervise the development and construction of sets.

Set designers make scale drawings of sets and scenic backgrounds, and often illustrate scenes and buildings with paintings or models. The miniature sets can be filmed for backgrounds, titles, and special effects. Set decorators determine the appropriate furnishings—such as draperies, pictures, and rugs—for film sets. They and their assistants place props, and check that cameras are not obstructed.

Costume designers outfit the actors in the pro-

duction. They may design and create costumes or rent them from costume-supply houses. They study scripts and conduct research to determine the styles of clothing needed. They must be available on set to check costumes and deal with last-minute changes.

Special-effects artists combine story lines with digital multimedia art to produce incredible film images. These computer artists often specialize in action films and intense dramatic presentations, creating scenes and events that are difficult or impossible

Well-designed costumes are an important part of successful feature film productions, particularly when period dress is required. A Fashion Institute of Design and Merchandising student, majoring in costume design, displays a finished project by wearing her design. Courtesy FIDM. Photo by Humphrey.

to film otherwise. For example, a burning airplane or an incredibly violent tornado can be provided by these multimedia artists without leaving their studio. (See page 138.)

Film editors work with producers and directors to view film every day and painstakingly edit to achieve the final version of the film. They are responsible for the correct sequencing in the film, and also oversee completion of the music and sound effects.

What qualities are helpful to film artists?

The two most important qualities are patience and perseverance. But film artists must also be ready to work when called upon (realizing that layoffs are part of the industry), like to work under pressure, and work well with others. These artists stay abreast of current trends in filmmaking and enjoy doing research. Because they must have a full understanding of the film they are working on, they must be creative and imaginative thinkers, able to solve problems quickly and decisively.

What other art careers require similar qualities?

Book editors and illustrators in the publishing industry and set designers and costume designers for the stage require similar qualities. Fashion designers, interior designers, graphic designers, and photographers work with similar interests and directions. Special-effects artists working with digital design and multimedia applications can move directly into CD-ROM or virtual reality game design, TV graphics, and other multimedia applications in industrial design and other fields.

What can you do now?

Study the set design, costumes, special effects and graphic presentation in films. Sign up for photography, set-design, film, drawing, painting, and sculpture classes. Work on plays with theater or school groups. Learn about lighting, costumes, set design, and computer graphics. Read about the film industry in trade journals (*Variety, Hollywood Reporter,* etc.). If possible, visit Hollywood and tour the studios.

What schools offer necessary programs?

Educational needs vary with the jobs. A bachelor's degree in liberal arts is a good foundation, and many colleges, universities, and art schools offer programs in cinematography, filmmaking, theater, film arts, and design. Many of these programs provide hands-on experience with equipment and the basics of film and stage production. Check the charts at the back of the book for schools with film programs; study catalogs or Web sites to determine whether the school specializes in your field of interest. Schools located near film studios might offer the added opportunity to intern in studio situations.

Film Animation Artist

An animation studio can be viewed as a 400-piece "visual orchestra"—with sections in animation, layout, storyboarding, and other specialty areas. Each section, or artistic department, adds its special "sound" to the visual orchestration we call an *animated film*. Therefore, there are many career paths associated with the animation field.

Aside from the artists listed here, there are producers, directors, voice actors, editors, track readers, and a myriad of other technical, support, and administrative personnel needed to facilitate the creation of an animated film. If you aspire to be an animation artist, remember that all of the departments that rely on visual artistry are built on the bedrock of classical drawing ability—solid, traditional drawing skills.

Youthful new talent is always needed in the animation industry. To illustrate the demand for current and future designers in digital animation, consider this: as this book is being prepared, the Walt Disney Studios in Burbank are searching for and trying to recruit 200 digital animators.

What does a film animation artist do?

Visual-development artists work with writers, directors, and studio executives to develop a variety of interpretations of scenic designs, settings, and animated-character designs to create the visual look of a film. These talented and creative artists must have skills in design, composition, story, color theory, quick sketch, life drawing, and rendering.

Storyboard artists create a visual script of small, sequentially staged drawings of each scene in an animated film. The storyboards they create determine the pacing, timing, and sequencing of the action in a story. A storyboard artist's skills and abilities include storytelling, acting, humor, drama, staging, cinematography, life drawing, and quick sketching.

Layout artists render the scenic designs that will eventually be painted by background artists. Working from storyboards and story sketches, they unite camera angles, perspectives, camera movement, values, textures, composition, and lighting to create the "stage" on which the animated characters per-

form. The artists have a strong background in drafting, composition, design, staging, and cinematography.

Background painters work from a layout drawing and create detailed backgrounds that will serve as the "stage" for animated-character performances. They have well-developed styles, skills, and techniques in a variety of art media.

Animators are a versatile combination of drafter and actor. Animation is acting that is drawn. The animator uses his or her special talents to create a wonderful characterization with a life of its own. An animator's many skills include life drawing of both humans and animals, animation mechanics, acting, timing, and the ability to breathe expression, attitude, and personality in powerful yet simple drawings.

C.G.I. animators (Computer Generated Imagery animators) have a unique blend of artistic talent and technical computer expertise. They create textures, effects, props, and environments, and also put life into characters and objects. They have a mastery of design, animation mechanics, composition, color theory, drawing, and painting—and of the computer as an artistic tool. Their job description could be "an animator who happens to use a computer."

Clean-up artists take the rough sketches of character "acting" from animators and render the final images seen on the screen. Clean-up and in-betweening artists use their thorough working knowledge of animation mechanics, timing, and drafting in order to render sequential drawings of exacting proportions.

In-betweening artists supply all the animated-character artwork between the major drawings of the animators. They complete the sequences established on storyboards and by clean-up artists. They must know animation mechanics and be able to note subtle changes in movement, direction, and facial features.

Effects animators bring objects and phenomena to life on the screen. Their work adds drama, mood, and excitement to the action, as well as enhancement of the story and the adding of dimension to the characters. An effects animator has skills in animation mechanics, timing, drawing, and painting, cinematography, design, and composition.

Only in the digital realm can Michael Jordan give a locker room pep talk to "animated" fellow athletes. Film still from *Space Jam.* © and ™ Warner Bros., 1996.

The Warner Brothers animation department.
Photo by Gerald Brommer.

What qualities are helpful to a film animator?

Dave Master, director of artist development and training for feature animation at Warner Brothers, says that one of the most frequently asked questions by educators, students, and artists is "What skills are needed for a career in animation?" The answer is as varied as the individual career paths within the art form itself. Although the basis of all parts of the art of animation is drawing ability, there is room for a variety of skills. Film animators must be able to draw, have a mastery of the processes involved, and work cooperatively to create a unified product. Patience, self-discipline, and the ability to meet deadlines and work for an extended time on a single project are also demanded. Animators must have a keen sense of design, color, and observation, and be able to follow the instruction of art directors.

What other art careers require similar qualities?

Technical, editorial, or fashion illustration, or a career in the fine arts such as painter, would be an appropriate pursuit for someone with an interest in film animation. Teaching animation is a good choice, too. Careers in entertainment, such as game designer, multimedia artist, continuity artist, scenic artist, or set designer would also be enjoyable.

What can you do now?

Sign up for all the drawing and painting classes possible, especially figure drawing from life. Classes in cartooning and design, art history, history, English, music, and literature provide an excellent background.

Study figures and backgrounds in all kinds of animated features. Draw figures, storyboards, and backgrounds in your sketchbook. Develop your own characters and ideas as you go along. Prepare a portfolio strong in drawing skills. Contact professional animation studios to get an idea of their specific portfolio requirements.

What schools offer necessary programs?

Schools near animation centers (New York, Los Angeles, and Toronto, for example) provide the necessary classes and background. Animation instructors generally have had practical experience in studio work. The schools might also give you the chance to visit animation studios and have animators visit your classes.

Individual studios have their own way of doing animation and using computers in their work, and some have special training programs for such purposes. After obtaining catalogs from schools or gleaning information from their Web sites, visit several to see what kinds of animation work are being produced. Digital animation is essential in the industry, often in combination with traditional animation techniques.

Game Designer

A career which is a true blend of artistic ability and technical expertise in the electronic realm, is that of game designer. As is true of many art careers, a game designer is likely to be a member of a team of creative individuals who work together for a common goal. New forms of electronic games are continually being developed and marketed. Game designing is a highly competitive field.

What does a game designer do?

A game designer plans, researches, and builds scenes, action, and characters to form a unique type of inter-active electronic entertainment. The design may be for games to be played in an arcade, on a home entertainment system, or in a portable hand-held format.

What qualities are helpful to a game designer?

Designers use a variety of software to develop and produce games, yet a solid art background is a key element for success. An understanding of three-dimensional space is critical. Intelligence, imagination, and patience are essential, as is the ability to focus on long-term projects. The ability to master complex computer programs, and desire to keep up to date with new technology are of extreme importance to anyone planning a career as a game designer.

What other art careers require similar qualities?

Special effects artists for film and television require similar qualities. Graphic artists of all kinds, and industrial and product designers, digital designers, multimedia artists, or film animation artists require a solid art and computer background. Those who are skilled in two-dimensional design may expand their abilities to the three-dimensional realm, especially in career areas such as model building, stage design, and virtual reality.

What can you do now?

Study electronic games, and film and television special effects and animation. Take all the art and design classes you can, particularly figure study and industrial design classes. Become proficient at a variety of computer programs, including those with three-dimensional rendering and those with action sequencing. Graphic design, technical drawing, a background in architecture, and video production skills can be useful in the game design field.

What schools offer necessary programs?

Schools with both an excellent art program and an outstanding computer program provide the necessary background for a career as a game designer. Engineering classes are an advantage as well.

Using 3-D animation programs, computer artists have the opportunity to create imaginary vehicles, creatures, and environments. Les Nelken, *Still Frame from 3-D animation*, 1998. Digital image courtesy the artist.

Playing Games: Serious Business

A flying snail helps save the world's animals; space explorers are kidnapped to an alien planet; a biker must reveal a murderer; a dog and rabbit scour the country for a missing Bigfoot; mutant tentacles threaten to take over the world; the Empire must be prevented from ruling the galaxy; and potent treasures must be kept out of the hands of the Nazis. These are a sample of the diverse stories brought to life by LucasArts Entertainment Company, one of the foremost companies in the United States when it comes to electronic game design.

The company's breadth of titles includes original concepts, as well as games based on the Star Wars and Indiana Jones properties. LucasArts strikes a balance between storyline, interactivity and technology in its games. To accomplish this, the company fosters a creative and supportive "organic" development environment in which designers have the freedom and resources to pursue their own game ideas.

With the artists in LucasArts' substantial in-house department specializing in fields as diverse as fine arts, traditional animation, graphic design, technical drawing, architecture, and video production, the company's games benefit from a great variety of art talent. LucasArts has pushed the boundaries of two-dimensional animation, three-dimensional graphics, motion capture, and live action in games.

Use of "off-the-shelf" software is the exception, rather than the rule, at LucasArts. To make the best games possible, the company is constantly developing new game engines and other technologies. Examples include SCUMM (Script Creation Utility for Maniac Mansion), and INSANE (INteractive Streaming and ANimation Engine). LucasArts integrates these engines to create titles with diverse gameplay.

LucasArts also uses its own patented interactive sound system, iMUSE (Interactive MUsic and Sound Effects), which allows a game's music and sound effects to respond smoothly and spontaneously to unpredictable player choices. This gives each game's musical score the quality and importance of a film score—creating pace, setting mood, building suspense and paying off dramatic moments. Real bands, orchestral scores and custom-designed sound effects highlight games. An internal team of composers/sound designers creates fully digital soundtracks for LucasArts' games.

It's evident that game design requires a team of serious players in order for a successful product to be brought to market. One of those players at LucasArts Entertainment Company is Garry Gaber, currently a co-project leader for *Star Wars: Force Commander*, an interactive strategy game. He describes his duties as being "responsible for a team of talented artisans that are putting the game together."

Gaber graduated from New York University with a degree in cinema production. He majored in film, with a minor in psychology.

Prior to his involvement at LucasArts, he worked for several years doing CAD (computer aided design). Gaber kept his focus on learning, becoming adept at working in a photorealistic world and eventually gaining jobs in the industrial end of design previsualization.

What's a typical day like for Gaber? "On any given day, I might be creating art, game designing, editing the script, discussing missions with level designers, or critiquing a composite for one of the cinematic sequences. In other words, I'm usually really busy, but not on any one task. It is exhilarating and tiring, all at the same time." When asked what he enjoys about his job, Gaber replies, "everything."

Being a member of a design team clearly has its positive aspects, as well as its challenges. At LucasArts, it's all part of serious fun.

—**Courtesy LucasArts Entertainment Company LLC, 1998.**

Digital Designer / Multimedia Graphic Artist

Designers who work on complex images, combining several separate elements in a computer, are working in the realm of *multimedia*. Such designers combine digital images, video, sound, other visuals, and special computerized effects. There is no layering of elements: all images and sounds are completely integrated, so the results are first-generation images, not copies.

The film industry uses multimedia-production techniques to design backgrounds, computer-built aliens, and other special visual effects. Stampeding dinosaurs, an inferno of exploding fuel, or a deceased president shaking hands with a contemporary actor are all the work of digital and multimedia designers. A variety of software programs and powerful computer systems linked together are required to build complex multimedia imagery.

Digital animation, for all of its technological complexity, begins with a simple story-board, hand drawn on paper. Courtesy the Technology Development Center in Ventura, California.

Not only the entertainment industry uses the graphic images developed by these designers: forensics, manufacturing, the medical industry, architecture, and airplane and automobile design (see page 114) are making increased use of digital technology. Because incredible detail is possible and alternate views of objects, people, or scenes from any angle are available, this technology has changed the way we perceive the designed world around us.

What do digital designers and multimedia graphic artists do?

Designers work on commercials, feature films, advertising, and digital graphics. They utilize two- and three-dimensional modeling and animation, video editing, and post-production techniques. The work of a multimedia graphic artist can range from enhancing live-action scenes to digitally creating entire scenes. They use a variety of software in developing their complex imagery, yet they are much more than technicians. They are artists who use computer monitors as their canvas. They sculpt images by altering lines and curves, and by manipulating light and shadow.

Those in charge of hiring designers for studios and multimedia companies comment that the portfolios of many digital-design applicants indicate computer skills but a lack of artistic skills. Both sets of skills, however, are essential for designers to succeed in the digital world.

What qualities are helpful to a digital designer?

Digital designers are intelligent, imaginative, and creative, and they can focus on long-term projects. They are accomplished in the use of sophisticated imaging software, enjoy working alone at their computer, and are intrigued by changing technology. These designers communicate easily with team members, can draw well, and have a solid design background.

What other art careers require similar qualities?

Nearly any design field requires the qualities that are helpful to digital or multimedia artists. Graphic design, product design, technical illustration, and any entertainment-oriented design such as careers in film

To prepare this animation sequence, the artist drew the trestle and train separately on his computer. Viewing angles, color, texture, and movement were then manipulated. Courtesy the Technology Development Center in Ventura, California.

or theater may interest a multimedia or digital designer. Model building, theme-park design, lighting design, and Web-site design are all possibilities.

What can you do now?

Take all the art and design classes possible, as well as computer classes. Draw, sketch, and develop design ideas into a portfolio. Build models or practice sculpting various materials to enhance the ability to conceptualize in three dimensions.

Study and become proficient in a variety of software, especially that related to video editing and special visual effects. Learn about hardware and the compatibilities of equipment. Contact professionals in the field for their advice as you proceed.

What schools offer necessary training?

Because the best candidates for success in the digital world have both computer skills and art skills, schools that have a good computer program and also excellent art and design programs are best to attend. Because the quality of the programs varies from time to time and is based on available equipment, investigate the schools in person; see what students are producing before you choose a school. Catalogs and Web sites may provide information, but a visit will give you a feel for the school's focus. Often, technology centers provide excellent up-to-date equipment and have direct ties to studios and industries that employ digital designers. They also often employ experienced professionals as teachers.

How to Develop Inspired Results

Intuition and concept are equally important aspects of a digital media education. The supreme editability of the digital medium encourages risk and experiment—the intuitive component. The ability to add "intelligence" to digital objects encourages the development of sophisticated concepts as well. Inspiration is the result of understanding the interaction between the two.

**—Michael Fuller, Director of Admissions,
Otis College of Art and Design**

Other Careers in Film, TV, and Multimedia

Advertising Agency TV Art Director

Ad agency TV art directors specialize in TV commercials and direct the use of print art, live action, animation, and digital techniques. (See Advertising Agency, page 62.)

Background Artist (Scenic Designer)

Background or scenic artists design and paint the visual environments against which soundstage action is filmed. They paint on huge canvas backdrops and after research, can simulate nearly any scene or interior. Much of this work is done on computers. A similar position exists for theater and stage work (see page 144), and some artists adapt their skills to create scenes for both film and theater.

Cameraperson

There are many types of camera positions in the film and TV industries, and all require training in film techniques, production, and design.

CAMERA OPERATOR: This person works both indoors on soundstages and outdoors on location, following the instructions of the director and cinematographer.

TV CAMERAPERSON: TV stations have a hierarchy of jobs for camerapeople. Photographers work with video tape as well as film, but their understanding of light, shadow, color, and design must be thorough. In some areas, such as news taping, speed and accuracy are more important than excellence of design. The work of the video specialist includes minicam operation, film and tape editing, electric news gathering (E.N.G.), photographic editing, and in-studio camera work.

CINEMATOGRAPHER: See page 132.

Continuity Artist

Continuity artists take scripts and break them down for shooting. They sketch possible scenes so that directors can envision them. Where special effects are involved, they sketch sequential scenes leading up to the major scenes. An average film involves 1,500 such sketches, which help convey the necessary mood and feeling of the film.

Costume Designer

(See pages 132, 148.)

Film Editor

The work of film editors starts after shooting is completed. They take all the footage and edit, splice, rearrange, and complete the final product. They are responsible for the "feel," pace, and continuity of the production and arrange all the parts of the film in cohesive fashion. (See also page 133.)

Since all digital media share a common toolbox, the converse is also true: a basic education in those shared tools leads in many directions. Individual students' approaches lead to an astonishing variety of careers, from digital animation to site design for the World Wide Web. Pictured is a digital media class in the Mac lab at Otis College of Art and Design. Photo by Ave Pildas.

Makeup Artist

Makeup artists, whose skills are based on a background in theater and sculpture, are responsible for the facial appearance of all actors in a production. They age young people, create monsters, and are expert at making beards and mustaches. They use rubber, plastic, and clay to produce miraculous results for film and video productions. They might work for hours on a single actor before he or she appears before the cameras.

Model Builder

Model builders are craftspeople who can build anything to scale. They use wood, plastic, cardboard, plaster, clay, glass, and natural materials to construct any structure or object that a script requires. They build some models to be destroyed; they build others to be used many times. Model builders have a background in stage and set design and construction, sculpture, special effects, carpentry, and metalwork.

Scenic Artist

(See Background Artist, above.)

Set Designer

(See page 132.)

Storyboard Illustrator

Storyboard illustrators work for large advertising agencies or film companies, or are hired on a freelance basis. They take rough sketches from art directors and develop them into finished sequential drawings for presentation to directors or clients. These drawings illustrate the action and direction of the film or video. Appropriate dialogue is scripted under each drawing in the series, which gives directors and clients an idea of how the tape or film might look before any money is spent on production.

Creativity: An Essential Focus

As a chief executive of a technology company that thrives on creativity, I want to work with people whose imaginations have been unleashed and who tackle problems as challenges rather than as obstacles. An education enriched by the creative arts should be considered essential for everyone.

—John Scully, former chairman and CEO, Apple Computer, Inc.

Theme-Park Designer

All the rides, booths, shops, environmental-graphic design, and vistas in theme parks must be designed by a variety of artists. The chief designer relies on art specialists such as creative designers ("imagineers"), landscape architects, environmental graphic designers, urban designers, architects, graphic designers, digital designers, background artists, and mural painters. Cooperation is essential among these artists and designers to produce a coherent and exciting venue filled with games, rides, concessions, parks, shops, walkways, and hotels.

Title Designer

Title designers are the graphic artists who design the hundreds of titles used at the beginning and end of TV programs and films. Some titles are animated; others are photographic; but all contain type, names, titles, and graphic effects. Many title designs are the products of top national graphic-design studios, and others are created in the graphic-design studios of small TV stations.

Web-Site Designer

(See Other Careers in Graphic Design, page 70.)

...there are a myriad of theatrical design jobs that haven't even been thought of yet.

Ron Husmann, actor, stage historian, and director

Ron Husmann

The Theater is dying

The Theater is dying

The Theater is practically dead

Someone each day writes

We have no more playwrights

The theater is sick in the head

—excerpt from lyrics by Sheldon Harnick, circa 1950

The above was true in the fifties and is probably more so today. However, there are all kinds of jobs for theatrical and stage design in the broader world of "show biz" including: computer graphics, Las Vegas-style scenic designs, theme park set design, and stage sets for legitimate theater on Broadway and in a variety of theaters and playhouses across the nation.

While there are fewer major legitimate theater productions being produced, both musical and non-musical, the trend is heavily weighted toward elaborate sets and costumes. With orchestra ticket prices on Broadway skyrocketing, audiences are demanding visual effects, even in one-set plays, that justify the price.

This same trend toward higher prices is raising the visual expectations of legitimate theater audiences even in the smaller civic productions across the country.

So, while there is less legitimate theater design, there are "theatrical" design-type opportunities springing up all over the world, involving new technologies and new forms of popular entertainment.

So, broaden your sights and look to your creative imagination. Don't think you can ignore technology; be inquisitive, take appropriate courses, and use your own ideas to create new art areas. I am absolutely certain that there are a myriad of theatrical design jobs that haven't even been thought of yet.

Not all theater takes place in an indoor setting. Based in San Francisco, Wise Fool Puppet Intervention combines giant puppetry, masks, stiltdancing, costumes, music, street theater, processions, installations, and celebrations. *Hope Puppet*, final tableau from the street theater piece *From My Window: A Folk History of Tenderloin*, 1996. Courtesy Wise Fool Community Arts. Photo by David Levingston.

Theater and Stage Design

Drama and theater had their beginnings in Greece in the fifth century BC, and their basic elements have remained constant over several thousand years. Architects are concerned with the structure, seating arrangements, and physical construction of the performing areas; art directors, directors, and stage designers create the sets and scenes that are the environment of the staged action.

Stage productions, whether on Broadway or in a high-school gymnasium, are the collaborative effort of actors, directors, stage managers, stage technicians, and the designers of scenes, sets, costumes, and props. Musical productions (opera, light opera, musical comedy) involve all of these people, plus singers, soloists, dancers, choreographers, musicians, and conductors.

Theaters have always included stages or performing areas and auditoriums or areas for the audience. Theater of ancient Greece, Shakespeare's era, or Japanese and Chinese tradition is performed on a platform surrounded by the audience on at least three sides. European and American theater is "illusory" in that the audience, separated from the action by a curtain or proscenium, watches performers on a raised and lighted stage; the actors usually perform their lines as if the audience is not there. The design and preparation of the stage is the realm of the scenic designer. His or her job is to make the elements on the stage seem real and convincing, or to suggest a particular scene to the audience.

Theater areas that directly involve career artists are scenic design, stage lighting, scene painting, property design and construction, costume design, and makeup. Visual artists in these areas are responsible for the sense of place in the play, the mood, the authenticity of effects, clothing, arrangement of props, and overall visual impact of everything on the stage. They coordinate their efforts with directors, stage managers, actors, and sometimes, the playwright.

Whether the action of a play is set in 2099 or in 1599, all the visual artists involved

must research their special area to make the final product as authentic as possible. This may involve buying or building furniture; securing or designing and sewing clothes; and finding rugs, furniture, and accessories from that period—or building and painting them to match actual items.

The world of the theater is a fascinating place for a visual artist who also has a strong interest in theater and drama. Regardless of size or style, theatrical performances rely on visual artists to complete the illusion begun by the playwright.

Scenic Designer

The responsibility for creating settings for plays, musicals, and operas has traditionally been handled by fine artists, scenic artists, and skilled artisans not schooled in theater arts. Today, however, most scenic designers have training in both theater and art, making them eminently qualified for the complexities of their work. Since the 1950s, the separate entities of carpentry, painting, and property and drapery shops have been unified in single scenic departments in many major American cities. Some resident theaters also maintain their own combined shops.

Stage scenery has run the gamut from highly elaborate Victorian decoration to minimal sets; from contained areas on a single platform to multiplatformed stages where wings, aprons, elevators, and rotating sections are used. Stage lights are sometimes hidden, sometimes exposed, and designers take advantage of every possibility to bring excitement to the stage. With the high price of tickets today, theatergoers expect spectacular stage sets. Some critics have said that the set is not only a major part, but actually the star of certain productions. Scenic designers often take part in the initial planning of a production because their work is such an integral part of the total effort.

What does a scenic designer do?

After reading the script, a scenic designer meets with the director to develop an overall plan for the production. Sketches are made and expanded into color renderings or scale models that become the basis for set construction. Dimensions, cross-sections, and floor plans are provided to set-construction workers, to ensure careful adherence to the designer's plans. Research on clothing, furniture, windows, doors, light, and accessories is necessary to create the desired visual atmosphere.

Staging calls for three-dimensional construction, and shops usually contain all the necessary equipment for production. Because steel is used in most sets, metalworkers are as important as carpenters on the production team. Plastic, cast in any desired shape, is finished to look like wood, metal, fabric, or stone. Furniture is bought or made by staff carpenters, and props and accessories are acquired. Gradually, the ideas of the scenic designer become reality, and the parts are ready to assemble. Everything is brought to the stage, tested, and put in place.

Traditional stage-construction techniques are still widely used, but scenic designers also experiment with new ways to use patterned lighting, electronic and computer technology, and hydraulic systems. Many playhouses use an open stage, an arena formation, and flexible-platform construction.

What qualities are helpful to a scenic designer?

Scenic designers can be viewed as a merger of historian, architect, sculptor, painter, antiquarian, poet, carpenter, electrician, and engineer—and actor. They must be able to develop and react to new ideas. Because they get their ideas from scripts and from history, they must enjoy reading and doing research. They must work well with others: they are only one part of the team. Because of time and space restrictions, they must have management skills and be able to work under deadlines. Creativity, intelligence, enthusiasm, and energy complete the picture of the successful scenic designer.

What other careers require similar qualities?

Any aspect of the theater arts will appeal to those interested in scenic design; they would enjoy a career in costume design, lighting, set painting, and perhaps acting. They could work in any of the similar positions in TV and film studios. Interior design might also be appealing. Designing large floats, working in property shops, teaching stagecraft in high school and college, and building period furniture require the same training and qualities needed by scenic designers.

What can you do now?

Take courses in art history, drawing, painting, and three-dimensional design. History and literature classes are also important, as are courses in drama and stagecraft. Wood and metal shop classes provide practical experience in construction techniques. Try to work on local plays and musical productions doing lighting, set design, set painting, and the like. Attend as many plays as possible, and study the design and construction of sets and their connection with the theme of the production. Read plays, design sets, build models, design costumes, and make layouts.

What schools offer necessary programs?

There are several schools that emphasize theater arts, and many colleges have excellent theater-arts departments that focus on scenic design, lighting design, and direction, as well as acting. Check the charts at the back of the book. Ask drama and stagecraft teachers about schools from which you can get catalogs, or search the Internet for such information. A college degree is not essential for success in scenic design, but college-based practical experience and possible connections in the field will give you the knowledge and experience you need to start a career in scenic design.

The stage sets for *Ragtime* were designed by Eugene Lee. Researching American Impressionist painting led Lee to the initial concept for his design. The Million Dollar Pier is just one set that Lee designed for the production. Others include Penn Station and Fifth Avenue. Atlantic City production photo of *Ragtime,* 1997. Design by Eugene Lee. Courtesy Livent, Toronto. Photo by Michael Cooper.

Scenic designer Dan Smith works with a broad range of theater-, film-, and TV-design skills. Here he is adding the finishing touches to a friendly face. Courtesy the artist.

Smith works on a flat set design painted to appear like a three-dimensional stone surface. Scenic designs are often devised to fool the eyes of the audience. Courtesy the artist.

Profile

Scenic Designer: Daniel John Smith

Ironically, while in junior college, Dan Smith became discouraged with the study of art. He was preoccupied with comic/cartoon art and did not feel encouraged to follow his impulses. He remembers being told by one of his teachers that he needed to explore other subject matter, and at this juncture, he switched academic majors and studied the theater arts of acting, directing, play writing, and stage design for the next six years.

Before completing his master's degree, Smith worked for Roger Corman's special-effects studio on feature films such as *Battle Beyond the Stars* and *Escape from New York*. As an assistant cameraman, his duties included camera operation and the lighting of miniatures for motion-control photography. Later, on *Jaws 3-D* and *Strange Invaders*, he also built and painted miniatures. One thing leading to another brought Smith into the world of the feature-film art department, doing carpentry, painting sets, and art directing on projects such as *Creature* and *Welcome Home, Roxy Carmichael*. Opting for the

more consistent work available in set-construction shops, he has concentrated on scenic art and has worked on innumerable projects for Disneyland, Universal Studios, the San Diego Zoo, and various TV specials such as *Comic Relief* and *The Soul Train Awards*. Disneyland projects have included *The Lion King Parade* floats and the *Pocahontas Stage Show*; Smith was lead scenic artist for *The Hunchback of Notre Dame: A Musical Adventure*, a six-million-dollar live stage show.

Smith says, "As a lead scenic artist, the challenge for me is the concoction of simple scenic treatments that satisfy the client and also keep costs well within a profitable margin. Unlike 'fine art,' I find that the art of painting scenery is in the speed and efficiency with which one can satisfy the requirements of any given project. Strong consideration is given to the audience's physical relationship to the scenery; if it is on stage, how far away is the audience? On film, this question of finish revolves around photographic depth of field; is this element in the background or is the actor standing next to it? In the latter case, the scenery piece needs much more attention to detail. My experience with cameras has been extremely valuable in understanding these theories.

I feel my varied experiences strongly qualify me as an art director or scenic designer, a direction in which I continue to expand and develop my career. I have designed many theatrical productions, video projects, and an interactive video convention environment for Time/Warner. I have also had an ongoing relationship with a major California bank as their corporate video art director.

Recent highlights have been being accepted into a Scenic Design Master Class with the well-known Ming Cho Lee; and in turn, teaching my own stage technology class at Hoover High School in Glendale, California.

My career curiously continues on a rather diverse trajectory. I find it ironic that the majority of my work is to create art for other people—the very reason I ended my formal study of art some twenty years ago. However, I do find fulfillment in the creative collaboration and problem solving with my clients. Also, through the years, I have continued to explore 'my' art in the medium of children's picture books. I have illustrated three projects, two of which I have written. Eventually, I feel my background in theater, film, and art will serve me well as a pictorial storyteller. Until then, I will continue diversely."

Many tools besides brushes are needed to finish huge stage sets. The designer is applying a final finish to huge "rocks" that will decorate a stage set. Courtesy the artist.

Costume Designer

Costume designers consult directors and scenic and lighting designers from the start of a production, and consider the color, shape, and line of all the costumes in relation to the sets and lighting plan. Some resident companies have their own costume designers and staff. Elsewhere, free-lance designers and costume companies bid on design jobs when a new play is in production.

Costume design requires fashion research, so a basic knowledge of fashion history is essential. This historical approach to fashion is stressed in schools that feature fashion design, drama, or theater arts. The production of authentic period costumes is the result of such study and background.

Paintings and sculpture of earlier artists often serve as sources of information for costume designers, who must therefore have knowledge of art history. Museums are excellent places for conducting research. A thorough knowledge of fabrics is essential in order to create authentic costumes.

What does a costume designer do?

After the costume designer reads the play and the director and scenic designer have been consulted, the designer does research and makes rough sketches of all the costumes that are needed. He or she may have to modify the sketches several times. After the director approves the sketches, the costume designer starts searching for fabrics. This may be easy if the play is set in contemporary times, but more difficult if set in the Middle Ages. If the play requires a fabric that cannot be duplicated today, the designer must know how to produce a substitute material that will look like the original fabric. Cloth swatches, chosen by the designer for their authenticity and color, are stapled to the sketches. When the cast is chosen, the designer redraws costume sketches according to the particular appearance of each actor. He or she is also responsible for accessories (glasses, purses, beads, shoes, gloves, watches, and the like).

If the costumes are made by the company's own shop, production of pieces can begin immediately. If not, the designs are opened to bidding. Experienced workers in costume houses or the company's own department make all costumes and their undertrimmings. They are fitted on the actors before muslin patterns are made for the overgarments. Cutters, drapers, and fitters work with the actors under the supervision of the costume designer. Patterns are made to fit only the actors in the play, and are fitted directly to them or an exact dress form. Every fitting is crucial; the second fitting (including accessories) and the third (complete wardrobe) require the designer's approval.

About ten days before opening night, a dress parade is held. All the costumes are worn in front of the appropriate sets so that the director and designer can be sure that the parts work together. There are always last-minute adjustments in color and lighting. When costumes are approved, they are turned over to the wardrobe staff, who take responsibility for them as long as the production runs.

What qualities are helpful to a costume designer?

Costume designers are under constant pressure to create costumes within a rigid time frame. They must be able to make critical decisions easily, adjust to last-minute changes, and think clearly in crisis situations, all while maintaining a good working relationship with the other members of the production. The designers must have a thorough knowledge and understanding of fabrics and fashion history; have a fine sense of color, texture, and style; and understand lighting and its effect on fabrics.

What other careers require similar qualities?

Other careers in theater costuming—such as wardrobe masters and fitters—carry less responsibility but may be of interest to costume designers. Careers in various parts of the fashion industry—such as fashion illustration, design consulting, and fashion-show direction and promotion—require qualities similar to those of a costume designer. Museum work that includes fashion history and the curatorial duties connected with it would be a natural alternative career. Teaching fashion history and costume design would make excellent

use of the accumulated knowledge of a costume designer. Film and TV studios have costume departments, which require designers to employ production techniques similar to those in the theater.

What can you do now?

Take all available art classes, especially drawing, painting, and art history. Literature, history, and English classes are also important. A class that includes sewing will provide practical experience.

Attend some plays and operas; pay special attention to the costumes and how they relate to the production. Volunteer to work on costumes and wardrobe in school or community productions.

Study sketching techniques in magazine and newspaper fashion ads, and apply them in your sketchbook. Try to visit a museum that has a good fashion department; study the characteristics of certain periods and places. Study paintings for the same reasons. View film and TV productions set in specific historical contexts; they can provide excellent close-up looks at period clothing.

What schools offer necessary programs?

Costume designers come from either a fashion background or a theater background, but both include costume-design courses. Check the catalogs or Web sites of schools that interest you to see if they offer sufficient training in costume design. Look also at the charts at the back of the book.

Schools with a theater-arts department offer practical experience in working on actual productions. Schools with a fashion-design department feature courses in fashion theory, drawing, illustration, and rendering, and the design aspect of costume work. Consult your drama coach or art teacher to discuss what direction might be for you.

Costume designers in every field of entertainment begin as fashion-design students in art schools, fashion institutes, or colleges. This elaborate ensemble was designed by Erin M. Tibbetts in a costume-design class at the Fashion Institute of Design and Merchandising in Los Angeles. Courtesy FIDM. Photo by Beth Herzhaft.

Other Careers in Theater and Stage Design

Art Director

In some large productions, such as operas, an art director assists the director and producer in supervising all aesthetic aspects of the production. He or she coordinates the work of all designers and production staff to ensure authenticity of costumes and sets and a unified visual impact. Art directors have had experience in most phases of design and production work.

Costume-Design Production Worker

Important members of the costume-design production team include cutters, patternmakers, sewers, and fitters—all who work under the direction of the costume designer. They often are skilled in different aspects of the process. In small shops, they may be required to perform several tasks.

Hair Stylist/Designer

Hair stylists are responsible for how both natural hair and wigs are styled for the actors. They research colors and styles to ensure authenticity, and they work with the costume designer to achieve the look that the director requires.

Lighting Designer

Lighting designers use the light in a darkened theater to control the mood and feeling of a production. In large theaters, they work with a staff of lighting technicians to develop the quality of light dictated by the production. They work with lights stationed throughout the theater, using washes, floods, and spots to provide general illumination or carefully controlled patterns of light.

Lighting designers use some programmed lighting and computer-directed cues, but many lighting programs are manually operated from a complicated schedule drawn up while the production is in development. Directors and scenic designers involved in this scheduling ensure continuity and the correct illumination of props, scenes, and costumes.

Makeup Artist

(See also Other Careers in Film, TV, and Multimedia, page 140)

Makeup artists produce magic from their boxes of makeup materials. They read the scripts and—with plastic, clay, and colorings—make the actors' appearance authentic. They are masters of special effects on the human body—bleeding wounds, for example—but can also strengthen the assets in an actor's face. They develop their skills with on-the-job experience, although they may have also taken courses in makeup at a school with a theater-oriented curriculum.

Opera or Ballet Worker

Operas and ballets often involve tremendous numbers of performers on huge stages. Workers in all traditional theater careers are required for such productions, but on a larger scale. Scenes and props are often complex. Costume design and wardrobe management are mammoth undertakings. Many opera and ballet companies have their own design staff. Historically, many fine artists have designed opera and ballet scenery and costumes.

Program Designer

Theater programs, posters, and media ads are usually contracted out to local graphic designers or free-lance artists. They attend a rehearsal to grasp the feeling of the play, then submit ideas for the producer and director to approve. They oversee the production of programs and ad material from concept to delivery, meeting crucial deadlines throughout the process.

Property-Shop Worker

Stage properties add detail to the words, action, or music of a production, and help make a stage situation seem authentic. Workers in property shops can produce almost anything—or a facsimile. They transform ordinary materials like wood, wire, and plastic into what look like gold, marble, or precious stones. These workers are masters of constructing with wood, steel, plastic, fabrics, muslin, wire, paper, paste, and paint. They create textures, stairs and windows, lighting fixtures, etc. Their products must be fireproof; authentic in color, shape, and size; and real enough to fool the audience. They work under the direction of the scenic designer, providing the props called for in the script and by the director. Property shops collect period furniture, lamps, accessories, paintings, and rugs. Their workers know how to obtain anything not kept on hand.

Puppet Designer

Puppet designers work with clay, papier-mâché, cloth, plastic, and other materials to create puppets of all types. Puppetry is a special type of theater entertainment that requires specialists who design, construct, and operate the puppets. Rod, hand, shadow, and string puppets also require stage sets and scenery. Many puppeteers design and construct their own puppets and stages, but some seek help from outside design sources.

Scene Painter

Scene painters provide the visual background for a stage production. They are masters of illusion, and can make an ordinary canvas look like walnut paneling or solid concrete. Their skill is essential to successful stagecraft. They must be able to draw, paint, and render surfaces and textures, and must know how colors will react to colored lighting. Scene painters work from small sketches that are enlarged to full size onstage.

Set-Construction Worker

While scene painters produce illusions on cloth, set-construction workers build three-dimensional designs for the stage. The platforms, walls, stairways, and balconies that are later painted, are first built by set-construction workers, who work under the supervision of the scenic designer. The design of such construction often emphasizes depth or size, or perhaps some type of distortion, to create the desired effect. Construction workers must be able not only to use a hammer and nails, but also to weld.

Wardrobe Worker

Wardrobe workers are responsible for the care and availability of costumes. They clean, press, and repair costumes in readiness for every performance. In larger productions, there may be elaborate track systems to bring hundreds of costumes to the right place at the right time. Work in a wardrobe department can provide excellent background for future costume designers, cutters, sewers, or fitters.

Cultural Growth and Enrichment

part five

Cultural Growth and Enrichment

Most of the art careers discussed in this book deal with the practical application of art to fields such as advertising, architecture, film, and product design. But there are artists who work primarily to enrich the life of others. Some of these specialists teach art; some devote themselves to a career in a museum where art is exhibited, or in a gallery where art is sold. Some write about art and artists, or publish art magazines and newsletters. The best-known but least understood of these art-career areas is probably fine art.

The economic impact of all of these career areas is not easy to determine, because students, purchasers of art, museum goers, and many others may not benefit immediately from the work of the career specialists, but will in years to come.

A career in the visual arts just isn't what it used to be . . .

Wendy Rosen, publisher, *American Style*

Wendy Rosen

Each June as the school year draws to a close, I receive invitations to speak at art schools and universities on the subject of "art in the marketplace." For many new graduates, this is the first time they've considered the subject of selling their work and making a living as an artist.

My visit stirs up the usual anxieties and fears of all new graduates upon entering the real world. But in the visual arts, career paths are never as clear as they seem to be in law or accounting. Years ago, graduate students could count on teaching college art classes while pursuing their own artistic work. Today, hundreds of applicants vie for the few available teaching jobs. Yet job opportunities outside the university system are abundant.

A career in the visual arts just isn't what it used to be...thank heavens! In the 1970s and early '80s, many art graduates went to work in other fields. Now they are returning. With the growth of arts communities, galleries and shops, opportunities abound for young artists to develop their own ideas and learn the "business" of art as well.

Across the country, studios established in the 1960s are looking for young, talented artists to bring in new ideas and designs. With an owner looking to retire in the not-too-distant future, the deal may include the understanding that in a few years the studio will be theirs to acquire.

Galleries need talented, knowledgeable art graduates to train as directors and managers. Many arts organizations want arts graduates to orchestrate art events and exhibitions. Consumers everywhere are demanding better-designed products, paintings, sculptures and the handcrafted quality found in galleries and fine shops. In a world where job security no longer exists, even in government, the visual arts are exploding. I often wonder how most parents first respond to their college-bound teenagers' announcement that they want to major in art. Are they disappointed? Do they try to urge them toward a business major? Today, parents can support the decision with confidence and enthusiasm.

Many artists earn degrees in art schools or colleges before they begin a career in the fine arts. Tamar Hecker, working toward a B.F.A., is seen fabricating *Be Careful* in the Barclay Simpson Studio. Photo courtesy California College of Arts and Crafts.

Fine Art

Fine art—painting, sculpture, printmaking, photography, and multimedia—is produced to be looked at and enjoyed. Although most career artists work in the more practical aspects of design, there are career opportunities for successful fine artists.

Fine artists must be self-motivated and self-reliant, confident of their creative abilities in a world of intense competition and rapid change. This challenge is met more easily with a strong education designed to provide exposure to many media, to art history, and to selecting profitable directions for the aspiring artist. The training, experience, instruction, and associations gained in art school are important to the development of fine artists. Although there are some self-taught artists, the majority of successful artists have had training from highly qualified teachers, and have obtained an advanced degree, such as a master's in fine arts (M.F.A.) in their chosen specialty area.

Fine art has traditionally been sold through galleries, but such art is also sold at established art fairs, street shows, and studios; through agents; and via the Internet. Many artists have had reproductions made of their work, which are sold at outlets nation- and worldwide. Even in light of growing sales areas, however, income from the sale of paintings or sculptures cannot be predicted, so most fine artists have other jobs—often in another field of art—that provide them with a steady income and allow them time to pursue their favorite fine-art medium. Some artists supplement their income by teaching or judging art. Some artists obtain grants in order to continue their work without distraction. And some sell enough of their work to maintain a comfortable life style.

Because they must produce work regularly in order to supply their customers or galleries, or to prepare for exhibitions, fine artists usually set up a schedule that allows them to produce artwork each day. Although most choose their own subject matter and working processes, some fine artists accept commissions. Working on a commission means that the artist receives assignments from customers, clients, or galleries.

The price of an artist's work is established by supply and demand, or by reputation. The work of beginning exhibitors will sell for less than that of more experienced artists or those with a more impressive reputation. Gallery directors help establish such price structures. Artists can build their reputation by entering local or national competitive exhibitions. They might also show in galleries (see page 195) or have a one-person show of their work.

Artists must keep excellent records, both of their finances (income and expenses) and of their work (where artworks are and who sold or bought them). Because fine artists are self-employed, they must work directly with state and federal tax agencies. Artists must keep inventories of their work, insure it, and provide for its shipment.

Painter

Painters must work at their art diligently and constantly to produce enough high-quality work to insure their continued success. Some artists begin their painting career upon completion of art school. Others may begin as illustrators and gradually develop a loyal following willing to purchase their paintings from galleries. Still others work at one art career (industrial design, for example) or some other job (such as teaching or real estate) and continue to work at their painting, exhibiting and selling what they can produce in their spare time. Although most require other jobs or activities to provide them with sufficient income, some very popular painters live comfortably from the sale of their work.

Painters work in studios of various kinds. A separate, designated space is best, as it can be devoted entirely to art production and need not be cleaned up every day. Studios may be located in lofts, in special rooms at the artist's home, or in rental space in office buildings, barns, or garages.

What does a painter do?

Painters work in many media: watercolor, acrylics, oil, egg tempera, casein, ink, collage, and some exotic combinations. Some painters travel to paint on location, or to sketch or take photographs from which to work in their studio. Some painters work with models, still-lifes, animals, or flowers as their subject. Others make up the designs and subject matter as they work on various surfaces.

What qualities are helpful to a painter?

Because painters work alone, with no one else to motivate them, self-discipline and self-motivation are essential. Painters in any medium must be articulate and businesslike in their dealings with gallery directors, museum curators, and customers. They must love to draw and paint, and continually produce high-quality work that will attract buyers and admirers. They must also be able to accept, and learn from, criticism. Painters must have some background in art history, and stay aware of current art directions and trends.

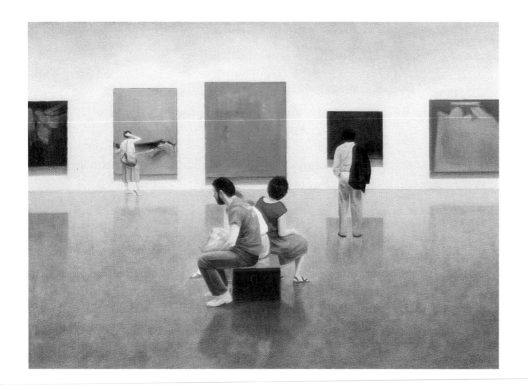

The goal of most painters is to have their work exhibited in galleries or museums. Steven DeLair paints a scene showing paintings in a gallery, observed by several interested people. His title, *Unspoken Conversation*, depicts the silent communication between artist and viewer through the artist's work. Oil on canvas, 36 x 60". Courtesy the artist and the Esther Wells Collection.

What's in Store for Fine Artists

The future of the fine arts will be shaped by artists who have the technical abilities to master rapidly changing technologies, but also have the critical perspective to make sense of the dramatic shifts in the social and cultural landscape.

—Otis College of Art and Design catalog

What other careers require similar qualities?

Self-motivation is required of all free-lance and fine artists. Free-lance designers and illustrators work as painters do, and often it is possible to combine these careers in one. Editorial illustrators (see page 78) work with similar techniques and products, and under the same conditions. Mural artists (see Other Careers in Fine Art, page 164) and background painters in animation studios (see page 134) require similar training and employ similar techniques. Art teachers are often trained as fine artists and teach techniques and methods of painting (see Art Education, page 177). Art schools and colleges seek painting instructors who have established reputations as painters, because they contribute to the institution's prestige.

What can you do now?

Take all available studio-art and art-history classes, especially drawing, painting, and design. You can never have too many drawing classes, so enroll in special Saturday drawing classes that some art schools or school districts provide. Get involved in as many art activities as your schedule allows. Sketch, paint, and draw on your own. Establish a ministudio in your home, perhaps in a corner of a room. Keep a sketchbook handy and work in it constantly. Read through fine-art magazines in libraries to see what is being produced and how artists work. See page 224 for titles.

What schools offer necessary programs?

Most colleges, universities, and art schools offer courses leading to an undergraduate degree in fine arts. Those with very strong programs also offer graduate degrees in painting, sculpture, printmaking, or other specialized disciplines. Check the charts at the back of the book for schools that emphasize the fine arts, and obtain catalogs or check course listings on the Internet to determine whether a school meets your individual needs. Community colleges generally offer basic courses in areas of fine art, and some colleges offer extension courses off-campus. Noncredit courses, workshops, and seminars can provide excellent help in painting. Sources can be found in *American Artist* and other art magazines.

Sculptor

The work of fine artists often keeps them self-directed as to where they take their art. If not self-directed, sculptors might work with galleries, museums, or agents to plot a strategy.

Sculptors create three-dimensional forms that vary in size from tiny to monumental. Traditionally, their materials were marble, wood, bronze, and clay, each of which has different qualities and requires specific techniques. Contemporary sculptors, however, make use of a range of materials and means of visual expression. Welding adds the dimension of construction to the sculptor's work; and electricity, motors, and computers provide opportunities for adding movement. Today's sculptors may work with light, sound, animation, cinematography, fibers, plastics, or such unconventional machines as chain saws and earth-moving equipment.

What does a sculptor do?

Sculptural processes vary in technique, materials, and method. Some sculptors work as painters do, in that they execute their work in the desired medium and display the pieces for sale in galleries. Some sculptural works—especially those in clay, welded metal, wood, or stone—are probably one of a kind, while bronzes, cast metals, stone, some clay or Fiberglas™ pieces, and works using new reproduction techniques are produced in multiples from a pair to fifty or more. The seller of such works—which are placed on consignment in galleries, shops, or stores—retains a percentage of the sales.

Large sculptural works are often commissioned by architects, builders, or developers to be placed in front of buildings, in open courtyards, or in other public places. In such cases, the sculptors usually receive part of the cost of the work when the contract is signed; they receive final payment upon completion. Large works of this type may take a year or more to complete, and can involve workers other than just the artist. Advance payments keep the project running smoothly and prevent the sculptors from depleting their own funds. Artists who work on such large projects may use business managers or agents to handle their financial affairs.

Not many sculptors, like painters, can make a comfortable living just by selling their work; they must supplement their art income by holding another job. Teaching sculpture in art schools or colleges is one way to work in sculpture and continue to sculpt creatively.

Kent Ullberg's large polished bronze sculpture *Whooping Cranes* provides a visual focus in front of the National Wildlife Federation offices. Courtesy National Wildlife Federation, Washington, D.C.

What qualities are helpful to a sculptor?

Sculptors must be self-disciplined and able to use their time efficiently. Because large works can take months to complete, the artists must be able to work with others, and must budget their funds and time. They must also be able to sustain interest in their work over extended periods. Along with skill in drawing and sketching, sculptors must enjoy working with their hands on textures and surfaces. An awareness of contemporary trends in art complements their ability to explore new directions and remain unstuck.

What other careers require similar qualities?

All fine artists (such as painters, printmakers, and craftspeople) require similar qualities of self-discipline and self-motivation. Model builders, set designers, and architects require skills in three-dimensional construction and manipulation of materials. Puppeteers, jewelry designers, and furniture designers must also work in three dimensions, although some of these careers may involve working for others. Some careers in industrial design require skills and abilities similar to those needed by sculptors.

What can you do now?

Take art classes of all types, especially sculpture and three-dimensional design. Drawing and art history are also important. Shop classes in metal, wood, and plastics can provide excellent background in working with these materials and developing techniques. Try to find part-time work that involves any three-dimensional activity (welding, constructing, finishing). Visit museums and galleries to see what past and present sculptors have done. Take special sculpture classes—at art schools, colleges, or magnet schools—that emphasize specific media. Make studies in your sketchbook of existing sculptures, or invent your own forms and ideas. See page 224 for names of periodicals that might have articles on sculpture.

What schools offer necessary programs?

Schools that offer fine-art majors generally offer enough courses in three-dimensional design and sculpture to satisfy most needs. However, if you have definite interests (such as bronze casting), be sure that appropriate facilities and experienced faculty are available. Check the charts at the back of the book. Write for and read catalogs to see if your needs will be met, or study the schools' Web sites.

At work in his large studio, Kent Ullberg is seen polishing his nine-foot-tall stainless-steel sculpture *Watermusic*. Photo courtesy the artist.

Printmaker

The term "prints" is sometimes misunderstood, especially by those who are not familiar with art and art techniques. "Prints" can correctly refer to both *printed reproductions* (done photographically in a print shop on large machines) and *multiple originals* (done by an individual artist in his or her studio). This second category is what is meant by "print" in regard to fine arts. Printmakers who produce these multiple originals are, in most cases, using production methods that are hundreds of years old.

Printmakers use several major techniques and many experimental methods and materials, but the work they produce is original, usually limited in number, printed by hand, numbered, and signed. Major techniques and processes include: **intaglio** (etching, engraving, drypoint), in which prints are created from ink that settles in grooves below the surface of the metal plate; **relief** (woodcut, linocut, cardboard print), in which prints are made from inked, raised surfaces; **lithography**, in which prints are pulled from inked-up limestone blocks or metal sheets; and **stencils** (serigraphy and other stencil methods), in which images are formed when ink passes through cut or brushed-on stencils. There are also many experimental techniques, such as collagraphs and photo-etching, and combinations of several techniques that have expanded the boundaries of printmaking. The printmaking process determines the effectiveness of the final product. Some processes require large presses, and printmaking studios must accommodate tools, equipment, paper, and an inventory of prints.

What does a printmaker do?

Like other fine artists, printmakers generally work on their own. They work in their studio, and budget their time and energy to create original finished prints, ready to exhibit or sell in galleries. Many galleries deal primarily in multiple-original creations; others may handle both prints and one-of-a-kind fine art.

Printmakers produce a certain number of each print, which they call one edition. The quality of these multiple units must be as equal as possible, and when a certain number (20, 60, or 100, for example) is completed, the source of the print—whether plate, stone, screen, or woodblock—is destroyed or marked so that no further prints can be made. Thus, the edition is limited. To assure gallery staff and buyers that there are only a limited number of the work available, the prints are titled, numbered, and signed, which helps establish the value of each print. In addition to the numbered prints in the edition, printmakers keep several examples for themselves. These are called artist's proofs: they usually remain in the printmaker's collection, or go into the portfolio that is shown to clients or gallery directors.

Printmakers may exhibit their work in regional or national exhibitions held by printmaking societies around the country. They might also exhibit in galleries, where the value of their work increases with their reputation. Like painters, printmakers must seek gallery representation with care: sales generated in this way provide the income from their art. To supplement their income, many printmakers teach in an art school, college, university, or high school.

What qualities are helpful to a printmaker?

Printmakers must like to work with a variety of materials and methods and must enjoy the entire printmaking process. Because the preparation of plates or other surfaces from which the prints will be made is time consuming, printmakers must be patient and careful. Like other fine artists, they must be self-disciplined and self-motivated. They must understand printing processes completely, stay abreast of contemporary directions in art, and experiment regularly, using their tools and equipment to develop new and exciting work. Conducting their art enterprise and establishing good working relationships with galleries or agents complete the business side of successful printmakers.

What other careers require similar qualities?

All successful fine artists must have similar qualities of self-motivation, attention to detail, interest in processes, and the desire to compete. Photography and careers in the printing industry may be of interest to printmakers. Some areas of graphic design (see Graphic Design, page 51) would be attractive because of the processes required (silkscreen printing, for example) and the need for multiple products. Many printmakers enjoy teaching the processes, and make excellent teachers at undergraduate and graduate levels.

What can you do now?

Take classes in drawing, printmaking, design, art history, and printing. While art classes are important, so too are business, English, history, and some humanities courses. Become a member of a local printmaking society, if there is one. Find out what print exhibitions, seminars, classes, or demonstrations are scheduled at local museums, galleries, art schools, or colleges. Try to find part-time work in a print shop, graphics studio, or a sign shop that uses silkscreen techniques. Work in an art-supply store will provide you with knowledge of available equipment and may acquaint you with local artists who work in print media.

What schools offer necessary programs?

Most art schools and colleges offer a major in printmaking. Some community colleges also offer printmaking courses, especially if there are experienced printmakers on the faculty. Check the charts at the back of the book for fine-art programs, write for catalogs, or find information on the Internet to determine the emphasis that each school offers.

Printmaker Louis Dow works with several large presses as he prints etchings and monotype prints. He not only prints his own pieces, but also works with other printmakers who use his presses, equipment, and large studio space to create their own prints. Photo by Gerald Brommer.

Kent Twitchell works on scaffolds that allow him to paint at any height. Murals of such size must be planned carefully because the artist cannot step back frequently to see how the work looks from a distance. Photo courtesy the artist.

Twitchell's portrait of head and hands dominates a Los Angeles street scene. His work often has religious overtones: the title of this realistic portrait is *7th Street Altarpiece*. Photo courtesy the artist.

Profile

Street Artist: Kent Twitchell

Street art is the mural painting of today. Artists work on large exterior walls and create images of personalities, children, athletes, landscapes, historical events, abstractions, and ethnic culture. Buildings, walls, freeway underpasses, and warehouses are the supports for mural art of any size. Kent Twitchell is a premier example of a successful and sincere street artist.

Born in Michigan, Twitchell was an illustrator for the air force in London during the early 1960s. He later worked in this country as a display artist in a large department store, attended East Los Angeles College for two years, and spent a couple of years searching out the hippie movement. When he realized he needed to develop self-discipline to become a successful artist, he entered Cal State University in Los Angeles. He began a series of public monuments to American cultural heroes in the streets of Los Angeles in 1971, painting the Ed Ruscha, Steve McQueen, and Strother Martin monuments.

He felt the need for more self-motivation and discipline and enrolled at Otis College of Art and Design, where he worked with the master drafter and teacher Charles White. Twitchell has now painted over 100 public portraits in the thirty or so mural projects he has completed, including a monument to Julius Erving in Philadelphia and monuments to Los Angeles visual artists Jim Morphesis, Lita Albuquerque, and Gary Lloyd. His monument to the Los Angeles Chamber Orchestra, painted across a nine-story set of walls overlooking the Harbor Freeway, brings the art of both painting and music to thousands of commuters daily.

As this book goes to press, Twitchell is seeking a site for a Charlton Heston monument in Hollywood, and one for Joan of Arc in Paris. He plans to paint Wyatt Earp and Will Rogers monuments in San Bernardino; Elvis Presley in Memphis; Johnny Cash in Nashville; and Marian Anderson beside Mario Lanza in Philadelphia. His murals, studio paintings, and drawings typically depict a lone standing figure looking directly at the viewer.

Twitchell relates an early experience that caused him great distress and could have changed the course of his art, but thankfully didn't:

"I was working on the seventy-foot-tall monument to Ed Ruscha in downtown LA, and on a Monday morning I was painting Ed's right eye. I felt truly rich—here I was, doing exactly what I would rather do than anything in the world. Suddenly I both heard and felt something fly past my left temple, a split second before it smashed against the wall in front of my face. An egg! I watched it spread across and down my precious painting. I looked down at the parking lot but saw nothing suspicious. My day turned suddenly sad, and the sadness deepened as I spent time cleaning my artwork. It was difficult to get back into the excitement I had felt on Monday morning. That Friday as I worked, toward the end of the day, I became aware of something different from the normal. As I looked down, my eyes finally focused on a crowd of people. They were looking up at me. They were smiling and applauding. I could not believe it! I was grateful for the applause, in fact humbly thankful, because of the sorrow I had felt earlier."

The multifigured portrait shows the principal members of the Los Angeles Chamber Orchestra in heroic size, with major figures standing over 80 feet tall. Photo courtesy the artist.

Other Careers in Fine Art

Appraiser
(See Other Careers in Art Services, page 218.)

Art Critic
(See Art Publications, page 203.)

Art Dealer (Gallery Owner/Director)
(See Galleries, page 195.)

Artist's Agent
Artists' agents represent artists to galleries, sales agencies, interior designers, or directly to major clients. They place advertisements for artists' work in art publications, show work to potential clients, and schedule shows, workshops, seminars, or demonstrations. They may arrange for print editions to be made of their clients' work.

Assemblage Artist
Assemblages are arrangements of three-dimensional materials that are freestanding or arranged as relief sculptures. Assemblage artists gather a variety of three-dimensional materials (wood, metal, plastic, glass, paper, stone, and the like) and adhere them to one another or to a backing or foundation.

Collage Artist
Collages are works of papers or fabrics adhered to supports such as cardboard, canvas, illustration board, or heavy paper. Collagists gather a variety of papers or fabrics in many colors, textures, sizes, and shapes. They tear or cut them as needed, adhering pieces with appropriate glues, pastes, or other materials.

Computer Artist
Design skill and technical proficiency are combined by computer artists to produce works in which electronic tools and digitally-generated images are the fine-art media. The work of computer artists is broad in scope, limited only by their imagination. Two-dimensional images may be printed in high-resolution color at poster size, or these artists may use multimedia and interactive design to develop art that is elec-

tronically displayed and sold either in galleries or via the Internet. A successful computer artist has a strong background in drawing, photography, and writing.

Conceptual Artist
Concept art is a style of expression in which an artist reveals ideas for a proposed artwork in verbal or diagram form; the actual artwork may or may not be completed. Conceptual artists work with galleries, museums, or art publications.

Craftsperson
(See Crafts, page 167.)

Educator/Teacher/Instructor
(See Art Education, page 177.)

Environmental Artist/Earth Artist
Environmental art or earth works are large formations of moved earth, excavated by artists (or under the direction of artists) and best viewed from high vantage points. Artists create their designs, often in deserts or other places uninhabited by humans. The formations are not made to be permanent, but are intentionally allowed to erode and change. Photographs of the construction process and of the eroding work are sold to offset production costs.

Fine-Art Photographer
Fine-art photographers require the same skills and equipment needed by other photographers (see page 91). They work for themselves, however, rather than for studios, agents, clients, or graphic designers. Their work is exhibited in galleries and museums, and is sold to collectors in the same way that paintings and drawings are sold. America's great fine-art photographers include Ansel Adams, Wynn Bullock, Edward Weston, David Meunch, Diane Ensign, Dorothea Lange, Paul Strand, and Edward Weston.

Framer
Framing protects and preserves paintings and drawings, and makes them presentable for exhibition and sale. Framers work with artists, galleries, and museums to design, construct, and finish frames. Framers know how to cut and join moldings, prepare liners, cut mats, and assemble frames that enhance the artworks and

preserve them properly. Production and wholesale framers supply frames to galleries, print sales representatives, photographers, distributors, and retailers; custom framers give each artwork individual attention.

Kinetic Artist

Kinetic sculptures are three-dimensional constructions of varying sizes that have moving parts. Some kinetic artists use air currents or gravity; others employ motors, solar cells, computers, or other means to move segments of their pieces. Kinetic works are sold in galleries or are placed in museums or public places. Kinetic artists are sculptors whose primary interest is the inclusion of movement in their artworks.

Master Printer

Master printers are printmakers who are expert in certain printmaking techniques, and who produce images developed by other artists. They work in their own studio or for large printmaking studios, using artist-printmakers' prepared plates, blocks, stones, or screens to execute the prints.

Medalist

Medalists are sculptors who work in relief and make the original sculptures from which medals are produced. They carve in wax to prepare a master copy from which a mold is made and copies are cast. Their work is usually done to commemorate a historic event or the life of an important person. Medalists must be adept at making portraits and figures, and in lettering in shallow space, fine detail, and small size.

Moldmaker

Moldmakers are craftspeople who make plaster, latex, or other types of molds in which sculptures or medals are cast. They provide indispensable services for sculptors who work with bronze or other metals in their castings. If there are to be many copies of an original, the mold must be designed for repeated use. For limited editions, moldmakers often create a separate mold from the original work for each casting.

Muralist (Mural Artist)

Muralists are fine artists who produce frescoes or images on walls in oil, acrylics, latex paint, or other media. They work by commission: a corporation, individual patron, government agency, or architect assigns and pays for the work required. The selected artist prepares a small-scale rendering of the proposed work, which is designed to fit a predetermined space. When the design is approved, contracts are signed, some advance payment is made, and the muralist begins work on the site. Some artists paint the mural in their studio (on canvas or panels) and transport it to the final location for installation, but most muralists paint directly on a wall.

Papermaker

(See Other Careers in the Crafts, page 174.)

Photographer

(See Fine-Art Photographer, above.)

Portrait Artist

Portrait artists specialize in painting likenesses of the human form, whether full figure or facial. In an attempt to capture character, they expertly reproduce the sitter's recognizable features, and perhaps a characteristic gesture, position, and attitude.

Quick-Sketch Artist

Quick-sketch artists use pencils, charcoal, pastels, or other media to sketch quick portraits, often emphasizing the subject's best or most pleasing features. These artists are often employed by theme parks, malls, recreation companies, circuses, or fairs.

Workshop Artist

Some artists supplement their regular gallery income by teaching in workshop situations. They travel from one location to another, teaching in studios or craft centers. For some artists, these workshops become their primary source of income. Some arrange their own workshops; others hire coordinators to do the publicity and preparation work.

Workshop Coordinator

(See Art-Program Director or Instructor, page 184.)

My own crafts training has influenced my entire life.

Ed Forde, ceramist and teacher

Ed Forde

The principal of a grammar school recently asked parents who possessed manual skills such as carpentry to come and demonstrate them for the students. The children had not seen people build things, and their own parents rarely did physical work at home. We are a culture that increasingly does not construct or fix things, but we buy everything ready made, and replace rather than repair. Working basic materials with our hands has become a lost art.

Into this void steps the contemporary crafts artist. In our modern world of plastics and other synthetics, there is still a need for artisans who can mold wood, clay, metal, and fibers. Crafts artists create the jewelry, furniture, pottery, and fabrics that stand out among all the mass produced consumer goods. Crafts are an area of tradition, uniqueness, and career opportunity.

In addition to solo and group exhibitions, many crafts artists work through commissions on projects for designers and architects, where crafts artists often have an advantage because of their technical knowledge and construction skills.

Although most housewares are now mass produced there still remains a strong market for functional craft objects. Galleries and many retail stores specialize in custom crafts such as pottery, jewelry, furniture, weavings, etc. Artists who work to develop their own distinct crafts can always find a market for their work.

One of the more important benefits of developing skills in crafts is their application to so many other areas of everyday living. Crafts artists need to master skills in conceptualizing, planning, constructing, and displaying objects. They have to invent forms, work and fabricate all the materials for their final completion. For all of its many applications and opportunities, craftwork is one of the most versatile careers available to the aspiring artist or designer. My own crafts training has influenced my entire life.

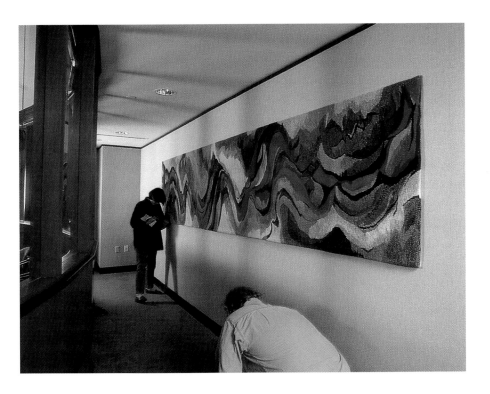

Artist Doris Bally installs one of her woven tapestries, which was commissioned by a Pittsburgh brokerage firm. The abstract work is now the focal point of a newly designed space. Photo courtesy the artist.

Crafts

Crafts are the original art of humanity. The baskets, bowls, beads, and fabrics of ancient peoples were the functional, utilitarian forerunners of today's product design. Craftspeople use their highly trained hands and eyes to produce aesthetically pleasing designs and objects—some practical, some that are considered fine art.

The crafts generally include work in ceramics, fibers, glass, metal, mosaic, wood, plastic, and jewelry. Most craftspeople cannot make a living by designing, producing, and selling their own handmade crafts. Therefore, many teach crafts in a school, university, or craft center; others have an unrelated job and work at their craft whenever they are able. Some artists can earn a living producing certain crafts in commercial situations, such as studios that specialize in ceramics, weaving, stained glass, mosaics, and decorative wrought iron. In such a situation, craftspeople can improve their production techniques, but are not usually producing work of their own design.

Art schools, craft centers, and colleges with a craft program provide the background and experience necessary to begin a craft career. Craftspeople need not have a college degree; buyers are interested only in the quality of their products. If craftspeople want to supplement their craft income by teaching, they will need teaching credentials or a degree from an accredited school. The best practical experience is obtained through an apprenticeship, during which developing artists study and work with master craftspeople. Those interested in crafts careers should keep up-to-date on what is happening in their field by reading crafts magazines. It is important to join craft organizations on local and state levels and visit crafts exhibitions, fairs, and festivals.

Craft shows, fairs, and studio sales are good places to sell individually crafted works. Regional and national competitive exhibitions award prizes for the best work submitted. Being accepted into such shows or winning prizes awarded by nationally recognized artist-jurors helps establish a craftsperson's reputation and makes his or her work more valuable. The work of top craftspeople is placed on a par with other fine art when it is recognized for its distinctive style and technique, and when it is in enough demand to allow the craftsperson to make a living from its sale.

Ceramist

Ceramists, also called potters or clayworkers, are artists who work with various types of clay. They may work as fine artists, producing one-of-a-kind pieces, or as production potters, turning out certain types of ware in quantity for a large company or individual owner. Ceramists work with clays, terra cotta, stoneware, or porcelain, and use such techniques as wheel throwing, coiling, slab construction, or modeling. They may decorate their work with glazes, stains, engobes, surface reliefs, decals, or paint. Some artists make utilitarian objects; others create sculptural forms that are aesthetic rather than practical.

Ceramist Harrison McIntosh works in his studio to throw a vase, formed with clay made to his specifications. Photo courtesy the artist.

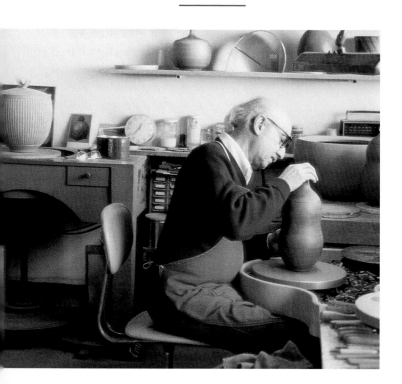

Nearly all art schools and colleges have a ceramics department. Their graduates produce pots, bowls, and other items for the highly competitive ceramics market. Galleries and shops of all sizes carry their work, but it is also sold at craft fairs, studio sales, and sidewalk and mall exhibits. Such an abundance of work and sales opportunities keep prices low for most ceramics. More accomplished ceramists—who have won awards and have an established reputation and a large clientele— may command higher prices for their work. The work of some ceramists sells in prestigious galleries and is considered fine art.

Successful potters develop an individual style and decorate their ware with glazes they create themselves. Ceramists need years of training in school to master the techniques of working with clay, formulating their own clay bodies (recipes for mixing clay), and developing glazing and decorating techniques. Ceramists can begin by working on their own, apprenticing with a master potter, or working in a production situation.

What does a ceramist do?

Regardless of the style, size, or use to be made of the clay piece, the basic procedures of all ceramists are much the same. They first conceive the idea, form, and design of the piece; and then build it or throw it on a wheel; decorate, glaze, and fire it; and finally sell it. The ideal of most ceramists is to have their own studio and kiln—and a ready market for their work.

The work of most successful ceramists has something unique about it. It may be size, form, use of glazes, type of clay, finish, or overall appearance. These unique qualities make the pieces more valuable to collectors and the public. There are hundreds of potters making similar objects; the challenge to any ceramist is to make his or her work stand out. The top ceramists are fine artists who have a following, gallery openings for their shows, invitations to be jurors, and acceptance by the museum community.

What other careers require similar qualities?

The qualities of self-discipline and motivation are required of all fine artists and craftspeople who work in their own studio and set their own production pace. The enjoyment of working with one's hands and developing working processes and procedures is common to all the crafts and to model builders, toy designers, and sculptors and other fine artists. The ability to work with chemical formulas can be of use in careers with companies that produce ready-made glazes or paints for industry and crafts. Ceramics teachers are hired by junior- and senior-high schools, colleges, graduate schools, and craft centers.

What can you do now?

Take ceramics, design, drawing, painting, and art-history classes. Chemistry and physics are important to an understanding of glaze formulations and kiln construction and operation. Business and English classes can help make a crafts career, especially an independent one, easier and more productive.

If possible, visit museums and galleries to study the work of contemporary potters and clay objects from past cultures. Visit craft fairs and festivals to see what crafts are new every year. Join crafts organizations if any are available. Take weekend ceramics classes whenever they are offered. Ask your ceramics teacher about related job openings, shows, and exhibits. For titles of magazines about ceramics, see page 224.

What schools offer necessary programs?

Almost every college, university, and art school has a ceramics department that offers the courses necessary to prepare for a career in this craft. An established or renowned ceramist on the faculty can offer considerable practical information, advice, and personal insight.

One of Harrison McIntosh's green bottle vases with brush spots. Photo courtesy the artist.

What qualities are helpful to a ceramist?

Ceramists must enjoy working with their hands and must be interested in all the processes—from concept to unloading the kiln. They must also be self-motivated toward continued growth and production. These artists must be constantly aware of competition and trends, and like to experiment and explore new directions as they develop unique techniques, forms, and glazes. An enjoyment of chemistry is a definite advantage. In addition to being creative and imaginative, ceramists have to meet gallery and client deadlines and keep accurate financial and inventory records.

Jewelry Designer

The creation and ownership of jewelry has been a source of pleasure and a sign of wealth for thousands of years. In nomadic societies, wealth was carried with the owner in the form of belts, buckles, fibulas, bracelets, necklaces, rings, earrings, pins, and medallions. Valuable stones and gems, caged or mounted on expensive metals, were crafted by designers who were honored for their abilities. Today, jewelry experts continue to design and construct personal adornments. Tools and techniques have changed, but jewelry design remains primarily a handwrought craft.

Students who major in jewelry design in college will study the design and drawing of jewelry; principles of casting, wax carving, and gemology (the study of gems and stones); chemistry; diamond grading; jewelry-design trends; soft jewelry design; and metalsmithing. A jewelry major may become a self-employed jeweler or designer; a designer, casting technician, chemist, or metalsmith in a jewelry manufacturing company; a costume-jewelry designer, production worker, or executive; or an employee of a company that manufactures items such as watches, belts, buttons, and class rings.

What does a jewelry designer do?

After years of study and work, jewelry designers have mastery of many processes. They know how to form and shape metals, treat and finish surfaces, cut and set gems and stones, and work with plastics, wood, bone, and found objects. They can use the hundreds of tools and the various materials needed to carry out their design ideas effectively.

Jewelry designers generally follow a three-step process: design, construction, and finish. Whether working on a single, unique piece or one that will be turned out by the thousands, the designer must first draw or render an idea, usually from several angles. When the idea is approved, the designer uses the appropriate tools to execute the design from the chosen materials. He or she then treats, textures, and finishes the surfaces.

Jewelry designers carry out their own designs from concept to finish, or they might work on commissioned pieces. An individual craftsperson is generally involved in all the processes, including the design, whereas workers in large jewelry manufacturing companies may be involved in only one or two of the processes, at which they become expert.

What qualities are helpful to a jewelry designer?

Jewelry designers must be organized, have a business sense, and be skilled in tools and techniques. They must enjoy working with their hands, usually on small pieces that involve detail and extreme care. They must keep abreast of current trends and ideas, yet also make use of classical styles. Strong drawing and sketching ability will aid the designers in facing stiff competition.

What other careers require similar qualities?

The process of design/construction/finish is typical of most craft areas. The ability to carry out an idea or design is essential in working with metal, wood, fibers, plastic, and ceramics. Organization and attention to detail are required of industrial designers, woodworkers, architects, and graphic designers.

Interest in jewelry may be transferred to careers in fashion design, consultation and sales, showroom management, and market assessment. Interest in gems and stones may lead to a career in selling, selecting, cutting, and polishing them for industrial or individual clients. The ability to work with metals could be applied to industrial design, metal fabrication, model building, foundry work, sculpture, or ornamental ironwork design or construction.

What can you do now?

Take drawing, design, and any available jewelry classes. Add sculpture, ceramics, and three-dimensional design courses. Chemistry and physics will help make processes and materials easier to understand; history and art history will provide a context for jewelry and all the crafts. Any work that allows you to use the

A Jeweler's Perspective

I see the enamels, metals, and stones as three separate instruments working in concert. In the designing of my work, the image in enamel is the melody. This is both underscored and embellished by the restatement of them in finely detailed fabricated metalwork. The goal is for the finished work to be so orchestrated that the melody is compelling and complete, and for the complex supporting variations (the details) to be unifying.

The underlying, sustaining motive for my work remains the same whether the subject is the natural, political, or mythical world: it is to get closer to the unbearable beauty and mystery of it, and through my work, momentarily turn away what is painful in the world by overpowering it with the beauty of benevolence.

All my work is unique; each is signed, dated, numbered, and titled with a poem; all of which is engraved on the back. This work is titled Kabuki Kachina comes to you with a glad heart...

—**Marianne Hunter**

Marianne Hunter, *Kabuki Kachina comes to you with a glad heart*, 1997. Grisaille and foil enamels, opal, tanzanite, tourmaline, and diamond, fabricated and engraved. Photo by George Post.

various tools of jewelrymaking will make you aware of your ability and aptitude. Join a jewelry club, and find out about gem societies in your area. Study ancient and contemporary jewelry design and techniques at museums, and in books and magazines. Visit local crafts and jewelry shops to see what is being done in jewelry design. See page 224 for titles of some magazines.

What schools offer necessary programs?

Some art schools and colleges have extensive jewelry programs, and some craft centers have teachers who can help you begin a career in jewelry design. Schools that feature strong crafts programs generally have a good jewelry department and teachers. Check the charts beginning on page 229, write to several schools for catalogs (or check their Web sites), and review course lists. Jewelry-design students study drawing, painting, design, and business, so the school you choose should have a good general program in art-career preparation. As in other craft areas, success in jewelry design does not depend upon a degree. A wide variety of art courses, however, will provide an extremely important foundation on which to develop your career.

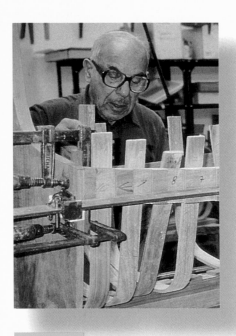

Sam Maloof at work in his spacious work-shop, surrounded by works in process. Photo courtesy the artist.

Maloof repeats some designs he finds particularly satisfying. His settee and other designs express his love and understanding of wood and of the hand processes he uses to shape wood into furniture. Photo courtesy the artist.

Woodworker: Sam Maloof

Born of Lebanese immigrants, Sam Maloof grew up in the Claremont, California, area. After service in World War II, he returned to attend the Claremont Graduate School as an art student. He began his art career by working at various graphic-design jobs and printing serigraphs for his friend and art teacher, Millard Sheets.

Because of a lack of money and furniture after he married in 1948, Maloof built furniture from scraps of plywood; his garage became his first studio/workshop. He says, "I learned just by trial and error. I did it by the seat of my pants." By 1951, his furniture was becoming increasingly admired, and he built a larger workshop, which he still uses, and in which, according to experts and authorities, much of the finest woodworking of the twentieth century has taken place.

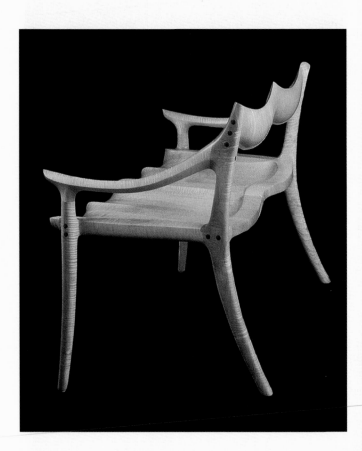

His working studio contains many racks on which his hand-selected wood is continuously turned and examined, and where pieces await his selection and expert touch. Maloof chooses each piece for the positive contribution it will make to the finished work, and he is completely familiar with his inventory of wood. A tour through this workshop reveals the respect, care, and concern that the artist shows his materials and tools.

Maloof has had to employ one or two woodworkers to assist him in turning out the approximately fifty orders for rare and valued furniture that are commissioned each year. He designs and builds furniture only by commission, and keeps a backlog of orders requiring three or more years to fill. Collectors wait eagerly for their rocking chair, settee, bench, chest, side table, or credenza to arrive. Maloof estimates that he has built at least 3,000 pieces since he first started crafting furniture about fifty years ago.

Maloof's early work was exhibited at the 1964 New York World's Fair, the Pasadena Museum, the Renwick Gallery of the Smithsonian Institution, and the Boston Museum of Fine Arts, which now holds fourteen of his pieces in its permanent collection. Today, most major museums in America have one or more of his pieces.

From a humble beginning, Sam Maloof has developed his woodworking craft to the highest possible level. He instructs at several California colleges and at Anderson Ranch Art Center in Snowmass Village, Colorado, where he and his wife provide scholarships for woodworking students. Maloof not only produces some of the finest crafted woodworking prod-ucts in the world, but he also shares his knowledge and skills in many ways to ensure the continuation of the craft.

Maloof's home is often visited by students, world-famous craftspeople, reporters, and countless art organizations. Every part of his home is handcrafted of exceptional materials —he has added to it until it seems to be a huge and complex piece of the woodworker's furniture.

When asked how he should be classified—as an artist or as a craftsman, this superb artist who works in wood replies simply, "I like to be thought of as a woodworker."

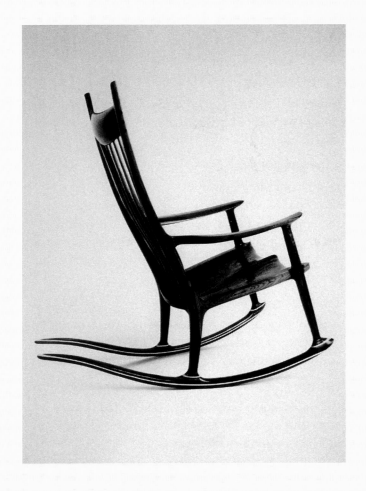

The flowing curves in this rocking chair reveal Maloof's sensitive melding of form and function. Photo courtesy the artist.

Other Careers in the Crafts

Some of the many craft careers are described briefly here.

Appliqué Artist

Appliqué artists make decorative pieces by stitching shapes of colored cloth to a background. Artists also use appliqué with paper (découpage) and with metals.

Basketmaker

Basketmakers use natural fibers to make plaited or woven objects. They produce baskets, boxes, animal forms, masks, and other three-dimensional forms.

Batik Artist

Batik artists use waxes, dyes, and various needles and brushes to create one-of-a-kind designs on fabrics. (The wax acts as a resist.)

Bookbinder

Bookbinders assemble and produce handmade books. They cut, trim, and stitch special papers, leathers, and other materials to produce unique books.

Candlemaker

Candlemakers use wax, colorants, and textural materials to make both utilitarian and complex, decorative candles.

Cloisonné Artist

(See Enamelist, below.)
Cloisonné is a specific enameling technique in which the artist fuses fine wires into melted glass, forming outlines to the design's shapes. Gemstones may also be included. The artist's finished work may be utilitarian or decorative.

Découpage Artist

A découpage artist covers an object's surfaces with cutout paper figures or designs. Découpage might be considered collaging on three-dimensional surfaces.

Embroiderer

An embroiderer uses needles and colored threads to embellish or decorate fabrics with raised designs on finished clothing or tableware.

Enamelist

(See Cloisonné Artist, above.)
Enamelists make artworks by fusing powdered, crushed glass to metal, firing at high temperature. The durability and luminous appearance of enamel might attract an artist to work in this medium. Often, multiple firings are necessary to achieve the desired results.

Fiber Artist

Fiber artists work with many kinds of materials and fibers to create fabrics, wall hangings, sculptures, tapestries, and wearable art. Macramé, fabric collage, and handpainted clothing are examples.

Gem Cutter

(See Lapidarist, below.)

Glass Artist

Glass artists make one-of-a-kind pieces for exhibition and sale. They use traditional glass techniques—blowing, forming, coloring, finishing—but produce unique work by varying the application of those techniques.

Glass Craftsperson

Glass craftspeople work for commercial glassware companies, which need many specialists in various areas of glass production.

GLASSBLOWERS remove a glass blob from the kiln and blow air into it through a long tube.

GLASS DECORATORS cut or etch designs in all types of glassware.

GLASS ENGRAVERS use stone, copper, and steel wheels to engrave designs, initials, or pictures in glassware.

GLASSWARE FINISHERS finish hand-blown or pressed glassware by forming and attaching pedestals, lips, decorative additions, and handles.

Goldsmith

(See Metalsmith, below.)

Lapidarist

Lapidarists, or gem cutters, cut, polish, and engrave gems or precious stones. These craftspeople must have technical knowledge of gems and stones, their quality, various cuts, and methods of polishing and setting.

Leather Worker

Leather artisans work on hides, often through all the processes of tanning, treating, toning, graining, cutting, embossing, carving, decorating, and finishing. They make leather accessories, clothing, and artworks.

Marquetry Artist

Marquetry artists inlay small pieces of wood veneer, mother of pearl, or metal in designs or patterns into wood or another surface.

Metalsmith

Metalsmiths work in many metals to create jewelry, body ornaments, chains, and decorative and functional objects. (See also Jewelry Designer, page 170.)

Mosaicist

Mosaicists make designs and pictures by setting *tesserae* (pieces of stone, glass, or ceramics) into a mastic or plaster grout. Mosaicists often work on murals and wall designs for churches, civic buildings, and public areas.

Musical Instrumentmaker

Craftspeople who make violins, violas, guitars, lutes, and other musical instruments from wood must be masters of their craft, with knowledge of the qualities of sound, tone, and resonance.

Needleworker

Needleworkers use many types of stitches in techniques such as patchwork, soft sculpture, appliqué, cloth collage, stitchery, embroidery, crochet, quilting, needlepoint, crewel, molamaking, and reverse appliqué.

Ornamental Ironworker

(See Other Careers in Industrial Design, page 118.)

Papermaker

Papermakers use plant fibers to form handmade paper. The fibers are cooked and beaten, and the resulting pulp is formed into sheets, pressed, and dried.

Puppeteer

(See Puppet Designer, page 151.)

Quilter

Quilters work both by hand and machine to make bed coverings or artworks for display. They stitch layers of fabric together and create intricate designs.

Rugmaker

Professional rugmakers design and complete custom-designed rugs for clients and interior designers, and for gallery exhibitions. They use their fingers, needles, latch hooks, and punch needles to tie the many types of knots for different rug styles.

Silversmith

(See Metalsmith, above.)

Stained-Glass Designer

Stained-glass designers make working drawings (called cartoons) and then prepare glass for fabrication into windows or art objects. They develop techniques for cutting and placing the glass, leading, soldering, and finishing.

Tapestry Worker

Tapestries are colorful hand- or loom-woven wall hangings with pictures woven into them. Tapestry workers include designers, cartoon patternmakers, loom workers who set up the looms and supervise the weaving process, and the loom operators themselves.

Weaver

Weavers use looms of various types and many kinds of fibers or yarns to create unique textiles. Usually, they create their own designs and patterns, which vary from extremely complex to elegantly simple.

Wood-carver

Wood-carvers use knives and various cutting tools and abrasives to create artworks from various woods.

Woodcrafter

Woodcrafters produce custom cabinetry, furniture, boxes, and office or household items. They have mastered all the techniques for cutting, forming, joining, and finishing woods. They often work on entire projects from concept to finished work, although several artisans may work together in larger studios, and thereby share the tasks.

The art teacher is often the catalyst in the development of future artists and designers.

Al Porter, secondary-art supervisor, professor of art education, Cal State, Fullerton

Al Porter

Perhaps no other career has the impact on our society that teaching has. The training and development of the young segment of our population should be given the highest priority of this nation's goals. The significance of the visual arts in both the economic and cultural vitality of this country cannot be overstated. Thus, the importance of preparing new candidates for careers as art teachers is profound.

The pressing needs for a host of art-trained specialists to meet the demands of industry are ever-growing. Practically every product manufactured involves the expertise of a designer. The art teacher is often the catalyst in the development of future artists and designers. Of equal importance is the growth in aesthetic judgment that art education gives to all students. This ability to make critical art decisions assures the best choices in what we buy and in our capacity for visual enjoyment.

The career of art teachers is one of creative growth and expanding knowledge. It offers the opportunity to develop fully as an artist and to broaden the opportunities for teaching on different levels. Advanced degrees and credentials provide promotional possibilities.

Teaching's greatest reward is working with students to develop their potentials. Sharing knowledge and insights on the important concepts and skills of art gives a satisfaction that is uniquely gratifying.

The need for well-qualified art teachers is nationwide. Choosing to teach will offer a professional career that provides creative growth and challenge.

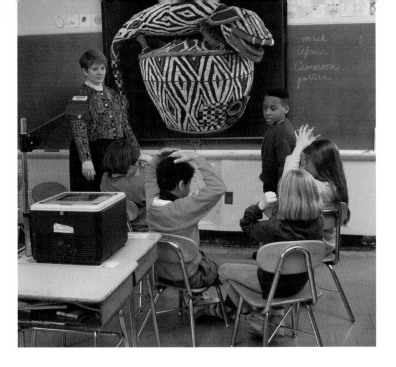

Art teachers use many visual technologies to aid in showing artwork, techniques, and historical examples to their students.

Art Education

At first glance, the bond of education to fine arts, crafts, and cultural enrichment may not be as obvious as the careers of sculptors, printmakers, and museum directors. School art programs, however, establish the foundation for a lifelong enjoyment of the visual arts.

Art education usually begins in preschool and kindergarten with painting and drawing, and exposure to illustrations and the works of past artists. It continues through the grades and into high school, where it becomes more specialized, more concerned with processes and techniques, and with preparation for college or careers in art. Colleges and art schools help prepare students for the careers described in this book, and provide instruction in art appreciation and art history.

Art education is not an isolated study of certain skills. It enriches the school curriculum and gives young children a way to react creatively to their environment; as they grow older, art teaches them to appreciate the skills and communicative abilities of others and to enjoy beautiful things. The art teacher is the catalyst in this enrichment process, and his or her art career can be extremely rewarding.

One of the goals of art teaching is to produce competent, expressive artists who have experience in a variety of artistic methods. Art teachers also understand the inherent value of art in the total educational process, its importance to economic and social interaction, and its capacity to enrich life. The teaching of art in elementary and secondary schools can be carried out in several practical situations: the general classroom, where all subjects are taught by a single teacher; the specialized artroom, where drawing, painting, and the like are taught by an artist-teacher; the magnet program, where art is the core upon which other studies in the school are built; and/or the integrated program, where all parts of the school curriculum are infused with art concepts. The basic components of an art program are activities that help students develop perceptual and expressive skills, understand their cultural heritage, and develop their abilities to make aesthetic judgments.

Art students entering colleges or art schools are faced with important decisions. Education at this level can lead either to an immediate teaching career or to advanced research and doctoral studies. Some graduates prefer administration, management, or the development of art programs and curricula. Museum education, community services, college instruction, research, and therapy are some other areas open to career-seeking students.

Art Teacher (K–12)

Teachers of art open the door to visual communication. Creative teaching is a dynamic process that can change the life of students, making them visually aware of their environment and the artistic expression of others. Art teachers must be familiar with all forms of visual expression, have a working acquaintance with all media, and a solid foundation in art history. Such a background helps them stimulate young people, sharpen their awareness, and open their eyes. Art can be the most exciting part of a school's curriculum. The magic that can happen in artrooms is both the responsibility and the reward of the art teacher.

What does a K–12 art teacher do?

It is not the task of art teachers to make artists of all their students. To teach art is to give students opportunities and experiences that will enable them to understand, record, and interpret new information creatively. Teachers help students learn to use a variety of media to express their ideas about the world around them, exploring as many avenues of visual communication as possible. Teachers are catalysts in the process whereby children learn to make aesthetic judgments. Art teachers must develop courses that will satisfy such goals. Every school in the country has a unique physical and social environment; sensitive art teachers must devise courses of study that will meet the individual requirements of each situation. They also must structure their courses to fulfill certain requirements, usually determined by school, district, state, or national standards. Within certain boundaries, the teachers select media, projects, and subjects that best satisfy those requirements.

Teachers arrange projects and lessons in a suitable sequence—outlines that become the art curricula. Teachers try to give their students as much experience, with media and tools, as resources and time will allow. How teachers meet this challenge depends on their individual feelings about teaching. Some wish to keep all members of their class working on the same project; others are comfortable with many activities happening simultaneously. The goals of both kinds of teachers may be the same, but they are reached by different routes. Teaching art is a creative career. There are many ways to teach, but all art teaching involves planning, demonstrating, providing materials, leading discussions, evaluating, and displaying the work of the students.

Teachers of upper-level grades will want to encourage students who wish to pursue a career in art. These students need both a solid foundation and expert guidance—for example, in helping seniors select work for their portfolio.

What qualities are helpful to an art teacher?

Art teachers must be enthusiastic about sharing their knowledge and skills, and must be able to communicate well with young people while demonstrating and explaining a variety of techniques in many media. They must also understand learning processes, work well on a one-to-one basis with each student, and offer students a sense of freedom within a structured situation. Organizational skills, especially for the set-up of materials, are critical.

An art teacher has the prime responsibility for developing the visual insights and directing the creative energies of his or her students. Fifth-grade teacher Catherine Leffler is working with a student to guide her in solving a visual-design problem. The J. Paul Getty Trust. Photo by Don Farber.

What other careers require similar qualities?

The ability to work with young people and to be able to organize vast amounts of material into relevant courses of study is required in all areas of art teaching: museum education, community workshops, adult programs, painting workshops, and the like. People who teach in colleges and art schools need similar qualifications and interests, but also need expertise in specialized fields. Art specialists and consultants (see Other Careers in Art Education on page 184), children's book authors and illustrators, and writers of student art materials, teachers' art magazines, and art books are often former (or current) art teachers.

What can you do now?

To establish a resource-rich background for teaching, take all available art courses: drawing, painting, printmaking, sculpture, crafts, design, and art history. Volunteer at a summer arts and crafts program in a recreation park, camp, school, or church. Such experience, as well as work in a crafts program for the elderly, is an excellent background for teaching. Watch your own teachers in class to discover the scope of an art teacher's career, and think about how you would do things under similar circumstances. Titles of magazines you may wish to see at the library are on page 224.

What schools offer necessary programs?

Most art schools do not train art students to be teachers. To become an art teacher, the program of study involves both education and art. Almost all colleges and universities that offer degrees in teaching provide such programs, as do state colleges and universities that have an education department. Check with your state university, and consult the charts beginning on page 229.

Inspiration

The energy that fuels the art teacher is joy—at unveiling a wider world to the child through art. In teaching, we are constantly renewing ourselves and our students through creativity.

—from the bulletin of the School of Visual Arts, New York City, 1996

Art teacher Joe Gatto works with exceptional high-school art students to explain design concepts in connection with a group painting project. Photo by Herb Shoebridge.

College Art Instructor

When we realize that all manufactured goods, decorative work, and fine arts are designed and often produced by artists, we begin to understand how great is the responsibility of the college art instructor. The art student's initial professional contact, growing awareness, and increasing competence in any area of art are usually developed in college artrooms and studios. This has not always been so. From ancient times until the seventeenth century, young people wishing to become artists would apprentice themselves to master artists from whom they learned the basics of drawing, color, design, and technique. The first art academy was established in France in the seventeenth century. Its teachers, hired by the government, taught what government officials thought was the best kind of art. In the late nineteenth century, American colleges opened art divisions, and teachers' colleges began programs to train future teachers in the instruction of art. Today, college art departments give students a basic foundation in every phase of art. Many schools include business classes in the art program so that students will be able to make intelligent financial decisions in their career.

What does a college art instructor do?

Art instructors must have a basic understanding of the institution's art program and must be able to devise courses of instruction that meet its goals. Following an outline, they instruct, guide, encourage, critique, and motivate their students to the highest possible degree of excellence. This is done both in classroom situations and with individual students. The instructor advises each student on his or her artwork, techniques, philosophy, and career selection.

Instructors are specialists, and are often competent artists in their own field. Architects, graphic designers, sculptors, stage designers, and art historians, for example, pass on to students the knowledge they have gained in their own professional career. Through relationships with their instructors, students begin to choose their own career.

College instructors who are successful professional artists are often encouraged by school administrators and department heads to continue their professional activities. Painters, sculptors, and craftspeople produce work for exhibitions and sale; architects serve as consultants; graphic artists and designers maintain their own commercial studio. These outside activities not only allow for personal professional

Graphics- and packaging-design students at Art Center College of Design discuss the appropriateness of shape and visual message for product packaging. Photo ©Steven A. Heller, Art Center College of Design, Pasadena, California.

growth, but also help keep teachers aware of trends in their field.

Instructors often serve on various committees: those that judge the portfolios of incoming freshmen, those that decide on new courses or graduate programs, and those that approve new faculty or counsel students on careers. These are important responsibilities that lie beyond the boundaries of actual classroom teaching.

What qualities are helpful to a college instructor?

The ability to work closely with students is as essential as the desire to communicate the importance of the arts. College teachers must have a historical perspective about the arts, excellent skills in their field, and an ability to communicate clearly. Cooperation with colleagues and staff is essential if the department is to function as a unit. Willingness to change and experiment is necessary, and instructors must be aware of contemporary trends and ideas in order to share new knowledge and skills, as well as demonstrate traditional techniques and skills.

What other careers require similar qualities?

All teaching and research situations require similar skills. Expertise in special areas is transferable to related art careers such as counselor, K–12 art supervisor, curriculum specialist, government art program advisor, author or lecturer in art, museum researcher and art historian, art publishing consultant, museum docent, art-project director, and consultant for or staff member of a historical society or corporate art program.

What can you do now?

Try to develop broad interest in all areas of art by taking available courses. As a college art teacher, you must be proficient in a specialized area, so choose it carefully. Review the career requirements in this book to help you determine what you can do now in each area of interest. Titles of magazines that may provide more information on specialized areas and on teaching are on page 224.

Art Instructors: A Perspective

[Art teachers are] cultural workers with a responsibility for transmitting a decent idea of the social to successive generations of students. The first glimmerings of that idea in art appear when children discover that their image making is more than a sign of their aliveness or an expression of their power over the phenomenal world. Teaching fosters that discovery: the social character of art instruction teaches children that art is a type of making for, showing to, and communicating with, someone else.

—Edmund B. Feldman, University of Georgia, 1996

What schools offer necessary programs?

There are no schools that specifically train people to be college art teachers. Art professors come from a professional art career or from an education background. Some college teachers begin their teaching career directly upon graduation from college or immediately after earning advanced degrees.

Art Historian

Today, the work of an art historian covers a range of specialties and activities, including research, writing, teaching, film production, lecturing, and library work in books, films, slides, video tapes, videodiscs, CD-ROMs, and other media. All these specialties deal with the history of art and the impact art has had on the world's societies. Art historians are concerned with the reasons people have created art and the influences one generation of artists has had on another.

The first art historian is considered to be Pliny the Elder, a first-century Roman scholar, who researched earlier sources to write a history of fine art. The subject was not studied again in depth until Giorgio Vasari, a sixteenth-century Italian, wrote about the painters, architects, and sculptors of the Renaissance period. While Pliny thought of artists as craftspeople (like furnituremakers), Vasari considered them professionals, the peers of philosophers and poets. With the establishment of the art academies in seventeenth-century Europe, art history became a subject to be studied, and has since become an increasingly sophisticated discipline.

What an art historian chooses to study and become expert in can vary from areas such as early Renaissance art in Europe to pre-Columbian art of Mexico to Nubian art of the eighth century BC. Some art historians specialize in the art of an area, a country, or a period; others make areas such as architecture or sculpture their emphasis.

What does an art historian do?

Hundreds of art books in stores today were written by art historians to help shed light on art and artists of the past and present. To gain the knowledge required to write such books, these authors conduct an enormous amount of research and travel internationally to view original art. Art historians who write must seek out the best sources of information. Their most accurate information is likely to be firsthand study of artwork and original historic documents; second best is the authoritative writing of other historians. The results of an art historian's research might provide information for other authors or the back-ground for a film, or may lead to a better understanding of an artist or artistic period.

Because many art historians wish to share their knowledge and experience with others, they often become teachers. Most colleges have at least one art-history teacher on their faculty. Some art-history instructors teach survey courses to the general student population, acquainting them with major artworks and the principal art movements and styles. Others teach in specialized areas such as Baroque art, Asian art, or the art of the sixties. As teachers, they are responsible for the transfer of knowledge about art to the next generation of artists and art historians. In schools with a small faculty, an art-history teacher might also teach studio classes or courses in art appreciation.

Many films, videos, and videodiscs are based on the life and works of various artists. Great visual resources such as artworks help filmmakers create visually exciting documentation, and the work of art historians plays a major role in such productions, which are shown on art-oriented TV stations, on public television, and in the nation's classrooms.

For the teaching of art history at all levels of education, there is a need for visual study aids such as slides, prints, videos, CD-ROMs, filmstrips, and other media. Those who produce and arrange these study aids must have an art-history background. Because they provide students with exposure to all types of artwork, slides are the backbone of the art-history teacher's instructional materials.

What qualities are helpful to an art historian?

Art historians must enjoy all facets of history including economic, political, and social influences. They must enjoy conducting research, which means that they are patient, organized, adept at notetaking, and able to organize researched material into easy-to-understand blocks of information. Because much of their original sources are in a foreign language, knowledge of several appropriate languages is helpful. Art historians must stay current with technology, be articulate, understand cause-and-effect relationships in art, and enjoy sharing their excitement about art history.

What other careers require similar qualities?

Historians of all types need similar abilities. Museum staff often have an art-history background, as do many writers for art magazines and other periodicals that include art features. Researchers, librarians, and writers in other fine arts (music, dance, drama) need similar abilities, but require a different background.

What can you do now?

Take art-history classes and general history classes, which will give you insight into political and social influences on art and artists. Try to visit museums and galleries of all types to see permanent collections and touring exhibits. Attend museum lectures and classes in various aspects of art history. Read books recommended by your art instructor or school librarian. Study another language.

What schools offer necessary programs?

Almost all schools have some courses in art history, but because the advanced study necessary to obtain a degree in art history is so specialized, only schools with extensive art programs offer sufficient courses. Check the charts at the back of the book. If a career in art history interests you, explore many areas, periods, and types of art before specializing. Select a college that fits your requirements. Write to schools or check the Internet for information on what art-history emphases are available.

A Course of Study in Art History

The variety of courses in art history is astonishing, and the selection at each college or art school will depend upon the interests and qualifications of the faculty members. This group of courses is typical of what is available in one university's art department.

Ancient and Medieval Art
Renaissance through Modern Art
African, New World and Oceanic Art
Introduction to East Asian Art
Classical Art and Archaeology
The Art of the Classical Age of Greece
Art of the Roman Empire from Augustus to Constantine
History of Greek Sculpture
History and Methodology of Classical Archaeology
Roman Painting
Greek Architecture
Roman Sculpture
Roman Architecture
Fieldwork in Ancient and Medieval Archaeology
Survey of Medieval Art
Early Medieval Art
Romanesque and Gothic Art
Medieval Architecture
Early Christian Art
Byzantine Art
History of Medieval Stained Glass
Renaissance and Baroque Art in Italy
Fourteenth- and Fifteenth-Century Art in Italy
Sixteenth- and Seventeenth-Century Art in Southern Europe
From van Eyck to Vermeer
Age of Rubens and Rembrandt
Trecento Italian Painting
Italian Art of the Fifteenth Century
Early Netherlandish Painting
Nineteenth-Century European Art
Twentieth-Century Art
American Art to 1913
American Architecture
Nineteenth-Century Painting
American Art to 1865
American Art 1865–1940
History of Photography
Introduction to African Art
African Art in Western Thought
Art of the South Pacific
Art of Pre-Columbian America
Art of Sub-Saharan Africa
Art, Craft and Technology in Sub-Saharan Africa
Survey of Islamic Art
Art of Japan
Art and Archaeology of Early China
Early Chinese Painting
Later Chinese Painting
History of Portraiture
Art and Perception
Art Theory
Images of Nature
Museum Studies and Museum Materials
History of Print
Russian Art

—from Indiana University, Bloomington

Other Careers in Art Education

Art-Center Education Director or Staff Worker

(See Art-Program Director and Instructor, below.)

Art Consultant

(See also Art Supervisor, below.)

Art consultants are school-district personnel who suggest programs to teachers but are not responsible for implementation or for the hiring of personnel. Available for consultations at the district offices, they provide new ideas and programs, hold in-service workshops, and demonstrate new techniques and teaching methods.

Art Coordinator

(See Art Supervisor, below.)

Art Curriculum Director

(See Art Supervisor, below.)

Artist-in-Residence

Some schools or school districts establish artist-in-residence programs in which successful and practicing artists are paid to set up a studio and work in the schools, just as they would in their own studio. Students visit the school studio to watch the artist at work, and to ask questions about careers, techniques, and concepts. Discussions, seminars, and lectures are usually part of the program, but the artist is often given the freedom to select media, subject, and type of work to be done. Artist-in-residence programs run for varying lengths of time and are temporary positions. Often, the artist's completed work remains at the school.

Art-Program Director and Instructor

(See also Workshop Instructor, below)

The director makes arrangements for recruiting students, obtaining facilities, and hiring instructors. Programs may vary from a Saturday printmaking workshop at a downtown workspace to a painting trip to China. Directors generally have a strong interest in art, are able to coordinate schedules, and make travel arrangements.

Workshop instructors demonstrate, lecture, and critique student work. Usually, they are hired because of their expertise, reputation, and artistic specialty. These artists must be accustomed to working on location.

Workshops and art centers are excellent places for people to develop their interest in various kinds of art. Some of these centers are sponsored by local art organizations, or are extensions of museum or gallery complexes. Others are run by individuals who advertise for students in art magazines or through the mail. Some centers provide space and personnel for student art exhibitions.

Art Specialist

(See also Art Supervisor, below.)

An art specialist usually has the same general job description as an art supervisor, but often specializes in one area, such as elementary-school art. If a specialist is hired to teach elementary-school art in a district, he or she may rotate from room to room or from school to school to work with students as their art teacher. Specialists may also be in charge of day-to-day contact with classroom teachers, helping them develop their own art lessons. In this capacity, specialists work under the district art supervisor.

Art Supervisor

Art supervisors are in charge of implementing art programs in school districts. Some districts have two programs—one for elementary and another for secondary schools, or they may have one supervisor for grades K–12. Art supervisors function at several levels. On one level, they are concerned with the administration of art programs: budgets, schedules, in-service training, and efficient use of personnel and time. On the other level, they are concerned with classroom teaching: student-teacher relationships, the physical environment of the artrooms, the quality of instruction, and the achievement of the national standards for art education. Supervisors are ultimately responsible to the school board for the development and implementation of art programs, but are also responsible to the public.

Author of Art-Education Books

(See also Art Writer, page 204.)
The 1980s saw the development of interest in art textbooks for schools. Student editions and teachers' guides are written and produced for elementary- and high-school classes. Authors are generally teachers or art supervisors who have a strong desire to share what they have learned about teaching. Art resource books help teachers instruct, and supply them with important information in subject matter or media.

Educational-Software Designer

While this career fits logically in the graphic-design section of this book, it is also an important cog in art education. Software programs that help teach art skills, techniques, concepts, imagery, and art history are helpful on a class or individual basis. The designers of these programs are often art teachers who have extensive computer skills and are interested in sharing their expertise.

Educational-Video Producer and Designer

People who produce educational video tapes in the arts gather artists, teachers, camerapeople, technicians, and sometimes students to develop theme-oriented video programs. The video might revolve around a subject (landscape or figure), a technique (collage or colored-pencil drawing), or a goal (understanding perspective drawing); or might focus on art history. The products—which demonstrate working methods, skills, concepts, and subject development—are used in classrooms and by individuals.

Museum Educator

(See page 187.)

Photography Teacher

(See Other Careers in Photography, page 100.)

Private Art Instructor

Private art instructors teach one art technique or several to children or adults, usually in a rented space or in their own studio. The teachers are responsible for recruiting students; for arranging for fees, supplies, models, and materials; and for instruction and critiquing.

Teacher's Aide

Teachers' aides need not have advanced training in art, but must have a strong appreciation of it and a desire to help students and teachers in the artroom. The aides help teachers carry out their schedules and help students as they work. Aides prepare work areas, supervise the checking in and out of tools and materials, and help with cleanup. Usually, aides are volunteers.

Workshop Instructor

Workshop instructors teach art to groups of every age, usually by demonstration, personal assistance, and critiques. They are hired by art associations, professional workshop agencies, travel agents, school districts, or state art-teacher organizations.

Workshop Promoters

Workshop promoters are agents who put together travel packages that bring artists and prominent artist-teachers together in a domestic or foreign situation. Some promoters specialize in overseas travel workshops; others provide sessions in picturesque locations in the United States.

"My initial contact at the museum captivated me . . ."

Richard Koshalek, director, Museum of Contemporary Art, Los Angeles

Richard Koshalek

My first contact with the arts was through architecture, as my father, an electrical contractor, would invite architects to our home for discussions of their projects. My passion for architecture eventually led me to advanced degrees in architecture and art history.

At my first job for an architectural firm, a chance meeting led to an opportunity to apply for a position at the Walker Art Center in Minneapolis. My initial contact at the museum captivated me with the tremendous energy and creative spirit encountered in the museum environment. I began work as an exhibition coordinator followed by positions of assistant curator, associate curator, and eventually full curator. I later worked for the National Endowment for the Arts as assistant director, which finally led to the directorships at the Fort Worth Art Museum, The Hudson River Museum of Westchester, and finally to the Museum of Contemporary Art in Los Angeles.

One of the more challenging tasks of museum director is fund raising. During times when national funding is decreasing, the raising of needed funds is critical to maintaining a high standard of programming.

Throughout my involvement with the arts, there have been many amazing opportunities to work with extraordinary individuals from all over the world—this includes not only artists and cultural leaders, but a wide spectrum of individuals in areas such as academia, architecture, politics, science, entertainment, and business.

Within the extremely demanding role as director of MOCA, I enjoy finding time to organize several important exhibitions, and I am currently working on one of the newly created works by Richard Serra and also a comprehensive exhibition on the history of architecture in the twentieth century.

Museum directors require charisma, enthusiasm, and boundless energy to provide the necessary leadership to integrate various artforms, people, and ideas to create a more original institution.

A major gallery space in the Museum of Contemporary Art contains selections from its permanent collection, including the paintings of Mark Rothko and the sculptures of Alberto Giacometti. At other times, the space features other artworks or important special exhibitions. Courtesy the Museum of Contemporary Art, Los Angeles. Photo by Sue Tallon.

Art Museums

In the simplest terms, museums are the custodians of and repositories for artwork. They make rare, valuable, and famous works available for public study, enjoyment, and appreciation.

There is no standard size for a museum. Some are small and may contain only the collection of a single family, as does the Frick Collection, in New York. Others are huge; the Louvre, in Paris, includes the art accumulations of the entire French nation. Some museums are the recipients of large individual collections such as the Kress and the Mellon collections, now in the National Gallery, in Washington, D.C. Many museums start with a single major collection and add to it with museum purchases and donations, gifts, and loans of works from interested people. Some museums contain collections from a single period; others may display a cross section of art from all periods of history. Some may exhibit only work from their permanent collection; others allow space for traveling exhibits, exchange exhibitions from other museums, or the work of local or other contemporary artists.

Although the primary and most obvious function of art museums is to show the viewing public the works of various artists, it is not the sole reason for their existence. *Education* is a major concern: lec-

tures, films, and slide programs for both children and adults can help them understand art, its history, and its contributions to world cultures. *Restoration* and repair of artworks is usually done by the museum's conservation department. Specialists use sophisticated equipment to detect deterioration in artwork, analyze present conditions, and repair the artwork. *Art libraries* are important adjuncts to most museums, and the collected books, catalogs, and pamphlets are available to staff, members of museum associations, scholars, researchers, writers, and—usually by special arrangement—the public. Museums must maintain comprehensive libraries of slides, photographs, and descriptions of each piece in their collections. Most museums maintain extensive databases on computer. They have storage and crating facilities for works not on display. Museum bookstores contain art books, slides, pictures, artifacts, and original crafts for sale. Some museums include rental galleries, from which the work of contemporary artists may be rented or purchased.

Museums also design and print many publications. The larger institutions have writers and graphic designers on staff to publish catalogs, booklets, books, calendars, and members' reports and bulletins. Staff photographers produce pictures and slides for publication, publicity, or reference purposes. Display artists design and build cabinets, display boxes and tables, podiums, and walls. They also design the lighting for displays of the artwork.

Museum Director and Curator

The size of a museum determines the number of curators on its staff, but there is only one director in charge of each museum's operations. Directors for America's 10,000 museums of various types achieve their position by climbing to the top of the curatorial ladder. Curators and directors have a background in art history, with emphasis on their area of special interest (such as Islamic, American, or European art; textiles; film; or prints and drawings). Some may have been painters or sculptors at one time, but most are art historians, knowledgeable about lecturing, research, and scholarly writing.

What does a museum director do?

Museum directors are in charge of the operation, growth, and functioning of the entire museum. They have an understanding of all museum jobs and positions—and are completely responsible for the organization of the staff, which may range from a dozen people to many hundreds. They are knowledgeable about all areas of art history, although they can also rely on the expertise of their curators when necessary. In addition to their scholarly achievements (many museum directors hold a Ph.D. degree), they are skilled in planning, development, budgets, and finances. They are often responsible to city or county governments and to a board of directors. Some directors have an assistant or deputy director to help handle administrative tasks.

Museum directors seek donations of important artwork to add to their collections, or they try to raise money to purchase such work. They arrange for financial grants and government assistance. Directors are highly visible people; they represent both the museum and the larger cultural community.

What does a museum curator do?

The visual presentations that the public sees are the work of curators. Curators in large museums may be in charge of a single, specialized area, such as Indian art; in smaller institutions, they may be in charge of everything that has to do with exhibitions and displays. Curators are generally art historians and administrators. Their career often begins in a registrar's office (see Other Careers in Art Museums, page 192), where they learn about research, collections, paperwork, insurance, cataloging, and other administrative details.

Curators purchase new works for collections, arrange for traveling exhibitions, work with display artists to install displays, work with budgets, and write essays for exhibition catalogs. They also search out sources such as galleries, auctions, other collections, artists' studios, and catalogs of all types for further acquisitions. They read specific and general art reference materials to stay abreast of developments in their area of expertise. If a curator has a particular specialty, he or she may be asked to be a guest curator at another museum, and be in charge of arrangements for gathering and mounting special exhibitions and preparing catalogs.

Richard Koshalek (at right), director of the Museum of Contemporary Art, discusses the installation of an exhibition in the museum's ongoing program to bring the best of contemporary art to the people of Los Angeles. Photo courtesy MOCA.

What qualities are helpful to a museum director and a curator?

Directors and curators are basically involved with art history, and must enjoy research, study, and writing. The challenge of determining and working with budgets must be of interest to them. They therefore must be able to organize their time, resources, physical environment, and schedule to achieve optimum results. The research and study aspects of their careers are constant, so directors and curators must remain current with their fields of expertise. Because they work with people at all levels of museum operation and with the public, they must be patient and tolerant of others' views. Museum directors—and curators, but to a lesser extent—must be able to associate easily with patrons and political leaders, be adept at public relations, and therefore be able to communicate effectively and tactfully.

What other careers require similar qualities?

All areas of museum work require people who are interested in art history and in the many tasks associated with operating an art museum. Directors and curators of other types of museums require the same dedication to budgets, details, organization, and communication. Librarians (in museums, art schools, universities, and private collections) require the same skills in organization, research, writing, study, display, and attention to details. They also must be familiar with the available resources and know how to assist researchers, curators, and students in obtaining information. Curators may wish to become art-history teachers or directors of research because of their knowledge in a specialized area of study.

Many museum curators and directors prefer the "Beaux Arts" style museum gallery seen here. Its features include a large, simple, rectangular space and natural overhead light. Courtesy the J. Paul Getty Trust. Photo by Tom Bonner.

What can you do now?

Enroll in all the studio courses possible. In addition to classes in art history, take history classes (European, American, Asian, African, and so on) to broaden your historical background. To expand your communicative skills, take public speaking, English, and writing classes. Part-time or volunteer work at a museum helps develop a feeling for this career area. Try to visit museums and galleries regularly, noting lighting, the way exhibits are arranged, and how items are grouped and displayed. See page 224 for titles of magazines of interest to curators.

What schools offer necessary programs?

A bachelor's degree is the minimum requirement for starting a curatorial career; a master's degree is preferable, as it demonstrates a job applicant's familiarity with research, writing, study, and content. Most museum directors have earned a Ph.D. An increasing number of universities offer professional training in museum administration, which includes art history, community relations, exhibition planning and installation, fund-raising, and business management. Check the charts at the back of the book, write for catalogs, and check the Internet for information.

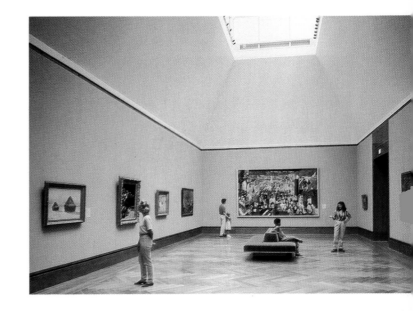

Conservator and Restorer

Every major museum has a conservation department staffed with conservators, restorers, computer experts, and artists with various specialties. These people study, authenticate, restore, clean, and touch up the artworks for the museum. Some specialists work with pieces being considered for purchase. Conservators and restorers have a deep concern for art history and understand materials, techniques, media, and styles. They use their knowledge of art along with sophisticated equipment to carry out their analyses and painstaking restorations and reconstructions.

Within the conservation field, there are separate categories that require extensive training, study, and practice. For example, in one museum, there may be separate laboratories for *analysis* (for identification, dating, determining materials), *objects* (for cleaning metal, wood, ceramics, and sculpture), *paper* (for protection from insects, mold, and fungus; and for mounting and cleaning), *textiles* (for washing, cleaning, restoring, reweaving, and redyeing), and *painting* (for study, restoration, determining media, repainting, and reframing). The conservation department is responsible for the care, protection, and authentication of all museum pieces (determining their age, style, history, and artist). Each piece is scheduled for periodic evaluations of deterioration or mutilation. Repairs are made as needed.

What does a conservator do?

A conservator's work is many-faceted. He or she treats each artwork in much the same way. After the piece is recorded by the registrar, it is examined, photographed, and sent to an appropriate laboratory. In the analysis laboratory, conservators give a date to the work, and test its materials to determine the best and safest way to treat and clean it. Here, conservators use various types of equipment for carbon-14 analysis (to determine age of certain materials), microscopy, and materials testing. Following such analysis, the work is sent to a laboratory where specialists clean, retouch, reweave, revarnish, repair, treat patinas, dry-clean, fumigate, and retard mold growth.

Conservators may use X-ray radiographic images and computer-image enhancement to separate images when two or more works exist, one over the other, on one canvas or wood panel. They may take infrared or ultraviolet readings to glean useful information. Some specialists use spacecraft photographic systems and image-processing equipment to study ancient works on paper. Conservators use preservation techniques such as Plexiglas encapsulation of works on paper to help maintain important documents, prints, drawings, and notes. Studies being made on the effects of ozone on art materials and the use of electrets and electrostatic charges to preserve works on paper might eliminate the need for fixatives.

What does a restorer do?

Restoration work plays an important part in the overall conservation of artworks. Restorers are specialists in repairing and restoring works made on canvas, paper, wood, tile, porcelain, metal, leather, and fabric. Restorers usually specialize in a single area, such as painting. They can reweave torn canvas, build up gesso grounds, eliminate worm holes, apply paint in the manner and style of the original artist, and refinish

Conservators make use of detailed photographic images to document the condition of an artwork. Photo by Adam Woolfitt.

Although frescoes often cover entire walls or ceilings, their restoration requires painstaking care and is accomplished inch by inch with the aid of tweezers, small sponges, and cotton swabs. Photo by Kim Newton.

the frame. This time-consuming, demanding, and important work can be done only after years of study and practice. Restorers sometimes undertake massive projects, like the renovation of the paintings on the inside dome of a state capitol or the restoration of the interior of an important theater. They also are involved with the restoration and reconstruction of architectural masterpieces, such as temples and monuments. Some restorers are employed by museums; others work in their own studio—for local museums, clients with extensive private collections, and the public.

What qualities are helpful to a conservation artist?

Artists who work in conservation and restoration must have extensive training in art history and at least one other specialized area, such as painting. They must enjoy working in detail, and spending time in study and research. They stay abreast of developing technologies, have confidence in their skills and abilities, and have patience for working long periods at one task. A studio background (painting, drawing, and the like) is essential to an understanding of the techniques and media they use, but just as important is a knowledge of chemistry and familiarity with chemical processes.

What other careers require similar qualities?

The combination of skills in research, art history, laboratory work, and a number of different art media are unique to this career area. Each skill may lead into other directions, but the combination is not required elsewhere. Conservators and restorers may teach their skills in museum workshops or university classes. Similar abilities and qualities (patience, care, attention to detail, ability to work for a long period at a single project) are necessary for work in museums, libraries, and collections.

What can you do now?

Take all the art-history and studio-art classes you can, and include courses in chemistry, physics, history, and computer technology. Read art books and frequent museums to study styles, finishes, colors, and techniques. Take a museum class, if available. Try to get part-time work at a museum or gallery. Titles of related magazines are listed on page 224.

What schools offer necessary programs?

Only a few universities offer programs in museum work (see the charts at the back of the book). Write to them for catalogs, which will indicate the extent of their course offerings, or look for information on the Internet. Check with museum schools about apprentice programs. Some museums offer courses in conservation. Solid training is a prime requisite for success in this career, so study, research, and degrees are essential.

Other Careers in Art Museums

Archaeologist

Much of the art from ancient cultures that can be seen in a museum is there because of the work of archaeologists. They uncover and identify the objects that belonged to past cultures in order to reveal and preserve a record of their life-style and art.

Art Historian

(See page 182.)

Bookstore Manager or Salesperson

Most art museums have a bookstore or museum shop where books, prints, artifacts, slides, and craft objects are sold. In larger museums, a manager runs the store; in smaller institutions, a volunteer or part-time worker might fill this position. Salespeople might be paid or might be volunteer docents. This is a career for sales-oriented people who are knowledgeable in art.

Computer Operator/Programmer

Computers are used in many aspects of art museum operations, such as inventory control, membership, mailings, data storage and retrieval, information on artists and artworks, and the technical aspects of conservation and restoration. Those interested both in computer technology and art may find fascinating applications in art-museum work.

Crate Builder

(See Other Careers in Art Services, page 218.)

Deputy Director

(See Museum Director and Curator, page 188.)

Display Artist/Designer

(See also Interior and Display Design, page 37.)
Display artists or designers design and build the cabinets, boxes, stages, podiums, and containers that are used to display objects in museum collections. These people are also responsible for the display lighting and environmental colors and textures. They work on staff in large museums, or they are outside artists who are hired by smaller museums to design and build the displays. Most display artists have a background in industrial design or interior design.

Docent

Docents are generally volunteers trained to lecture on special aspects of items in a museum. They take classes in art, study the museum collections carefully, and lead tours and explain techniques, styles, and periods of art that may be of interest to visitors.

Educational Services Coordinator

Educational services coordinators work with museum teachers (see below) in the planning and structuring of educational programs for children, teens, and adults. These might be classes, workshops, seminars, artist-in-residence programs, visiting lecturers, films, or tours.

Exhibitions and Publications Coordinator

Exhibitions and publications coordinators join the efforts of curators of special exhibits with those of the publications staff (writers, photographers, artists, historians, printers, and publishers). Exhibitions and publications departments develop meaningful literature and effective and attractive catalogs.

Film-Program Coordinator

Many art museums have extensive film collections. Either the films are historically important in and of themselves to the study of film, or their subject is art or artists. Film-program coordinators work with curators and the museum staff to develop schedules of film that are pertinent to current offerings.

Graphic Designer

(See also Graphic Designer, page 52.)
Art museums publish many catalogs, bulletins, newsletters, magazines, and books, all of which require graphic-design work. Graphic designers design both the banners and posters to celebrate exhibition openings, and the hundreds of signs and labels that guide visitors through the galleries. They coordinate the production and printing of these items. Large museums have their own graphic-design studio with an art director and designers.

Illustrator

(See also Publications Design and Illustration, page 73.)
Illustrators provide the museum publications with necessary artwork. Some of their work is technical (when working with conservators and restorers); some is creative and free in style. Illustrators work with graphic designers to develop catalogs and promotional literature. They may also illustrate some of the display areas, providing paintings and drawings for use as background or explanatory graphics.

Librarian

(See also Other Careers in Art Services, page 218.)
Large art museums have extensive libraries stocked with art books, catalogs, pamphlet files, and specialized writings and materials. The libraries are available to staff members, researchers, historians, graduate students, members of museum associations, and occasionally, the public. Their librarians have a broad background in art history and biographical materials, as well as the necessary skills in library science. Their work is extremely valuable to museum staff.

Museum Art Teacher

(See also Art Education, page 177.)
Museum art teachers hold classes in the museum's instructional areas. They may teach ceramics, painting, drawing, design, weaving, maskmaking, or other classes to children, teens, or adults. Their classes are generally oriented toward more experimentation than is possible in the school classroom, and their programs supplement the work of the art teachers in the community.

Museum Educator

Large museums usually have an education department liaison whose staff works with public and private schools in the community, arranging visits and tour schedules for students. In addition, the department arranges lectures, films, and other programs for children and adults in the community.

Museum Photographer

(See also Photography, page 91.)
Generally, a museum has a photograph of every work in its collections. Conservators require photographs; graphic designers and public relations officers also use these images. Large museums might have several photographic specialists on staff, but smaller institutions use outside photographers.

Public-Relations Officer

Public-relations officers prepare articles and releases for magazines and newspaper features. They work with newspapers and national wire services to provide information on museum activities, acquisitions, building programs, installations, exhibitions, and the like. To keep the public informed on museum events and developments, they arrange TV interviews and press conferences for directors, curators, and administrators.

Registrar

The registrar's office is the nerve center of an art museum. Registrars and their assistants compile and store vital information (history, conservation, insurance value, condition, previous history, documentation, photographs) about every work in the collections. They also track each object's current history (movement and location, conservation and restoration reports, and so on). Their computers hold information on thousands of pieces of art.

Researcher

Researchers are on call to the rest of the museum staff. They delve into museum records and library holdings to find required bits of information on artists or their work. They might also carry out research for free-lance writers or other museums. Prior to important exhibitions, they provide essential information for catalogs and other documentation.

Slide Librarian

Most museums have extensive slide collections of the work in the museum and of other art subjects. The librarian keeps the slides in meticulous order and makes them available for lectures, classes, or seminars.

Writer

Museums need writers for the material in their catalogs, bulletins, art magazines, scholarly works, books, and other publications. Writers of such material have a background in both art history and creative and technical writing.

The art dealer performs a very important cultural function . . .

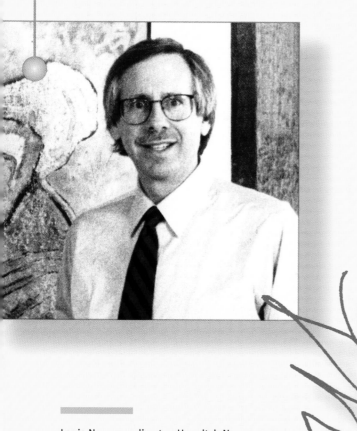

Louis Newman, director, Horwitch Newman Gallery, Scottsdale, Arizona

Louis Newman

Being an art dealer requires a great deal of experience, a strong aesthetic point of view, and effective communication skills—qualities neither easily nor quickly acquired. It can be particularly difficult for artists or students to make a career transition in which a person's own views and interests must be subjugated to representing the viewpoints and biases of other artists. However, there are often opportunities for interested people to participate in gallery intern or trainee programs in which an individual can garner much information about the inner workings of gallery operations as well as gain exposure to dealer-client relations.

I have found that many artists incorrectly believe that most art is sold through art galleries. The truth is that while this is a very important channel, it is not the only one. Some artists represent themselves and are successful in selling directly to clients; a significant amount of art is sold by private dealers, designers, and architects; and do not forget the importance of the auction houses and the various trade shows.

While these venues are a significant part of the art market, the art dealer performs a very important cultural function beyond just selling art. They find, direct, encourage, and cultivate collectors. They find and encourage artists. They often provide important opportunities for viewing art of newcomers as well as mid-career artists, senior artists, and historical materials.

While art dealers are vitally important to the art community and their work can be useful to both artists and collectors, the road to becoming an art dealer is challenging. This is no simple pastime; but there are many rewards if one is patient and persistent.

This gallery in El Paso, Texas uses focused lighting and a spacious floor plan to enhance the visitor's experience. Courtesy Adair Margo Gallery. Photo by Joel Salcido.

Galleries

While art museums display artwork that they own or have acquired on loan, galleries display artwork that is for sale. The work of many fine artists is displayed in galleries in order to be sold to collectors, decorators, and anyone else interested in art.

Commercial sales galleries are the most familiar. There are many such galleries in the United States. New York alone has over 500 of them. Most commercial galleries are in large urban areas or in resort areas, where there are more people likely to purchase fine art. However, there are also galleries in small towns that do excellent business. Large galleries may be able to hang hundreds of paintings and also show sculpture or ceramic pieces. Small galleries may be able to hang only a few select pieces.

Auction galleries sell artwork of all types to the highest bidders. *Antiques galleries* sell older art and craftwork. *Discount galleries* sell prints, copies, and imported work at discount prices. Some art museums operate *rental galleries* to benefit certain museum programs or auxiliary groups. In *vanity galleries*, artists rent space to exhibit their work. *Cooperative galleries* are operated by several artists who share in both profits and the responsibility for sales, management, staffing, and overhead. Some dealers have *private galleries*, which are open by appointment only. Galleries tend to reflect the personality and artistic preferences of the owner or director, and may specialize in a certain media (watercolor, oil, or mixed media), period (contemporary, early twentieth century, European), or form of expression (impressionist, expressionist, minimalist).

Generally, artists leave their work at a gallery *on consignment*: the artist is not paid until a sale is made. For the expenses, experience, and labor of their staff (overhead, sales force, advertising, brochures, exposure to the gallery's clientele), galleries retain a percentage of every sale. This amount varies from forty to sixty percent (depending on the artist, the location, and the circumstances), with fifty percent being about average. Production and sale of art is a cooperative experience: the artist produces the work, and the gallery makes the contacts and sales. Neither could survive long without the other, and in ideal situations, there is complete trust between them. Both are in business, however, and all transactions should be handled in a businesslike way.

Gallery Owner/Director (Art Dealer)

In addition to the owner, other people who work at some large galleries are salespeople, office workers, accountants, and a director. However, most galleries are small operations; in these, the owner is the director, and the sales staff might be only one person.

The gallery business is highly competitive and involves much more work than appears on the surface. And it requires enough initial funding to run the business for several years, until a steady clientele has been established.

What do gallery owners and directors do?

Gallery owners and directors control all the operations involved in running galleries. They must develop a corps of exhibiting artists whose work is sufficiently varied to meet the diverse needs of purchasers, yet similar enough to appeal to most of the regular clientele. Although artists may leave a gallery to exhibit their work elsewhere, or may cut down their production, there are always many new artists who desire gallery representation. All are hoping to exhibit with a well-established gallery, and art dealers continually seek artists who will supply appropriate artwork for a long time.

The artists represented by each gallery generally desire a one-person show every year or two years. To accommodate this, the director sets an exhibition schedule to which both the gallery and the artists must adhere. Prior to the opening of each show, there are many things to be done. The artwork is photographed; brochures and announcements are produced and distributed; the reception for the opening is arranged; the artwork is delivered; and the show is displayed. At the opening itself, the director and the sales staff must provide information, make introductions, and try to sell the featured artwork. The work of well-known artists sells more easily than that of newcomers. After the reception, the responsibilities continue. The director must invite more people to see the work, and he or she encourages reviews by the media. An average show lasts for about three weeks. Sellout shows are infrequent; most financially successful exhibits are the result of hard work by the director and staff.

While the one-person show is on display, the director must not disregard all the other artists who are represented by the gallery. Visitors may wish to see the work of a certain artist, or may not like the featured artist and may request to see other work. There is constant activity and shifting of artwork in a successful gallery.

When artwork is sold, gallery directors must then accept and record payments, set up payment schedules, send bills, pay artists, adjust inventories, and acquire new artwork. They must be aware of the latest work of their artists and the needs of their clients, and try to match these in order to make sales.

What qualities are helpful to a gallery director and owner?

Gallery directors and owners are in the business of selling art. They must be astute business people, and run their office efficiently and productively. They must be very organized, able to schedule events and procedures months in advance. Art dealers must enjoy talking and working with customers, and must be tactful, friendly, and approachable. Computer literacy (for keeping files, client lists, inventories, and so on), an interest in display techniques, and knowledge of art styles and techniques are the signs of successful art dealers.

What other careers require similar qualities?

Any sales-oriented careers require the qualities of organization, tact, sensitivity, and interest in people. Sales might include art books, supplies, and products, both retail and wholesale. Traveling art representatives and agents place artwork in galleries around the country. Work in mail-order sales of prints and reproductions of all types, art consulting, or selling art services to the art community might also be of interest.

What can you do now?

Successful operation of a gallery requires a businessperson who is interested in art. Therefore, take all the art classes you can schedule (especially art history), and emphasize business courses of all types. Psychology, history, graphic-design, and English courses are also important. Part-time work in a gallery will help you understand the various tasks involved. Try to visit galleries and attend openings; notice the methods used by successful gallery directors. Collect gallery announcements, posters, brochures, and pamphlets; file them for future reference. Attend seminars and workshops in artist-dealer relationships (listed in art magazines such as *American Artist*).

What schools offer necessary programs?

There are no formal courses in gallery ownership or directorship. Some college extension programs have courses that include gallery visits, and seminars and workshops are given by gallery dealers' associations. Learning on the job, however, is the best way to become well-versed in the gallery business. Business courses are most important, and many universities and business schools can provide what is needed. Most useful for this career is a major in business with a minor in art: a solid business background is more essential than an extensive art background.

Effective art installation is one of the gallery director's many duties. Opening receptions draw interested clients, such as those shown discussing the paintings in a major show. Courtesy Horwitch Newman Gallery, Scottsdale, Arizona.

Auction Galleries

When we learn that a van Gogh or Rembrandt painting sold for many millions of dollars, or that a combine painting by Robert Rauschenberg went for many thousands, we are hearing about the work of auction galleries. They help provide the glamour aspect of art sales around the world and often startle the economic market. Not all auction galleries deal with such huge cash sales, nor are the sales so glamorous or newsworthy. There are auction galleries in most major cities around the world, and they deal in all kinds of art. They often auction an entire estate collection of many works of art, but will auction a family's single valuable art possession. Auction galleries are where business and art collecting often come together, and a career in this arena is more concerned with business than with art. The end result of an auction, however, is an economic exchange and the movement of art from one person or collection to another.

At an auction of art or craftwork, the auctioneer takes the bids, wields the gavel, and finally proclaims, "Sold!" Before auctioneers do their work, however, staff members spend months gathering, classifying, appraising, authenticating, photographing, and cataloging the merchandise. These specialists come from a variety of backgrounds and interests. While no colleges offer courses in auctioneering, everyone brings to his or her career the personal interests and expertise essential to the operation.

What do auction-gallery staff do?

The auction gallery business has many facets. In small companies, one person may handle several tasks; in large operations (such as Christie's or Sotheby's), each person is a career specialist in a single, specific area.

Auctioneers conduct the sales, announce the bid amounts, and control the activities. They close the sales and direct the porters to the highest bidder.

Appraisers set the value on each piece according to the current market, recent sales, scarcity of the item, and current trends in the public's interest. They work with the consignors (those selling the works) to establish worth and base bidding prices. Usually, an appraiser has had museum curatorial experience or has worked as an insurance appraiser of art.

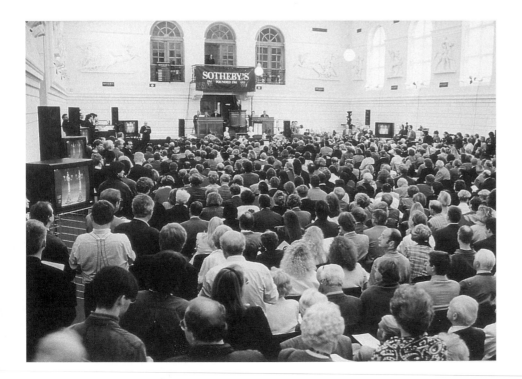

Hundreds of auction bidders gather in the medieval castle of St. Emmeram of the royal family of Thurn and Taxis in Regensburg, Germany. ©Reuters/Corbis-Bettmann.

Department heads secure artwork to be auctioned, negotiate its potential value and price, have it photographed, authenticate its historical background, write catalog descriptions, have the catalog printed, and set up the displays. They may travel worldwide to find suitable articles for auction and sale. Most speak several languages, so they can negotiate with various owners and potential buyers. Their background might be in art history, gemology, sales and management of jewelry operations, museum work, curatorship, appraising, insurance, or commercial art gallery sales. Although there is no regular "ladder" to climb, auction galleries hire the best people to do the work for successful selling programs. Department heads preside over such areas as painting, sculpture, jewelry, crafts, silver, antiques, and oriental carpets. Knowledge of various styles, media, periods, forms, languages, and appraisal techniques is required for each of these areas.

Large auction systems also need office workers, accountants, salespeople, and security officers who enjoy art but are also expert and efficient in their own work.

What qualities are helpful to auction-gallery staff?

The various careers associated with an auction gallery require different skills and qualities, but the people involved must be expert in their special field, and are well educated, with an emphasis in art history. They must be skillful in handling expensive art objects, and in dealing with people. The specialization, knowledge, and skills among auction-gallery staff are quite varied.

What other careers require similar qualities?

The skills for auction-gallery careers closely parallel those for work in museums, commercial galleries, jewelry sales, and teaching. With these skills, an individual might move from one career to another; for instance, someone who does appraisals as part of auction-gallery work might establish his or her own appraisal service.

What can you do now?

Enroll in all the art, art history, and craft classes available. Also take business courses, English, several languages, history, and literature. Attend auctions to see how they are carried out, but remember that experience in basic areas (such as sales, research, management, and museum curatorship) is required before positions in auction firms can be considered. See page 224 for titles of some magazines that can provide insight into the auction world.

What schools offer necessary programs?

There is no special training for a career in auction-gallery work, but there is schooling available in all the specialized areas (art history, painting, crafts, museum work, and so on). Proficiency in a single specialized area is essential for a career in auction work. Check the charts beginning on page 229.

Other Careers in Gallery Work

There are many specialized careers in gallery work that may be unique to individual businesses. Only general preparations can be made for such positions. The careers described below are generally associated with large gallery operations, or are carried out on a fairly large scale.

Accountant

Recording sales, arranging for financing, paying artists, sending statements, paying taxes, paying utilities and expenses, and keeping careful financial records are all the responsibility of the accountant. Because galleries are businesses, they must conform to business practices, tax laws, and other legal restrictions. An accountant need not have an art background, but a person with interest in both art and finance would be best for this position.

Advertising Manager

Art magazines are filled with advertisements for artists and galleries across the country. Someone on the gallery staff is in charge of purchasing advertising space in art publications and for arranging for any publicity needed. The gallery director or the person on staff in charge of advertising must deal on a regular basis with magazine advertising departments.

Appraiser

(See also Other Careers in Art Services, page 218.) Appraisers evaluate artworks, crafts, jewelry, and collectibles, placing a current value on them so that galleries know how much to charge. Appraisers determine the insurance value of works in museum and auction-gallery collections.

Art Consultant

(See also Other Careers in Art Services, page 218.) Art consultants are hired by clients and galleries to locate artworks in other galleries or at auctions, and to arrange for purchase or rental of such works. Art consultants are usually independent business people.

Art Dealer

(See Gallery Owner/Director, page 196.)

Artist's Agent

(See Sales Representative, below.)

Computer Specialist

Computers are used for bookkeeping and for mailing, inventory, and client lists. Computers also link galleries together, providing exposure and sales possibilities for both galleries and artists through Web sites. The computer specialist is in charge of gallery use of the computer and the updating of the gallery's Web site.

Corporate Sales Specialist

A corporate sales specialist is employed by a gallery to represent it to corporations wishing to purchase art. Corporations may seek art for their private collections or for their offices. The specialists work with corporate executives or their representatives to ascertain the needs and tastes of the purchasers, gather possible artwork, and make presentations, usually at the corporate office. These salespeople may carry out these responsibilities in addition to their regular sales work in the gallery.

Crater, Packer, and Shipper

Large galleries take care of their own crate building, packing, and shipping of the work they sell to clients. Smaller galleries, however, usually have local packers and shippers crate and arrange for the shipping of sold pieces. Often a staff member, who may be a salesperson, is in charge of shipping, or he or she makes arrangements for someone to come into the gallery to do this work.

Exhibit Coordinator for Street Galleries

Coordinators organize and stage street exhibits of gallery works in shopping malls, parking lots, parks, and other public spaces. They maintain files on available artists, arrange for the correct number and size of booths and displays, secure city permits, make all arrangements, and handle publicity. For many artists, such exhibits are an alternative to a conventional gallery show.

Exhibit Designer

Exhibit designers are responsible for the arrangement of artwork in galleries. They analyze subjects, colors, and sizes, and then group the pieces to show them to best advantage. In small galleries, the director does this work. In larger galleries, staff specialists usually arrange for shipment of artwork to the gallery and then carry out an exhibit design.

Gallery Assistant

Many young artists begin a career in art as a gallery assistant. Assistants do not sell art, but are responsible for hanging and dismantling shows, wrapping work for customers, and maintaining the gallery itself. Free-lance gallery assistants may handle the gallery's graphic-design needs by planning and developing brochures, announcements, or catalogs. Receptionists, usually found only in large galleries, meet the public, answer phones, schedule meetings, and so on.

Salesperson

At the heart of gallery operations is the sales staff. Salespeople study the artwork in the gallery and learn as much as possible about the artists so that they can favorably represent both to the customers. At times, they deliver and install artworks in the client's home or office.

Sales Representative

Sales representatives (artists' agents) actually operate a gallery out of their office and truck or van. They act as wholesalers between the artist and galleries that are far from where the artist works. They represent several artists as they travel to selected galleries around the country. Both the artist and the gallery pay the agent's commission. Such representation allows artists to have work in various and distant galleries without having to travel extensively to maintain inventories and sales.

Often, large galleries show paintings and sculptures concurrently, as in this view of part of the **New Masters Gallery** in Carmel, California. Courtesy New Masters Gallery.

You could become . . . a force in helping people understand what art is all about . . .

M. Stephen Doherty, editor in chief,
American Artist

M. Stephen Doherty

For those of us whose primary interest is in creating artwork, it often happens that our secondary talents make it possible for us to find a career in the art world. We may be passionate about painting, but our ability to hang an exhibition, market art supplies, restore damaged pictures, or write criticism provides us the opportunity to earn a living.

I work for a publishing company in New York City where many of the editors, production managers, advertising sales people, and executives are also professional musicians, actors, painters, and dancers. While those people may still spend their evenings and weekends playing in bands, writing poetry, or painting still lifes, they devote their days to working on publications that are read by other professional and amateur artists all over the world.

As the Editor-in-Chief of *American Artist* magazine, I am responsible for the articles that are published each month. I select the artists to be featured, hire the writers, supervise the editing and design, and manage the expenses related to these activities. The most important skill I apply to this job is making judgments about the artwork and manuscripts submitted to me—a skill I really developed while studying art in high school, college, and graduate school, nourishing an understanding about the creative process that helps me every day of the week.

There are many opportunities to apply your talents to a job in publishing, where you can have a big impact on the opinions and actions of many other people. If you are a good writer, you could be the art critic for a newspaper. You could become the author of an art history book or edit magazines or books and become a force in helping people understand what art is all about.

If you are interested in the way words and pictures can communicate ideas and influence other people, and if your involvement in art has given you an insight into the creative process, then perhaps you should consider a career as an art writer or editor.

Joyce Cohen writes about the contemporary art world for regional and national publications, reviews shows, and contributes text for artists' catalogues and for exhibition labels. Courtesy Joyce Cohen.

Art Publications

The activities of artists, craftspeople, museums, and galleries are reported in magazines, newspapers, bulletins, and books, as well as over the Internet. The most effective way for people in the art community to keep current (not only in their field, but also in art around the nation and the world) is through the use of both the Internet and the print media.

There are a myriad of art publications (see page 224 for some titles), and several new art magazines and dozens of art books come onto the market annually. The art publishing business—spanning interests from kindergarten textbooks to professional art journals—has an important impact on our economy.

Who writes the art books, magazine and Internet articles, advertisements, critiques, and news reports? Pick up an issue of any art magazine, such as *ArtForum* or *Art in America*, and notice that all the feature articles, reviews, editorials, business articles, and advertisements are written about art and directed toward artists, collectors, or other art-oriented people. For those with an interest in both journalism and various forms of art, writing and editing art magazines and newspapers is an exciting career possibility.

Art magazines of various types are primary sources of information for artists to learn new techniques and broaden their knowledge and ideas about art. Professional artists not only look for new ideas, but also want to know what their colleagues around the world are doing. Like most specialized magazines, art magazines make possible the exchange of information and new ideas between people with common interests. The all-encompassing scope of art magazines includes graphic design, industrial design, fine arts, crafts, education, architecture, and every other career detailed in this book.

Every major newspaper in the country employs at least one art critic and one architecture critic. These writers usually come from one of four sources: 1) artists who are trained in art and are also writers; 2) writers who are trained in journalism and have a strong interest in art; 3) writers who have studied and trained to be critics, especially in the field of art; 4) art historians and museum curators who enjoy research and scholarly writing and who write the catalogs, museum publications, essays, and artist biographies.

Art Writer

More art books and magazines are being published today than at any other time. Museum members read the bulletins and newsletters published by the museum. Gallery directors read newspapers and magazines to learn who is showing in other galleries. Teachers get ideas and inspiration from art magazines and books. A variety of art people write in some capacity for these publications.

What does an art writer do?

Some possibilities are mentioned here:

ART-BOOK WRITER

Art books are devoted to areas such as biographies of artists, art history (general surveys and specific periods, movements, and works of art and architecture), theme books (flowers, landscapes, or portraits, for example), textbooks (on techniques, history, drawing, painting, and the like), coffee-table books (luxurious formats depicting artists, styles, and themes), and how-to-do-it and how-I-do-it books (artists showing how they make their art). Teachers, professional writers, artists, museum workers, researchers, and compilers write these books for novices and professionals of all ages. Some art books are written for a particular market, such as students, architects, photographers, and nonartists.

ART CRITIC

(See page 206.)

ART-MAGAZINE AND -NEWSPAPER WRITER

The writing in art magazines and art newspapers covers widely differing areas. Some publications, for instance, treat all areas of arts and crafts, and are written for a broad market of artists and the public. Others deal with museum topics, antiques, photography, contemporary art movements, galleries, regional development or themes such as Western art, portraits, crafts, or animal paintings.

Some art organizations publish monthly papers to inform their members about recent or upcoming events or legislation. Often, these art publications contain reviews of exhibits and commentary on current trends, which keep artists abreast of developments in the art world. All of these types of magazines and papers require writers.

BULLETIN AND CATALOG WRITER

Curators, researchers, museum personnel, and recognized experts contribute to the local or national monthly bulletins that museums send to their members. Their articles contain information on current shows, new exhibits and acquisitions, featured works or artists, and museum events.

Writers work for national art organizations, gallery associations, teachers' organizations, antique dealers, and auction houses to produce regular bulletins of interest to members, potential members, and subscribers. Some of these bulletins feature scholarly research of various staff members. For the elaborate exhibition catalogs that most large museums publish and often sell in bookstores and at other museums, writers are hired to produce critical reviews, documentation, and descriptions of the work in the exhibit. On the local level, writers work for art organizations and art clubs to produce their bulletins.

MAGAZINE AND NEWSPAPER FEATURE WRITER

Many general-interest magazines and daily newspapers devote a section to art and feature artists, shows, book reviews, museum exhibitions, architecture, or archaeological discoveries. A free-lance writer or staff art editor writes such articles, and his or her purpose is to interest the general public in art activities around the world or close to home. Some publications contain art-related articles in each issue; others treat them as special features.

There are many career opportunities for those who have studied journalism, enjoy writing, and also understand and enjoy art. Writing for art publications means helping readers understand the activities and the visual communication of artists.

What qualities are helpful to an art writer?

People who write for art magazines and books need to have a strong desire to share their philosophy, expertise, knowledge, and understanding with other artists and the general public. They must also be organized in their thinking and writing, have a well-developed writing style, and understand publishing processes. These writers must be able to accept feedback from editors and meet deadlines.

What other careers require similar qualities?

Good writing skills are useful for all artists, but are essential for art historians and teachers. Critical writing about crafts, stage productions, dance, music, books, industrial and graphic design, and other areas in the arts might be of interest to art writers.

What can you do now?

The best way to learn to write about art is to write about art. Also read what others have written in books, magazines, newspapers, and bulletins; analyze what you like or dislike about style, content, design, organization, and so on. Become proficient at keyboarding and using word-processing software. Because you must become adept at both writing and art skills, enroll in English and writing classes, and also art classes that will provide skills and understanding of media, subject matter, and techniques.

What colleges offer necessary programs?

Writing is taught in nearly every college and university. Schools that offer teaching, art history, and journalism courses may be most helpful to the aspiring art writer.

Art writers often have a thorough knowledge of design and art history. Norman Sibley, who has an extensive background in graphic design and production, works at his home office in Etna, New Hampshire. He is a coauthor of a textbook on photography and is writing and designing a textbook about digital imaging. Photo by Michaela D'Angelo.

Art and Architecture Critics

The chief goal of art criticism is to promote understanding of the meaning, merit, aesthetics, and purpose of art and architecture. Critics are not so much interested in art history (although they have a solid background in it) as in the reasons for the existence and importance of an artwork, the historical events and art that influenced the artist, the analysis of its importance, the effects it has on other art and artists, and its value to the total scope and influence of art or architecture.

Art critics review artworks, installations, and exhibitions in museums and galleries and report their findings and opinions in newspaper columns, magazine sections devoted to art, art magazines, or journals. Through their writing and judgments, they help set standards for artistic excellence. Their subjective opinions—although the critics try to be as objective as possible—are based upon their experience and their knowledge of art criticism, art history, the social implications of art, and current trends in collecting and art dealership.

Architecture critics scrutinize and analyze a finished structure and report on its materials, construction techniques, unique features, the architect's philosophy and goals, the building's aesthetic influence on the urban environment, and landscape features. The work of architecture critics appears in major newspapers and in architectural magazines and journals.

What do art and architecture critics do?

Critics look at art and architecture, analyze it, and express their thoughts and conclusions about it in writing. The process of criticism may be divided into the following steps, which explain how critics often evaluate a piece of art, a one-person show, an exhibition, or a building.

First, critics describe the work, and perhaps how the artist created it. Architecture critics describe appearance, materials, and processes of construction and finishing.

Then they discuss design, format, materials, media, use of color, drafting, proportions, and principles of organization, elaborating upon these topics according to their own standards. They might also discuss techniques and how the techniques of one artist compare to the handling of the same media by other artists.

Critics will then often attempt to interpret or express the meaning of the work, and what impact it might have on viewers. The critics make their opinions known through their interpretation, which might describe why the art was done, what possibly influenced the artist, and what principle and message the artist is trying to communicate.

Finally, critics make a judgment of the work, an evaluation based on their analyses. The art is therefore given a sort of rating, as compared to other works of similar types. Some judgments are based on historical models; predictions of future worth; craftsmanship; aesthetic appeal; uniqueness, visual impact, or shock value; or utility and social significance. Most judgments are based on some combination of these.

What qualities are helpful to an art and architecture critic?

Art and architecture critics must be extremely knowledgeable in their field, and have an excellent background and training. They must be inquisitive and able to communicate easily and understandably. Along with being analytical and perceptive, critics must give reasons for their opinions, and be flexible enough to change over time. They must, however, trust that their opinions are valid. In turn, they must be able to accept criticism themselves.

What other careers require similar qualities?

All art careers that involve writing would probably be enjoyable for critics. Art-magazine writers, art feature writers, free-lance writers, and authors must have the ability to communicate about art.

David Pagel is a free-lance art critic writing for the *Los Angeles Times* and *Art Issues*. He works from his home office, submitting articles via e-mail.

Critical Art Writing: A Sample Entry

The smallest painting in Monique Prieto's buoyant exhibition at ACME Gallery ranks among the spunkiest she has made. Comprised of only six eccentric shapes of crisp color, this multipurpose picture compresses into 18 x 14" of raw canvas no less than four genres of painting: portraiture, still life, landscape, and modernist abstraction.

On first glance, Prieto's playful composition looks like a jaunty offshoot of an early Jules Olitski. Having sharpened the edges of the spray-painted blobs that punctuate the color-field painter's quirky canvases, Prieto has also rendered these loopy shapes in uniform hues and shrunk them down to size, transforming their overblown aspirations into a goofy, user-friendly cartoon.

The remaining nine paintings in Prieto's impressive exhibition similarly shift between abstraction and representation. With great efficiency and deftness, they demonstrate that neither type of image-making tells the whole story.

Titled "The Big Picture," Prieto's show insists upon the repressed Pop edginess of color-field painting. This devilishly clever maneuver reveals that redeeming the most derided style of modernist abstraction is infinitely more interesting than criticizing its shortcomings.

You don't have to know the sources of her smart, generous pictures to have fun looking at their exuberantly animated compositions.

—**David Pagel, art critic**

What can you do now?

Enroll in art classes to gain an understanding of art processes and media. Take art history, design, and appreciation classes to develop a background in art and to investigate the opinions of others. Take English, journalism, and writing classes, as well as psychology, sociology, and history. Attend galleries and museums: read what critics say about what you see. Study critical-writing techniques that appeal to you—not only in art or architecture, but also in music, dance, drama, and film. Read the critiques and reviews in magazines such as *ArtForum*, *Art in America*, and *American Art*, and in the larger newspapers. Write your own opinions about the art you see.

What colleges offer necessary programs?

Art and architecture criticism is not taught in every college or art school, although some schools with a large fine-arts department offer courses in criticism and art writing. Check catalogs or Web sites for such offerings. Schools with courses in art management, administration, and art history sometimes offer art-criticism classes. Check university extension courses and classes offered by museums: critics sometimes give seminars or courses in critical writing. Ask local critics where they obtained their background and which courses they found most helpful.

Other Careers in Art Publications

Art-Book Editor

After a book is written for a publisher, an art-book editor at the publishing house reworks the copy by suggesting and making changes, and then supervises the design and layout of all the elements of the book. The editor must understand the subject of the book in order to make meaningful and necessary alterations in the text. He or she understands graphic design and can make important suggestions to the book designers. Art-book editors need not be artists, but they must have a strong interest in art and a solid comprehension of the subjects on which they are working.

Art-Bulletin Editor

Museums, art organizations, national art clubs, art schools, and colleges often publish bulletins that appear periodically. They may be very elaborate, as is the bulletin of the Metropolitan Museum of Art, in New York, and include color, special articles, and scholarly writing. The bulletins of smaller art organizations may be more modest. Editors must solicit articles and illustrations (or do the writing and illustrating themselves) and deliver materials to the printers on schedule. Such bulletins are usually the primary communication link between organizations and their members.

Art-Magazine Editor

Editors are responsible for everything in the magazine, from the front cover to the smallest advertisement. They delegate various responsibilities to their staff, but the editors must oversee every part of the operation. They plan the scope, theme, and format of each issue many months in advance of its publication date. They assign editors, assistant editors, contributing editors, and production staff to cover every aspect of preparation. They contact free-lance writers and photographers for special projects. They follow every article from concept to final editing, offering suggestions and pulling the entire staff together to meet pro-

duction deadlines. Often, editors write or edit articles themselves to fit a designated space or emphasize a certain point. They coordinate prepress operations and check color proofs to assure artists of the best possible reproduction of their work.

Associate or Assistant Editor

Associate or assistant editors work on a magazine staff and are required to write regularly or as often as the editor assigns them features. Some may be in charge of special sections of the publication, such as letters, media, exhibitions, do-it-yourself tips, book reviews, and show reviews. The editorial hierarchy leads from assistant editor to associate editor to senior editor to managing editor to editor-in-chief.

Calendar Editor

Metropolitan gallery associations or small cities with an assortment of galleries often produce bulletins and calendars to let tourists, buyers, collectors, and the public know what exhibits are being shown in the area. Museums have calendars that list opening, continuing, and upcoming exhibitions, and special programs and tours. Calendar editors compile information, edit it to fit the desired format, oversee production, and approve the finished schedule. Newspaper calendar editors include brief descriptions of the shows along with all pertinent information, such as artists' names, galleries, dates, and times.

Contributing Editor

Contributing editors are not on the regular staff of an art magazine, but are writers who contribute articles that they develop or articles assigned by the editor or publisher. They are paid per article, and they usually are asked to supply several articles per year. Their name often appears in the masthead of the publication. A recent issue of *American Artist*, for example, lists five contributing editors who are respected authors whose writing appears often but not monthly. *ArtForum* lists fourteen contributing editors.

Copy Editor for Art Books

Copy editors are editorial specialists who read manuscripts from authors and make suggestions, alterations, and changes that will improve the final book.

They clarify content, and stress consistency of punctuation, spelling, and writing style. They make authors' manuscripts more acceptable to book editors and publishers.

Free-lance Writer

Free-lance writers have no regular ties to any specific art magazine, but they write articles on subjects that interest them (on artists, media, shows, features, and so on) and then submit them for publication. Their work might be rejected by one magazine but used in another, or never accepted at all. They enjoy the freedom of selecting their own subjects and arranging their own schedule, but do not have any assurance that their writing will be published.

Researcher

Researchers are adept at investigating old books, original writings, letters, archives, and collections to find information pertinent to specific stories or articles. Researchers usually do not do the writing, but are hired to gather the required information for authors who are working on books or articles. Researchers gather data, verify authors' ideas and recollections, and secure illustrations, permissions, and authentications necessary to document the author's work.

Reviewer

Reviewers are often magazine staff members who read and report on new art books, videos, CD-ROMs, and videodiscs for every issue. However, some reviewers are free-lance writers who review for several different magazines. In some cases, reviewers are contributing editors who read, analyze, evaluate, and recommend what other authors have written.

Writing about art is a big business. Magazines are aimed at art historians, and at artists with a variety of skill levels. Art books also are written for every possible interest. Photo by Gerald Brommer.

Art Services

M. AUTHENTIC
WORK OF ART.

part six

Art Services

Economic predictions indicate that there will be continued increases in many service industries in the coming years. Art services will likely experience similar expansion, and this section of the book explores careers that provide services by and for artists.

Some art services are provided by people with a background in art (such as police and court artists, art therapists, art advisors, and art investment consultants); some services are provided directly for artists and their work (by framers, shippers, art-supply dealers, photographers, and so on); and some services, also provided for artists (by lawyers, Internet services, accountants, agents, exhibit coordinators and sponsors, and so on), address the business aspects of art careers.

Many of those employed in art-service careers do not have an art background but are educated in business, law, education, library science, or psychology. Some service careers are built around combinations of interests such as art, education, and psychology; art history and library science; or art and business.

We have placed the interests of the fine arts market foremost...

Dan Smith, Daniel Smith Artists' Materials

Daniel Smith

My company, Daniel Smith, makes and sells fine artists' materials. We have a store in Seattle, and distribute the Daniel Smith Catalog of Artists' Materials on a worldwide basis. As an independent, locally owned company, we have placed the interests of the fine arts market foremost in everything we've accomplished. As a U.S. manufacturer of printing inks, oil paints, and gesso, and watercolors, our desire is to provide exceptional products at a good price, and to provide reliable research and development.

When I started the company twenty years ago, my goal was to make better quality artists' etching inks. I also knew, from working in my parents' hardware store, that good service is what inspires customers to remain loyal to a business.

Today, artists from around the country rely on our catalog and our sales staff for the information they need to make good choices. Therefore, we find it imperative to not only sell top quality art supplies, but to know what we sell. Most of our sales staff are working artists with considerable art training and experience, who enjoy the ongoing give and take with other artists. Tips and techniques are continually learned and shared, and the products we carry are often based on customers' recommendations.

I have based my company on the belief that serious artists almost always use professional materials because they are made better and will perform better. Being an artist requires courage. We must believe in our efforts enough to spend our money on art supplies and use our valuable time to convey our thoughts and conceptions for others to see and experience.

My advice—buy the best materials you can, use them with trust, treat your art with respect, and relax about the ultimate outcome. Most of all, when you create, enthusiastically enjoy what you do!

Richard Hernandez of Designers
Services Group in Marina del Rey,
California, consults with a client about
framing. Photo by Gerald Brommer.

A Variety of Services

Creative people in many service areas adapt their skills and knowledge to meet the needs of artists, architects, designers, collectors, gallery directors, and craftspeople. These people—who have business skills and expertise plus a strong interest in art—design services that free artists to spend more creative time on their art. The following describe what a few people do to provide some of the many services by and for artists.

- A successful accountant who has a deep interest in art and in art collecting devised bookkeeping and accounting procedures that help galleries simplify and regulate their business. He is the tax accountant for several major galleries in various parts of the country.
- Using her video equipment, a woman developed a business that documents important art-collection inventories for both individual and commercial clients. She videotapes artworks for insurance purposes and inventory control.
- Artists' agents abound, but one woman formed a firm called Business and Arts, which specializes in corporate cultural programs and activities. She works with corporations and consults with officers, gallery directors, and artists to arrange purchasing programs, corporate collections, commissions, and corporate exhibitions in a business setting.

- A New York lawyer with an intense interest in art is a specialist in representing visual and performing artists. He is expert on prosecution and defense positions in regard to contracts, copyright, resale royalties, health hazards, insurance, taxes, and a number of other legal issues that concern artists.
- Internet-service companies help artists and designers develop their own Web site, which lets their artwork reach thousands of potential buyers and clients around the world. Without ever having to leave their studio, they can market their work through the Web site and by other on-line technology.

The Art Store in Los Angeles, an example of
one of the retail services with which artists are
most familiar. Photo ©Serge Azadian 1996.

Art Therapist

Training for art therapy is a twentieth-century development, which became important in the 1950s. The people who pioneered this effort were independent practitioners, but the field today is unified and organized. Art therapy is a human-service profession in which specialists use art to help people with certain physical and emotional problems. Art therapy can be used to diagnose and treat those problems by encouraging self-awareness and personal growth.

Some art therapists work in group situations in psychiatric hospitals, clinics, community centers, drug and alcohol treatment centers, schools, and prisons; others have a practice built around individual or family counseling and therapy. Art therapists work with people of all ages.

Art therapist Anna Hiscox, pictured with decorated gourds, her own artwork. Often, a decision to become an art therapist is preceded by an enjoyment of art making.

This artwork by a 15-year-old patient is a good example of what art therapists attempt to achieve in their work. The mandala on the left was drawn at the time of hospital admission for depression; the one on the right was drawn after three weeks of therapy when the patient began to see hope for his future. Photo courtesy Anna Hiscox.

What does an art therapist do?

Art therapists use art as a vehicle for positive human change. In some settings, they integrate art and creative expression into the psychotherapy process. Their methods are based on extensive studies, preparation, and work; they use drawing, painting, and other forms of artwork in diagnosis, treatment, rehabilitation, and education. They encourage a patient to draw or paint, and through the artwork, are often able to interpret the patient's feelings and identify and clarify problems. Therapists then use art processes to strengthen the patient's self-image and help them relieve their emotional tension. Extensive training and background prepares therapists to be sensitive to all types of responses and to use positive responses productively.

Therapists keep the artwork of their clients confidential, just as medical doctors keep such information from the public, but they share such information with colleagues when developing programs for rehabilitation. They often collaborate with social workers and psychologists in order to provide the best and most comprehensive treatment programs.

What qualities are helpful to an art therapist?

Any therapist must be interested in helping people solve problems, and must be sensitive, inquisitive, and thorough. Art therapists must understand all forms of art and visual expression, psychology, and psychiatry; and they must constantly refine and strengthen this understanding through study and application. They must feel equally comfortable in group and in individual sessions. Their work demands that they read and understand medical journals and other publications that deal with psychopathology, psychotherapy, and clinical psychology.

What other careers require similar qualities?

Various areas of psychology and psychiatry require similar interests and background, the qualities of sensitivity and thoroughness, and the desire to help others with problems. A career as an art teacher might be of interest, as might a college teaching position for which a background in both art and psychology is necessary.

What can you do now?

Take all the art classes possible, especially drawing, painting, three-dimensional design, and ceramics. If you are in high school, take psychology, English, and biology: these areas are emphasized in art-therapy training programs in college, and a strong start in high school is beneficial. Get involved in art activities in school or in the community. Help children with special needs in crafts classes, summer camps, YMCA programs, and so on. Teach at Sunday school or vacation school, and for recreation programs in parks: all these are experiences that will help you develop a strong background. Consult magazines such as *The Journal of the American Art Therapy Association*. Find information on schools, projects, bibliographies, and current literature in the field.

Art Therapist at Work

On January 17, 1994, a powerful earthquake shook the Los Angeles area and left devastation behind in the form of crumbled freeways, crooked apartment houses, fires, trembling grounds, power failure, lack of phone communication, and thousands of people without homes. The entire nation was aware of this powerful natural disaster.

In an article in *Art Therapy*, Jasenka Roje of Los Angeles discusses the role of art therapy in her work with twenty-five distressed elementary-school students following the devastating earthquake.

She writes: *"In the course of therapy children were encouraged to tell their earthquake story in words and in pictures, to explore their current and repetitive thoughts, and to work through their feelings toward the resolution of the trauma. The use of art was instrumental in accessing children's internal processes and helping them return to normal functioning."*

—*Art Therapy* (Number 4, 1995)

What schools offer necessary programs?

Obtain a current list of schools that offer art-therapy programs by writing to the American Art Therapy Association (AATA) (see Professional Societies and Organizations, page 226). Those who are hiring career specialists in art therapy prefer applicants who have graduated from a master's degree program with AATA approval. Master's programs require a solid liberal arts undergraduate degree. A background in art and psychology, and a strong foundation in drawing, painting, ceramics, and sculpture are helpful. Check the charts beginning on page 229.

Michelle Isenberg (right) with client Joan Kessler at Kessler & Kessler's offices under construction in Century City. Isenberg meets with clients at the start of construction, then coordinates commissions of artwork to fulfill timelines of the project. Photo by Mark Berndt.

Isenberg in discussion with Douglas Chrismas, director of Ace Contemporary Exhibitions in Los Angeles. Isenberg frequently meets with artists' representatives and gallery directors to review and select work for upcoming projects. Photo by Mark Berndt.

Fine-Art Advisor: Michelle Isenberg

Michelle Isenberg says, "Most people limit art to galleries and museums, when in reality art surrounds us everywhere. The career path of a fine art advisor is little-known outside the art world, but working in the profession feeds a passion for art and a love of the creative process."

Isenberg works directly with clients, each with their own unique set of considerations. Whether working with a city to develop public art programming, a private corporation to develop a corporate art collection, a design team (architect, landscape architect, and artist) to create a cohesive "environment," or a private collector in building a collection, she aims to find the perfect work to suit the client's budget, tastes, and needs. In her projects, she works jointly with the artist and client "to create work that will transform space."

For the Screen Actors Guild's new headquarters in Los Angeles, Isenberg melded the arts and entertainment fields by

employing historical Hollywood memorabilia, photographs, and contemporary artworks. She used art to promote a sense of place for members, visitors, and employees. Arsen Roje was commissioned to paint *Union*, a centerpiece singling out specific actors such as Sally Field, Marlon Brando, and Henry Fonda, yet conveying the work of the actor, rather than the celebrity. Other artworks for the project were produced by an artist whose entire body of work is based on *Life* magazine covers, and by another artist team which designed vividly colored murals based on movie posters.

The firm of Michelle Isenberg & Associates, Inc. provides professional art advisory services to the public and private sectors for the development of fine art programs. The firm is responsible for the concept, coordination, and management of all aspects of art programs. In her career, Isenberg has advised many important clients including: Sony Pictures Entertainment, Twentieth Century Fox Film Corporation, Litton Industries, Universal Studios in Orlando, Sony Disc Manufacturing in Springfield, Oregon, Culver City Studios in Culver City, California, as well as many private collectors.

Isenberg states, "To excel as a fine arts advisor, you must realize that the first critical step is a degree in art history. In addition, you need to take classes in architecture, landscape architecture, and interior design, since professionals in these fields are intrinsic to the field of fine arts advising. Interning with a gallery or museum and volunteering for nonprofit, arts-related groups are great 'real-world' experiences to prepare for a career as a fine arts advisor. Most importantly, *you must have a passion for art*."

Arsen Roje, *Union*, oil on canvas. Michelle Isenberg worked closely with the arts committee of the Screen Actors Guild to develop a program for their Los Angeles headquarters. Marc Wanamaker of Bison Archives provided historic material for the project. Photo by Arsen Roje.

Other Careers in Art Services

Accountant

Some accountants are expert in setting up and handling the finances of artists, architects, and galleries. They understand tax laws that affect artists, and they advise their clients in regard to investments, tax schedules, business relationships, and bookkeeping.

Agent

(See Sales Representative, page 201.)

Appraiser

(See also Other Careers in Gallery Work, page 200.) Appraisers fix a dollar value on artworks, basing decisions on the history of the artist, current price trends, inflation, and supply and demand.

Art Consultant

Many kinds of consultants work with artists, with corporations, and with clients who need the services and work of artists. Consultants know the work of designers, architects, artists, and photographers; and they search for appropriate artwork for clients. Some consultants advise artists in their business, and help them choose galleries, write contracts, or find lawyers and insurance agencies. Some consultants work with gallery owners.

Art Librarian

Art librarians are specialists in library science and enjoy helping people, but they also have a special interest in the arts. In addition to library science, most have studied art history, art theory, and various art-production methods. Art librarians are employed by university and art-department libraries, art-school libraries, private art libraries, and museums.

Art-Materials Dealer

Art-materials dealers provide the supplies needed by all kinds of artists and designers. They are in constant contact with artists and often perform other services for them, such as stretching canvases; cutting mats; suggesting new materials, media, and books; and referring artists to framers, accountants, and agents.

Career Counselor

(See Guidance Counselor, below)

Crate Builder

Crate builders, often artists themselves, work with wood, fiberboard, cardboard, and plastics to build crates and containers for shipping artwork. Some crate builders also ship packages for artists.

Desktop Publisher

Artists are often in need of printed materials such as résumés, brochures, mailing lists, and invitations. Desktop publishers handle artists' needs of this type.

Documentation Expert

(See also Conservator and Restorer, page 190.) Documentation experts verify that an artwork was produced by a certain artist. They make use of sophisticated equipment to determine the type of ink or paint used, age of the canvas or paint, and the composition of underpainting and pigments.

Document Restorer

(See Conservator and Restorer, page 190.)

Foundry Manager or Craftsperson

Foundries provide services to sculptors and to anyone needing assistance with metal sculpture. The manager deals with clients and oversees the art processes. Foundry craftspeople are highly skilled artisans who may specialize in enlarging, molding, retouching, casting, finishing, patina, mounting, or installation.

Foundries may provide maintenance and conservation services for museums, parks, and collectors. Another service a foundry often provides is commemorative design of monuments or plaques.

Framer

(See Other Careers in Fine Art, page 164.)

Framing-Workshop Instructor

Instructors regularly conduct framing courses in locations across Canada and the United States. Sponsored by molding suppliers, art dealers, or various training centers, they provide extensive hands-on workshops in framing, matting, mat cutting, box framing, and other techniques for beginners to advanced framers.

Guidance Counselor

Guidance counselors work in art schools and colleges, but also in city offices, where they are specialists in finding art and design jobs. The counselors put prospective designers in touch with studios and businesses who need artists.

Insurance Agent

Specialized insurance agents provide types of insurance coverage that are unique to artists. Artists must insure their work while it is in their studio, in transit, at a gallery, or in a museum. Agents also offer life and health insurance for self-employed artists.

Lawyer

Lawyers familiar with local, state, and federal laws that affect artists offer important services to the art community.

Mail-Order Art-Supply Retailer

Mail-order art-materials suppliers in North America satisfy the needs of artists who do not live near art-supply stores. They print and send out catalogs so that artists can order by mail, phone, fax, or e-mail.

Manufacturer of Art Supplies

Many companies make papers, inks, pencils, paints, pigments, boards, erasers, pens, plastics, glues, markers, pastels, and media of all types. Manufacturers also supply drawing tables, easels, palettes, portfolios, lights, and other equipment.

Photographer

(See Photographer of Fine Art, page 101.)

Printer

Some printers have developed businesses that print postcards and announcements of shows for artists. They may work from original slides, transparencies, or digital photographs. Other printers provide artists with full-scale reproductions of their work, to be sold in galleries that specialize in reproductions.

Producer of Art Fairs

Art fairs, mall shows, and other public sales venues are produced as a service to artists by people interested in art as a commercial enterprise. These producers arrange and provide space, advertise in magazines, and usually manage several exhibitions every year.

Restorer/Cleaner

(See also Conservator and Restorer, page 190.) Restorers and cleaners examine the surface, test the stability of canvas or paper, and determine the media and correct process to use for reconstructing or retouching damaged artwork. They use solvents to clean surfaces and can restore damaged works to their original condition. These specialists work for artists, galleries, museums, or owners.

Shipping and Storage Provider

Both shipping and storage services are provided to artists, galleries, museums, and private owners. Usually the shipping company builds crates (see Crate Builder, above) and stores work. The company ships the artwork by any appropriate means, moving art from galleries to customers, from artists to museums and galleries, and so on.

Stock-Photography Service Provider

Designers, artists, writers, and others who need to acquire images quickly can select photos from a variety of sources. Printed catalogs distributed by mail and image collections found on the Internet enable artists to find photographs, thus avoiding the time and expense of hiring a photographer for a specific project. The on-line service is especially advantageous to graphic designers, who can punch in a credit-card number and download the photo for immediate use.

Video Producer

Some video producers record artists as they demonstrate, teach, or lecture to other artists. These producers provide a professional look to the video by arranging for camera operators, sound technicians, studio space, editing, and marketing.

Web-Site Gallery Provider

Technology has entered the gallery and art-sales scene with Web sites and other on-line services. Artists can arrange to have their own Web site, or they can work with Web-site galleries or organizations formed especially for Web marketing.

Resources

part seven

Resources

An important aspect of selecting an art career is gathering information about your area of interest from a variety of sources.

• Books and video tapes with both general and specialized career information are readily available resources.

• Art magazines in your areas of interest provide information about contemporary work, thinking, and resources. Many are listed in the art magazines section, on page 224.

• Professional societies and organizations also provide information and resources on career choices. See the societies and organizations section on page 226.

• Some Web sites have art-related information. Addresses for some of these sites, whose numbers expand daily, are in the Web Sites section on page 228.

• A listing of colleges and art schools that offer programs in your selected career area begins on page 229.

Bibliography

Further Reading

American Art Directory, 1995–96. New York: R. R. Bowker, 1997.

Cahan, Susan, and Zoya Kocur. *Contemporary Art and Multicultural Education.* New York: The New Museum of Contemporary Art, 1996.

The Best New Animation Design. Rockport, MA: Rockport Publishers, 1995.

Careers Encyclopedia. Lincolnwood, IL: NTC Publishing Group, 1996.

Careers in Museums: A Variety of Vocations. Washington, DC: American Association of Museums, 1994.

Chajet, Clive. *Image by Design from Corporate Vision to Business Reality.* Reading, MA: Addison-Wesley, 1991.

Charles, Jill. *Directory of Theatre Training Programs.* Dorset, VT: American Theatre Works, Inc., 1995.

Cochrane, Diane. *The Business of Art.* New York: Watson-Guptill Publications, 1988.

Computer Graphics. Rockport, MA: Rockport Publishers, 1994.

Computer Graphics 3. Rockport, MA: Rockport Publishers, 1995.

Corbett, Ruth. *Art as a Living.* New York: Art Direction Book Co., 1983.

Cox, Mary. *Artist's and Graphic Designer's Market.* Cincinnati, OH: Writer's Digest Books, 1997.

Craig, James. *Graphic Design Career Guide.* New York: Watson-Guptill Publications, 1992.

Creative Black Book. New York: William Morrow & Co., 1995.

Cyberdesign in Photography. Rockport, MA: Rockport Publishers, 1995.

DuBoff, Leonard. *Art Business Encyclopedia.* New York: Allworth Press, 1994.

Feldman, Edmund Burke. *Philosophy of Art Education.* Upper Saddle River, NJ: Prentice Hall, 1996.

Folke, Ann, and Richard Harden. *Opportunities in Theatrical Design and Production.* Lincolnwood, IL: NTC Publishing Group, 1995.

Glasbergen, Randy. *How to Be a Successful Cartoonist.* Cincinnati: North Light Books, 1996.

Goldfarb, Roz. *Careers by Design.* New York: Allworth Press, 1993.

Grant, Don. *The Business of Being an Artist.* New York: Allworth Press, 1993.

Graphic Design: A Career Guide and Education Directory. New York: The American Institute of Graphic Arts, 1996.

Great Movie Graphics. Rockport, MA: Rockport Publishers, 1995.

Great Store Design. Rockport, MA: Rockport Publishers, 1994.

Haubenstock, Susan H., and David Joselit. *Career Opportunities in Art.* New York: Facts On File Publications, 1994.

Holland, D. K., and Cheryl Lewin. *Great Package Design 2.* Rockport, MA: Rockport Publishers, 1994.

Knackstedt, Mary V. *Marketing and Selling Design Services.* New York: Van Nostrand Reinhold, 1993.

Lubliner, Murray J. *Global Corporate Identity.* Rockport, MA: Rockport Publishers, 1993.

Maisel, Eric. *A Life in the Arts.* New York: G. P. Putnam's Sons, 1994.

Marsh, William M. *Landscape Planning, Environmental Application.* New York: John Wiley & Sons, 1991.

Martin, Diana. *Graphic Design.* Rockport, MA: Rockport Publishers, 1995.

Meyerowitz, Michael, and Sam Sanchez. *The Graphic Designer's Basic Guide to the Macintosh.* New York: Allworth Books, 1994.

NAEA Art Scholarship Book. Reston, VA: National Art Education Association, 1996.

Paetro, Maxine. *How to Put Your Book Together and Get a Job in Advertising.* Chicago: The Copy Workshop, 1990.

Parker, Jennifer. *An Artist's Resource Book. (Grants and Fellowships, etc.)* Long Island City, New York: Go Far Press, 1993.

Peterson's Professional Degree Programs in the Visual Arts. Princeton, NJ: Peterson's, 1996.

Piersol, Edna Wagner. *Living by Your Brush Alone.* Cincinnati: North Light Books, 1989.

Pintoff, Ernest. *The Complete Guide to Animation and Computer Graphics Schools.* New York: Watson-Guptill Publications, 1995.

Ralston, Trudy, and Eric Foster. *How to Display It. (Merchandise and Display Careers)* New York: Art Direction Book Co., 1990.

Reppert, Marjorie L. *Guidance for Choosing a Career in the Visual Arts.* Mechanicsburg, PA: Remembrance Press, 1992.

Sebastian, Liane. *Electronic Design and Publishing: Business Practices.* New York: Allworth Press, 1994.

Smith, Constance. *Art Marketing Source Book for the Fine Artist.* Penn Valley, CA: Art Network, 1995.

Society of Publication Designers. *Publication Designers' Annual.* Rockport, MA: Rockport Publishers, [yearly].

Sweetow, Linda, and Carol Brown. *The Art Student's College Guide.* New York: Arco Publishing, 1996.

Supon Design Group. *Design Direction.* Rockport, MA: Rockport Publishers, 1995.

Ulman, Elinor, and Penny Dachinger. *Art Therapy in Theory and Practice.* Chicago: Magnolia Street Publishers, 1996.

Vaz, Mark Cotta, and Patricia Rose Duignan. *Industrial Light and Magic: Into the Digital Realm.* New York: Balantine Books, 1996.

Vitali, Julius, *Fine Artists Guide to Marketing and Self-promotion.* New York: Allworth Press, 1996.

West, Janice. *Marketing Your Arts and Crafts.* Fort Worth: The Summit Group, 1995.

Video Tapes

Craven, Mike. *Artistry: The Business of Art.* Hollywood, CA: Craven Home Videos, 1995. An eleven-part series dealing with careers in art.

Available through Crystal Productions, PO Box 2159, Glenview, IL, 60025:

Art Galleries. How artists can work with galleries; and how a successful gallery business operates.

The Art Critic. What art critics do, and how they review art shows.

Calligraphy 1: Learning the Art of Beautiful Writing. Introduction to lettering techniques and pen work.

Careers in Fine Art: General, Volume 1. An overview of career possibilities in the fine arts, emphasizing a painter, pastelist, art appraiser, and gallery owner.

Careers in Fine Art: General, Volume 2. Business and marketing skills; also features a potter, sculptor, and printmaker.

Careers in Fine Art: General, Volume 3. Careers in art education, restoration, art history.

Cartooning. The entire process of creating and marketing cartoons.

Commercial Art: General, Volume 1. An overview of the design field. Graphic designer, computer artist, and neon designer.

Commercial Art: Design, Volume 3. Includes careers in fashion and industrial design as well as architecture. Entering the job market.

Commercial Art: Media, Volume 2. Careers in cartooning, scenic designing, and photography.

Desktop Design 1. Basic electronic graphic techniques, software, and hardware.

Graphic Artist. The role and function of graphic design; the business of design.

Graphic Design 1: Demonstrating Values of Good Design. Fundamentals of good design and the process of presenting design work to clients.

Graphic Design 2: The Application of Good Design. Using tools and media to create and present multicolor projects.

Learn and Earn with Calligraphy. How to produce needed calligraphy and market your work.

Printing Basics for Non-Printers. Analysis of the printing process, from designers to production artists.

Art Magazines

Art magazines provide extensive information on art career fields. Write for subscription information or request a sample copy.

ENVIRONMENTAL DESIGN

Architectural Digest, 350 Madison Ave., New York, NY, 10017-3136

Architectural Record, 1221 Avenue of the Americas, 41st Flr., New York, NY, 10020

Architecture, 1515 Broadway, New York, NY, 10036

Crit, 1735 New York Ave., Washington, DC, 20006

Designer/Builder, 2405 Maclovia Ln., Santa Fe, NM, 87505

Fine Gardening, PO Box 5506, Newtown, CT, 06470

Interior Design, PO Box 52331, Boulder, CO, 80323

Interiors, 1515 Broadway, New York, NY, 10036

Landscape Architecture, 4401 Connecticut Ave. NW, Washington, DC, 20008

Landscape Design, 68–860 Perez St. Sta. J, Cathedral City, CA, 92234-7248

Preservation News, 1785 Massachusetts Ave. NW, Washington, DC, 20036-2117

Progressive Architecture, 600 Summer St., Stamford, CT, 06904

DESIGNING FOR COMMUNICATIONS

American Photo, 1633 Broadway, New York, NY, 10019

Aperture Magazine, 20 E. 23rd St., New York, NY, 10010

Art Direction, 10 E. 39th St., 6th Flr., New York, NY, 10016-5905

Byte, 1 Phoenix Mill Ln., Peterborough, NH, 03485

Camerawork, 70 12th St., San Francisco, CA, 94103

Cartoonist, PO Box 20267, New York, NY, 10023

Communication Arts, 410 Sherman Ave., Palo Alto, CA, 94306

Computer Graphics, 1515 Broadway, 17th Flr., New York, NY, 10036

Critique, PO Box 51572, Palo Alto, CA, 94303-9407

Cyberstage, 985 Ossington Ave., Toronto, ON, M6G 3V7, Canada

Design Graphics, 1130 Cleveland Rd., Sandusky, OH, 44870

Design News, 275 Washington Ave., Newton, MA, 02158-1630

Design Quarterly, 55 Hayward St., Cambridge, MA, 02142-1399

Design World, 1130 Cleveland Rd., Sandusky, OH, 44870

Flash Art News, 769 Broadway, Room 226, New York, NY, 10003

Foto Flash, 23 Latham Ave., Scarborough, ON, M1H 1Y3, Canada

Graphis, 141 Lexington Ave., New York, NY 10016

Graphic Design: USA, 1556 Third Ave., Ste. 405, New York, NY 10128

HOW, PO Box 5250, Harlan, IA, 51593-0750

Issue, 20 Park Plaza, Boston, MA, 02116

Online Design, 2261 Market St., #331, San Francisco, CA, 94114-1600

Print, 104 5th Ave., New York, NY, 10011

Step-By-Step, PO Box 1901, Peoria, IL, 61656-9941

Studio Light, 445 Broadhollow Rd., Ste. 21, Melville, NY, 11747-1706

Visual Merchandising and Store Design, 407 Gilbert St., Cincinnati, OH, 45202-2285

Wired, PO Box 191427, San Francisco, CA, 94119

X-RAY, 2700 19th St., 1st Flr., San Francisco, CA 94110

PRODUCT AND FASHION DESIGN

Applied Arts, 885 Don Mills Rd., Ste. 324, Don Mills, ON, M3C 1V9, Canada

Global Packaging & Brand Identity, 1562 1st Ave., Ste. 364, New York, NY, 10028-4004

Harpers Bazaar, 224 W. 57th St., New York, NY, 10019

ID, (Industrial Design), 440 Park Ave. South, 14th Flr., New York, NY, 10016

Packaging Technology and Engineering, 401 N. Broad St., Philadelphia, PA, 19108

Product Design and Development, 1 Chilton Way, Radnor, PA, 19089-0001

ENTERTAINMENT DESIGN

American Cinematographer, 1782 N. Orange Dr., Los Angeles, CA, 90028-4307

Backstage, 1515 Broadway, 14th Flr., New York, NY, 10036

Opera Monthly, PO Box 1475 Church St. Station, New York, NY, 10008

Videography, 2 Park Ave., 18th Flr., New York, NY, 10016

CULTURAL GROWTH AND ENRICHMENT

Technology and Conservation of Art, Architecture and Antiques, 1 Emerson Pl., Boston, MA 02114

Airbrush Action, 1985 Swarthmore Ave., Lakewood, NJ, 80701

American Art, 300 Park Ave. South, New York, NY, 10010

American Artist, 1 Color Ct., Marion, OH, 43305

American Ceramics, 9 E. 45th St., New York, NY, 10017

American Craft, 72 Spring St., New York, NY, 10012-4019

American Photo, 1633 Broadway, New York, NY, 10019

American Style Magazine, PO Box 96063, Washington, DC, 20078-7115

Aperture Magazine, 20 E. 23rd St., New York, NY, 10010

Art and Auction, PO Box 37051, Boone, IA, 50037

Art Education Journal, 1916 Association Dr., Reston, VA, 22091-1590

ArtForum, PO Box 3000, Danville, NJ, 07834

Art in America, 575 Broadway, New York, NY, 10012

Artist's Magazine, 1507 Dana Ave., Cincinnati, OH, 45207

Art News, 48 W. 38th St., New York, NY, 10018

Arts and Activities, 591 Camino dela Reina, Ste. 2001, San Diego, CA, 92108

Arts and Antiques, 3 E. 54th St., New York, NY, 10022

Camerawork, 70 12th St., San Francisco, CA, 94103

Canadian Art, 70 The Esplanade, 2nd Flr., Toronto, ON, M5E 1R2, Canada

Ceramics Monthly, PO Box 6102, Westerville, OH, 43086-6102

Fiberarts, 50 College St., Asheville, NC, 28801-2818

Fine Woodworking, PO Box 5506, Newtown, CT, 06470-5506

Foto Flash, 23 Latham Ave., Scarborough, ON, M1H 1Y3, Canada

Metalsmith, 5009 Londonderry Dr., Tampa, FL, 33647

Museum News, 1225 Eye St. NW, Washington, DC, 20004-1902

Ontario Crafts, 35 McCaul St., Toronto, ON, M5T 1V7, Canada

Rangefinder, 1312 Lincoln Blvd., #1703, Santa Monica, CA, 90401-17064

SchoolArts, 50 Portland St., Worcester, MA, 01608

Sculpture, 1050 17th St. NW, Ste. 250, Washington, DC, 20036

Sculpture Review, 1177 6th Ave., 15th Flr., New York, NY, 10036-2705

Southwest Art, PO Box 460535, Houston, TX, 77056

Stained Glass, 6 SW 2nd St., Ste. 7, Lee's Summit, MO, 64063

Studio Photography, 445 Broadhollow Rd., Ste. 21, Melville, NY, 11747

Studio Potter, PO Box 70, Goffstown, NH, 03045

Surface Design Journal, PO Box 20799, Oakland, CA, 94620

Writer's Digest, PO Box 2123, Harlan, IA, 51593

SERVICES BY AND FOR ARTISTS

Art & Reality, PO Box 25689, Santa Ana, CA, 92799

Art and Design Career Briefs, PO Box 1190, Moravia, NY, 13118-1190

Art Business News, 19 Old Kings Hwy. South, Darien, CT, 06820

Art Calendar, 25742 Frenchtown Rd., Westover, MD, 21871

Art Job, 236 Montezuma Ave., Santa Fe, NM, 87501

Art Therapy, 1201 Allanson Rd., Mundelein, IL, 60060-3808

Occupational Outlook Documents (Careers in Art), Superintendent of Documents, U.S. Government Printing Office, Washington, DC, 20402

Professional Societies and Organizations

Each major art-career category has societies and organizations that keep members updated on trends in the industry, provide relevant information, advertise jobs, recognize members' work, and present awards. Artists and students can often obtain career information from these organizations.

American Abstract Artists
470 W. End Ave. Apt. 9D
New York, NY 10024
(212) 874-0747

American Advertising
 Federation
1101 Vermont Ave. N.W.
Suite 500
Washington, DC 20005
(202) 898-0089
aaf@aaf.org
www.aaf.org/

American Art Therapy
 Association (AATA)
1202 Allanson Rd.
Mundelein, IL 60060
(847) 949-6064

American Artists
 Professional League, Inc.
47 Fifth Ave.
New York, NY 10003
(212) 645-1345

American Center for Design
233 E. Ontario St.
Suite 500
Chicago, IL 60611
(800) 257-8657
(312) 787-2018
ACDChicago@aol.com

American Ceramic Society
P. O. Box 6136
Westerville, OH 43086
(614) 890-4700
info@acers.org
www.acers.org/

American Council for the Arts
1 E. 53 St.
New York, NY 10022-4210
(212) 223-2787
(212) 223-4415

American Craft Council
72 Spring St.
New York, NY 10012-4019
(212) 274-0630

American Federation of
 Television and Radio
 Artists (AFTRA)
260 Madison Ave.
New York, NY 10016
(212) 532-0800

American Film Institute
 Center for Advanced Film
 and Television
2021 N. Western Ave.
Los Angeles, CA 90027
(213) 856-7741
www.afionline.org/afi-
homes/education.home.html

American Institute for
 Conservation of Historic
 and Artistic Works (AIC)
1717 K St. N.W., Suite 301
Washington, DC 20006
(202) 452-9545

American Institute of
 Architects (AIA)
1735 New York Ave. N.W.
Washington, DC 20006
(202) 626-7300
(202) 626-7472

American Institute of
Graphic Arts (AIGA)
164 Fifth Ave.
New York, NY 10010
(212) 807-1990
www.aiga.org

American Society of Artists
P. O. Box 1326
Chicago, IL 60078
(312) 751-2500
(708) 991-4748

American Society of
 Contemporary Artists
c/o 130 Gail Pl. #9H
New York, NY 10463
(718) 548-6790

American Society of
 Furniture Designers
P. O. Box 2688
High Point, NC 27261

American Society of Interior
 Designers (ASID)
608 Massachusetts Ave. N.E.
Washington, DC 20002
(202) 546-3480
education@asid.noli.com
www.asid.org

American Society of Land-
 scape Architects (ASLA)
4401 Connecticut Ave. N.W.
Washington, DC 20008
(202) 686-2752
(202) 898-2444
www.asla.org/asla/

American Society of Media
 Photographers (ASMP)
14 Washington Rd., Ste. 502
Princeton Junction, NJ
08550-1033
(609) 799-8300
(609) 799-2233
www2.asmp.org/asmp/

American Society of Portrait
 Artists (ASOPA)
2781 Zelda Rd.
Montgomery, AL 36106
(334) 270-1600
(334) 270-0150

Architectural League of NY
457 Madison Ave.
New York, NY 10022
(212) 753-1722
www.arch-
online.com/organ/arleag.htm

Art Dealers Association of
 America
575 Madison Ave.
New York, NY 10022
(212) 940-8590

Art Directors Club, Inc.
250 Park Ave. S.
New York, NY 10003
(212) 674-0500
(212) 228-0649

Association of American
 Editorial Cartoonists
4101 Lake Boone Trail
Suite 201
Raleigh, NC 27607
(919) 787-5181

Association of Art Museum
 Directors
41 E. 65 St.
New York, NY 10021
(212) 249-4423

Association of Handicapped
 Artists Inc.
5150 Broadway
Depew, New York 14043
(716) 683-4624

Association of Medical
 Illustrators
1819 Peachtree St. N.E.
Suite 712
Atlanta, GA 30309
(404) 350-7900

Corporate Design
 Foundation
20 Park Plaza, Suite 321
Boston, MA 02116
(617) 350-7097
www.cdf.org/

Directors' Guild of America
7920 Sunset Blvd.
Los Angeles, CA 90046
(310) 289-2000
www.dga.org/dga-
info/address.html

Education Council of the
 Graphic Arts Industry
4615 Forbes Ave.
Pittsburgh, PA 15213
(412) 749-7812

Federation of Modern
 Painters and Sculptors
234 W. 21 St.
New York, NY 10011
(212) 568-2981

Graphic Artists Guild
90 John St., Room 403
New York, NY 10038
(212) 791-3400

Guild of Book Workers
521 Fifth Ave.
New York, NY 10175
(212) 757-6454

International Alliance of
 Theatrical Stage Employees
1515 Broadway
Suite 601
New York, NY 10036
(212) 730-1770
www.iatse.lm.com/index.html

International Association of
 Lighting Designers (IALD)
1133 Broadway
Suite 520
New York, NY 10010-7903
(212) 206-1281
IALD@acenet.com

International Center of
 Photography
1130 Fifth Ave.
New York, NY 10128

International Furnishings
 and Design Association
1200 19 St. N.W., Suite 300
Washington, DC 20036
(202) 857-1897
www.ifda.com

International Interior Design
 Association (IIDA)
341 Merchandise Mart
Chicago, IL 60654-1104
(312) 467-1950
iidahq@aol.com
www.iida.com/

National Antique and Art
 Dealers Association of
 America, Inc.
12 E. 56 St.
New York, NY 10022
(212) 826-9707

National Artists Equity
 Association, Inc.
Central Station
P. O. Box 28068/3726
Albemarle St. N.W.
Washington, DC 20038
(800) 628-9633
(202) 628-9633

National Assembly of State
 Arts Agencies
1010 Vermont Ave. N.W.
Suite 920
Washington, DC 20005
(202) 347-6352

National Association of
 Women Artists, Inc.
41 Union Sq. W.
Room 906
New York, NY 10003
(212) 675-1616

National Cartoonists Society
P. O. Box 20267
New York, NY 10023-1484
(904) 767-0657

National Network for Artist
 Placement
935 West Ave. 37
Los Angeles, CA 90065

National Society of Mural
 Painters, Inc.
c/o American Fine Arts
 Society
215 W. 57 St.
New York, NY 10019
(718) 389-7607

National Society of Painters
 in Casein and Acrylic, Inc.
969 Catasauqua Rd.
Whitehall, PA 18052
(610) 264-7472

National Trust for Historic
 Preservation
1785 Mass. Ave. N.W.
Washington, DC 20036

Ontario Crafts Council
170 Bedford Rd., Suite 300
Toronto, Ontario M5R 2K9
(416) 925-4222
www.canartscene.com

Professional Photographers
 of America (PPA)
57 Forsyth St. N.W.
Suite 1600
Atlanta, GA 30303
(800) 786-6277
(404) 522-8600
member@ppa-world.org
www.ppa-world.org

Professional Picture Framers
 Association
4305 Sarellen Rd.
Richmond, VA 23231
(804) 226-0430
www.ppfa.com

Royal Architectural Institute
 of Canada
55 Murray St., Suite 330
Ottawa, Ontario K1N 5M3
(613) 241-3600
www.raic.org/

Screen Cartoonists Guild
1616 W. 9 St.
Los Angeles, CA 90015

Sculptors Guild, Inc.
Soho Bldg #305
110 Greene St
New York, NY 10012
(212) 431-5669

Society for Calligraphy and
 Handwriting
P. O. Box 3761
Bellevue, WA 98009

Society of American Graphic
 Artists
32 Union Sq.
Room 1214
New York, NY 10003
(212) 260-5706

Society of American
 Historical Artists
P. O. Box 409
Jericho, NY 11753
(516) 681-8820

Society of Architectural
 Historians
1232 Pine St.
Philadelphia, PA 19107
(215) 735-0224
(215) 735-0246

Society of Illustrators
128 E. 63 St.
New York, NY 10021
(212) 838-2560

Society of North American
 Goldsmiths
5009 Londonderry Dr.
Jacksonville, FL 33647
(813) 977-5326

Society of Operating
 Cameramen
P. O. Box 2006
Toluca Lake, CA 91610
(818) 382-7070
info@soc.org
www.soc.org/

Society of Publication
 Designers
60 E. 42 St., Suite 721
New York, NY 10165
(212) 983-8585
(212) 983-6043
spdnyc@aol.com
www.spd.org/aboutspd/about
logo.html

Special Interest Group on
 Computer Graphics
11 W. 42 St. #3FL
New York, NY 10036
(212) 869-7440

Publications by Professional Societies and Organizations

Art Scholarships at American Colleges, National Art Education Association, 1916 Association Dr., Reston, VA, 22091-1590

Directory of Accredited Art & Design Schools, National Association of Schools of Art and Design, 11250 Roger Bacon Drive, Reston, VA, 20190-5202

Directory of Interior Design Programs, Foundation for Interior Design Education Research, 60 Monroe Center NW, Suite 300, Grand Rapids, MI, 49503-2920

Guide to Architecture Schools, Association of Collegiate Schools of Architecture, 1735 New York Avenue NW, Washington, DC, 20006

List of Resource Reports on Museum Careers, American Association of Museums, PO Box 4002, Washington, DC, 20042-4002

Listing of Industrial Design School Programs, Industrial Designers Society of America, 1142 Walker Rd., Great Falls, VA, 22066

Membership Directory/Resource Guide, Society for Photographic Education, PO Box 222116, Dallas, TX, 75222

Membership List of Art and Design Schools, Association of Independent Colleges of Art and Design, 3957 22nd St., San Francisco, CA 94114

Packet of Industrial Design Information, Industrial Designers Society of America, 1142 Walker Road, Suite E, Great Falls, VA 22066

Web Sites

The Internet changes every day with the addition of URLs pertaining to art careers. Therefore, a comprehensive listing of Web sites is impossible. The career-based sites listed here provide a starting place for those seeking information on the Internet. Check the listing of Professional Societies and Organizations on page 226 for URLs of specific organizations.

Art careers
www.nmu.edu/art-design/AD_Career-Jobs.html
Based at Northern Michigan University; contains resource listings and valuable links related to art careers.

Art jobs
www.lib.muohio.edu/libinfo/depts/artarch/RedNotebook/ArtCareers.html
A listing of resources to identify possible employers.

Art jobs
www.westaf.org/artjob/
Provides an opportunity to subscribe to an online listing of available art jobs; also contains useful links.

Artists online
www.onlineart.com
State of the art online computer technology to market artwork.

Corporate Design Foundation
www.cdf.org/
A variety of resources including a listing of design firms and information about Green design.

National Association of Independent Artists
www.avocet.net/naia/
For fine artists and craftspeople; excellent arts links.

Peterson's online
www.petersons.com
A comprehensive site for information on educational institutions.

Colleges and Art Schools

The charts on the following pages list United States and Canadian schools that offer a major in art, leading to an undergraduate degree such as a B.A. or B.F.A. Many of the universities listed offer a graduate program leading to an M.F.A.

Community and junior colleges are not listed here; nor are art schools with two- or three-year programs. You can obtain their addresses at a public library. The information presented in these charts changes frequently, as departments add or drop programs. Some of the listed schools are affiliated with national organizations. Such associations do not guarantee the quality of the programs offered, but do recommend their consideration. The initials in the chart refer to the following:

ASID—student chapter of the American Society of Interior Designers
ASLA—accredited by the American Society of Landscape Architecture
FIDER—accredited by the Foundation for Interior Design Education Research
NASAD—member of the National Association of Schools of Art and Design

Categories in the charts:

Administration/Management indicates areas of museum management, curatorship, and directorship, but also refers to administration of art programs and art educational systems, and management of galleries and art centers.

Advertising indicates a focus on commercial art and advertising. Usually this is a concentration within a program in Graphic Design and Computer Art.

Architecture often includes landscape architecture and environmental and city planning. Schools with NAAB designations offer degrees; others offer prearchitectural majors (studies must continue at NAAB schools).

Art History usually refers to professional training leading to advanced degrees for museum work or art-history teaching; it may also refer to survey courses.

Art Education usually refers to professional training to become an art teacher; offers studio courses and practice-teaching experiences.

Art Therapy usually refers to programs that train art therapists. Those schools with AATA listings offer degrees.

Crafts/Fabrics covers a wide range of skills and special interests.

Fashion Design covers training in design and illustration for the fashion industry. Some schools have only one or the other; others have both.

Film/TV/Video Some schools have entire film or video departments and include all aspects of film production; others offer only a few courses.

Fine Arts includes courses in the fine arts.

Graphic Design/Computer Art includes courses in all areas of this field. Schools with AIGA designations usually have complete programs.

Illustration refers to training for commercial illustration. Cartooning is often included.

Industrial Design refers to training in all types of product design, and to such specialized areas as furniture, automotive, or computer-assisted design.

Interior Design usually includes all interior-design courses, but also can include special emphases, such as facility planning or interior environmental design.

Landscape Architecture includes environmental and urban planning.

Medical Illustration is a specialized area of technical illustration. Courses are available in a number of medical schools that are part of university campuses.

Museum Work/Conservation is specified by some schools. Many museums have apprentice programs to train people to fill specific career positions.

Photography refers generally to still photography.

Theater Arts/Stage refers to emphasis on stage and set design, as well as costume design and makeup.

Institution	Administration/Management	Advertising	Architecture	Art History	Art Education	Art Therapy	Crafts/Fabrics	Fashion Design	Film/TV/Video	Fine Arts	Graphic Design/Computer Art	Illustration	Industrial Design	Interior Design	Landscape Architecture	Medical Illustration	Museum Work/Conservation	Photography	Theater Arts/Stage	Associations
UNITED STATES																				
ALABAMA																				
Alabama State U. Montgomery 36101	✔		✔	✔	✔		✔	✔	✔	✔	✔			✔			✔	✔	✔	
Athens State College 35611			✔	✔	✔					✔					✔			✔	✔	
Auburn U. 36830		✔	✔	✔	✔		✔			✔	✔	✔	✔	✔	✔		✔			ASID, ASLA, FIDER, NASAD
Auburn U. at Montgomery 36117			✔	✔	✔				✔	✔	✔			✔				✔	✔	
Birmingham Southern College 35204			✔	✔				✔		✔										
Huntingdon College Montgomery 36106			✔	✔	✔					✔	✔							✔	✔	
Jacksonville State U. 36265			✔	✔	✔					✔	✔							✔		NASAD
Samford U. Birmingham 35209			✔	✔	✔					✔	✔			✔				✔	✔	
Spring Hill College Mobile 36608	✔		✔	✔	✔	✔		✔	✔								✔			
Troy State U. 36081			✔	✔	✔			✔	✔	✔	✔							✔	✔	
Tuskegee Inst. 36088		✔	✔	✔			✔													
U. of Alabama University 35486			✔	✔	✔					✔	✔		✔				✔			
U. of Alabama at Birmingham 35294			✔	✔	✔					✔	✔						✔			NASAD
U. of Alabama at Huntsville 35807			✔	✔				✔	✔	✔	✔						✔			
U. of Montevallo 35115			✔	✔	✔	✔	✔	✔	✔	✔	✔			✔				✔	✔	NASAD
U. of North Alabama Florence 35630			✔	✔	✔			✔	✔	✔	✔			✔				✔	✔	ASID, NASAD
U. of South Alabama Mobile 36688			✔	✔				✔	✔	✔								✔	✔	NASAD
ALASKA																				
U. of Alaska Anchorage 99504			✔	✔	✔					✔								✔	✔	NASAD
U. of Alaska Fairbanks 99701			✔		✔					✔										
ARIZONA																				
Arizona State U. Tempe 85281		✔	✔		✔					✔	✔			✔				✔		ASID, FIDER
Grand Canyon College Phoenix 85017			✔	✔						✔	✔							✔	✔	
Northern Arizona U. Flagstaff 86001			✔	✔	✔	✔	✔			✔	✔	✔		✔				✔		ASID
U. of Arizona Tucson 85721		✔	✔		✔			✔		✔				✔	✔		✔	✔		ASLA
ARKANSAS																				
Arkansas Art Center Little Rock 72203			✔		✔													✔	✔	
Arkansas State U. Jonesboro 72467			✔	✔	✔			✔	✔	✔								✔	✔	
Arkansas Tech U. Russellville 72801			✔		✔				✔	✔								✔		
Harding U. Searcy 72143			✔	✔	✔				✔	✔	✔			✔						ASID
Ouachita Baptist U. Arkadelphia 71923			✔	✔	✔	✔				✔				✔				✔		
Southern Arkansas U. Magnolia 71753	✔		✔	✔	✔					✔	✔							✔		
U. of Arkansas Fayetteville 72701		✔	✔	✔	✔					✔	✔			✔	✔			✔		ASID, ASLA, FIDER
U. of Arkansas at Little Rock 72204			✔	✔	✔		✔	✔	✔	✔	✔			✔		✔	✔	✔		NASAD
U. of Arkansas at Monticello 71655			✔	✔	✔					✔	✔									
U. of Arkansas at Pine Bluff 71601			✔	✔	✔	✔	✔	✔										✔	✔	
U. of Central Arkansas Conway 72032			✔		✔					✔				✔						ASID, NASAD
U. of the Ozarks Clarksville 72830			✔		✔					✔										
CALIFORNIA																				
Academy of Art College San Francisco 94105	✔		✔		✔		✔	✔	✔	✔	✔	✔	✔	✔				✔		ASID, FIDER, NASAD
Art Center College of Design Pasadena 91103			✔					✔	✔	✔	✔	✔	✔	✔				✔		NASAD

School	Administration/Management	Advertising	Architecture	Art History	Art Education	Art Therapy	Crafts/Fabrics	Fashion Design	Film/TV/Video	Fine Arts	Graphic Design/Computer Arts	Illustration	Industrial Design	Interior Design	Landscape Architecture	Medical Illustration	Museum Work/Conservation	Photography	Theater Arts/Stage	Associations
Art Inst. of S. California Laguna Beach 92651									✔	✔	✔									NASAD
Azusa Pacific College 91702			✔	✔		✔		✔	✔	✔	✔	✔						✔		
Biola U. La Mirada 90639			✔	✔	✔	✔		✔	✔	✔								✔		
California Baptist College Riverside 92504			✔			✔				✔				✔						
California College of Arts & Crafts Oakland 94618	✔		✔	✔		✔			✔	✔	✔			✔				✔		NASAD
California Inst. of the Arts Valencia 91355				✔					✔	✔								✔	✔	NASAD
California Lutheran U. Thousand Oaks 91360			✔	✔		✔	✔		✔								✔	✔	✔	
California Polytechnic State U. San Luis Obispo 93407		✔	✔	✔		✔			✔	✔	✔		✔	✔				✔		ASLA, NASAD
California State College at Bakersville 93309		✔		✔	✔					✔								✔		
California State U. Stanislaus Turlock 95382	✔		✔			✔	✔	✔	✔	✔							✔	✔		
California State Polytechnic U. Pomona 91765		✔	✔	✔		✔	✔		✔	✔	✔			✔				✔		ASLA
California State U. Chico 95929	✔		✔	✔		✔				✔				✔					✔	ASID, NASAD
California State U. Dominguez Hills Carson 90747			✔	✔	✔				✔	✔						✔				
California State U. Fresno 93740			✔	✔		✔		✔	✔					✔				✔		ASID, FIDER
California State U. Fullerton 92634			✔	✔		✔						✔	✔	✔				✔		NASAD
California State U. Hayward 94542	✔		✔	✔		✔			✔	✔					✔			✔		NASAD
California State U. Long Beach 90840	✔		✔	✔			✔	✔	✔	✔	✔	✔	✔	✔		✔	✔	✔	✔	ASID, NASAD
California State U. Los Angeles 90032			✔	✔		✔	✔		✔	✔				✔					✔	NASAD
California State U. Northridge 91321			✔	✔		✔		✔	✔	✔			✔	✔				✔		ASID, NASAD
California State U. Sacramento 95819	✔		✔	✔	✔	✔		✔	✔	✔				✔				✔	✔	ASID, FIDER, NASAD
Chapman College Orange 92666			✔	✔		✔	✔	✔	✔	✔	✔			✔		✔		✔		
Cogswell Polytechnical College Sunnyvale 94089									✔	✔										
College of Notre Dame Belmont 94022	✔	✔		✔	✔		✔			✔	✔			✔				✔	✔	
Dominican College of San Rafael 94901	✔			✔	✔		✔			✔	✔							✔	✔	
Humboldt State U. Arcata 95521				✔	✔		✔			✔	✔							✔		NASAD
Laguna Beach Sch. of Art 92651				✔			✔			✔	✔							✔		
La Sierra U. Riverside 92515		✔		✔			✔			✔	✔	✔						✔		
Loyola Marymount U. Los Angeles 90045	✔			✔	✔	✔			✔	✔	✔	✔						✔	✔	NASAD
Mills College Oakland 94613				✔	✔		✔		✔	✔								✔		
Mount St. Mary's College Los Angeles 90049				✔	✔		✔			✔	✔	✔						✔	✔	
Occidental College Los Angeles 90041				✔	✔		✔		✔	✔	✔							✔		
Otis Art Inst. Los Angeles 90057				✔			✔	✔	✔	✔	✔	✔						✔		
Pacific Union College Angwin 94508				✔	✔		✔			✔	✔	✔		✔				✔		
Pepperdine U. Malibu 90265				✔	✔		✔			✔										
Pitzer College Claremont 91711				✔			✔		✔	✔								✔		
Pomona College Claremont 91711				✔			✔		✔	✔	✔							✔		
San Diego State U. 92182	✔	✔	✔	✔	✔		✔	✔	✔	✔	✔	✔		✔				✔		ASID, FIDER, NASAD
San Francisco Art Inst. 94133				✔			✔		✔	✔							✔			NASAD
San Francisco State U. 94132				✔	✔		✔	✔	✔	✔	✔			✔			✔	✔		ASID, NASAD
San Jose State U. 95192	✔			✔	✔		✔		✔	✔	✔	✔	✔	✔						ASID, NASAD
Scripps College Claremont 91711			✔	✔		✔				✔								✔		
Sonoma State U. Rohnert Park 94928	✔			✔	✔	✔	✔		✔	✔	✔							✔	✔	NASAD
Southern California Inst. of Arch. Los Angeles 90066			✔																	
Stanford U. 94305				✔	✔				✔	✔								✔		
Stanislaus State College Turlock 95380																				
U. of California at Berkeley 94720			✔	✔	✔				✔						✔	✔				ASID, FIDER, NASAD

	Administration/Management	Advertising	Architecture	Art History	Art Education	Art Therapy	Crafts/Fabrics	Fashion Design	Film/TV/Video	Fine Arts	Graphic Design/Computer Arts	Illustration	Industrial Design	Interior Design	Landscape Architecture	Medical Illustration	Museum Work/Conservation	Photography	Theater Arts/Stage	Associations
U. of California at Davis 95616		✔	✔		✔			✔		✔	✔			✔	✔			✔		ASID, ASLA
U. of California at Irvine 92717		✔	✔		✔			✔	✔	✔	✔			✔				✔		ASID
U. of California at Los Angeles 90024		✔	✔	✔	✔		✔	✔	✔	✔	✔	✔		✔				✔		FIDER
U. of California at Riverside 92521			✔							✔	✔							✔		
U. of California at San Diego La Jolla 92093			✔			✔				✔	✔							✔		
U. of California at San Francisco 94103																✔				
U. of California at Santa Barbara 93106			✔			✔				✔								✔		
U. of California at Santa Cruz 95064	✔		✔	✔		✔			✔	✔		✔			✔			✔	✔	
U. of the Pacific Stockton 95211	✔		✔	✔					✔	✔	✔							✔	✔	NASAD
U. of Redlands 92373			✔	✔		✔				✔	✔							✔		
U. of San Diego 92110	✔		✔	✔	✔	✔				✔	✔				✔			✔		
U. of San Francisco 94117							✔	✔	✔	✔	✔	✔	✔	✔				✔		
U. of Santa Clara 95053	✔		✔			✔			✔	✔	✔							✔		
U. of Southern California Los Angeles 90007		✔	✔			✔				✔	✔	✔					✔	✔		
Woodbury U. Burbank 91510		✔	✔			✔	✔			✔	✔	✔	✔	✔				✔	✔	ASID, FIDER
COLORADO																				
Adams State College Alamosa 81102			✔	✔		✔				✔								✔		
Colorado Inst. of Art Denver 80203							✔	✔	✔	✔	✔		✔					✔		ASID
Colorado State U. Fort Collins 80523			✔	✔		✔			✔	✔	✔		✔		✔			✔		ASID, FIDER, NASAD
Colorado Women's College Denver 80220			✔	✔		✔	✔			✔								✔	✔	
Fort Lewis College Durango 81301			✔	✔		✔				✔	✔	✔						✔		
Loretto Heights College Denver 80236		✔	✔	✔		✔				✔								✔		
Metropolitan State College of Denver 80204			✔	✔		✔			✔	✔	✔	✔						✔		
Rocky Mtn. College of Art & Design Denver 80218		✔	✔			✔	✔		✔		✔		✔	✔				✔		ASID
U. of Colorado at Boulder 80309			✔	✔	✔		✔	✔	✔	✔								✔		
U. of Colorado at Denver 80202			✔	✔					✔	✔	✔				✔			✔		ASLA
U. of Denver 80208	✔		✔	✔		✔			✔	✔	✔							✔		
U. of Northern Colorado Greeley 80639	✔		✔	✔		✔				✔	✔							✔		
U. of Southern Colorado Pueblo 81001	✔	✔		✔	✔		✔			✔	✔	✔	✔	✔				✔		
Western State College Gunnison 81230			✔	✔		✔				✔								✔		
CONNECTICUT																				
Albertus Magnus College New Haven 06511		✔	✔	✔	✔	✔				✔	✔							✔	✔	
Central Connecticut State College New Britain 06050	✔	✔			✔			✔	✔	✔	✔			✔						
Connecticut College New London 06320	✔		✔			✔			✔	✔	✔	✔						✔		
Fairfield U. 06430			✔							✔	✔							✔		
Paier College of Art Inc. Hamden 06511			✔					✔		✔	✔	✔		✔				✔		ASID
Sacred Heart U. Fairfield 06432			✔						✔	✔	✔	✔	✔					✔	✔	
Southern Connecticut State College New Haven 06515	✔	✔		✔				✔	✔	✔					✔					
Trinity College Hartford 06106			✔								✔							✔		
U. of Bridgeport 06602			✔	✔		✔			✔	✔	✔	✔	✔	✔				✔	✔	NASAD
U. of Connecticut Storrs 06268			✔	✔		✔				✔	✔	✔		✔				✔	✔	NASAD
U. of Hartford West Hartford 06117		✔		✔	✔		✔			✔	✔							✔		
U. of New Haven West Haven 06516			✔				✔	✔	✔	✔	✔	✔		✔		✔		✔		ASID
Wesleyan U. Middletown 06457			✔	✔	✔		✔			✔	✔			✔				✔		

Institution	Admin/Mgmt	Advertising	Architecture	Art History	Art Education	Art Therapy	Crafts/Fabrics	Fashion Design	Film/TV/Video	Fine Arts	Graphic Design/Computer Arts	Illustration	Industrial Design	Interior Design	Landscape Architecture	Medical Illustration	Museum Work/Conservation	Photography	Theater Arts/Stage	Associations
Western Connecticut State College Danbury 06810	✔	✔	✔		✔		✔	✔									✔			
Yale U. Sch. of Art New Haven 06520																				
DELAWARE																				
Delaware State College Dover 19901		✔		✔	✔					✔	✔			✔				✔		
U. of Delaware Newark 19711		✔			✔		✔		✔	✔	✔	✔		✔				✔		
DISTRICT OF COLUMBIA																				
American U. 20016	✔			✔	✔					✔	✔	✔								
Catholic U. of America 20064		✔	✔	✔	✔	✔	✔	✔						✔			✔	✔		
Corcoran Sch. of Art 20006			✔		✔			✔	✔	✔	✔	✔	✔	✔				✔		NASAD
Georgetown U. 20057				✔						✔	✔								✔	
George Washington U. 20052				✔	✔		✔			✔								✔		
Howard U. 20059		✔	✔		✔			✔	✔	✔	✔	✔		✔				✔		ASID, NASAD
U. of the District of Columbia 20001	✔			✔	✔					✔	✔	✔						✔		
FLORIDA																				
Art Inst. of Ft. Lauderdale 33316	✔	✔	✔					✔	✔	✔	✔	✔		✔				✔		ASID
Barry College Miami 33161	✔			✔	✔	✔				✔	✔	✔						✔		
College of Boca Raton 33431				✔	✔	✔				✔	✔			✔				✔	✔	
Eckerd College St. Petersburg 33733				✔	✔					✔								✔		
Flagler College St. Augustine 32084	✔			✔	✔					✔	✔	✔						✔		
Florida A & M U. Tallahassee 32307		✔	✔	✔	✔					✔	✔									
Florida Atlantic U. Boca Raton 33432	✔	✔	✔	✔	✔		✔			✔	✔					✔				
Florida International U. Miami 33199				✔	✔					✔					✔			✔		ASLA
Florida Southern College Lakeland 33802	✔			✔	✔					✔	✔							✔		
Florida State U. Tallahassee 32306				✔	✔	✔				✔	✔	✔		✔			✔	✔		ASID, FIDER, NASAD
Jacksonville U. 32211	✔			✔	✔					✔	✔							✔	✔	
Ringling Sch. of Art & Design Sarasota 33580				✔						✔	✔	✔		✔				✔		ASID, FIDER, NASAD
Rollins College Winter Park 32789				✔	✔					✔								✔		
Stetson U. DeLand 32720				✔	✔					✔										
U. of Central Florida Gainesville 32611		✔		✔				✔	✔	✔	✔	✔		✔		✔		✔	✔	ASID
U. of Miami Coral Gables 33124		✔	✔	✔	✔	✔				✔	✔	✔						✔	✔	
U. of North Florida Jacksonville 32224										✔	✔							✔		
U. of Southern Florida Tampa 33620				✔	✔		✔	✔		✔								✔		
U. of Tampa 33606	✔			✔	✔					✔								✔		
U. of Western Florida Pensacola 32504				✔	✔				✔	✔	✔	✔						✔		
GEORGIA																				
Agnes Scott College Decatur 30030				✔		✔				✔										
Art Inst. of Atlanta 30326		✔	✔				✔			✔	✔	✔		✔				✔		ASID, FIDER
Atlanta College of Art 30309	✔		✔		✔		✔	✔	✔	✔	✔			✔				✔		NASAD
Augusta College 30910				✔	✔					✔	✔							✔		
Berry College Mount Berry 30149				✔	✔				✔	✔								✔		
Clark Atlanta U. 30314				✔	✔		✔		✔	✔	✔							✔		
Columbus College 31907				✔	✔		✔			✔	✔							✔	✔	
Georgia Inst. of Tech. Atlanta 30332		✔	✔	✔						✔	✔		✔	✔	✔					

Institution	Administration/Management	Advertising	Architecture	Art History	Art Education	Art Therapy	Crafts/Fabrics	Fashion Design	Film/TV/Video	Fine Arts	Graphic Design/Computer Arts	Illustration	Industrial Design	Interior Design	Landscape Architecture	Medical Illustration	Museum Work/Conservation	Photography	Theater Arts/Stage	Associations
Georgia Southern U. Statesboro 30458		✓	✓	✓	✓					✓	✓	✓		✓				✓		ASID, NASAD
Georgia Southwestern College Americus 31709			✓	✓	✓		✓	✓		✓	✓							✓		
Georgia State U. Atlanta 30303			✓	✓	✓					✓	✓	✓		✓				✓		ASID, NASAD
LaGrange College 30240			✓	✓	✓					✓								✓		
Medical College of Georgia Augusta 30912																✓				
Mercer U. Macon 31207			✓	✓	✓					✓									✓	
North Georgia College Dahlonega 30597			✓	✓	✓					✓								✓		
Piedmont College Demorest 30535			✓	✓	✓					✓	✓							✓		
Savannah College of Art & Design 31401										✓	✓			✓						ASID
Shorter College Rome 30161		✓	✓	✓	✓					✓	✓	✓								
Tift College Forsyth 31029			✓	✓	✓					✓	✓	✓						✓		
U. of Georgia Athens 30602			✓	✓	✓					✓	✓	✓		✓	✓			✓		ASID, ASLA, FIDER, NASAD
Valdosta State U. 31698		✓	✓	✓	✓					✓	✓	✓						✓		NASAD
Wesleyan College Macon 31297	✓	✓	✓	✓	✓					✓	✓	✓						✓		
West Georgia College Carrollton 30117			✓	✓	✓					✓	✓			✓				✓		
HAWAII																				
Brigham Young U. Laie 96762					✓					✓										
Honolulu Academy of Arts 96814										✓										
U. of Hawaii at Manoa Honolulu 96822			✓							✓	✓							✓		
IDAHO																				
Boise State U. 83725		✓	✓	✓	✓					✓	✓	✓		✓				✓		
Idaho State U. Pocatello 83209			✓	✓	✓					✓										
Lewis-Clark State College Lewiston 83501				✓	✓				✓	✓									✓	
U. of Idaho Moscow 83843			✓		✓					✓	✓			✓	✓			✓		ASID, ASLA
ILLINOIS																				
Aurora College 60507					✓					✓	✓									
Barat College Lake Forest 60045			✓	✓	✓					✓				✓				✓	✓	
Bradley U. Peoria 61625			✓		✓					✓	✓	✓						✓		NASAD
Columbia College Chicago 60605	✓	✓	✓	✓	✓	✓	✓	✓	✓	✓	✓	✓	✓	✓				✓		
DePaul U. Chicago 60614			✓							✓								✓		
Eastern Illinois U. Charleston 61920			✓	✓	✓					✓	✓									NASAD
Governors State U. University Park 60466			✓		✓				✓	✓								✓		
Greenville College 62246			✓	✓	✓					✓	✓							✓		
Harrington Inst. of Interior Design Chicago 60605														✓						ASID, FIDER, NASAD
Illinois Inst. of Tech. Chicago 60616								✓		✓	✓		✓					✓		
Illinois State U. Normal 61761			✓	✓	✓		✓			✓	✓	✓		✓				✓		ASID, NASAD
Illinois Wesleyan U. Bloomington 61701			✓		✓					✓	✓							✓		
Inst. of Design Chicago 60616		✓							✓		✓	✓	✓					✓		
Judson College Elgin 60120			✓	✓	✓					✓								✓	✓	
Knox College Galesburg 61401			✓		✓					✓								✓		
Loyola U. Chicago 60611			✓	✓						✓	✓						✓	✓		
Millikin U. Decatur 62522	✓		✓	✓						✓	✓							✓		
Morton College Cicero 60650		✓	✓		✓					✓								✓		
Northeastern Illinois U. Chicago 60625			✓	✓	✓					✓								✓		

Institution	Administration/Management	Advertising	Architecture	Art History	Art Education	Art Therapy	Crafts/Fabrics	Fashion Design	Film/TV/Video	Fine Arts	Graphic Design/Computer Arts	Illustration	Industrial Design	Interior Design	Landscape Architecture	Medical Illustration	Museum Work/Conservation	Photography	Theater Arts/Stage	Associations
Northern Illinois U. DeKalb 60115	✔	✔		✔	✔	✔	✔		✔	✔	✔			✔		✔		✔	✔	NASAD
North Park College Chicago 60625		✔		✔	✔		✔			✔	✔							✔		
Northwestern U. Evanston 60201			✔	✔															✔	
Olivet Nazarene College Kankakee 60901				✔	✔			✔	✔	✔								✔		
Quincy College 62301		✔		✔	✔		✔		✔	✔	✔							✔		
Ray College of Design Chicago 60611	✔	✔	✔			✔			✔	✔	✔		✔	✔				✔		
Rockford College 61107			✔		✔					✔								✔		
Sangamon State U. Springfield 62708	✔		✔		✔			✔		✔								✔	✔	
Sch. of the Art Inst. of Chicago 60603			✔	✔	✔	✔	✔	✔	✔	✔	✔			✔			✔	✔	✔	NASAD
Southern Illinois U. at Carbondale 62901			✔	✔	✔					✔				✔			✔	✔		ASID, FIDER, NASAD
Southern Illinois U. at Edwardsville 62025			✔	✔	✔					✔	✔							✔		
U. of Chicago 60637	✔	✔	✔						✔	✔								✔		
U. of Illinois at Chicago 60680		✔		✔	✔				✔	✔	✔	✔	✔					✔	✔	NASAD
U. of Illinois at the Medical Center Chicago 60612																✔				
U. of Illinois at Urbana-Champaign 61820	✔		✔	✔	✔		✔	✔	✔	✔	✔	✔	✔	✔						NASAD
Western Illinois U. Macomb 61455		✔	✔	✔	✔				✔	✔	✔									
INDIANA																				
Anderson College 46011	✔	✔	✔	✔	✔					✔	✔		✔					✔	✔	
Ball State U. Muncie 47306			✔	✔	✔				✔	✔				✔	✔			✔		ASLA, NASAD
De Pauw U. Greencastle 46135			✔	✔	✔					✔								✔		
Earlham College Richmond 47374			✔		✔		✔			✔								✔	✔	
Franklin College 46131			✔		✔					✔										
Grace College Winona Lake 46590		✔	✔	✔	✔					✔	✔	✔						✔		
Hanover College 47243		✔	✔	✔	✔				✔	✔	✔							✔	✔	
Herron Sch. of Art Indianapolis 46202			✔	✔	✔			✔	✔	✔	✔							✔		NASAD
Indiana-Purdue U. Fort Wayne 46805			✔	✔	✔					✔	✔							✔		
Indiana State U. Terre Haute 47809			✔	✔	✔					✔	✔			✔				✔		NASAD
Indiana U. Bloomington 47401				✔	✔					✔	✔			✔				✔		ASID, FIDER, NASAD
Indiana U. at South Bend 46615			✔	✔	✔					✔	✔							✔		
Indiana U.-Purdue U., Indianapolis 46202			✔	✔	✔			✔	✔	✔	✔							✔		
Indiana U. Southeast New Albany 47150	✔		✔	✔	✔					✔								✔		
Marian College Indianapolis 46226			✔		✔	✔				✔	✔			✔				✔	✔	
Marion College Marion 46952			✔	✔	✔					✔	✔			✔				✔	✔	
Purdue U. West LaFayette 47907		✔	✔	✔	✔		✔	✔	✔	✔	✔		✔	✔	✔			✔	✔	ASID, FIDER, ASLA
Purdue U. Calumet Hammond 46323		✔		✔	✔		✔	✔										✔	✔	
St. Francis College Fort Wayne 46808	✔		✔	✔	✔		✔			✔	✔	✔						✔		
St. Mary's College Notre Dame 46556			✔	✔	✔					✔								✔		NASAD
Taylor U. Upland 46989	✔		✔	✔	✔					✔								✔	✔	
U. of Evansville 47702			✔	✔	✔	✔				✔	✔								✔	
U. of Notre Dame 46556		✔		✔	✔					✔	✔			✔	✔			✔		
Valparaiso U. 46383			✔	✔	✔					✔	✔							✔		
IOWA																				
Clarke College Dubuque 52001			✔	✔	✔					✔	✔							✔	✔	
Coe College Cedar Rapids 52402	✔	✔	✔	✔	✔		✔	✔	✔	✔	✔							✔	✔	
Cornell College Mount Vernon 52314			✔							✔								✔		

School	Administration/Management	Advertising	Architecture	Art History	Art Education	Art Therapy	Crafts/Fabrics	Fashion Design	Film/TV/Video	Fine Arts	Graphic Design/Computer Arts	Illustration	Industrial Design	Interior Design	Landscape Architecture	Medical Illustration	Museum Work/Conservation	Photography	Theater Arts/Stage	Associations
Des Moines Art Center 50312							✓			✓								✓		
Drake U. Des Moines 50311			✓	✓	✓	✓				✓	✓	✓		✓				✓	✓	NASAD
Grand View College Des Moines 50322				✓	✓					✓	✓							✓	✓	
Grinnell College 50112			✓	✓			✓			✓									✓	
Iowa State U. Ames 50010			✓	✓	✓	✓				✓	✓	✓		✓				✓		ASID, FIDER
Iowa Wesleyan College Mt. Pleasant 52641			✓	✓		✓				✓								✓		
Loras College Dubuque 52001			✓	✓						✓										
Luther College Decorah 52101	✓		✓	✓		✓					✓						✓		✓	
Morningside College Sioux City 51106			✓	✓		✓				✓								✓		
Mount Mercy College Cedar Rapids 52402			✓	✓		✓				✓	✓							✓		
Northwestern College Orange City 51041			✓	✓		✓				✓								✓		
St. Ambrose College Davenport 52803		✓	✓	✓		✓				✓	✓	✓						✓		
Teikyo-Marycrest U. Davenport 52804		✓	✓	✓		✓	✓	✓	✓	✓								✓	✓	
U. of Iowa Iowa City 52242			✓	✓		✓		✓	✓	✓			✓	✓				✓		
U. of Northern Iowa Cedar Falls 50614			✓	✓		✓				✓	✓	✓		✓				✓		NASAD
Wartburg College Waverly 50677		✓	✓	✓		✓				✓	✓							✓		
Westmar College Le Mars 51031	✓	✓	✓	✓		✓				✓										
William Penn College Oskaloosa 52577			✓	✓		✓				✓	✓									
KANSAS																				
Bethany College Lindsborg 67456				✓	✓	✓				✓								✓		
Bethel College North Newton 67117			✓	✓		✓				✓	✓							✓		
Emporia State U. 66801			✓	✓	✓	✓				✓		✓		✓				✓	✓	
Fort Hays State U. Hays 67601			✓	✓	✓	✓				✓	✓	✓		✓				✓	✓	
Friends U. Wichita 67213				✓		✓				✓	✓							✓		
Kansas State U. Manhattan 66506		✓	✓	✓		✓	✓			✓	✓	✓		✓	✓			✓		ASID, FIDER, ASLA
Marymount College Salina 67401			✓	✓		✓				✓								✓		
Pittsburg State U. 66762			✓	✓	✓	✓	✓			✓	✓		✓	✓				✓	✓	
Sterling College 67579					✓					✓	✓			✓				✓		
U. of Kansas Lawrence 66045		✓	✓	✓		✓	✓			✓	✓	✓	✓	✓				✓	✓	NASAD
Washburn U. Topeka 66621			✓			✓				✓	✓							✓		NASAD
Wichita State U. 67208			✓	✓		✓	✓	✓		✓	✓	✓						✓		
KENTUCKY																				
Asbury College Wilmore 40390			✓	✓		✓				✓	✓							✓		
Berea College 40404			✓	✓		✓				✓										
Brescia College Owensboro 42301			✓	✓		✓				✓	✓			✓				✓		
Campbellsville College 42718		✓	✓	✓		✓				✓	✓							✓	✓	
Centre College Danville 40422			✓							✓									✓	
Cumberland College Williamsburg 40769			✓	✓		✓				✓				✓				✓	✓	
Eastern Kentucky U. Richmond 40475			✓			✓				✓				✓						ASID
Georgetown College 40324			✓	✓		✓				✓	✓	✓						✓		
Kentucky State U. Frankfort 40601			✓	✓		✓	✓			✓	✓									
Kentucky Wesleyan College Owensboro 42301						✓														
Louisville Sch. of Art Anchorage 40223		✓				✓				✓	✓							✓		
Morehead State U. 40351	✓			✓		✓	✓	✓	✓	✓	✓							✓		
Murray State U. 42071			✓	✓		✓		✓	✓	✓	✓			✓				✓		ASID, NASAD

	Administration/Management	Advertising	Architecture	Art History	Art Education	Art Therapy	Crafts/Fabrics	Fashion Design	Film/TV/Video	Fine Arts	Graphic Design/Computer Arts	Illustration	Industrial Design	Interior Design	Landscape Architecture	Medical Illustration	Museum Work/Conservation	Photography	Theater Arts/Stage	Associations
Northern Kentucky U. Highland Heights 41076			✔	✔	✔					✔	✔							✔	✔	
Spalding College Louisville 40203			✔		✔					✔										
Thomas More College Crestview Hills 41017	✔		✔	✔	✔					✔								✔	✔	
Transylvania U. Lexington 40508			✔	✔	✔	✔	✔			✔								✔	✔	
U. of Kentucky Lexington 40506			✔	✔	✔			✔		✔	✔			✔	✔				✔	ASID, ASLA, FIDER
U. of Louisville 40292			✔	✔	✔	✔				✔	✔			✔				✔		
Western Kentucky U. Bowling Green 42101			✔	✔	✔					✔	✔			✔				✔		ASID, NASAD
LOUISIANA																				
Louisiana College Pineville 71360		✔	✔	✔	✔					✔	✔	✔						✔	✔	
Louisiana State U. Baton Rouge 70803			✔		✔					✔	✔			✔	✔					ASID, ASLA, FIDER, NASAD
Louisiana State U. at Eunice 70535			✔	✔	✔					✔					✔			✔		
Louisiana Tech. U. Ruston 71270		✔	✔	✔	✔	✔	✔	✔		✔	✔	✔		✔				✔		ASID, FIDER, NASAD
McNeese State U. Lake Charles 70609	✔		✔	✔						✔	✔			✔				✔		ASID
New Orleans Art Inst. 70119								✔		✔	✔	✔				✔				
Nicholls State U. Thibodaux 70301			✔	✔	✔					✔	✔	✔						✔		
Northeast Louisiana U. Monroe 71203	✔				✔					✔								✔		
Northwestern State U. of Louisiana Natchitoches 71457	✔		✔	✔	✔					✔								✔		
Southeastern Louisiana U. Hammond 70402			✔	✔						✔										
Southern U. A & M College Baton Rouge 70813		✔		✔																
Tulane U. (Newcomb College) New Orleans 70118		✔	✔		✔					✔	✔							✔		
U. of New Orleans 70122			✔							✔	✔							✔		NASAD
U. of Southwestern Louisiana Lafayette 70501	✔	✔		✔		✔				✔				✔				✔		ASID, FIDER
Xavier U. of Louisiana New Orleans 70125			✔		✔					✔										
MAINE																				
Bates College Lewiston 04240			✔		✔					✔										
Maine College of Art Portland 04101		✔	✔		✔					✔	✔			✔				✔		NASAD
U. of Maine at Orono 04469			✔	✔						✔								✔		
U. of Southern Maine Gorham 04038			✔	✔	✔			✔		✔								✔		NASAD
MARYLAND																				
Bowie State College 20715			✔	✔	✔			✔		✔	✔							✔		
College of Notre Dame of Maryland Baltimore 21210	✔		✔	✔	✔					✔	✔	✔						✔		
Coppin State College Baltimore 21212	✔		✔	✔	✔		✔			✔	✔							✔	✔	
Frostburg State College 21532	✔		✔	✔	✔	✔				✔	✔							✔		
Goucher College Baltimore 21204					✔					✔								✔	✔	
Hood College Frederick 21701			✔	✔	✔		✔													
John Hopkins U. Baltimore 21205										✔	✔	✔				✔		✔		
Maryland Inst. College of Art Baltimore 21217			✔	✔	✔					✔	✔	✔		✔				✔		ASID, FIDER, NASAD
Morgan State U. Baltimore 21239		✔	✔	✔	✔					✔	✔	✔			✔			✔	✔	ASLA
Mount St. Mary's College Emmitsburg 21727			✔							✔									✔	
St. Mary's College of Maryland St. Mary's City 20686		✔							✔									✔		
Salisbury State U. 21801	✔		✔	✔	✔					✔	✔							✔		
Towson State U. 21204		✔	✔	✔	✔						✔							✔		
U. of Maryland College Park 20742			✔		✔					✔								✔		

College	Administration/Management	Advertising	Architecture	Art History	Art Education	Art Therapy	Crafts/Fabrics	Fashion Design	Film/TV/Video	Fine Arts	Graphic Design/Computer Arts	Illustration	Industrial Design	Interior Design	Landscape Architecture	Medical Illustration	Museum Work/Conservation	Photography	Theater Arts/Stage	Associations
Western Maryland College Westminster 21157				✔	✔					✔	✔							✔		
MASSACHUSETTS																				
Amherst College 01002				✔						✔										
Anna Maria College Paxton 01612	✔	✔		✔	✔		✔			✔								✔	✔	
Art Inst. of Boston 02215		✔		✔	✔				✔	✔	✔	✔						✔		NASAD
Assumption College Worcester 01609			✔	✔	✔		✔			✔									✔	
Boston Arch. Center 02115			✔							✔				✔						
Boston College Chestnut Hill 02167				✔			✔	✔										✔		
Boston U. 02215				✔	✔					✔	✔							✔		
Bradford College 01830		✔		✔				✔	✔	✔									✔	
Brandeis U. Waltham 02154				✔						✔										
Butera Sch. of Art Boston 02116		✔		✔	✔					✔	✔	✔						✔		
Clark U. Worcester 01610	✔				✔					✔	✔	✔						✔		
College of the Holy Cross Worcester 01610			✔	✔			✔			✔	✔	✔						✔		
Emmanuel College Boston 02115			✔	✔	✔	✔	✔			✔	✔									
Framingham State College 01701	✔			✔			✔			✔										
Harvard U. Graduate Sch. of Design Cambridge 02138		✔	✔					✔	✔	✔	✔			✔	✔		✔			ASLA
Massachusetts College of Art Boston 02215		✔	✔	✔	✔		✔	✔	✔	✔	✔	✔	✔					✔		NASAD
Massachusetts Inst. of Tech. Cambridge 02139			✔																	
Montserrat College of Art Beverly 01915				✔						✔	✔	✔						✔		NASAD
Mount Holyoke College South Hadley 01075										✔										
New England Sch. of Art & Design Boston 02116		✔	✔							✔	✔	✔		✔				✔		ASID, FIDER
Northeastern U. Boston 02115		✔	✔					✔	✔	✔	✔							✔		
Salem State College 01945		✔		✔	✔		✔			✔	✔	✔	✔					✔		NASAD
Sch. of the Museum of Fine Arts Boston 02115		✔		✔	✔		✔		✔	✔	✔							✔		NASAD
Smith College Northampton 01063			✔	✔						✔	✔				✔			✔		
Springfield College 01109	✔	✔		✔	✔	✔	✔			✔	✔						✔	✔	✔	
State College at Westfield 01066			✔	✔	✔					✔	✔	✔								
Tufts U. Medford 02155			✔	✔	✔			✔		✔	✔	✔								
U. of Massachusetts Amherst 01003	✔	✔	✔	✔						✔	✔			✔	✔			✔		FIDER, ASLA
U. of Massachusetts Lowell 01854			✔							✔	✔	✔						✔		NASAD
U. of Massachusetts North Dartmouth 02747			✔	✔	✔	✔				✔	✔	✔				✔		✔		NASAD
Wellesley College 02181			✔	✔						✔								✔		
Williams College Williamstown 01267			✔	✔					✔	✔								✔		
MICHIGAN																				
Adrian College Adrian 49221	✔			✔	✔			✔		✔				✔				✔		ASID
Albion College 49224				✔						✔								✔	✔	
Alma College 48801		✔		✔	✔		✔		✔	✔	✔				✔			✔		
Andrews U. Berrien Springs 49130			✔	✔	✔					✔	✔							✔		
Aquinas College Grand Rapids 49506			✔							✔								✔		
Calvin College Grand Rapids 49506			✔		✔	✔		✔		✔								✔		
Center for Creative Studies Detroit 48202		✔	✔				✔	✔	✔	✔	✔	✔	✔	✔				✔		NASAD
Central Michigan U. Mount Pleasant 48859			✔	✔	✔					✔	✔			✔				✔		ASID
Cranbrook Academy of Art Bloomfield Hills 48013		✔			✔					✔								✔		NASAD
Eastern Michigan U. Ypsilanti 48197			✔	✔	✔					✔	✔	✔		✔				✔		ASID, FIDER

Institution	Admin/Mgmt	Advertising	Architecture	Art History	Art Education	Art Therapy	Crafts/Fabrics	Fashion Design	Film/TV/Video	Fine Arts	Graphic Design/Computer Arts	Illustration	Industrial Design	Interior Design	Landscape Architecture	Medical Illustration	Museum Work/Conservation	Photography	Theater Arts/Stage	Associations
Grand Valley State U. Allendale 49401			✔	✔	✔					✔	✔									NASAD
Hillsdale College 49242			✔	✔	✔					✔								✔	✔	
Hope College Holland 49423			✔	✔	✔					✔								✔		NASAD
Kalamazoo College 49001			✔	✔	✔					✔										
Kendall College Grand Rapids 49503	✔		✔					✔	✔	✔	✔	✔		✔				✔	✔	ASID, FIDER, NASAD
Lawrence Tech. U. Southfield 48075		✔												✔						ASID, FIDER, NASAD
Marygrove College Detroit 48221	✔		✔	✔	✔					✔	✔							✔		
Michigan State U. East Lansing 48824			✔	✔	✔		✔	✔		✔				✔	✔			✔		ASID, ASLA, FIDER
Northern Michigan U. Marquette 49855			✔	✔	✔		✔	✔		✔	✔	✔						✔		
Oakland U. Rochester 48063			✔																	
Olivet College 49076	✔		✔							✔										
Saginaw Valley State College University Center 48710	✔		✔	✔	✔					✔	✔	✔						✔	✔	
Siena Heights College Adrian 49221		✔	✔	✔	✔					✔	✔							✔	✔	NASAD
Spring Arbor College 49283	✔				✔					✔	✔	✔								
U. of Detroit 48221		✔																		
U. of Michigan Ann Arbor 48109			✔		✔					✔	✔		✔		✔			✔		ASLA, NASAD
Wayne State U. Detroit 48202	✔		✔		✔					✔		✔	✔					✔		ASID
Western Michigan U. Kalamazoo 49012			✔	✔	✔					✔	✔			✔				✔		ASID, NASAD
MINNESOTA																				
Augsburg College Minneapolis 55454			✔	✔	✔					✔								✔	✔	
Bemdji State U. 56601	✔		✔	✔	✔					✔	✔									
Bethel College St. Paul 55112			✔	✔	✔					✔	✔							✔		
College of St. Benedict St. Joseph 56374			✔		✔					✔								✔		
College of St. Catherine St. Paul 55105			✔	✔	✔					✔	✔	✔						✔		
College of Associated Arts St. Paul 55102										✔	✔	✔						✔		
Gustavus Adolphus College St. Peter 56082			✔	✔	✔					✔										
Hamiline U. St. Paul 55104			✔	✔	✔					✔										
Mankato State U. 56001	✔		✔	✔	✔					✔	✔	✔						✔		NASAD
Minneapolis College of Art & Design 55404	✔	✔	✔	✔	✔		✔	✔	✔	✔	✔					✔		✔		NASAD
Moorhead State U. 56560			✔		✔		✔			✔	✔	✔						✔	✔	NASAD
St. Cloud State U. 56301			✔	✔	✔					✔	✔									NASAD
St. John's U. Collegeville 56321			✔		✔					✔								✔	✔	
St. Mary's College Winona 55987		✔	✔	✔	✔					✔	✔	✔						✔	✔	
St. Olaf College Northfield 55057		✔	✔	✔	✔		✔	✔		✔	✔			✔				✔		
Sch. of Associated Arts St. Paul 55102	✔		✔							✔	✔	✔						✔		
U. of Minnesota Minneapolis 55455			✔		✔					✔					✔					ASLA
U. of Minnesota at Duluth 55812	✔		✔	✔	✔		✔			✔	✔	✔						✔		
U. of Minnesota at Morris 56267			✔		✔					✔										
MISSISSIPPI																				
Belhaven College Jackson 39202			✔							✔								✔		NASAD
Blue Mountain College 38610	✔		✔							✔	✔									
Delta State U. Cleveland 38733	✔		✔	✔	✔	✔				✔	✔	✔		✔						ASID, NASAD
Jackson State U. 39217			✔	✔	✔					✔	✔									ASID, NASAD
Mississippi College Clinton 39058			✔	✔	✔					✔	✔			✔						

Institution	Administration/Management	Advertising	Architecture	Art History	Art Education	Art Therapy	Crafts/Fabrics	Fashion Design	Film/TV/Video	Fine Arts	Graphic Design/Computer Arts	Illustration	Industrial Design	Interior Design	Landscape Architecture	Medical Illustration	Museum Work/Conservation	Photography	Theater Arts/Stage	Associations
Mississippi Museum of Art Sch. Jackson 39205					✔					✔							✔	✔		
Mississippi State U. Mississippi State 39762					✔					✔	✔			✔	✔		✔			ASLA, FIDER, NASAD
Mississippi U. for Women Columbus 39701		✔	✔	✔	✔	✔				✔	✔	✔		✔			✔	✔		ASID, NASAD
U. of Mississippi University 38677		✔		✔	✔					✔	✔	✔		✔						NASAD
U. of Southern Mississippi Hattiesburg 39401				✔	✔					✔	✔	✔		✔			✔			ASID, FIDER, NASAD
William Carey College Hattiesburg 39401				✔	✔					✔				✔	✔		✔	✔		
MISSOURI																				
Avila College Kansas City 64145				✔	✔					✔	✔	✔					✔	✔		
Central Missouri State U. Warrensburg 64093				✔	✔					✔	✔	✔		✔						ASID, NASAD
College of the Ozarks Point Lookout 65726					✔					✔	✔									
Columbia College 65201		✔			✔	✔				✔	✔	✔					✔	✔		
Culver-Stockton College Canton 63435		✔			✔	✔											✔	✔		
Drury College Springfield 65802		✔	✔		✔					✔							✔	✔		
Fontbonne College St. Louis 63105				✔	✔					✔	✔	✔		✔			✔			
Kansas City Art Inst. 64111		✔			✔			✔		✔	✔			✔			✔			NASAD
Lindenwood College St. Charles 63301				✔	✔					✔	✔						✔			
Missouri Southern State College Joplin 64801					✔					✔	✔						✔			
Missouri Western State College St. Joseph 64507	✔		✔	✔	✔					✔	✔	✔					✔			
Northeast Missouri State U. Kirksville 63501					✔					✔							✔			
Northwest Missouri State U. Maryville 64468				✔	✔					✔	✔						✔			
St. Louis U. 63701					✔					✔							✔			
Southeast Missouri State U. Cape Girardeau 63701	✔	✔				✔		✔	✔	✔				✔						ASID
Southwest Baptist U. Bolivar 65613			✔	✔	✔	✔				✔	✔	✔		✔			✔	✔		
Southwest Missouri State U. Springfield 65802				✔	✔					✔	✔			✔						ASID
Stephens College Columbia 65201		✔	✔	✔	✔		✔	✔	✔	✔	✔			✔			✔	✔		
U. of Missouri Columbia 65211					✔					✔				✔			✔			ASID, FIDER
U. of Missouri Kansas City 64110			✔							✔	✔						✔			
U. of Missouri St. Louis 63121			✔							✔	✔						✔			
U. of St. Louis 63141		✔	✔	✔	✔			✔		✔	✔	✔		✔			✔			
Washington U. St. Louis 63130		✔	✔	✔	✔		✔	✔	✔	✔	✔	✔	✔	✔			✔	✔		NASAD
Webster U. St. Louis 63119	✔		✔	✔	✔				✔	✔							✔	✔		
William Jewell College Liberty 64068					✔					✔	✔						✔			
William Woods College/Westminster College Fulton 65251	✔		✔	✔	✔	✔				✔				✔	✔		✔	✔		ASID
MONTANA																				
Montana State U. Billings 59101			✔	✔	✔					✔								✔		
Montana State U. Bozeman 59717			✔		✔					✔	✔				✔	✔				
Rocky Mountain College Billings 59102			✔	✔	✔					✔	✔							✔		
U. of Montana Missoula 59812			✔	✔	✔					✔								✔		
Western Montana College Dillon 59812		✔	✔	✔	✔					✔										
NEBRASKA																				
Bellevue College 68005	✔	✔		✔	✔					✔										
Chadron State College 69337			✔	✔	✔					✔							✔			
Concordia College Seward 68434		✔			✔					✔	✔	✔								

	Administration/Management	Advertising	Architecture	Art History	Art Education	Art Therapy	Crafts/Fabrics	Fashion Design	Film/TV/Video	Fine Arts	Graphic Design/Computer Arts	Illustration	Industrial Design	Interior Design	Landscape Architecture	Medical Illustration	Museum Work/Conservation	Photography	Theater Arts/Stage	Associations
Creighton U. Omaha 68178		✔	✔	✔	✔	✔				✔								✔	✔	
Dana College Blair 68008		✔		✔	✔	✔			✔	✔								✔		
Hastings College 68901				✔	✔	✔				✔								✔		
Nebraska Wesleyan U. Lincoln 68504	✔	✔		✔	✔	✔			✔	✔								✔		
Nebraska Western College Scottsbluff 69361				✔	✔	✔		✔	✔									✔	✔	
Peru State College 68421				✔	✔	✔				✔								✔	✔	
U. of Nebraska Lincoln 68588		✔		✔	✔				✔	✔	✔			✔				✔		ASID, FIDER, NASAD
U. of Nebraska Kearney 68847			✔	✔	✔	✔	✔	✔	✔	✔	✔			✔	✔			✔	✔	
U. of Nebraska Omaha 68182				✔	✔	✔				✔								✔		
Wayne State College 68787		✔		✔	✔					✔				✔				✔		ASID
NEVADA																				
U. of Nevada Las Vegas 89154		✔			✔			✔	✔					✔				✔		ASID, NASAD
U. of Nevada Reno 89557		✔	✔		✔				✔	✔				✔				✔		ASID
NEW HAMPSHIRE																				
Colby-Sawyer College New London 03257		✔		✔					✔	✔	✔							✔	✔	
New England College Henniker 03246		✔			✔		✔		✔	✔								✔	✔	
Notre Dame College Manchester 03104	✔	✔		✔	✔				✔	✔	✔							✔		
Plymouth State College 03264			✔	✔	✔				✔	✔								✔	✔	
Rivier College Nashua 03060			✔	✔	✔	✔		✔	✔	✔	✔							✔		
U. of New Hampshire Durham 03824			✔	✔	✔					✔								✔		
NEW JERSEY																				
Caldwell College 07006			✔	✔	✔	✔		✔	✔	✔								✔		
Centenary College Hackettstown 07840													✔	✔						ASID
Drew U. Madison 07940			✔		✔	✔			✔	✔								✔	✔	
duCret Sch. of the Arts Plainfield 07060			✔		✔	✔			✔	✔	✔			✔				✔		
Farleigh Dickinson U. Rutherford 07070		✔		✔			✔	✔	✔	✔								✔		
Georgian Court College Lakewood 08701		✔		✔	✔		✔	✔		✔	✔	✔						✔	✔	
Jersey City State College 07305		✔		✔	✔	✔	✔		✔	✔	✔	✔	✔	✔				✔		NASAD
Kean College of New Jersey Union 07083	✔	✔		✔	✔		✔		✔	✔	✔	✔		✔			✔	✔		ASID, NASAD
Mason Gross Sch. of the Arts New Brunswick 08903						✔	✔	✔								✔	✔			
Monmouth College West Long Branch 07764			✔	✔		✔			✔	✔								✔		
Montclair State U. Upper Montclair 07043			✔	✔		✔				✔								✔		NASAD
Newark Sch. of Fine & Industrial Arts 07102			✔	✔		✔			✔	✔	✔							✔	✔	
New Jersey Inst. of Tech. Newark 07102		✔																		
Princeton U. 08540			✔															✔		
Rider College Lawrenceville 08648									✔	✔										
Ridgewood Sch. of Art 07450			✔		✔	✔	✔		✔	✔	✔							✔		
Rowan U. Glassboro 08028				✔		✔		✔	✔	✔	✔	✔	✔							NASAD
Rutgers State U. of New Jersey Camden 08102			✔			✔			✔	✔							✔			
Rutgers State U. of New Jersey Newark 07102			✔	✔		✔			✔	✔								✔		
Rutgers State U. of New Jersey New Brunswick 08903		✔							✔					✔				✔		ASLA, NASAD
St. Peters College Jersey City 07306		✔	✔	✔			✔		✔	✔								✔		
Seton Hall U. South Orange 07079	✔		✔	✔		✔	✔		✔	✔	✔			✔				✔		
Trenton State College 08625		✔		✔	✔		✔		✔	✔	✔			✔				✔		

	Administration/Management	Advertising	Architecture	Art History	Art Education	Art Therapy	Crafts/Fabrics	Fashion Design	Film/TV/Video	Fine Arts	Graphic Design/Computer Arts	Illustration	Industrial Design	Interior Design	Landscape Architecture	Medical Illustration	Museum Work/Conservation	Photography	Theater Arts/Stage	Associations
William Patterson College of New Jersey Wayne 07470	✔		✔		✔					✔	✔							✔		
NEW MEXICO																				
American Classical College Albuquerque 87106			✔	✔						✔	✔	✔								
College of Santa Fe 87501			✔	✔	✔	✔		✔		✔								✔	✔	
Eastern New Mexico U. Portales 88130		✔	✔	✔	✔			✔		✔	✔	✔	✔					✔	✔	
New Mexico Highlands U. Las Vegas 07701			✔	✔	✔			✔		✔	✔	✔						✔	✔	
New Mexico State U. Las Cruces 88003			✔		✔			✔		✔	✔	✔						✔		
New Mexico State U. Farmington 87401				✔	✔		✔	✔		✔								✔		
U. of Albuquerque 87112			✔	✔	✔			✔		✔	✔							✔	✔	
U. of New Mexico Albuquerque 87131		✔	✔		✔		✔	✔		✔								✔	✔	
Western New Mexico U. Silver City 88061			✔	✔	✔					✔								✔		
NEW YORK																				
Adelphi U. New York 10021	✔		✔		✔	✔				✔	✔			✔				✔		
Bernard Baruch College CUNY New York 10010		✔	✔		✔					✔	✔	✔						✔		
Brooklyn College CUNY 11210			✔	✔	✔					✔	✔							✔		
City College CUNY New York 10031		✔	✔	✔	✔			✔		✔	✔			✔				✔		
City College of New York 10036			✔												✔					ASLA
Colgate U. Hamilton 13346			✔						✔	✔								✔		
College of New Rochelle 10801			✔	✔	✔	✔	✔	✔		✔	✔			✔				✔		
College of St. Rose Albany 12203			✔		✔					✔	✔							✔		NASAD
College of Staten Island SUNY 10301	✔	✔	✔	✔	✔			✔		✔	✔	✔						✔		
Columbia U. New York 10027			✔	✔	✔					✔										
Columbia U. Teachers College New York 10021				✔	✔					✔								✔		
Cooper Union Sch. of Art & Arch. New York 10003			✔	✔	✔			✔		✔	✔			✔				✔		
Cornell U. Ithaca 14853	✔		✔							✔	✔			✔	✔			✔		ASLA, FIDER
Daemen College Amherst 14226		✔	✔	✔		✔				✔	✔	✔						✔		
Dominican College of Blauvelt Orangeburg 10962			✔	✔						✔										
Eisenhower College Seneca Falls 13148			✔		✔			✔		✔								✔		
Elmira College 14901			✔	✔		✔	✔	✔										✔		
Fashion Inst. of Tech. New York 10007		✔	✔				✔	✔	✔	✔	✔	✔	✔	✔				✔	✔	ASID, FIDER, NASAD
Fordham U. at Lincoln Center New York 10023			✔							✔								✔	✔	
Hartwick College Oneonta 13820			✔		✔					✔	✔							✔		NASAD
Herbert H. Lehman College Bronx 10468			✔							✔										
Hobart & William Smith Colleges Geneva 14456		✔	✔							✔								✔		
Hofstra U. Hempstead 11550				✔		✔				✔								✔		
Hunter College CUNY New York 10021			✔							✔										
Ithaca College 14850			✔							✔	✔									
Long Island U. Southhampton 11968			✔							✔	✔	✔					✔	✔		
Long Island U. C. W. Post Campus Brookville 11548	✔		✔	✔	✔	✔		✔		✔	✔	✔						✔	✔	
Long Island U. of Brooklyn Center 11201	✔		✔	✔		✔				✔					✔					
Manhattan College Bronx 10471			✔	✔		✔		✔	✔	✔								✔		
Manhattanville College Purchase 10577		✔	✔	✔		✔				✔	✔	✔						✔		
Marymount College Tarrytown 10591		✔	✔	✔		✔	✔	✔	✔			✔		✔				✔	✔	
Molloy College Rockville Center 11570			✔	✔		✔				✔	✔							✔	✔	
Nazareth College of Rochester 14610			✔	✔	✔	✔				✔								✔		

	Administration/Management	Advertising	Architecture	Art History	Art Education	Art Therapy	Crafts/Fabrics	Fashion Design	Film/TV/Video	Fine Arts	Graphic Design/Computer Arts	Illustration	Industrial Design	Interior Design	Landscape Architecture	Medical Illustration	Museum Work/Conservation	Photography	Theater Arts/Stage	Associations
New York Inst. of Tech. Old Westbury 11568		✔						✔		✔	✔			✔	✔		✔			ASID
New York Sch. of Interior Design 10022		✔	✔							✔	✔			✔						ASID, NASAD
New York State Coll. of Ceramics at Alfred U. 14802		✔		✔	✔	✔	✔										✔			NASAD
New York Inst. of Tech. Old Westbury 11568			✔						✔	✔	✔		✔					✔		
New York U. New York 11208	✔			✔	✔	✔	✔	✔	✔	✔		✔						✔	✔	
Parsons Sch. of Design New York 10011	✔	✔	✔	✔	✔			✔	✔		✔	✔	✔	✔	✔			✔		ASID, NASAD
Pratt Inst. Brooklyn 11205			✔	✔		✔			✔	✔	✔	✔	✔	✔				✔		ASID, FIDER, NASAD
Pratt-New York Phoenix Sch. of Design New York 10016	✔			✔		✔	✔	✔						✔						
Queens College Flushing 11367		✔	✔	✔	✔					✔		✔						✔		
Rensselaer Polytechnic Inst. Troy 12181					✔			✔		✔								✔		
Roberts Wesleyan College Rochester 14624		✔	✔		✔				✔	✔								✔		NASAD
Rochester Inst. of Tech. 14623					✔		✔	✔		✔		✔						✔		NASAD
St. Johns U. Jamaica 11432										✔	✔							✔		
St. Lawrence U. Canton 13617		✔	✔		✔					✔								✔		
St. Thomas Aquinas College Sparkill 10976		✔		✔	✔	✔		✔		✔	✔							✔	✔	
Sarah Lawrence College Bronxville 10708			✔		✔					✔	✔							✔		
Sch. of Visual Arts New York 10010		✔	✔	✔	✔			✔		✔	✔	✔		✔				✔		ASID, NASAD
Skidmore College Saratoga Springs 12866		✔	✔		✔					✔	✔							✔		NASAD
State U. College at Brockport 14420		✔			✔					✔										
State U. College at Buffalo 14222		✔		✔			✔											✔		NASAD
State U. College at Cortland 13045	✔	✔	✔		✔			✔		✔	✔							✔	✔	
State U. College at Fredonia 14063		✔			✔					✔	✔							✔		
State U. College at Geneseo 14454		✔	✔		✔					✔								✔		
State U. College at Oneonta 13520		✔	✔		✔	✔				✔	✔							✔		
State U. College at Oswego 13126		✔			✔					✔	✔							✔		
State U. College at Plattsburg 12901		✔			✔					✔	✔	✔						✔		
State U. College at Purchase 10577		✔			✔						✔							✔		
State U. College at Potsdam 13676		✔			✔					✔								✔		
State U. of New York at Albany 12222		✔			✔					✔								✔	✔	
State U. of New York at Alfred 14802			✔		✔			✔		✔	✔		✔					✔		
State U. of New York at Binghamton 13901		✔							✔	✔	✔									
State U. of New York at Brockport 14420		✔			✔					✔								✔		
State U. of New York at Buffalo 14214		✔								✔								✔		
State U. of New York at New Paltz 12561										✔	✔							✔		NASAD
State U. of New York at Old Westbury 11568					✔		✔			✔								✔		
State U. of New York at Stony Brook 11794		✔			✔					✔								✔		
State U. of New York at Syracuse 13210		✔	✔							✔					✔			✔		ASLA
Syracuse U. 13201		✔	✔	✔	✔			✔		✔	✔	✔	✔	✔			✔	✔		ASID, FIDER, NASAD
Union College Schenectady 12308		✔								✔								✔	✔	
U. of Rochester 14627		✔								✔								✔		
Utica College of Syracuse U. Utica 13502		✔			✔					✔								✔	✔	
Vassar College Poughkeepsie 12601		✔	✔		✔					✔	✔									
Wells College Aurora 13026		✔								✔								✔	✔	
NORTH CAROLINA																				
Davidson College 28036			✔						✔	✔								✔		

Institution	Administration/Management	Advertising	Architecture	Art History	Art Education	Art Therapy	Crafts/Fabrics	Fashion Design	Film/TV/Video	Fine Arts	Graphic Design/Computer Arts	Illustration	Industrial Design	Interior Design	Landscape Architecture	Medical Illustration	Museum Work/Conservation	Photography	Theater Arts/Stage	Associations
Duke U. Durham 27708				✓		✓				✓										
East Carolina U. Greenville 27834	✓	✓		✓	✓	✓				✓	✓	✓		✓						ASID, FIDER, NASAD
Elizabeth City State U. 27909				✓						✓								✓		
Greensboro College 27420				✓	✓					✓								✓	✓	
Guilford College Greensboro 27410				✓		✓				✓								✓		
Mars Hill College 28754		✓		✓	✓	✓				✓	✓							✓	✓	
Methodist College Fayetteville 28301				✓	✓	✓				✓								✓		
North Carolina Central U. Durham 27707		✓		✓	✓	✓				✓	✓	✓								
North Carolina State U. Raleigh 27650			✓												✓					ASLA
Pembroke State U. 28372				✓	✓	✓				✓	✓							✓		
St. Andrews Presbyterian College Laurinburg 28352		✓	✓				✓	✓		✓					✓					
U. of North Carolina at Asheville 28814				✓	✓	✓				✓								✓		
U. of North Carolina at Chapel Hill 27514				✓		✓				✓										
U. of North Carolina at Charlotte 28223		✓		✓	✓	✓		✓		✓	✓	✓			✓					
U. of North Carolina at Greensboro 27412				✓	✓	✓				✓				✓				✓		ASID, FIDER
U. of North Carolina at Wilmington 28406				✓		✓				✓										
Wake Forest U. Winston-Salem 27109				✓						✓									✓	
Western Carolina U. Cullowhee 28723	✓			✓	✓	✓				✓	✓	✓		✓				✓		ASID, FIDER
Winston-Salem State U. 27102				✓	✓					✓										
NORTH DAKOTA																				
Dickinson State College 58601		✓		✓	✓	✓				✓	✓							✓	✓	
Jamestown College 58401	✓			✓	✓	✓				✓								✓		
Minot State College 58701		✓		✓		✓				✓								✓		
North Dakota State U. Fargo 58102		✓	✓			✓				✓				✓				✓	✓	ASID, ASLA, FIDER
U. of North Dakota Grand Forks 58202				✓	✓	✓				✓				✓	✓			✓		NASAD
Valley City State College 58072				✓	✓	✓				✓								✓		
OHIO																				
Antioch College Yellow Springs 45387						✓														
Art Academy of Cincinnati 45202	✓			✓	✓					✓	✓	✓						✓		NASAD
Ashland U. 44805	✓			✓			✓	✓		✓	✓	✓		✓				✓		
Bowling Green State U. 43403	✓		✓	✓	✓	✓				✓	✓							✓		NASAD
Capitol U. Columbus 43209	✓			✓	✓	✓				✓								✓	✓	
Case Western Reserve U. Cleveland 44106		✓	✓	✓		✓	✓			✓						✓		✓		
Central State U. Wilberforce 45384	✓			✓	✓	✓				✓										
Cleveland Inst. of Art 44106				✓	✓	✓		✓	✓	✓	✓	✓	✓			✓		✓		NASAD
Cleveland State U. 44115				✓	✓	✓				✓								✓		
College of Mt. St. Joseph Cincinnati 45051				✓	✓	✓				✓	✓			✓				✓		
College of Wooster 44691		✓	✓	✓		✓				✓								✓		
Columbus College of Art & Design 43215	✓							✓		✓	✓	✓	✓	✓						ASID, NASAD
Denison U. Granville 43023		✓	✓			✓				✓	✓							✓		
Edgecliff College Cincinnati 45206		✓	✓	✓	✓	✓				✓	✓	✓		✓					✓	
Kent State U. 44242			✓	✓	✓	✓	✓	✓	✓	✓	✓	✓		✓						ASID, FIDER, NASAD
Kenyon College Gambier 43022				✓						✓								✓		
Malone College Canton 44709				✓	✓	✓				✓	✓							✓	✓	
Marietta College 45750		✓		✓	✓	✓				✓	✓									

School	Administration/Management	Advertising	Architecture	Art History	Art Education	Art Therapy	Crafts/Fabrics	Fashion Design	Film/TV/Video	Fine Arts	Graphic Design/Computer Arts	Illustration	Industrial Design	Interior Design	Landscape Architecture	Medical Illustration	Museum Work/Conservation	Photography	Theater Arts/Stage	Associations
Miami U. Oxford 45056		✔	✔	✔	✔		✔	✔		✔	✔	✔		✔				✔		ASID, NASAD
Oberlin College 44074			✔	✔						✔	✔							✔		
Ohio Northern U. Ada 45810			✔	✔	✔					✔								✔		
Ohio State U. Columbus 43210		✔	✔		✔					✔	✔			✔	✔			✔	✔	ASLA, FIDER, NASAD
Ohio U. Athens 45701			✔	✔	✔	✔				✔	✔	✔		✔				✔		ASID, FIDER
Ohio Wesleyan U. Delaware 43015			✔	✔	✔					✔	✔							✔		
Toledo Museum of Art Sch. of Design 43697			✔	✔	✔					✔	✔						✔			
U. of Akron 44325			✔		✔	✔				✔	✔	✔		✔	✔			✔		ASID, NASAD
U. of Cincinnati 45221			✔	✔	✔	✔	✔			✔				✔				✔		ASID, FIDER, NASAD
U. of Dayton 45469			✔	✔	✔					✔	✔	✔						✔		
U. of Findlay 45840	✔		✔	✔	✔					✔	✔							✔		
U. of Toledo 43620	✔		✔	✔	✔					✔								✔		
Wilberforce U. 45384										✔	✔									
Wilmington College 45177			✔	✔	✔					✔								✔	✔	
Wittenberg U. Springfield 45501			✔	✔	✔					✔	✔	✔		✔				✔		
Wright State U. Dayton 45435			✔							✔								✔		
Youngstown State U. 44555	✔		✔	✔	✔					✔	✔	✔		✔				✔		NASAD
OKLAHOMA																				
East Central U. Ada 74820			✔	✔	✔					✔								✔		
Langston U. 73050			✔	✔	✔					✔								✔		
Northeastern Oklahoma State U. Tahlequah 74464			✔	✔	✔	✔				✔								✔	✔	
Northwestern Oklahoma State U. Alva 73717			✔	✔	✔					✔										
Oklahoma Baptist U. Shawnee 74801			✔	✔	✔					✔								✔		
Oklahoma State U. Stillwater 74078	✔	✔	✔		✔					✔	✔	✔		✔	✔					ASID, ASLA, FIDER
Phillips U. Enid 73701	✔		✔	✔	✔					✔								✔		
Southwestern Oklahoma State U. Weatherford 73096	✔		✔	✔		✔			✔	✔	✔									
U. of Central Oklahoma Edmond 73034			✔	✔	✔					✔	✔			✔				✔		ASID
U. of Oklahoma Norman 73069			✔	✔	✔		✔	✔		✔	✔			✔	✔			✔		ASID, ASLA, FIDER
U. of Tulsa 74104			✔	✔	✔					✔										
OREGON																				
Eastern Oregon State College La Grande 97850			✔	✔	✔					✔								✔		
Lewis & Clark College Portland 97219			✔		✔					✔										
Linfield College McMinnville 97128			✔	✔	✔					✔								✔		
Marylhurst Education Center 97036			✔		✔	✔				✔	✔			✔				✔		
Museum Art Sch. Portland 97205			✔		✔					✔	✔	✔						✔		
Oregon College of Art Ashland 97520										✔	✔	✔	✔					✔		
Oregon State U. Corvalis 97331			✔	✔	✔					✔	✔	✔		✔				✔		ASID
Pacific Northwest College of Art Portland 97205					✔					✔	✔	✔						✔		NASAD
Portland State U. 97207		✔	✔		✔					✔	✔									NASAD
Southern Oregon U. Ashland 97520	✔		✔	✔	✔					✔	✔							✔		
U. of Oregon Eugene 97403		✔	✔	✔	✔		✔	✔		✔	✔	✔		✔	✔			✔		ASLA, FIDER
Western Oregon U. Monmouth 97361			✔	✔	✔			✔		✔	✔							✔	✔	
PENNSYLVANIA																				
Allegheny College Meadville 16335			✔		✔	✔	✔	✔										✔	✔	

	Administration/Management	Advertising	Architecture	Art History	Art Education	Art Therapy	Crafts/Fabrics	Fashion Design	Film/TV/Video	Fine Arts	Graphic Design/Computer Arts	Illustration	Industrial Design	Interior Design	Landscape Architecture	Medical Illustration	Museum Work/Conservation	Photography	Theater Arts/Stage	Associations
Art Inst. of Philadelphia 19103		✔	✔			✔		✔		✔	✔							✔		ASID
Art Inst. of Pittsburgh 15222								✔	✔	✔	✔	✔	✔	✔				✔		ASID
Beaver College Glenside 19038			✔	✔	✔	✔				✔				✔				✔		NASAD
Bloomsburg State College 17815			✔			✔			✔	✔								✔		
Bryn Mawr College 19010			✔																	
Bucknell U. Lewisburg 17837			✔			✔				✔										
Carnegie-Mellon U. Pittsburg 15235		✔						✔	✔	✔	✔			✔						NASAD
Chatham College Pittsburg 15232			✔	✔				✔		✔								✔		
College Misericordia Dallas 18612			✔	✔	✔	✔			✔	✔	✔				✔			✔		
Dickinson College Carlisle 17013			✔			✔				✔								✔		
Drexel U. Philadelphia 19104	✔	✔	✔				✔	✔	✔	✔	✔			✔				✔	✔	ASID, FIDER
Duquesne U. Pittsburgh 15219			✔																	
East Stroudsburg State College 18301			✔	✔		✔				✔	✔									
Franklin & Marshall College Lancaster 17604		✔	✔							✔										
Indiana U. of Pennsylvania 15705			✔	✔		✔				✔	✔									
Kutztown U. 19530	✔		✔	✔		✔				✔	✔	✔						✔		
LaRoche College Pittsburgh 15237	✔		✔			✔	✔			✔	✔	✔	✔	✔				✔		ASID, FIDER, NASAD
Lehigh U. Bethlehem 18015		✔	✔							✔	✔							✔		
Lock Haven State College 17745			✔	✔		✔				✔								✔		
Lycoming College Williamsport 17701	✔		✔	✔		✔	✔			✔								✔		
Mansfield State College 16933	✔		✔	✔		✔				✔	✔									
Mercyhurst College Erie 16546	✔		✔	✔	✔	✔				✔	✔			✔				✔		ASID
Millersville State College 17064	✔		✔	✔		✔		✔	✔	✔	✔							✔		
Moore College of Art & Design Philadelphia 19103				✔	✔			✔	✔	✔			✔			✔				ASID, FIDER, NASAD
Pennsylvania Academy of Fine Arts Philadelphia 19102										✔										NASAD
Pennsylvania State U. University Park 16802		✔	✔	✔		✔				✔	✔				✔			✔		ASLA, NASAD
Philadelphia College of Textiles & Science 19104			✔	✔				✔		✔				✔						ASID, FIDER
Point Park College Pittsburgh 15222		✔	✔					✔	✔	✔				✔				✔	✔	
Seton Hall College Greensburg 15601	✔		✔	✔		✔			✔	✔								✔		
Shippensburg State College 17257			✔			✔				✔										
Slippery Rock State College 16057			✔			✔	✔			✔								✔		
Temple U. Philadelphia 10122			✔	✔	✔	✔		✔	✔	✔	✔			✔				✔		ASLA
Thiel College Greenville 16125			✔			✔				✔					✔			✔		
U. of the Arts Philadelphia 19102		✔	✔	✔	✔	✔		✔	✔	✔	✔	✔						✔	✔	NASAD
U. of Pennsylvania California 15419	✔		✔	✔		✔	✔			✔	✔	✔		✔				✔		
U. of Pennsylvania Cheyney 19319						✔				✔										
U. of Pennsylvania Clarion 16214		✔	✔	✔		✔	✔		✔	✔	✔							✔		
U. of Pennsylvania Edinboro 16444	✔		✔	✔	✔	✔		✔	✔	✔								✔		
U. of Pennsylvania Philadelphia 19104		✔				✔				✔				✔						ASLA
U. of Pennsylvania West Chester 19380			✔			✔		✔	✔	✔								✔		
U. of Pittsburgh 15260			✔			✔				✔	✔									
Villanova U. 19085			✔	✔						✔									✔	
Washington & Jefferson College Washington 15311		✔	✔		✔					✔				✔	✔					
Waynesburg College 15370			✔	✔		✔		✔	✔	✔							✔	✔		
Westminster College New Wilmington 16140			✔	✔		✔				✔										
Wilkes U. Wilkes-Barre 18766	✔		✔	✔		✔	✔	✔	✔	✔	✔							✔		

Institution	Administration/Management	Advertising	Architecture	Art History	Art Education	Art Therapy	Crafts/Fabrics	Fashion Design	Film/TV/Video	Fine Arts	Graphic Design/Computer Arts	Illustration	Industrial Design	Interior Design	Landscape Architecture	Medical Illustration	Museum Work/Conservation	Photography	Theater Arts/Stage	Associations
RHODE ISLAND																				
Brown U. Providence 02912		✔	✔		✔				✔	✔										
Rhode Island College Providence 02908	✔		✔	✔	✔				✔	✔	✔							✔		NASAD
Rhode Island Sch. of Design Providence 02903		✔		✔	✔		✔	✔	✔	✔	✔	✔	✔	✔				✔		ASID, ASLA, NASAD
Roger Williams College Bristol 02809	✔	✔	✔		✔				✔	✔	✔						✔	✔	✔	
Salve Regina U. Newport 02840			✔	✔	✔				✔	✔	✔	✔						✔	✔	NASAD
U. of Rhode Island Kingston 02881		✔		✔	✔				✔	✔				✔				✔	✔	ASLA
SOUTH CAROLINA																				
Bob Jones U. Greenville 29614		✔		✔	✔		✔	✔	✔	✔	✔	✔						✔	✔	
Claflin College Orangeburg 29115		✔		✔	✔				✔	✔								✔	✔	
Clemson U. 29631		✔	✔	✔	✔		✔		✔	✔	✔				✔			✔		ASLA
Coker College Hartsville 29550			✔	✔	✔			✔	✔	✔	✔							✔		
College of Charleston 29401			✔	✔	✔					✔									✔	
Columbia College 29203		✔	✔		✔					✔								✔		NASAD
Converse College Spartanburg 29301	✔	✔	✔	✔	✔	✔	✔		✔	✔				✔				✔		ASID
Francis Marion College Florence 29501			✔	✔	✔		✔	✔	✔	✔								✔	✔	
Furman U. Greenville 29613		✔	✔	✔	✔				✔	✔								✔		
Newberry College 29108	✔		✔		✔					✔								✔		
Presbyterian College Clinton 29325			✔	✔	✔					✔										
South Carolina State College Orangeburg 29117				✔	✔					✔										
U. of South Carolina Columbia 29208		✔	✔	✔	✔				✔	✔	✔			✔			✔	✔		
Winthrop U. Rock Hill 29733		✔	✔	✔	✔		✔		✔	✔	✔	✔		✔				✔		FIDER, NASAD
SOUTH DAKOTA																				
Dakota State College Madison 57042			✔	✔	✔					✔										
Mount Marty College Yankton 57078				✔	✔					✔								✔		
Northern State College Aberdeen 57401		✔	✔	✔	✔			✔	✔	✔	✔							✔		
South Dakota State U. Brookings 57006			✔	✔					✔	✔				✔						ASID
U. of South Dakota Vermillion 57069	✔		✔	✔	✔		✔		✔	✔								✔	✔	NASAD
Yankton College 57078			✔	✔	✔			✔	✔	✔								✔	✔	
TENNESSEE																				
Austin Peay State U. Clarksville 37040			✔	✔	✔				✔	✔	✔							✔		NASAD
Carson-Newman College Jefferson City 37760			✔	✔	✔				✔	✔								✔		NASAD
East Tennessee State U. Johnson City 37601			✔	✔	✔				✔	✔				✔				✔		NASAD
Fisk U. Nashville 37203				✔	✔					✔										
George Peabody College Nashville 37203			✔	✔	✔		✔			✔								✔		
Memphis Academy of Arts 38112				✔	✔				✔	✔	✔	✔						✔		
Memphis College of Art 38104		✔	✔	✔	✔				✔	✔	✔	✔						✔		NASAD
Memphis State U. 38152	✔			✔	✔				✔	✔	✔			✔				✔		
Middle Tennessee State U. Murfreesboro 37132				✔	✔		✔	✔	✔	✔				✔						ASID, FIDER
O'More College of Design Franklin 37064								✔		✔				✔				✔		ASID, FIDER
Southwestern College Memphis 38112	✔		✔	✔					✔	✔							✔	✔		
Tennessee State U. Nashville 37209	✔			✔	✔		✔		✔	✔	✔	✔		✔	✔	✔		✔		NASAD
Tusculum College Greenville 37743				✔	✔					✔										
Union U. Jackson 38301			✔	✔	✔					✔								✔		

Institution	Administration/Management	Advertising	Architecture	Art History	Art Education	Art Therapy	Crafts/Fabrics	Fashion Design	Film/TV/Video	Fine Arts	Graphic Design/Computer Arts	Illustration	Industrial Design	Interior Design	Landscape Architecture	Medical Illustration	Museum Work/Conservation	Photography	Theater Arts/Stage	Associations
U. of Tennessee Chattanooga 37403			✔	✔	✔					✔	✔	✔		✔				✔		ASID, NASAD
U. of Tennessee Knoxville 37996		✔	✔		✔			✔	✔	✔	✔			✔		✔				ASID, FIDER, NASAD
Vanderbilt U. Nashville 37235		✔			✔			✔	✔									✔		
TEXAS																				
Abilene Christian U. Abilene 79699			✔	✔	✔					✔	✔									
Austin College Sherman 75090			✔		✔					✔								✔		
Baylor U. Waco 76703			✔	✔	✔					✔	✔			✔				✔		ASID
Eastern Texas State U. Commerce 75428	✔		✔	✔	✔		✔	✔	✔	✔	✔							✔		
Hardin-Simmons U. Abilene 79698				✔	✔					✔	✔							✔	✔	
Houston Baptist U. 77036			✔	✔	✔					✔										
Incarnate Word College San Antonio 78201	✔		✔	✔	✔					✔								✔	✔	
Lamar U. Beaumont 77710	✔		✔	✔	✔	✔		✔	✔	✔			✔	✔				✔	✔	ASID
Lubbock Christian U. 76708			✔	✔	✔					✔	✔									
McMurry U. Abilene 79697			✔	✔	✔					✔										
Midwestern State U. Wichita Falls 76308	✔		✔	✔	✔					✔	✔							✔		
Our Lady of the Lake U. San Antonio 78285			✔	✔	✔					✔	✔							✔		
Rice U. Houston 77001			✔	✔					✔	✔								✔	✔	
Sam Houston State U. Huntsville 77340	✔		✔		✔					✔		✔		✔						ASID
Southern Methodist U. Dallas 75275			✔		✔					✔								✔		
Southwest Texas State U. San Marcos 78666	✔		✔	✔	✔		✔	✔	✔	✔			✔					✔		ASID, FIDER
Stephen F. Austin State U. Nacagdoches 75962	✔		✔	✔	✔		✔	✔		✔	✔		✔					✔	✔	ASID, FIDER
Sul Ross State U. Alpine 79832			✔		✔					✔	✔	✔								
Texas A & I U. Kingsville 78363	✔		✔	✔	✔					✔										
Texas A & M U. College Station 77843		✔						✔			✔			✔			✔			ASLA
Texas A & M U. Corpus Christi 78404	✔		✔	✔	✔		✔	✔	✔	✔					✔		✔			
Texas Christian U. Fort Worth 76129			✔	✔	✔					✔	✔			✔				✔		ASID, FIDER
Texas Southern U. Houston 77004				✔	✔					✔										
Texas Tech U. Lubbock 79409			✔	✔	✔					✔	✔	✔		✔	✔			✔		ASID, ASLA, FIDER, NASAD
Texas Woman's U. Denton 76204																				
Trinity U. San Antonio 78284			✔							✔								✔		
U. of Dallas Irving 75061		✔	✔	✔	✔					✔	✔									
U. of Houston 77004			✔	✔	✔			✔	✔					✔				✔		ASID
U. of North Texas Denton 76203	✔		✔	✔	✔	✔			✔	✔	✔			✔				✔		ASID, FIDER
U. of St. Thomas Houston 77030			✔																	
U. of Texas at Arlington 76019	✔		✔	✔	✔			✔	✔	✔	✔				✔			✔		ASLA
U. of Texas at Austin 78712		✔	✔	✔	✔	✔	✔	✔	✔	✔				✔				✔		ASID, FIDER
U. of Texas at El Paso 79968			✔	✔	✔					✔	✔									
U. of Texas Health & Science Center Dallas 75235																✔				
U. of Texas, Pan American Edinburg 78539	✔		✔	✔	✔					✔	✔	✔						✔		
U. of Texas of Permian Basin Odessa 79761					✔					✔										
U. of Texas at San Antonio 78285			✔		✔					✔								✔		NASAD
U. of Texas at Tyler 75701			✔	✔	✔					✔	✔			✔				✔	✔	
Wayland Baptist College Plainview 79072					✔					✔										
Western Texas State U. Canyon 79016	✔		✔	✔	✔					✔	✔	✔								

	Administration/Management	Advertising	Architecture	Art History	Art Education	Art Therapy	Crafts/Fabrics	Fashion Design	Film/TV/Video	Fine Arts	Graphic Design/Computer Arts	Illustration	Industrial Design	Interior Design	Landscape Architecture	Medical Illustration	Museum Work/Conservation	Photography	Theater Arts/Stage	Associations
UTAH																				
Brigham Young U. Provo 84602			✔	✔	✔					✔				✔						ASID, NASAD
Southern Utah State College Cedar City 84720					✔					✔	✔	✔								
U. of Utah Salt Lake City 84112			✔	✔	✔			✔		✔	✔	✔						✔		
Utah State U. Logan 84322		✔	✔	✔	✔					✔	✔	✔		✔	✔			✔		ASID, ASLA, FIDER
Weber State College Ogden 84408		✔	✔	✔	✔					✔	✔	✔		✔				✔		ASID
Westminster of Utah Salt Lake City 84105			✔	✔	✔					✔								✔		
VERMONT																				
Bennington College 05201			✔	✔	✔					✔								✔		
Castleton College 05735	✔		✔		✔			✔	✔	✔								✔		
Goddard College Plainfield 05602			✔	✔	✔			✔		✔								✔		
Johnson State College 05656			✔	✔	✔					✔								✔		
U. of Vermont Burlington 05405		✔	✔	✔	✔			✔		✔	✔							✔		
VIRGINIA																				
Bridgewater College 22812				✔		✔				✔								✔		
Christopher Newport College Newport News 23606				✔	✔	✔				✔								✔	✔	
College of William & Mary Williamsburg 23189		✔	✔	✔	✔					✔										
George Mason U. Fairfax 22030				✔	✔					✔	✔							✔		
Hampton U. 23666					✔					✔				✔		✔		✔		
James Madison U. Harrisonburg 22801		✔		✔	✔	✔	✔			✔	✔			✔				✔		ASID, FIDER, NASAD
Longwood College Farmville 23901	✔	✔		✔	✔					✔		✔						✔		
Mary Baldwin College Staunton 24401	✔				✔		✔	✔	✔					✔				✔	✔	
Mary Washington College Fredericksburg 22401			✔		✔					✔								✔		
Norfolk State U. 23504			✔		✔					✔								✔		
Old Dominion U. Norfolk 23508		✔	✔	✔	✔					✔	✔	✔						✔		
Radford U. Radford 24142			✔	✔	✔		✔			✔	✔			✔				✔		ASID
Randolph-Macon Woman's College Lynchburg 24503			✔		✔					✔								✔		
Roanoke College Salem 24153		✔	✔	✔	✔					✔	✔							✔	✔	
Sweet Briar College 24595			✔	✔	✔					✔								✔	✔	
U. of Richmond 23173			✔		✔					✔								✔		
U. of Virginia Charlottesville 22903			✔		✔					✔	✔			✔	✔			✔		ASLA
Virginia Commonwealth U. Richmond 23284	✔		✔	✔	✔	✔	✔	✔	✔	✔	✔			✔			✔	✔	✔	ASID, FIDER, NASAD
Virginia Intermont College Bristol 24201	✔		✔	✔	✔	✔	✔	✔	✔	✔	✔			✔				✔		
Virginia Polytechnic & State U. Blacksburg 24061		✔	✔		✔					✔	✔	✔		✔	✔					ASID, ASLA, FIDER
Virginia State U. Petersburg 23803		✔	✔	✔	✔					✔	✔	✔						✔		NASAD
Virginia Wesleyan College Norfolk 23502			✔	✔	✔					✔	✔							✔	✔	
Washington & Lee U. Lexington 24450			✔							✔									✔	
WASHINGTON																				
Central Washington U. Ellensburg 98926		✔	✔	✔	✔					✔	✔	✔						✔		
Cornish College of the Arts Seattle 98102		✔	✔					✔	✔	✔	✔	✔	✔					✔	✔	NASAD
Eastern Washington U. Cheney 99004	✔		✔	✔	✔		✔			✔		✔						✔		
Fort Wright College Spokane 99204			✔	✔	✔					✔										
Gonzaga U. Spokane 99258				✔	✔					✔										
Pacific Lutheran U. Tacoma 98447		✔	✔	✔	✔					✔	✔	✔						✔		

College	Administration/Management	Advertising	Architecture	Art History	Art Education	Art Therapy	Crafts/Fabrics	Fashion Design	Film/TV/Video	Fine Arts	Graphic Design/Computer Arts	Illustration	Industrial Design	Interior Design	Landscape Architecture	Medical Illustration	Museum Work/Conservation	Photography	Theater Arts/Stage	Associations
St. Martins College Lacey 98503				✔	✔	✔				✔										
Seattle U. 98122				✔	✔					✔										
U. of Puget Sound Tacoma 98416				✔	✔					✔								✔		
U. of Washington Seattle 98195				✔	✔					✔	✔			✔				✔		ASLA
Washington State U. Pullman 99164					✔					✔	✔			✔	✔			✔		ASID, ASLA, FIDER
Western Washington State College Bellingham 98225	✔	✔		✔					✔	✔										
Whitworth College Spokane 99251	✔			✔	✔	✔				✔	✔									
WEST VIRGINIA																				
Bethany College 26032				✔	✔					✔	✔	✔						✔		
Concord College Athens 24712		✔		✔	✔					✔	✔	✔								
Davis & Elkins College Elkins 26241				✔	✔					✔	✔									
Fairmont State College 26554				✔	✔	✔				✔	✔							✔		
Marshal U. Huntington 25701				✔	✔					✔	✔									
Salem U. 26426	✔		✔	✔	✔	✔				✔	✔	✔			✔	✔	✔	✔		
Shepherd College Shepherdstown 25443				✔	✔	✔				✔	✔							✔		
U. of Charleston 25304				✔	✔					✔				✔						ASID
West Liberty State College 26074		✔		✔	✔		✔			✔	✔	✔						✔	✔	
West Virginia State College Institute 25112				✔	✔					✔	✔							✔		
West Virginia U. Morgantown 26506				✔	✔					✔	✔			✔	✔			✔		ASID, ASLA, FIDER, NASAD
WISCONSIN																				
Beloit College 53511		✔	✔	✔						✔								✔		
Carroll College Waukesha 53186									✔	✔									✔	
Carthage College Kenosha 53141	✔		✔	✔						✔	✔							✔		
Lawrence U. Appleton 54912				✔	✔					✔								✔		
Marian College Fond du Lac 54935				✔	✔					✔	✔	✔						✔		
Milwaukee Inst. of Art & Design 53202	✔		✔							✔	✔	✔	✔	✔				✔		NASAD
Mount Mary College Milwaukee 53222	✔	✔	✔	✔	✔	✔	✔	✔	✔	✔	✔	✔		✔				✔	✔	ASID, FIDER
St. Norbert College De Pere 54115				✔	✔					✔	✔	✔						✔		
Silver Lake College Manitowoc 54220				✔	✔					✔	✔							✔		
U. of Wisconsin at Eau Claire 54701	✔			✔	✔					✔	✔	✔						✔		
U. of Wisconsin at Green Bay 54302				✔	✔					✔	✔							✔	✔	
U. of Wisconsin at La Crosse 54601				✔	✔					✔	✔									
U. of Wisconsin at Madison 53706				✔	✔					✔	✔	✔		✔	✔			✔	✔	ASID, ASLA, FIDER, NASAD
U. of Wisconsin at Milwaukee 53201				✔	✔					✔	✔		✔					✔		
U. of Wisconsin at Oshkosh 54901	✔			✔	✔					✔								✔		
U. of Wisconsin at Parkside Kenosha 54141				✔	✔				✔	✔								✔		
U. of Wisconsin at Platteville 53818				✔	✔					✔	✔	✔						✔		
U. of Wisconsin at River Falls 54022				✔	✔	✔	✔	✔	✔	✔					✔	✔		✔		
U. of Wisconsin at Stevens Point 54481		✔	✔	✔	✔					✔	✔			✔				✔		ASID, FIDER, NASAD
U. of Wisconsin at Stout Menomonie 54751				✔	✔	✔				✔	✔	✔	✔	✔						ASID, NASAD
U. of Wisconsin at Superior 54880	✔			✔	✔	✔				✔								✔		
U. of Wisconsin at Whitewater 53190				✔	✔					✔	✔	✔						✔		
Viterbo College La Crosse 54601	✔			✔	✔					✔								✔		

	Administration/Management	Advertising	Architecture	Art History	Art Education	Art Therapy	Crafts/Fabrics	Fashion Design	Film/TV/Video	Fine Arts	Graphic Design/Computer Arts	Illustration	Industrial Design	Interior Design	Landscape Architecture	Medical Illustration	Museum Work/Conservation	Photography	Theater Arts/Stage	Associations
WYOMING																				
Teton Inst. of Art & Photography Jackson 83001				✔	✔	✔				✔										
U. of Wyoming Laramie 82071			✔	✔	✔				✔	✔										
PUERTO RICO																				
Catholic U. of Puerto Rico Ponce 00731		✔	✔		✔				✔	✔										
Inter American U. of Puerto Rico San German 00753		✔	✔		✔					✔						✔				
U. of Puerto Rico Mayaguez 00708		✔	✔		✔					✔								✔		
U. of Puerto Rico Rio Piedras 00931		✔	✔		✔				✔	✔										
U. of Puerto Rico San Juan 00931		✔								✔								✔		
CANADA																				
ALBERTA																				
Alberta College of Art & Design Calgary T2M 0L4					✔					✔								✔		
U. of Alberta Edmonton T6G 2C9		✔								✔	✔		✔							
U. of Calgary T2N 1N4			✔	✔	✔					✔								✔		
U. of Lethbridge T1K 3M4			✔	✔	✔				✔	✔								✔	✔	
BRITISH COLUMBIA																				
Kootenay Sch. of Art Nelson V1L 3C7	✔		✔	✔			✔	✔	✔	✔	✔	✔						✔		
U. of British Columbia Vancouver V6T 1W5		✔	✔							✔										
U. of Victoria V8W 2Y2			✔		✔					✔								✔		
MANITOBA																				
U. of Manitoba Winnipeg R3T 2N2		✔	✔		✔					✔	✔			✔	✔			✔		
NEW BRUNSWICK																				
Mount Allison U. Sackville E0A 3C0			✔							✔								✔		
U. de Moncton E1A 3E9			✔	✔	✔				✔	✔								✔		
U. of New Brunswick Fredericton E3B 5A3		✔	✔		✔	✔			✔	✔	✔							✔		
NOVA SCOTIA																				
Technical U. of Nova Scotia Halifax B3J 2X4		✔	✔							✔								✔		
U. of Nova Scotia College of Art & Design Halifax B3J 3J6	✔	✔	✔			✔	✔	✔								✔				
ONTARIO																				
Artists' Workshop Toronto M5S 2M7			✔				✔	✔	✔	✔	✔	✔						✔		
Carleton U. Ottowa K1S 5B6			✔																	
McMaster U. Hamilton L8S 4M2			✔							✔										
New Sch. of Art Toronto M5S 2M7			✔				✔	✔		✔								✔		
Ontario College of Art Toronto M5T 1W1	✔	✔	✔				✔	✔	✔	✔	✔	✔	✔					✔	✔	
Queens U. Kingston K7L 3N6			✔	✔						✔										
St. Lawrence College of Applied Art Cornwall K6H 4Z1		✔		✔			✔	✔	✔						✔					
U. of Guelph N1G 2W1			✔		✔				✔	✔					✔			✔		ASLA
U. of Ottawa K1N 6N5	✔		✔		✔				✔	✔								✔		

	Administration/Management	Advertising	Architecture	Art History	Art Education	Art Therapy	Crafts/Fabrics	Fashion Design	Film/TV/Video	Fine Arts	Graphic Design/Computer Arts	Illustration	Industrial Design	Interior Design	Landscape Architecture	Medical Illustration	Museum Work/Conservation	Photography	Theater Arts/Stage	Associations
U. of Toronto M5S 1A1		✔	✔				✔	✔	✔						✔					ASLA
U. of Waterloo N2L 3G1			✔		✔			✔	✔	✔	✔						✔			
U. of Western Ontario London N6C 1E9			✔							✔							✔			
U. of Windsor N9B 3P4			✔			✔				✔							✔			
York U. North York M3J 1P3										✔							✔			
SASKATCHEWAN — *see below* QUEBEC																				
Concordia U. Montréal H3G 1M8			✔	✔	✔	✔		✔		✔								✔	✔	
Loyola of Montréal H4B 1R2		✔	✔							✔				✔	✔			✔		
McGill U. Montréal H3A 2T6	✔	✔																		
Sir George Williams Campus Montréal H3G 1M8			✔	✔		✔		✔		✔		✔						✔	✔	
U. de Montréal H3C 3J7			✔					✔		✔										
U. de Québec Trois Rivières G9A 5H7		✔	✔			✔				✔										
U. Laval Québec G1K 7P4								✔	✔	✔	✔						✔			
SASKATCHEWAN																				
U. of Regina S4S 0A2		✔	✔			✔			✔											
U. of Saskatchewan Saskatoon S7N 0W0		✔	✔			✔			✔								✔			

Index

Acknowledgments

In the year it took to compile all the illustrations, photographs, and interviews necessary to authenticate and complete the revision of this book, we contacted many dozens of people for help. Top designers, artists, architects, photographers, and craftspeople responded with everything we needed. We especially want to thank Bride Whalen, executive director of the Society of Publication Designers for introducing us to so many talented and productive designers; and also Barry Tronstad, director of the Technology Development Center in Ventura, for introducing and guiding us through the digital-design and multimedia maze.

We also want to thank architects Frank Gehry, Michael Graves, Arata Isozaki, Richard Meier, Cesar Pelli, Michelle Rickman, and Donald Stull; interior designers Steve Chase, Zoltan Kovacs, and Linda Umgelter-Shull; trade show booth designer Neil Forsythe; graphic and digital designers Mitchel Ahearn, Gary Ashcavi, Ed Benguiat, Norbert Florendo, Tobias Frere-Jones, Garry Gaber, Wayne Hunt, Ron Kriss, Ed Noriega, and Mike Salisbury; illustrators Don Maitz, George Molina, and Chris Polentz.

Also helpful were editorial designers Joy Aquilino, Janis Owens, Charles Pates, Douglass Scott, and Bride Whelan; calligrapher Marilyn Pinaud; cartoonist Jim Borgman; food stylist Shirley Seto; photographers Mark Berndt, Douglas Bradshaw, Clayton Fogle, Betty Jenewin, Craig Schwartz, and Fred Watkins; industrial designers Afaf Farah, John Gardiner, Terry Herron, William J. Knight, Sam Lucente, Stephen Peart, Douglas Spranger, and Bryan Zvibleman; toy designers Lorraine Alkire, Sean Lee, and Larry Wood; furniture designers Charles Gibilterra and Sam Maloof; and fashion designers and illustrators Stephen Bieck, Vickie Estridge, and Jane Wu.

We also are indebted to publisher Wendy Rosen; film-and-animation people Marci Gray, David Master, and Tim Sarnoff; entertainment-business artists Bob Crowley, Ron Husmann, K. Ruby, and Daniel John Smith; artists Doris Bally, Steven DeLair,

Louis Dow, Edward Forde, Marianne Hunter, Harrison McIntosh, Kent Twitchell, and Kent Ullberg; art writers Joyce Cohen, Stephen Doherty, David Pagel, and Norman Sibley; art educators and art-school administrators Frances Anderson, Jody Brotherston, David Brown, Kit Brown, Timothy Christian, Edmund B. Feldman, Steven Lavin, Gabriel Olszewski, Al Porter, David Rhodes, and Diane Seidensticker.

We appreciate the help of museum and gallery directors Bill Hill, Richard Koshalek, Isaac Lopez, Sheila Low, Louis Newman, and Myrna Smoot; art-services providers Richard Hernandez, Michelle Isenberg, and Dan Smith; and art therapist Susan Sabini.

Finally, we want to acknowledge Rebecca Bubenas at the J. Paul Getty Trust, Ian Rand at Livent, Inc., Kevin Thays at Fiskars, Christa Reed at the Brooks Institute of Photography, and the researchers at the TRW photo library for help with photo acquisitions. Tom Sarris and Jeremy Salesin at LucasArts Entertainment Company and Neil Hoffman and Michael Fuller at Otis College of Art and Design provided invaluable information as well.